COLORS FOR FASHION

COLORS FOR FASHION

NANCY RIEGELMAN

NINE HEADS MEDIA

Colors for Fashion—Drawing fashion with colored markers by Nancy Riegelman

Published by 9 Heads Media

Website: www.fashionfinishingschool.com
Copyright © 2013 9 Heads Media

Printed in China

Publisher's Cataloging-in-Publication Data

Riegelman, Nancy

Colors for Fashion—Drawing fashion with colored markers by Nancy Riegelman
1st edition

336pp 33 x 23 cm

ISBN: 978 0 9702463 6 3

1. Fashion Drawing 2. Drawing—technique I Title

Lib. Cong. Class. No. TT509 DDC 741.672

The paintings by James Whistler and Sir Joshua Reynolds are reproduced courtesy of the Tate Gallery, London and Art
Resource, New York; the painting by Jean-Honoré Fragonard is reproduced courtesy of the Hermitage Museum, St.
Petersburg, Russia and Art Resource New York; Vik Muniz's work appears courtesy of Brent Sikkema Gallery in New York,
Xippas Gallery in Paris and Fortes Vilaça, São Paulo. The drawings by Ruben Alterio and Demetrios Psillos appear cour-
tesy of the artists. Inquiries regarding these artists should be directed to the publisher.

colors for fashion

contents

colors for fashion

nancy riegelman

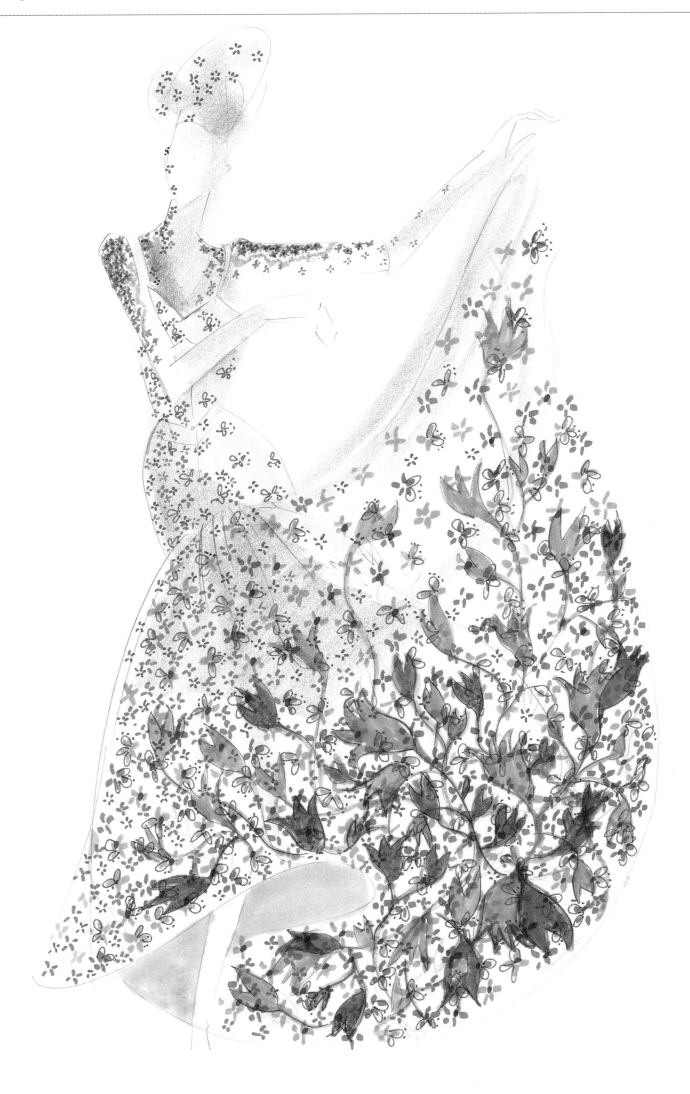

colors for fashion

Colors for Fashion

Colors for Fashion is written for all those who wish to learn how to draw fashion to an advanced level, in color. It is the second part of a complete course in drawing fashion, following on from *9 Heads—a guide to drawing fashion by Nancy Riegelman* and covers all aspects of fashion drawing from an intermediate through to an advanced level.

While, as the title suggests, the focus of *Colors for Fashion* is on drawing in color, the book has in fact a broader purpose—to teach how to draw fashion to an advanced level, an important aspect of which is of how to use color, a key element of fashion and fashion drawing.

Colors for Fashion is written for all those who love to draw, love drawing and love fashion and are interested in developing advanced fashion drawing skills. It can be used as textbook for intermediate to advanced fashion drawing courses at university level, as a self-teaching guide for those who wish to learn to draw to be able to give expression to their own design visions or for students of fashion who are keen to hone their drawing skills, increasingly valued in today's highly competitive market for jobs in the fashion industry.

Drawing with Colored Markers

The drawing medium used in *Colors for Fashion* is colored markers, now universally accepted as the best medium for drawing fashion, being quick, convenient, easy-to-use and learn and quite economical compared to more traditional artistic media. All the techniques for mastering the use of colored markers are shown in detail, along with extensive information on how to make selections of markers, the small amount of other equipments and materials required for working with markers, and how to use markers in combination with other artistic media, such as colored pencils and gel pens, to achieve powerful graphic effects. All of the large number of drawings in cluded in this book (except a small number of examples of drawings using ink, pencil or watercolors) were created with colored markers.

Drawing with other media

While the emphasis is on drawing with markers, extensive use is also made in *Colors for Fashion* of colored pencils, often in combination with markers, and the techniques demonstrated in the book are all easily adaptable to other media, such a gouache or watercolors.

Drawing—the most powerful tool for designing fashion

Underpinning the content of *Colors for Fashion* are a number of strongly held views about fashion and fashion drawing: First, drawing is the most powerful tool that exists for designing fashion. It is a basic and necessary skill for fashion designers, and one that gives important advantages to those professionals who acquire it.

Drawing is a unique and extremely flexible tool for communicating fashion ideas: Drawing allows us to communicate ideas for new garments, (or changes to existing garments) quickly, easily and almost without cost. Drawing not only allows us accurately to communicate the physical characteristics of a garment (often one that does not exist), the silhouette, detailing, fabric type and weight, fit and drape, but also to give a good sense of the mood of the garment, how it should be styled, the age group and market it is intended for.

Drawing is the universal language of fashion design: if we can draw then we can communicate much more quickly and effectively than if we are unable to and have to rely on spoken or written language. If we can speak, read and write a language—a written and spoken language, that is— with a high degree of proficiency then we are able to communicate more effectively with those we live and work with. In the same way, being able to draw "well" (and we will discuss what that means shortly below) will allow us to communicate our fashion ideas more effectively. If we are a fashion designer or other fashion professional or a student of fashion this skill will give us an enormous advantage in developing our ideas and communicating them to others.

colors for fashion

demetrios psillos

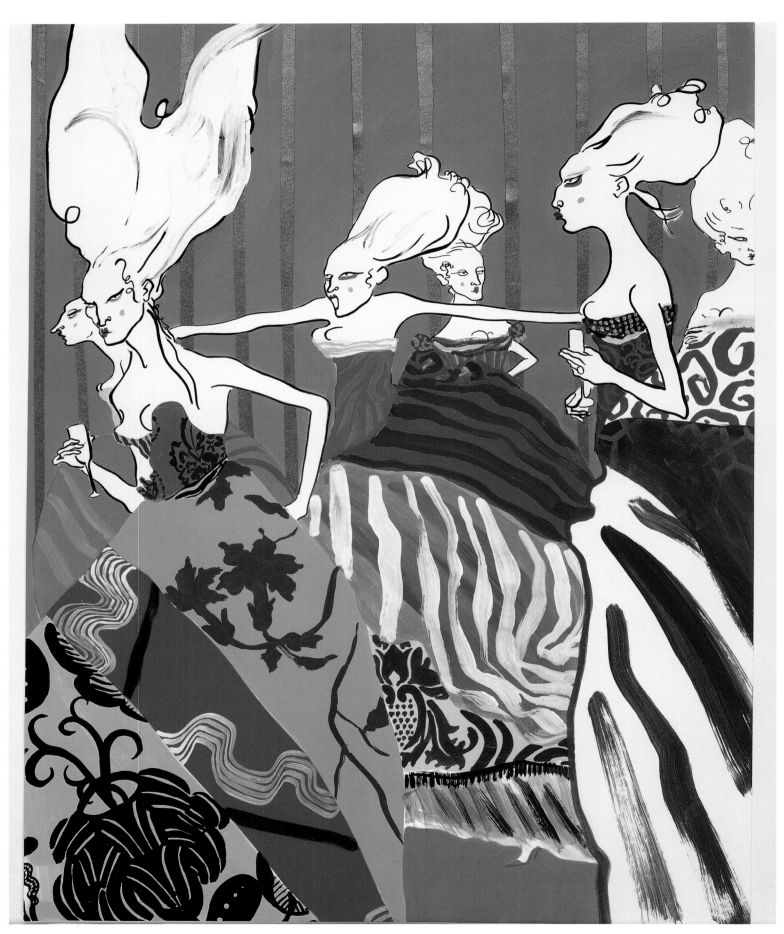

Demetrios Psillos
Ball-Gown

colors for fashion

learning to draw/colored markers

Drawing–a skill that can be acquired by all

One of the other strong convictions uderlying the instructional content of this book, and one that has become progressively stronger over many years of teaching successive genera- tions of students of fashion, is that **it is possi- ble for almost anyone to learn to draw fashion to a degree of competence where they can communicate design ideas accu- rately, in an attractive and effective man- ner.**

This conviction flies in the face, of course, of most popular preconceptions about drawing skills–that an ability to draw is a "gift" that some have and some do not. In the author's long experience this is not true. Some will find learning to draw easier than others but every- one has to learn and the important thing is that virtually everyone is able to learn. Of the thousands of students the author has taught the great majority have after an introductory course of three months been able to draw well enough to create easily understandable, accurate and attractive design drawings.

It should also be remembered that fashion drawing is a tool of design; the end product is not the drawing itself but the garment it repre- sents. Our interest is not to create beautiful fashion drawings--those are a bi-product--but to create beautiful designs. We should all strive to learn to draw as well as possible, of course, but what matters most is acquiring a level of skill where we can communicate our fashion ideas clearly, accurately and with a degree of realism that allows them to be easi- ly understood.

This book teaches how to achieve that level of skill–a level that is advanced, and requires an investment of time and effort over at least a period of months to attain, but which almost everyone, if they make that investment, can attain.

How long does it take to learn to draw fashion?

Very often the most rapid progress in learning to draw fashion comes at the early stages. Beginners–students of fashion drawing with no prior formal instruction or self-instruction using a guide like 9 Heads--will over the course of a three-month period studying about 3 hours a week usually acquire a degree of competency that can be considered as an intermediate level. Developing skills from an intermediate to an advanced level–the phase covered by this book– can take longer, depending on the amount of study and prac- tice, but usually takes three to six months studying at least 3 hours a week.

Those who are reading this book are more than likely already well into their studies of fashion and fashion drawing and are well aware of the benefits that come from being able to draw fashion well. Even for those who do not find the process easy, if a firm commit- ment is made then with practice and experi- ence the skills will eventually come.

What is "good" fashion draw- ing?

This book is about learning to draw fashion *well*, to a relatively advanced level. What exactly, though, does drawing "well" mean? What is good drawing? What are the aspects of "good" fashion drawing that make it so powerful and valuable to the designer?

There is in fact more than one single aspect of drawing that makes it "good", and as these aspects of good fashion drawing are appear in the teaching throughout this book it is worth- while considering them here:

Accuracy and Realism in Fashion drawing

First, fashion drawing is a type of design drawing where the main purpose of the draw- ing is to depict accurately and realistically an object—in this case a garment, (or, of course, a part of a garment or an outfit of garments). We would like our drawings to be as accurate and realistic as possible so that they give a very clear idea of the garment we have in mind. Ideally, in fact, we would like our draw- ings to be so clear and accurate that, with per- haps only a little extra information on sizing, we could give them to a seamstress and she would be able to make up the garment from the drawing alone.

colors for fashion

christian lacroix

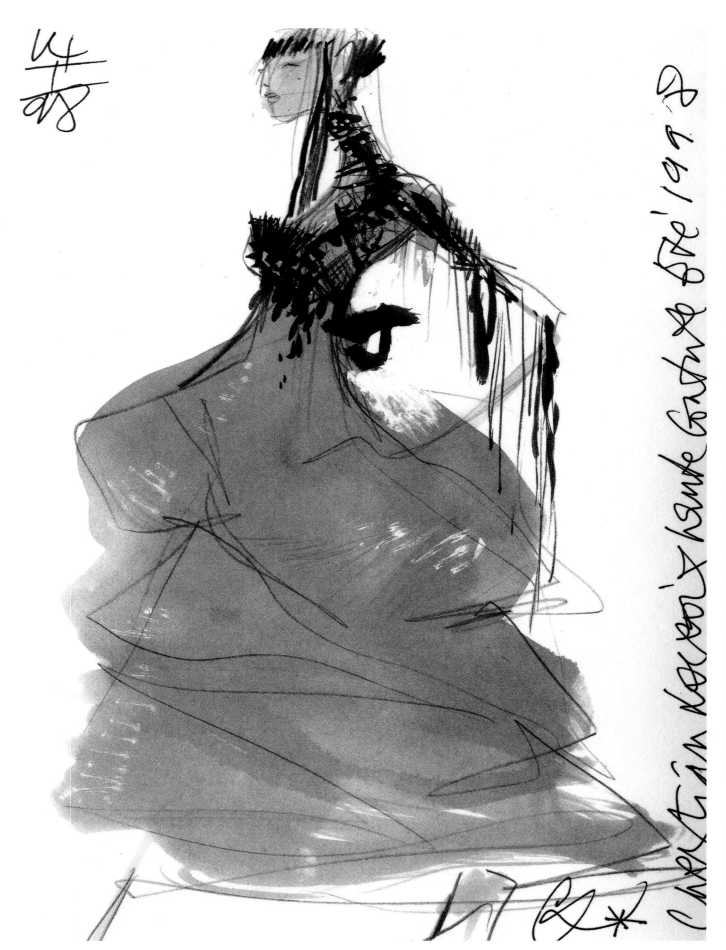

Christian Lacroix
Spring Collection 1998

colors for fashion

Over the last decade with the widespread growth of the internet and social media women's fashion has evolved at an increasingly faster pace than ever before. Communication of styles and trends is now virtually instantaneous and design and production cycles have shrunk considerably. As a result, the need to communicate new fashion ideas quickly and accurately is greater than ever.

What, though, is "realism" in fashion drawing. It is in fact a matter of degree: At one extreme we have photo-realism, where drawings look almost like photos. This is a level of realism that is difficult (sometimes impossible) and time-consuming to achieve and usually not worth the considerable effort it requires, seldom conveying any more information than much "less realistic" drawings. At the other extreme are drawings where the type of garment, its color, shape and details can be seen, but little else besides: the drawing might give little or no idea of the three-dimensional form of the garment, the type of fabric it is made from, whether it is shiny or matt, its texture and weight, how it drapes and forms folds and how it is cut and fits the body.

These, though, are the most important features of a garment. If we can clearly see all these different aspects of a garment in our drawings it will be possible immediately to understand the garment: the image they conjur in our mind's eye will be of a real garment. This is the level of accuracy and realism we need to incorporate into our fashion drawings if we wish them to communicate our ideas clearly and unambiguously.

Accuracy and realism is more important in some areas of fashion drawing than others, but, as a rule, as we are making our drawings to communicate ideas about things—garments—rather than as works of art, making our drawings to a degree of accuracy and realism in the way outlined above almost invariably makes sense.

A note should be made on personal style v. accuracy and realism: It is not being suggested that accuracy and realism should be strived for at the cost of compromising our own personal styles. If, for example, we like to make our

heads large, or our croquis with fuller-than-normal figures, then although this deviates from strict accuracy and realism, we can do so as long as we are clear and consistent. If we are consistent this artistic license will quickly be recognized as part of an individual style and allowance made. This book does not in fact make any judgment about whether one style of drawing is preferable to any other. A wide range of different drawing styles are included in the book, including examples in this introduction by a number of acclaimed illustrators, and are all equally valid. The criteria for "good" fashion drawing lie outside of considerations of style.

Conveying information

The second aspect of "good" fashion drawings is that our drawings should communicate as much information as possible about the garments. This requirement is obviously related to the previous one of realism and accuracy and sometimes the two cannot be separated: often if information is not conveyed with accuracy then it can be said that no information is conveyed at all. For example if we want to indicate the type of fabric a garment is made of in a drawing then we draw it accurately, giving a realistic representation of the surface appearance of the fabric and how it drapes, forms folds and fits the body. If it is not drawn accurately then it will not be possible to say what the fabric is and we are not really conveying information.

Apart from these instances, though, where information has to be accurate in order to be considered information, we sometimes separately have to be aware of the type and amount of information we are conveying in our drawings: We do not usually design our garments in a vacuum but have a clear idea of the type of person who will wear our garment and when and where it will be worn: the gender and age of the wearer; the type of occasion; the season; indoors or outdoors; what budget it is designed for, and so on. We can, to varying degrees, convey this type of information in our fashion drawings in the way we style our drawings: In fashion drawing the emphasis is always on the clothes themselves but we usually draw clothes on the figure, and the way we draw the figures and the other graphic elements we include in our drawings by way of background

colors for modern fashion

sir joshua reynolds

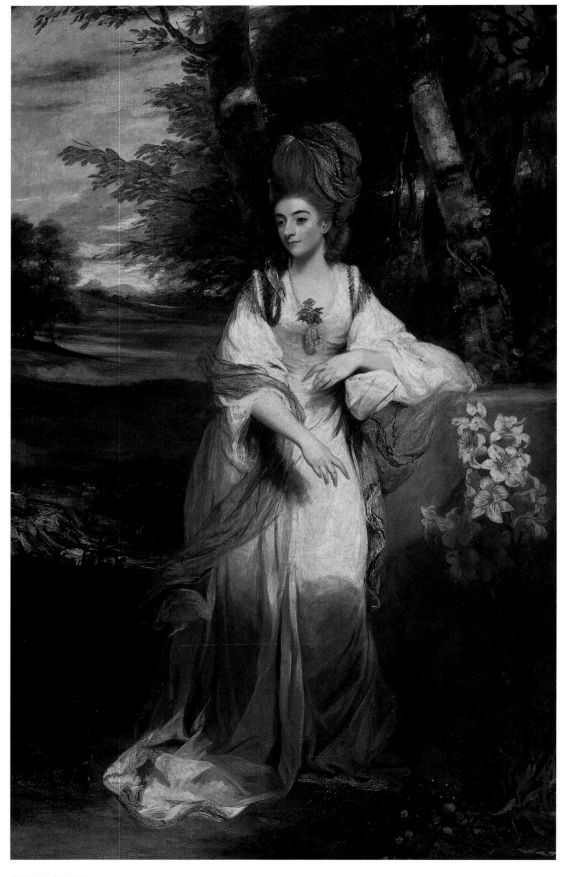

Sir Joshua Reynolds
Lady Bampfylde
Tate Gallery, London, Great Britain

colors for modern fashion

how this book is organized

or decorative elements—in short, the way we compose our fashion drawings, can provide information that help us understand the intention behind the design of the clothes. An important part of styling is, just as in real life, the way we accessorize our figures. In drawing, our choice of accessories is only limited by our imaginations, so we ample scope to choose the right accessories to convey exactly the right information about the garments.

Fashion drawings must be attractive and engaging

The third aspect of "good" fashion drawing is, quite simply, that our drawings must be as attractive and engaging as possible.

Fashion itself is designed to be attractive and to make us appear attractive when we wear it. We all respond to attractive things and our drawings will command more attention and find a better reception if they are attractive. "Attractive" is of course subjective, but we can at the very least make our best efforts when drawing.

A large part of what is considered good taste and design is based on principles and elements that are discussed in depth in this book, along with how to make effective and attractive drawings of well-designed garments. Younger students of fashion whose tastes and preferences are still developing will benefit from becoming aware of these principles, which do not have the same status as laws of physics or mathematics, but have evolved over several centuries as beliefs held by most of those with talent and proficiency in this area. As with theory underlying the nature of color and how colors interact with each other, which is covered in the same chapter (Chapter Two), this part of the book is somewhat abstract and sometimes not easy to follow, but it is knowledge that often has unexpected practical application and can be referred to time and again for enlightenment and inspiration.

These aspects of fashion drawing, then— **accuracy and realism, the conveying of information and drawings that are attractive and engaging** are what it is believed fashion drawing has to embody to be considered "good" fashion drawing , the qualities necessary for fashion drawing to be effective and achieve its goals. These aspects of fashion drawing are the continual focus and essence of the teaching of this book and are reflected in all the drawings.

Hand drawing v Drawing with computers/ using computer software programs

Another increasingly important aspect of fashion drawing is the use of computer software applications in the drawing process.

Computers have become part of every aspect of our everyday lives and are as frequently used throughout the fashion industry as anywhere. It is now possible to draw directly on a computer—there are numerous applications available that work with touch screen tablets using a stylus. Some of these programs offer some advantages of speed and ability to introduce shading and textures more quickly than they could be drawn by hand.

What is often overlooked, though, is that drawing on a computer tablet is simply drawing in a different medium; a computer can make some aspects of drawing easier and quicker but it does not draw by itself. To be able to draw well on a computer it is necessary first to learn to draw, in other words to acquire, besides the particular skill set of drawing with pencil, pen, markers or other tools, the body of knowledge about drawing that is independent of the medium: how to understand the appearance of light and shadow on surfaces, perspective, line weight and so on.

In some areas of fashion drawing the use of Photoshop and Illustrator is well established. Virtually all modern communication is digitized and portfolio drawings are almost all scanned and digitized for ease of reproduction and transmission and sometimes digital enhancement. The latest edition of 9 Heads includes an extended section with tutorials on how to prepare and make minor changes to drawings using Photoshop.

When it comes to using computer programs to create fashion drawing, however, except for the production of usually two-dimensional flats, the results are not always impressive, often, unless ideas of shading and drape are consciously applied, looking flat and charmless. Until the

colors for modern fashion

nancy riegelman

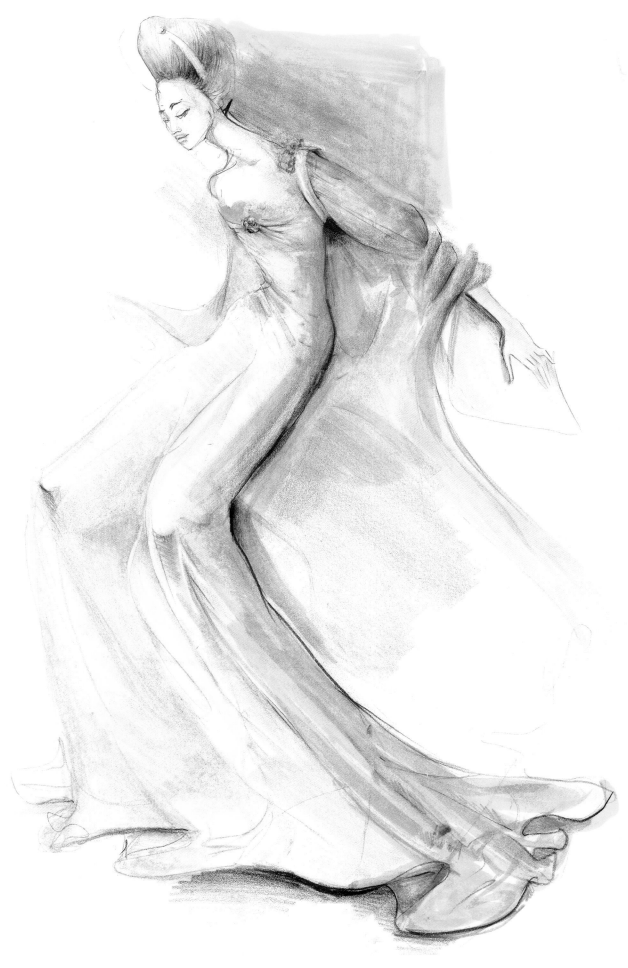

Nancy Riegelman
21st Century Lady Bampfylde

colors for modern fashion

overview of/how to use this book

capabilities of the technology, but the effects should be evaluated dispassionately and an honest evaluation be made of whether they indeed add to the underlying hand drawing. It almost invariably seems to be the case that the effectiveness of drawings that have been manipulated in Photoshop depends on the quality of the hand drawn inputs.

The Evolution of *Colors for Fashion*

Colors for Fashion has evolved from its predecessor book. *Colors for Modern Fashion*, first published in 2006. Those familiar with its predecessor will recognize that many drawings and indeed whole sections of some of the chapters have been woven into the fabric of this new book. So much has changed, though, that it was felt necessary to re-name the book rather than issue it as a new edition of the old.

Perhaps the most striking difference in the teaching of fashion drawing at the time of writing compared to when *Colors for Modern Fashion* was first published is the adoption of colored markers as the principal medium for drawing, for reasons discussed earlier in this introduction. Drawing styles have evolved and are for the most part are now more graphic, less "artistic" that those seen a decade or so before. The drawings shown in *Colors for Fashion* mostly reflect this more graphic look.

What is always the case–or, in the author's view, what should always be the case (but not always is)–with books on fashion drawing is that they must be fully revised at least every 6-8 years to update the fashion. Our desire to draw fashion reflects our need to be constantly on the leading edge, to be anticipating the designs of the future, not admiring those of the past. If we can learn the most important tool of our trade working with designs that are contemporary then our efforts will seem that much more relevant and appropriate. This thought was also behind removing the word "modern" from the book's title: by definition all fashion is "modern" and to call it so seemed, on reflection, oxymoronic.

While working with the possibility of a completely fresh approach in deciding what to include in *Colors for Fashion*, the structure that emerged was surprisingly similar to that of its predecessor. The chapter on marker technique was clearly indispensable, and is virtually unchanged from the predecessor. Likewise, the theory-heavy chapter on **Composition and Design,** including sections on the principles and elements of design and color theory, was felt to be necessary but has been refined and modified, though is still in some ways a work in progress.

The other chapters of the book seemed also to define themselves as they had done for its predecessor (with the exception of **Basic garments** which was felt to be no longer necessary). **Fabrics, Beginning to Draw, Women's, Men's and Children's Fashion** are all central to fashion drawing. The approach in some of these chapters evolved significantly, however, mainly in response to experiencing first hand where students continued to have difficulties. **Chapter Three: Fabrics** now includes a much more detailed overview of the process of shading and the differences between various types of fabrics, techniques that are central to developing advanced fashion drawing skills. It now includes step-by-step instructions of how to shade a range of basic garments. **Chapter Four: Beginning to Draw** uses the same step-by-step demonstrations of how fashion drawings are constructed as before and as this method has proven most effective in helping students develop their drawing skills it is now extended into **Chapter Six: Women's Fashion** where drawings are broken down into three steps. **Chapter Seven: Men's Fashion** and **Chapter Eight: Children's Fashion** are updated overviews of those areas. The main techniques for drawing clothes in those areas are the same as for women's fashion and those looking to draw particular types of clothes will, if not encountered in those chapters, find similar clothes in Chapter Six to act as examples. As mentioned above, an **Appendix** has been included to give some pointers on how to use Photoshop in conjunction with hand drawing to extend the graphic range of one's drawing.

materials and equipment

traditional artistic media/markers

Oils and watercolors. These types of paints each have a set of advantages and disadvantages as disucssed in the text.

Pastels. Like pencils, pastels are a "dry"medium, easy-to-use but not the best choice for producing deep saturated colors or covering a large area of paper evenly.

Markers and Traditional Media

Over the last decade or so colored markers (usually referred to simply as "markers") have come to be used extensively in fashion drawing. Before markers were used fashion drawings in color were made using watercolors, oils and other media, which are still used to varying extents today. Using these traditional media to make fashion drawings is a longer process and one that requires more effort: given the speed and ease-of-use of markers it is possible to produce accurate and realistic drawings in color much more quickly, output is increased and more ideas can be developed to a more advanced stage than was usual before they came into use.

To understand how markers are used and to appreciate some of their advantages, it is revealing to compare them directly with the traditional artistic media that were in use for several centuries before their invention. Some of these media are still used to stunning effect in fashion drawing today by a number of contemporary illustrators and designers, some examples of whose work are included in this book.

Oils.

Oil paint is made of oils and pigments and is diluted in a number of ways, usually with the use of linseed oil and turpentine. There are numerous techniques for applying oil, both with wet-on-wet and wet-on-dry coats.
Advantages: A wide variety of effects can be achieved, with a full range of hues and values, transparencies and saturations. Oil is the only "paint" that can be applied in very thick layers so that the surface of the painting appears to have a textural depth. The effect of "luminosity" —the appearance of light originating inside the painting—is stronger with oils than any other medium.
Disadvantages: Complex preparation; very slow drying for wet-on-dry application, expensive and difficult to learn and use.

Watercolors.

Watercolors are pigments that are soluble in water. They can be applied wet-on-wet or wet-on-dry.
Advantages: Watercolors are relatively easy to prepare and apply. By varying the degrees of dilution a number of effects can be achieved, including unique transparencies and tonal variations. Watercolors have a special and unique "luminosity", particularly when applied on white paper.
Disadvantages: It is difficult to achieve opaque, highly saturated colors using watercolors. Though not as long as for oil, the drying time between coats can be lengthy.

Gouache.

Gouache is a water-based paint but with different ingredients from watercolors that give it more opacity. It can be applied wet-on-wet and wet-on-dry.
Advantages: A wide variety of effects can be achieved, from dense opacity to luminosity approaching that of watercolor. Its opacity makes it ideal for covering large areas.
Disadvantages: Gouache tends to crack if applied too thickly. It lightens in color as it dries, does not

have the depth and texture of oil and does not quite achieve the transparency of watercolor. It is also relatively expensive.

Acrylic.

Acrylic is a synthetic paint made of pigments in an emulsion base. It is soluble in water and a number of gels and can be applied dark over light and vice versa.
Advantages: Acrylic dries quickly, is versatile in use and long-lasting. It is possible to achieve a wide variety of effects with acrylic.
Disadvantages: The preparation for acrylic is complex; it dries more quickly than oils but is still slow compared to some other media. Acrylic is an expensive art medium.

Colored pencils/pastels.

These are dry media that can be used directly and do not need further media for application onto paper. Colored pencils come in wax-based, pastel-based or water soluble forms. Wax-based are most common. Pastels are either so-called soft pastels—dry crayons of powdered pigment bound in a gum solution—or oil pastels, which are pigment in a wax and fat base.
Advantages: Quick and easy-to-use, relatively cheap. Blend easily and can usually be easily erased; they produce a range of subtle effects, are good for fine, detailed work, and combine easily with other media, such as markers.
Disadvantages: Do not easily produce saturated applications of color; it is difficult to cover large areas evenly.

Colored Markers.

Available with solvent-based inks (permanent markers) and water-based inks (watercolor markers). Markers have a range of felt tips so they can be applied in variety of thicknesses.
Advantages: Quick and easy-to-use. Easy-to-learn—techniques can be mastered in hours, compared with weeks or longer for other media. Efficient and clean, no preparation and no clean-up is necessary. Markers blend easily with other markers and colored pencils. Markers are available in wide range of colors and produce a wide range of effects including high saturation and luminosity. Color-coded markers can be calibrated to computer colors and color systems such as Pantone®.
Disadvantages: Markers make a permanent mark that is difficult to erase or change with darker colors.

materials and equipment

markers/purchasing markers

A typical selection of markers for beginners. It is best first to buy a set of twelve to fifteen markers corresponding to the twelve hues of the color wheel (see Chapter Two) plus black and grey and a colorless blender.

Selection of markers for more advanced users. Grey tones, neutrals and pastels have been added to the beginner's selection.

Materials and equipment needed for drawing with markers

Colored markers are a versatile drawing and coloring medium that combine well with a number of other media. In this book markers are used together with other materials and equipment to achieve the effects used to make the fashion drawings shown here. The amount of other materials and equipment needed is relatively small, and is all that is needed to achieve all the effects required for the drawings shown in the book. Even when taking the other materials and equipment into account markers are one of the most economical media for producing drawings with a full range of colors and effects.

The additional materials are, most importantly, **colored and black (lead graphite) pencils**, which add a range of soft and subtle effects to markers; **white gel pen** for highlights and **ink pen** for fine contour or detail work. Markers do, however, also combine well with paints of various types, pastels and inks, and the more adventurous might wish to explore some of these other combinations once the main techniques for applying markers and the additional media used in drawing fashion have been mastered.

The materials and equipment used for drawing with markers are described below, and recommendations are given for purchasing an initial suppy and for how to add to it. These materials are all available at art supply stores or on-line outlets.

Colored Markers

The markers used in this book are **permanent markers**—inks in an alcohol solvent base. The marker ink is held in a felt pad inside the body of the marker and flows onto the paper through the tip, which can be of two or three different widths. Most markers have a broad beveled tip at one end and a fine tip at the other; some have two fine tips.

When first introduced, the range of marker colors was limited. Nowadays literally hundreds of colors are available, often with ranges of values and intensities for specific colors, full ranges of blacks, greys, neutrals and even fluorescents. A number of trends have caused this expansion, one that has been particularly influential being the rise in popularity of Japanese manga comics that has given rise to the development of new ranges of metallic and iridescent colors. Markers are now available that correspond with standard printing colors and, as mentioned, coded to match color recognition systems.

Purchasing Colored Markers.

When purchasing markers the color is always indicated on the outside by a name, number, cap color or combination of those, and marker manufacturers provide charts with the range of colors available. It is always best, however, to test the marker before buying to check the color and freshness. A fresh marker will make clean, even strokes with no variation of color or intensity over an area of a few strokes. It should not be necessary to press down hard on the marker: markers that require pressure

to make a mark, and that "squeak" in use, are partly dried out and will not function as well as fresh markers. It should also be noted that a marker's color will vary according to the paper that is used (see below). If in doubt, the art supply store will usually supply a sample of the actual paper that will be used for drawing to test the color.

When making a first purchase of markers, it is best to buy a set of twelve markers corresponding to the twelve hues of the color wheel (as shown in the picture at left—the color wheel is discussed in the next chapter of the book) *plus* black and a grey—perhaps a cool grey 10%, according to taste—*plus* a colorless blender. Using colorless blender, a wide range of colors can be achieved by mixing these first markers, and new marker colors can be added over time. More colors mean more flexibility.

Markers are available from a number of companies. The drawings in this book were made using Letraset Tria markers. These markers were chosen for a number of reasons, including the wide range of colors, particularly pastels, ease of use, ease of mixing and that they each have three tips of different widths, giving great flexibility in the type of marks that can be made on the paper. Virtually all the colors used in the drawings of this book, however, can be found in other brands of markers, and the final choice of brand is a matter of personal preference.

Recommendation. Start with a set of 12 to 15 markers corresponding to the hues on the color wheel, plus black and cool grey and a colorless blender. Add new colors as required (or coveted!).

materials and equipment

papers/colored pencils

Specialized marker paper for final drawings.
This paper is particularly suited for use with markers with a number of advantages over other papers. It is moderately translucent and has a medium absorption rate and capacity.

Layout drawing paper used to plan the drawing.

Colored pencils are used to draw the initial croquis and silhouette and are also used to combine with markers to produce a range of subtle and delicate effects.

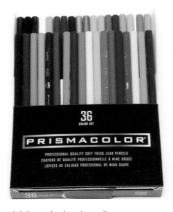

A full set of colored pencils.

Papers

A number of paper manufacturers make specialized marker paper, and a number of other non-specialized papers can also be used when drawing with markers.

Paper, including marker paper, has three main characteristics: the **surface tooth**, the **translucency** and the **ink-absorption rate and capacity**.

The **surface tooth** of a paper is its roughness– or graininess—which is what determines the appearance of marks on the surface. The **translucency** is the amount of light that passes through the paper—how transparent or opaque it is. The **ink-absorption rate and capacity** is the rate at which ink is absorbed by the paper and the total quantity of ink that can be absorbed.

Papers such as **vellum** have a low surface tooth and feel smooth to the touch. Vellum papers have a low absorption rate and marks made on them with markers and pencils appear soft and of limited intensity.

Papers such as **bond** paper have a high surface tooth with relatively high absorption, resulting in intense colors.

Specialized marker paper is moderately translucent, with a medium absorption rate and capacity and a medium-high surface tooth. It allows for a wide range of tonal gradation and color saturation as well as the precise line quality that is necessary for detailed fashion drawing. The translucency, combined with the absorptive properties allows for pleasing, almost luminous type effects to be achieved.

Vellum tracing paper has a very low absorbency rate so does not allow for intense colors or subtle effects, but it is useful for copying or transferring images—for example, some of the croquis included in this book.

For drawings with markers, on balance it is best to use either a specialized marker paper or a bond paper. The drawings in this book were all made using specialized marker paper, which is particularly effective in creating the range of effects developed in this book, but the choice is one of personal taste and the reader should make a comparison before deciding.

Recommendation: For the final drawing use a specialized marker paper or bond paper, depending on personal preference. Use a branded layout or other bond paper for layout drawings and a vellum tracing paper for copying silhouettes.

Colored Pencils

As mentioned, the principal disadvantage of colored pencils is that it is difficult to achieve deep saturation and smooth, even applications over large areas with them. When used together with colored markers, though, they are an almost perfect complement, adding an important range of delicate and subtle effects: Together markers and colored pencils are virtually all that is needed to achieve the full range of colors and effects required for fashion drawing and are used extensively in the drawings throughout this book.

materials and equipment

mechanical pencils/pens/colorless blenders/gel pens/sharpeners/erasers/palettes

Gel pens. Useful for adding highlights to a drawing.

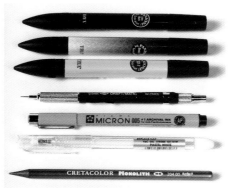

Black marker, colorless blender, turquoise marker, mechanical pencil, Micron.005 pen, white gel pen, graphite pencil. Together with colored markers these tools allow a full range of effects to be achieved.

Wax-based colored pencils are the most common and are easy to apply and blend. They are sturdy and keep a fine point (it is important to work with sharp pencils at all times—best points are achieved with electric pencil sharpeners). A number of good quality brands of colored pencils are available. Pencils are cheap, so the more the merrier.

Recommendation: Start with a set of 12 colored pencils in the same colors as markers plus black and grey. Always use an electric pencil-sharpener to ensure fine, long points.

Mechanical Graphite Pencils

Mechanical pencils are easier to use than wood and graphite pencils: the lead does not need sharpening and line thickness is always uniform. Use a 0.5mm lead. A number of brands are available.

Ink Pens

A specialty pen such as a **Micron .005mm** is best for detailed work. Other brands are also available.

Colorless blenders

Colorless blenders are markers without the color pigmentation and are important for mixing markers and for a number of effects where the original color is diluted and reduced in saturation. They often come in a white tube. and are used extensively for the effects used in the drawings iin this book.

Gel Pens

Gel pens are readily available in a number of brands and in different colors. White is the color used in this book for highlights, though other colors can be used for experimenting.

Electric pencil sharpener. These sharpeners produce better points than manual sharpeners.

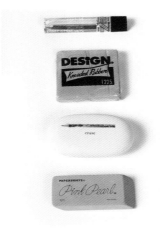

Lead for mechanical pencil, erasers.

Pencil Sharpeners

As mentioned, it is important to draw only with sharp points so fine lines can be achieved (if a wider line is needed a mark can be made with the side of the pencil lead). Plastic pencil sharpeners are almost useless—they make short, stubby points that make short, stubby lines. An electric pencil sharpener is well worth the investment and can greatly enhance line quality. A number of different brands are available.

Erasers

Erasers should always be kept handy. Mechanical pencils often have a built-in eraser. Kneaded erasers knead into any shape to remove marks cleanly and easily without damaging the surface. Pink pearl erasers are good general pencil erasers. Electric erasers are more expensive but can erase large areas more quickly and more cleanly than manual erasers.

Palettes

Sheets of acetate work well as palettes for mixing markers with blender and other media. Tracing and wax papers, which do not absorb the alcohol base of the markers, can also be used.

Acetate palette. Acetate sheets work well as palettes for mixing markers with blender and other media.

marker application and technique

preparing to draw/holding the marker

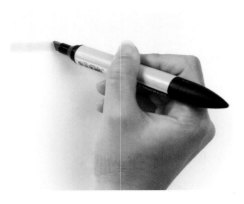

Holding the marker—usual position.
The marker is held in the middle for a long, smooth mark. This is the most comfortable position for holding the marker.

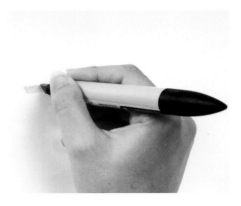

Holding the marker:—short strokes.
The marker is held very close to the tip for shorter strokes.

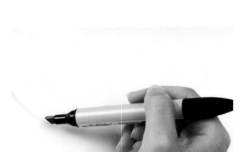

Holding the marker—nuanced lines.
When the broad tip of the marker is being used, a rotation of the wrist brings the beveled (sharpened) tip into contact with the paper, quickly and conveniently changing the width of the line. (called a "nuanced line").

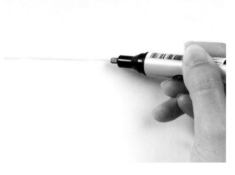

Holding the marker:—detailed work.
The marker is held close to the tip for detailed work.

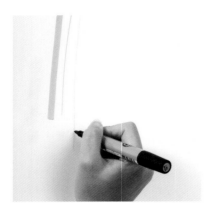

Holding the marker—fine lines.
A fine line is created using the fine tip of the marker.

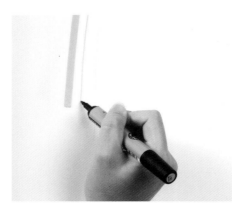

Holding the marker:—medium lines.
A medium line is created using the medium tip of the marker.

Marker Application and Technique

As with all artistic media—oil, watercolors, gouache and the various others—in order to be able to use markers correctly a number of techniques have to be learned. The following section describes and illustrates in detail these basic and essential techniques, those that are used in making the drawings included in this book. Those who do not already have experience using markers should practice *all* the techniques illustrated over the next few pages before attempting to make drawings. This will give a good sense of how markers feel and how different effects are achieved with them.

To attain true proficiency in drawing fashion in color using markers it is essential to master these techniques so they become second nature. When moving on to study and copy the garments included later in the book continual reference should be made to this chapter when a particular technique or effect is mentioned.

Preparing to Draw

Before starting to draw a number of tasks of preparation should be performed:

1. Assemble everything that will be needed for the drawing: the various papers (marker paper for the final drawing, layout paper for preliminary drawings and tracing paper to copy silhouettes), the markers, blenders, pencils, erasers, pencil sharpener, fabric swatches and images.
2. Practice a few croquis to confirm what the pose will be.
3. If the drawing is to be made with reference to actual fabric swatches examine them and decide how they will fit together; hold them to the light and move them to get an idea of how they will drape.
4. Sketch out possible shapes for the hair and gestures and other elements to be included in the drawing.
5. Select the palette of markers to be used and test each one on scrap paper.
6. Try out some mixes and blended effects.
7. Make sure the points of the markers are clean. If they are not clean rub them on paper.
8. Sharpen pencils.

Sit in a well-lit place, at a table or desk, with an upright posture, in a comfortable chair. In order to be able to control the marker keep the elbow on the surface and the weight on the forearm so that the wrist is free to move across the page. Keep the touch light—pressing too hard spoils markers and makes heavy lines.

Holding the Marker

The marker is held with the same grip as that used for holding a pen or pencil, that is with the shaft of the marker between the index and middle finger, with the pressure of the thumb balancing and guiding it. The marker is held in different positions according to the mark being made. For most applications the marker is held in the center. This leaves the wrist flexible so a wide variety of lines and marks can be made.

For **small strokes** hold the marker near the tip.
For **long strokes** hold the marker in the middle.

marker application and technique

holding the marker/blending and mixing/colored pencils

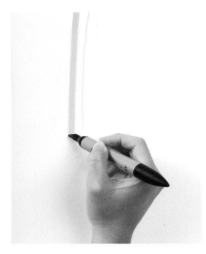

The broad tip of the marker is used to create a broad line.

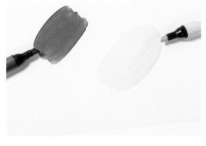

Mixing on a palette. Step 1.
Mixing allows subtle new colors to be produced, often not available directly from the marker. First the colors to be mixed are applied side-by-side onto the acetate palette.

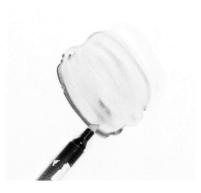

Mixing on a palette. Step 2.
The colors are mixed together using colorless blender. Colorless blender is neutral, without color, so ensures the mix is in proportion to the actual amounts of each color applied to the palette. To see how the mixed color will actually appear it is necessary to apply it onto paper.

For **long strokes** hold the marker in the middle. As mentioned, most markers have two or three tips: Every marker has a **broad tip** for wider marks with a **beveled**, or sliced, edge which allows for slimmer but still saturated applications of color. The opposite end of the marker has a **pointed tip** for finer marks. Letraset Tria markers have a third point hidden under the pointed tip, a super-fine tip that is used for precise detailing.
For **fine strokes** use the fine tip or super-fine tip of the marker.
For **medium strokes** use the beveled edge.
For **broad strokes** use the flat edge.

Blending and Mixing Techniques

In this book "blending" a marker is the term we use to refer to the process of **diluting a single marker color with colorless blender** (in this book colorless blenders are also referred to simply as blenders). Blending produces a more transparent, less intense version of the original color, depending on the proportions of marker color and colorless blender used. " Mixing" is the process of mixing two or more marker colors together to form new colors, also using a colorless blender.

In general the best effects are obtained using markers directly, without having to alter their color, and given the large ranges of marker colors now available this is often quite feasible. It will however at times be necessary to blend or mix markers to obtain new colors, either because (i) the selection of markers available is limited, or (ii) the required color is not available, or (iii) because a subtle color variation outside the available range of colors is required (particularly to show the gradation of tone necessary to depict the shading of drape, as used extensively throughout this book). .

The main blending and mixing techniques are described below. Experimenting is fun and can yield interesting results. Remember that best results are obtained by mixing colors close to each other—the further apart they are the more they will tend to "muddy" (as described in Chapter Two: Color and Design).

Mixing. A: Markers with colored pencil

Markers can be mixed with colored pencils (especially wax-based pencils) to create subtle variations in hue and value ("hue" is another word for color; "value" is the technical term for referring to the level of darkness or lightness of a color and is discussed at length in the next chapter). For example, adding blue pencil to a yellow marker base results in a new greenish hue; a dark brown pencil when added to a light skin tone creates a shift in value in the original skin tone, making it darker. Colored pencils can also be used with blended marker colors (as described below) to yield even more subtle color variations.

Mixing. B: Marker-to-marker (the Kissing Technique)

When only a small amount of additional color is needed it is possible to create this by combining the inks of two markers directly by rubbing their broad tips together: a coat of the new color emerges on both tips. After applying the new color, clean the marker tips by continuing to scrub them on scrap paper until the original color reappears.

Mixing and blending on a palette

When a sizeable amount of a mixed or blended color is required it is possible to blend one marker color with colorless blender or to mix the inks of two or more markers on a palette and then apply directly to the paper. Palettes can be made of any material that does not absorb marker ink, such as tracing vellum, which has a very low absorption capacity, or acetate sheet—usually the best option as it is light, stiff and transparent. Applying marker inks onto a non-absorbent surface spreads the inks, making them more transparent. This carries through to the blended colors, making the technique particularly suitable for obtaining subtle colors.

To mix colors using a palette, first place the palette on a flat surface. If using transparent acetate sheet, place a white piece of paper underneath so that the true colors can be seen. Gauge how much mixed-marker ink will be required for the task in hand and apply an appropriate amount of the first marker onto the surface of the palette with a rotating motion of the wrist. Lay down the second color next to the first and continue with further colors until all the chosen colors appear side-by-side on the palette. Next, the colorless blender is used. Colorless blender is pure marker solvent without color that will dilute and mix regular markers. A colorless blender is used in the same way a wet brush is used to dilute and mix watercolors: insert the colorless blender into one of the marker colors, "drag" it to the other colors and mix. Further amounts of either color can be added until the desired color emerges. Test the color on paper to see if it is the desired color and if so apply to the drawing with the tip of the colorless blender.

Using a blender allows a range of gradated tones to be achieved. This is particularly useful where softer colors are required and for detailed shading. Using only a small range of colors, with colorless blender it is possible to produce an almost limitless range of colors.

A considerable, and unique advantage markers have over other media when blended is that the blended color survives on the palette almost indefinitely. Even when the alcohol base has evaporated, the pigments remain, and an application of blender brings them instantly back to life. If colorless blender is not available, it is possible to refresh dried marker using any light-colored marker, though the resulting blend will of course contain that color.

Blending colored pencils together

An additional valuable blending technique can be achieved by blending colored pencils together. They can be blended the same way as markers, using colorless blender, but must be blended on **paper**, as they do not make a mark on acetate or vellum. Once the pencil is mixed with blender, however, it can then be transferred onto a palette or vellum.

marker application and technique

blending marker/blending colored pencil/mixing—marker-to-marker/mixing on a palette

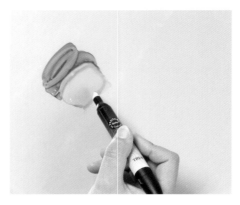

Blending marker on a palette. Step 1.
"Blending" is diluting a color to obtain a more transparent version that can be used for delicate applications. A quantity of marker ink is applied onto the acetate with a circular motion. The color is "pulled out" using a colorless blender.

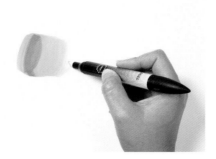

Blending marker on a palette. Step 2.
The blended color is transferred from the acetate onto the marker paper. The darker area is where a double layer has been applied.

Blending marker on a palette. Step 3. The final effect.
A less saturated, more transparent version of the color results (seen here alongside the original color).

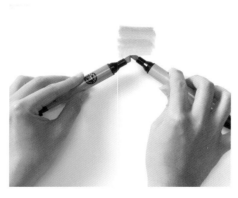

Mixing markers, marker-to-marker—the"kissing technique".
When a small amount of mixed color is needed markers can be mixed directly by rubbing the broad tips together. A small amount of the new color is left on the tip of each marker.

Blending colored pencil.
Colored pencil cannot be applied to acetate so is applied to marker paper and then mixed with colorless blender, making the color from the pencil less granular.and more ink- like. Blended colored pencil is used when a pastel or delicate transparent color is required.

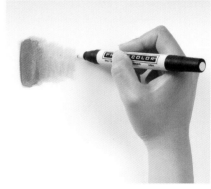

Gradation of tone with colored pencil.
Colored pencil is applied to paper and then "pulled out" using the colorless blender to give progressively less-saturated tones. This technique is useful in creating shading in very light colors.

Mixing marker and colored pencil on a palette. Step 1.
A liberal quantity of marker of the chosen color is applied onto the acetate palette.

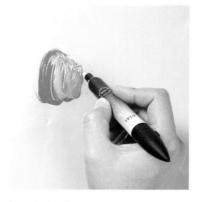

Mixing marker and colored pencil on a palette. Step 2.
The marker ink is "pulled out" using colorless blender with a "to-and-fro motion" of the wrist, moving the hand towards the body, resulting in a more transparent "blended color."

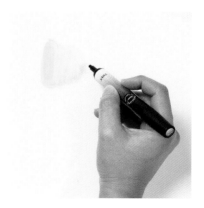

Mixing marker and colored pencil. Step 3.
Colored pencil is applied to a different part of the paper and diluted using another (clean) colorless blender, creating a light, transparent color.

marker application and technique

layering/drawing croquis and silhouette/shading /sheen/highlights

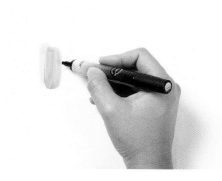

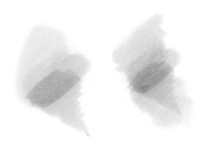

Mixing marker and colored pencil. Step 4.
The blended marker ink (red) on the end of the colorless blender is added to the diluted colored pencil to create a new mixed color (orange). The new mixed color is then transferred onto marker paper.

Layering. Step 1.
Layering gives variations of color, depth and complexity. Three blended colors are applied on top of each other and , provided they are light colors will each show through. Allow each coat to dry for ten seconds or so before applying the next or the colors will mix to form a new single color.

Layering. Steps 2 and 3.
Step 2. Further colors (blended red, violet) are applied. Adding extra colors gives even greater depth and color complexity. Step 3. Applications of further colors give even more subtlety, depth and luminosity to the drawing.

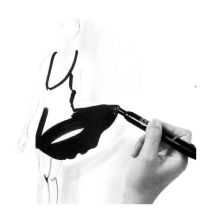

Filling in the silhouette using a scrubbing motion.

Drawing the croquis with a light-colored pencil.
Light-colored pencils give a clear line and do not "muddy" the color of the markers.

Drawing the silhouette.
The silhouette of a garment is drawn with a grey or other light-colored pencil.

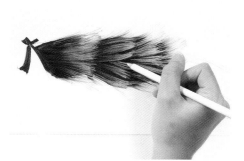

Shading with pencil.
Creating heavier line weights in areas where the body bends gives a sense of depth.

Creating soft white sheen with pencil.
Sheen is seen on the surface of fabrics with luster such as leather, cottons, velvet, crepes and others. It is drawn in using the side of the pencil.

Creating white highlights with the tip of a white pencil.
Highlights .are brighter, sharper whites than sheen and appear in highly reflective fabrics such as patent leather, satin, taffeta, lycra and others.

basic techniques for applying color

shading/adding detail/saturating color/layering

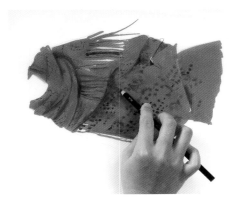

Deepening the value of a color.
Shadows in folds are indicated using the side of a black pencil over the color of the fabric. The pencil is held from above so downward pressure can be applied. For shorter strokes the pencil is held close to the tip.

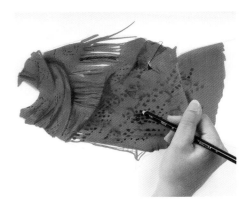

Adding Detail.
Detail is applied with the tip of a pencil. The pencil is held close to the tip for precision control.

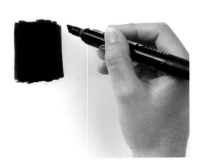

Creating saturated color. Step 1.
Color is applied to the front side of the paper. In this example black is used, for which it is often difficult to achieve good saturation, but the technique is the same for all dark colors.

Creating saturated color. Step 2.
Color is next applied from the reverse side of the paper, further saturating the color. This technique also has the effect of evening out the color and obscuring any streaking or uneven application of color.

Creating saturated color. Step 3.
The paper is turned back to the front side and a third layer of marker is added resulting in an even application of deeply saturated color.

Layering with the same color and different medium.
Adding black pencil over black marker to give depth and texture. This technique is often used for tweeds and velvets.

Basic techniques for applying color

Shading—deepening the value (darkness) of a color

Shading is used to express changes in surface appearance where a fabric drapes and parts bend in (become concave) causing a shift into shadow (see Chapter Three: Fabrics for detailed explanations of drape and shading in different fabrics).

To achieve the effect of dark shadow on a colored surface, apply either black marker or black pencil in the areas where shadows are to be indicated. Black markers will create a flat tone as the ink is absorbed into the paper. Applying black pencil over the black marker will give a slight reflective quality to the shadow, giving the impression of black shadow on a contoured, three-dimensional—as opposed to a flat—surface.

Creating saturated (deep) colors

To achieve highly saturated color effects with markers, after making the first application of marker on the surface of the paper, reverse the paper and apply marker again from the underside using a firm scrubbing motion. Another layer can then be added to the top side of the paper. When dry, a beautiful saturated color will result. This technique works particularly well with dark-valued colors such as black, blue and red.

Layering

Layering is the application of a series of colors in sequence, each successive color being applied over the preceding color, but leaving part of the preceding color uncovered so that the progression of colors can be seen. Layering is a technique that can be used with the same (or very similar) color to achieve a subtle gradation of value of the same hue (as in skin tone for example) or with different colors, where the effect is to give a richness and luminosity to the resulting color as more colors are layered in. Layering different colors yields new colors, according to the principles of color mixing, but with layering a "memory" of the original colors survives the process and is perceived in the resulting layered color.

In layering, the edge of each applied color is visible, almost like slices of ham on a platter. This is distinct from the effect of gradating tone, discussed below, where no edges are visible and the color shift is seamless. When layering colors, start with the lighter colors and progress to the darker colors.

basic techniques for applying color

adding shine, highlights, detailing /skin tone on body and face

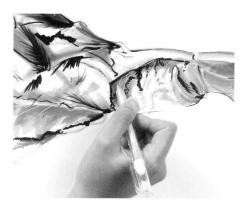

Adding shine, highlights and detailing.
White gel pen is brighter than pencil and is used to add light anywhere on a composition in the form of shine or highlights—pinpoints of light. It can also be used for details such as top-stitching, beading, sequins, paillettes and shines on patent leather and metallic surfaces. White gel pen is also useful for erasing mistakes makde on white paper.

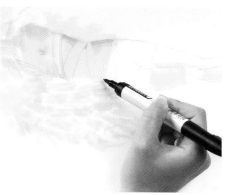

Adding skin tone and shading to the body. Step 1.
Skin tone is applied to the figure with medium strokes of a beige marker held in the middle

Adding shine and highlights

An object has highlights—or "shine"—at those points where light strikes it and is reflected, as opposed to the parts where light is absorbed and the object appears to have color. Highlights are indicated by applying white pencil over the underlying color. White gel pens can also be used: these contain an opaque white ink and are effective in creating very strong, almost luminescent white marks. Gel pens are also available in a range of iridescent colors which can yield intriguing effects.

Gradating tone (gradual darkening or lightening)

To achieve a gradation of tone—a gradual darkening or lightening shift in the tonal value of a color, often used in shading draped garments—a technique is used where a color is applied and then "dragged out" to become progressively more diluted. First the original marker color is applied to the paper, and, when dry, colorless blender is added, moved backwards and forwards to loosen the pigments and then "dragged" in the intended direction. The color becomes more transparent and the result is a continuous, seamless progression of color from darker and more saturated to lighter and less saturated. This technique was invented by Leonardo da Vinci in the 16th century and is known as *sfumato* —literally "shaded off"—from the Latin "fumare", to smoke. The effect is similar to seeing an object through mist or smoke and is particularly useful in shading fabrics.

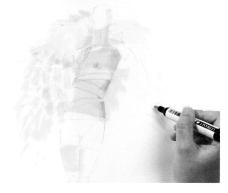

Skin tone and shading. Step 2.
Deepen the color of the skin tone by adding shadows with a blended color applied with a colorless blender.

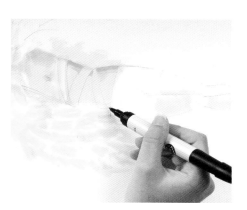

Skin tone and shading. Step 3
The remaining skin tone is filled in with beige marker. Marker is applied with horizontal strokes in the torso and with vertical strokes in the legs and arms.

Adding skin tone and shading to the face. Step 1.
Once the contours of the face are drawn, skin tone is added with even strokes of a beige marker. To avoid streaking do not lift the tip of the marker from the page.

Adding skin tone and shading to the face. Step 2.
The planes of the face are defined by adding shadows with a beige marker to the areas that recede from the light .

basic techniques for applying color

sfumato/stippling/luminosity/tints/shades/neutralizing colors/drawing lines

Sfumato. A smoky effect created by gradating tones using colorless blender, traditionally used as a background. Different gradated colors can be layered to increase the impression of depth.

Stippling.
Stippling is a spotted or speckled effect created by up and down movements with the marker held vertically. Stippling is used to create texture of fabrics with threads of uneven thickness and an uneven surface- tweeds, raw silk and others.

Luminosity.
A vibrant, luminous effect is created by adding a bright color from the reverse side of the paper.

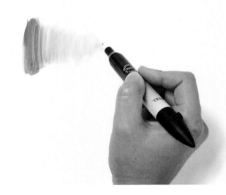

Creating a tint (lighter version of a color).
Creating a tint by diluting a color with colorless blender to allow the white of the paper to show through.

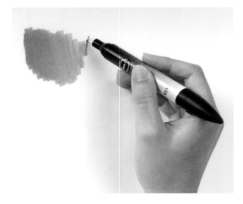

Creating a shade (a darker version of a color).
A shade is created by adding to the original color blended grey (or black) marker that is darker than the original color using colorless blender on a palette. The colorless blender is used here to mix the colors.

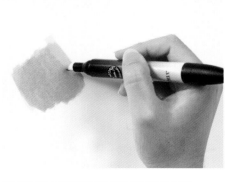

Neutralizing a color (reducing the amount of color).
Neutralizing a color–reducing the amount of "color" in a color by adding a neutral color—white, black or grey— or mixing it with its complementary color. The colorless blender is used here to mix the colors.

Creating Shades

Shades are the variations that result from adding **black** to colors, darkening (reducing the value) and lowering the saturation of the original color. To create shades with markers, black, or a grey that is darker than the color to be darkened, is added to the original marker color using colorless blender on a palette. The more black or darker grey that is added, the darker the shade of the original color becomes. With black pencil, apply to the paper, add blender and transfer the resulting color to the color to be shaded on the palette.Shades created with pencil do not dilute the original color as much as black marker.

Creating tints

This is the opposite of creating shades. Tints are lighter versions of a color (often pastels, which are soft and delicate colors) and are achieved by the addition of white coloring. The effect can be achieved in two ways: either mixing white pencil directly with another color on a palette using colorless blender, or diluting a color directly with colorless blender on the paper, creating a transparent color which, applied to white paper, allows the whiteness of the paper to show through, yielding a tint/pastel effect.

Neutralizing Colors

Neutral colors have no "color"—or "chroma"—they are, technically, the "achromatic" black, white and greys, though dull, muddy colors with a small amount of color are also commonly referred to as neutrals. To "neutralize" a color is to remove some of its color. This is done by adding black, white or grey or mixing it with its complementary color. A fuller description of neutralizing colors and complementary colors is included in Chapter Two: Color and Design.

Note on drawing lines

A line made with a single sweeping gesture is usually more elegant than a line made up of a series of small lines, sometimes referred to as "chicken scratches". Being able to draw elegant, expressive lines is a technique that requires practice to master. To draw graceful lines, it is important to *sit* gracefully, upright and perpendicular to the page. Keep the weight on the elbow and draw from the wrist. Focus on achieving precision and control—the qualities that need to be developed so that the lines of a garment can be drawn quickly and accurately. It is difficult to draw well when fatigued or upset.

mastering technical fashion drawing

do not do's of fashion drawing with markers

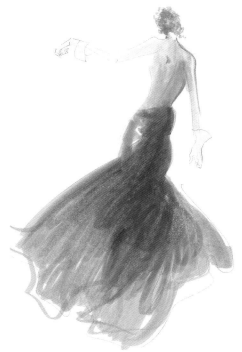

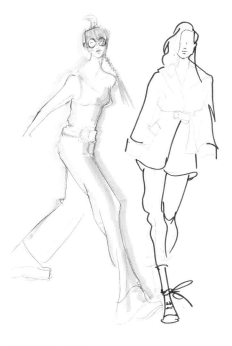

Do Not Do. When too many colors are mixed the result becomes muddied and dull. Adding a small amount of an unmixed, pure hue to the composition as an accent will bring the drawing back to life.

Do Not Do. Left figure, do not draw one side of the figure and then the other—they invariably do not match up. Right figure, do not outline the figure in heavy black—it flattens the drawing, making it appear two-dimensional.

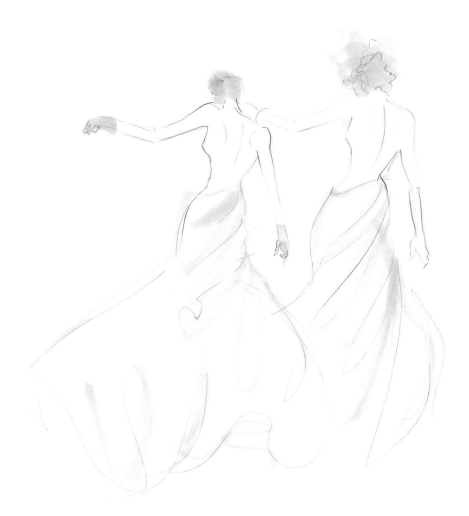

Do Not Do Left figure, hands are too small; right figure, the head is too large. It is essential to keep body proportions correct as the eye is sensitive to the smallest discrepancies.

Mastering Technical Fashion Drawing

Fashion drawing is a form of **technical drawing**: its purpose is to communicate information, both technical information about construction and detail and also less precise ideas about overall style and appearance. Like so many highly evolved human activities (ballet, synchronized swimming, gymnastics and opera singing spring to mind) technical drawing is (for the vast majority of us) not a skill and activity that is instinctive but one that has to be learnt through study and practice.

To make precise technical drawings, whether they are of fashion or in other areas of design —architecture, product design, automobile design, for example— it is essential to develop a set of drawing skills and to practice constantly to refine these skills. In order to be able to draw objects accurately the eye has to be trained to see clearly shapes, shifts in hue (color) and value (lightness/darkness), and details . It is important always to keep in mind that technical drawing is a visual language used to communicate ideas. In the same way as it is necessary to speak or write clearly to be understood, in drawing too it is always necessary to present ideas clearly.

Do not Do's of fashion drawing with markers

There are many pitfalls on the road to mastering fashion drawing— or any type of drawing in fact— and many of them have to be experienced first hand in order to learn how they are to be subsequently avoided. Some of the worst mistakes *can* be avoided, though, by studying the following **"Do not Do's" and "Do's"**. These "moral commandments" of fashion drawing with markers are the hard-learnt lessons of many years experience in making and correcting mistakes and can save the reader much frustration and expenditure of fruitless energy.

DO NOT try to fill in one side of an object (e.g., a garment) completely and then fill in the opposite side attempting to match it to the original side. Things almost never line up so easily, even with the simplest poses.

DO NOT use a heavy black outline around objects or figures unless a two-dimensional effect is intended.

DO NOT outline noses in black.

DO NOT make hands very small.

DO NOT make heads very large.

DO NOT use too many neutral colors or the palette can appear muddy.

DO NOT shade with lines.

DO NOT keep several markers open at the same time.

DO NOT eat, drink or smoke around markers. Work can be easily messed up.

mastering technical fashion drawing

applications of technique/do's of fashion drawing with markers

Application of technique: saturated color.
A deep, saturated color created with using a scrubbing motion of the marker from the front and reverse sides of the paper.

Application of technique: shading with blended color.
Blended colors are used to indicate shading as they are softer, less-saturated colors that can be easily gradated. Shadows fall on the undersides of these transparent cascading folds.

Application of technique: indicating contour with nuanced lines.
Nuanced lines show the subtle texture of the petals of a flower. The fluidity of gesture in the line quality in this drawing expresses the delicacy of the flower.

Application of technique: sheen.
White pencil is applied over the base color to show sheen-here on fringe.

Application of technique: layering of colors to show texture and shadow.
Layered colors are used in representing saturated colors: colors appear brighter and more saturated when layered in coats as opposed to single flat applciation.Here saturated colors are achieved by using colored pencil over marker.

Application of technique: saturated color.
Rich, saturated color is achieved by applying marker from both sides of the paper and deepening the shadows with black marker.

Do's of Fashion Drawing in Color

DO try to work in a well-lit environment: either in daylight or, if working at night, using a light-source that is not too yellow or blue.

DO apply colors from light to dark.

DO always check that a marker is clean before applying it to a drawing.

DO apply color by using a scrubbing circular motion of wrist to avoid streaking.

DO be careful when using black—it is unforgiving and usually cannot be reversed.

DO observe work from a distance of at least three or four feet every twenty minutes or so—some effects are difficult to judge from close-in.

DO use layered color for beautiful rich effects.

DO make sure to cover up markers, as open they expose the user to fumes and dry out.

DO close all markers tightly at the end of the work session or they will dry out.

DO keep pencils sharp. Start each session with sharp points.

DO remember that the first drawing is not always the final drawing. It takes a while to warm up, and it is usually necessary to draw for a while before one begins to draw well.

DO stop and rest when fatigued.

DO apply color from front and back of paper for extremely saturated color.

DO remember to breathe.

DO keep the work area ventilated.

practice and exercises

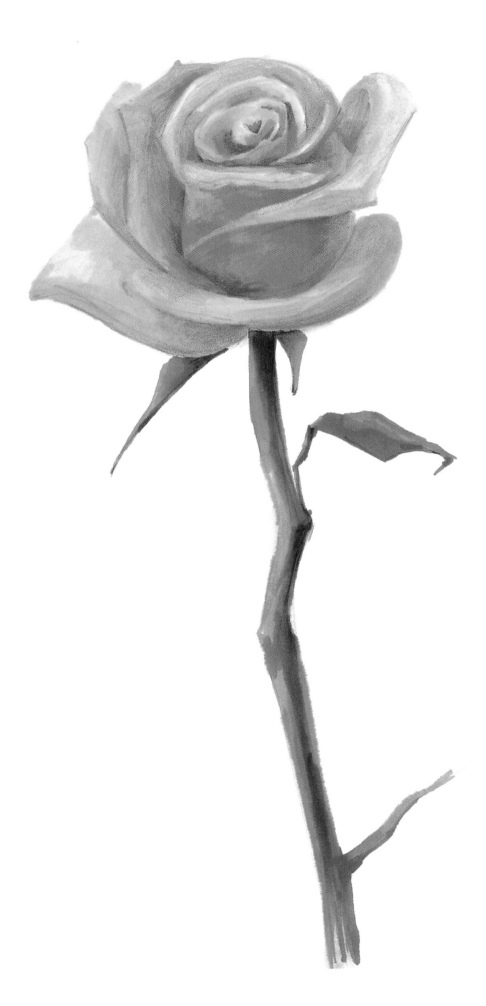

1. Following the instructions for holding markers, fill a page with thin, medium and wide lines.

2. Make a series of lines that change width by rotating the marker.

3. Apply areas of yellow, red and turquoise marker to acetate or vellum. Dilute each color separately with colorless blender and apply the new color onto marker paper. (Note: clean off the tip of the colorless blender between colors by rubbing it on paper until the color disappears).

4. Choose three colors and apply onto acetate or vellum. Pick up each color in turn with a colorless blender and apply to marker paper to create a constant gradation of tone from the original color to its most transparent form.

5. (i) Apply a yellow, green, orange and pink colored pencil to marker paper. Blend each with a colorless blender. Transfer to marker paper and experiment mixing combintations of colors. (ii) Mix the different blended colored pencil colors separately with light blue and light green markers.

6. Copy (by tracing or drawing freehand) a croquis from Chapter Three and fill in with any colored marker using a scrubbing motion.

7. Copy a croquis from Chapter Four and fill in with a light beige marker. Apply layers of blended pink and finally blended orange over the first layer.

8.(i) Copy one of the croquis from Chapter Five: Beginning to Draw using light grey colored pencil. (ii) Copy one of the croquis with simple outfits from Chapter Four also using light grey pencil.

9. Copy a croquis with clothes from Chapter Three and add shading in the folds of the fabric using colored pencil.

10. Copy a croquis with clothes from the Chapter Three. Fill in with a medium to dark color. Using a white pencil add a. highlights on the surface of folds b. sheen on the broad surfaces of the fabric. Using a colored pencil add stippling to any area of the fabric to create a texture resembling tweed or raw silk.

11. Copy the silhouette of any garment in this book. Create a *sfumato* background using layers of blended color.

12. Copy the silhouette of any garment in the book and fill in with saturated color by applying markers from the front and reverse sides of the paper.

CHAPTER TWO

COLOR AND DESIGN

modern fashion drawing

great masters of fashion drawing/fragonard

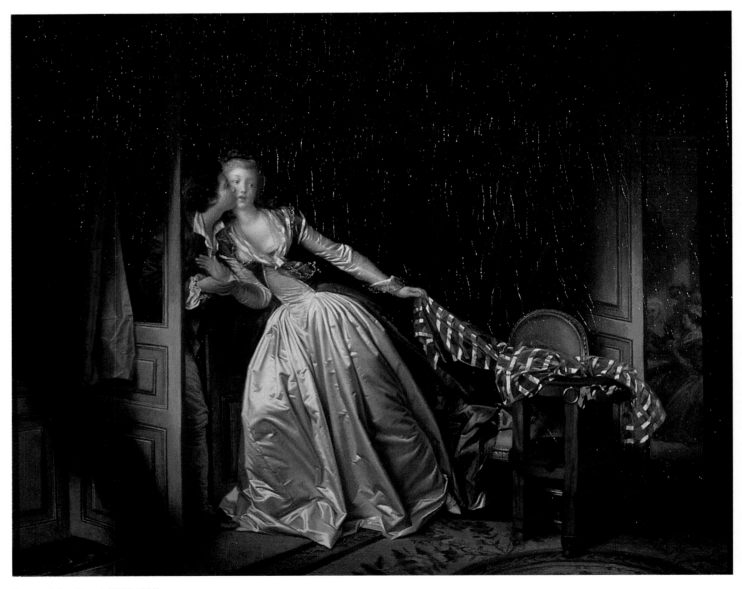

Fragonard, Jean-Honoré (1732-1806)
The Stolen Kiss.
Hermitage, St. Petersburg, Russia

modern fashion drawing

great masters of fashion drawing

Modern Fashion Drawing

Fashion drawing as it is known today is a relatively recent development, dating from around the turn of the twentieth century. Prior to that time, drawings or paintings showing fashion garments were made as works of fine art—usually portraits of nobility in their finery or in sporting or religious scenes. Many of the portraits and scenes drawn and painted by the great European masters from the Renaissance onwards, (and American artists from the 19th century) include highly skilled renderings of beautiful high-fashion garments. These works of art often served to introduce the work of a particular couturier or dressmaker to a wider public and to inspire copies and similar designs from other dressmakers (a process that continues to this day).

Scope of Modern Fashion Drawing

In modern times fashion drawing has narrowed in scope and purpose and is now mainly used as a tool for fashion design rather than an art form (mention should be made, though of a small number of fashion artists/illustrators who draw fashion purely for the sake of drawing, some examples of whose work is included in this book). A modern fashion drawing is usually executed in not more than two or three hours , often much less, and very rarely approaches the scope and complexity of paintings by Fragonard, Goya or Whistler, for example, which of course took much longer to complete.

Composition in Fashion Drawing

Even though its purpose is now more often functional than purely artistic fashion drawing is, nevertheless, still "composed", and embodies a number of design decisions that play a crucial role in determining the success of the drawing. Whether drawn for art or for commercial illustration, the purpose of fashion drawing is to present beautiful garments in as appealing a manner as possible. To achieve this end the drawing itself should be made as appealing and attractive as possible.

The modern fashion drawing is now based on the **nine-head figure or "croquis"**—an idealized, elongated version of the human form (which is naturally equivalent to about eight heads in length) that flatters both the figure and the garments, making them appear larger than life. Good composition of the drawing based on the nine-head figure is one of the vital ingredients in making a drawing attractive and securing its overall success.

Fashion Drawing in Color

Color is a central part of vision and how the world appears to us. In art and design it is a powerful, complex and unique design element. When fashion drawings are made in color, not surprisingly color plays a major role in their composition beyond that of simply indicating the color of the garments. A knowledge of the properties of color and the way colors combine and interact is an important part of a preparation for learning to make sound decisions on the use of color in the composition of fashion drawings and, by extension, the use of color in fashion design. This chapter reviews the basic principles and elements of good composition, the properties of color and the main theories of how colors contrast and interact with each other.

modern fashion drawing

great masters of fashion drawing/whistler

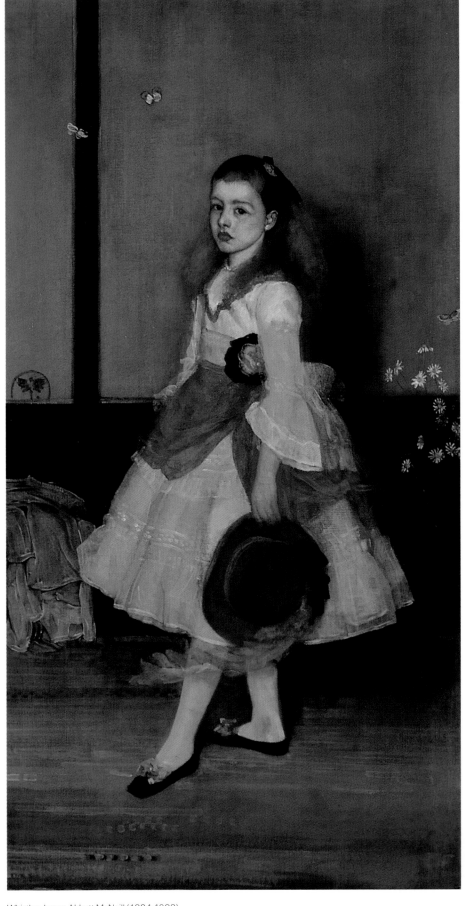

Whistler, James Abbott McNeill (1834-1903)
Harmony in Grey and Green: Miss Cicely Alexander, 1872-1874.
Tate Gallery, London, Great Britain

modern fashion drawing

composition and design

Composition and Design

In the other chapters of this book the term "design" almost always refers to fashion design—the design of the garments. In this chapter the term "design" is used with its broader meaning, equivalent to "composition." Fashion design is indeed simply a branch of the larger field of "Design" that covers virtually every type of object or activity made by man, from architecture to automobiles, from interior and product design to the design of industrial devices, from computer graphics to books. Since the time of **Leonardo da Vinci** and the Renaissance, efforts have been made to create rules that apply not just to one field of design but across all of them.

Composition of a drawing

The composition—or "design"—of a drawing or painting is the range of decisions made about how the subject matter—the "content"—is presented. This presentation of the content—the purely visual aspects of a drawing or painting—is referred to in art as the "form" of the drawing or painting. In fashion drawing the principal content is the garments themselves (the figures and other elements being secondary content) and the form the way that they are presented.

Purpose of drawings

Drawings are often made with different purposes and audiences in mind and focus on and emphasize different things. As in the case of fashion drawings, some focus more on technical or informational aspects such as construction and details, others on capturing the beauty of the design. No matter, however, what the intended purpose or audience for a drawing, a drawing is always more effective if it feels balanced, engaging, easy on the eye and easy to understand. If a drawing displays these qualities it will capture the viewer's attention and seduce the eye.

A large part of what makes up a compelling drawing is the quality of the drawing itself, and showing how to draw well in color is the main purpose of this book. The composition of the drawing, though, is a significant part of the final product. If its various elements have been assembled with care and consistent regard for the principles of good form and color composition it is more likely to succeed in its purpose than otherwise.

Although *every* drawing is "composed", time constraints mean that often no more than a few moments can be taken to plan a quick concept sketch. More sophisticated drawings or drawings for more advanced stages of presentation, however—when making a detailed drawing of a final design, a drawing for a portfolio, or an editorial illustration for a magazine, for example—require considerable prior thought and planning if they are to be successful.

composition

nine heads croquis

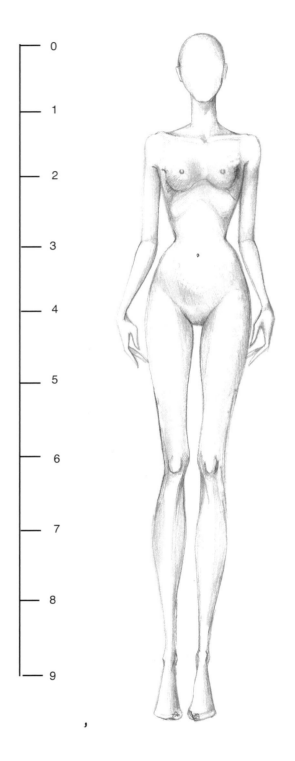

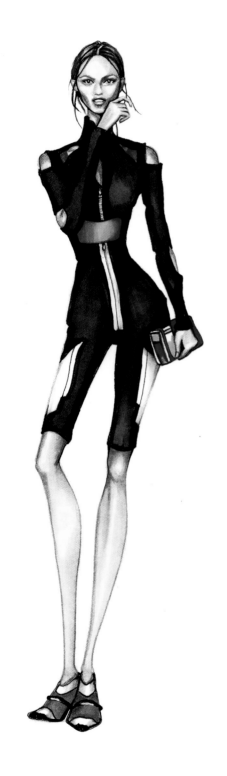

The nine head croquis is the basis for all modern fashion drawing. The legs are longer and the pelvis shorter than in real life. The figure is symmetrical about a central axis line.

Simple composition using nine-head croquis. The elongated legs and arms make the clothes appear larger than life.

composition

principles and elements of design/fashion drawing black and white v. color

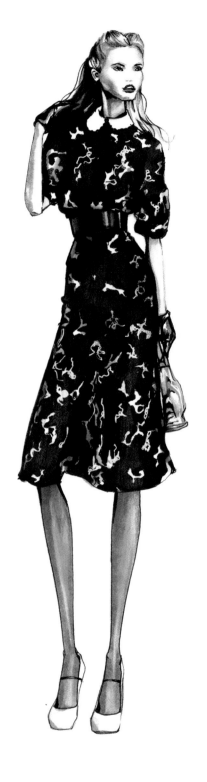

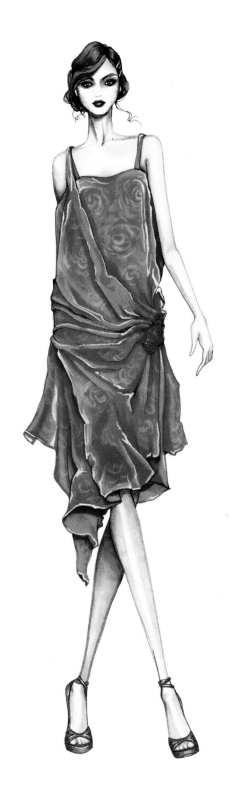

Principles of Design/Elements of Design

Over the centuries the ideas and methods underlying good art and design have been continually studied by artists and educators and distilled over time into a body of guidelines, or prescriptions, generally known as the **Principles of Design**. These principles are: **Harmony/Unity, Focal Point/ Emphasis, Balance, Scale and Proportion.** These so-called **principles of design** are not rules or laws as in science (there are no firm rules in art and design) but are guidelines for making designs that present content in an effective and pleasing way.

The visual variables used in making art and design—**Line, Space, Shape, Value, Texture** and **Color**—are generally referred to as the **Elements of Design**. This chapter discusses in depth how the **Principles of Design** can be applied when making a fashion drawing in color and how the various **Elements of Design** are used to best effect in drawing fashion.

Fashion Drawing—Black and white v. Color

Black and white drawing—line drawing using pen and/or ink on paper—allows for garments to be presented with a high degree of accuracy: the silhouette of a garment, its drape, the type and weight of fabric used in its construction, the detailing, how the fabric wraps around and falls from the body—these key characteristics of a garment can all be expressed with no more than a pencil and paper.

The Power of Color

Fashion drawing in **color** produces all of the effects of black and white drawing but adds a powerful new dimension, allowing a truer, more complete representation of the clothing to be made. Color is a strong defining feature of a garment, and the use of color in a fashion drawing supplies the main piece of information absent from a black and white drawing.

Color is also a valuable tool for accurately and convincingly representing the **three-dimensional reality of a garment**, as it allows **subtle gradations of hue and value to be shown in the drape of the garment and in the figure.** The ease with which, in almost any medium, color can be applied to large areas, and the effectiveness of a solid block of saturated color compared to a solid block of greyscale pencil or ink shading means also that a whole range of superior effects can be achieved with color.

As well as increasing the accuracy and realism of a drawing, the addition of color, when well done, allows the direct emotional, sensual, and cultural impact of the clothes that is directly related to their color to shine through. The drawing becomes exciting and engaging, arousing the interest and attention of the audience in a way it is difficult for a black and white drawing to do.

Fashion drawing in black and white (greyscale).

Fashion drawing in color.

composition

principles of design in fashion drawing

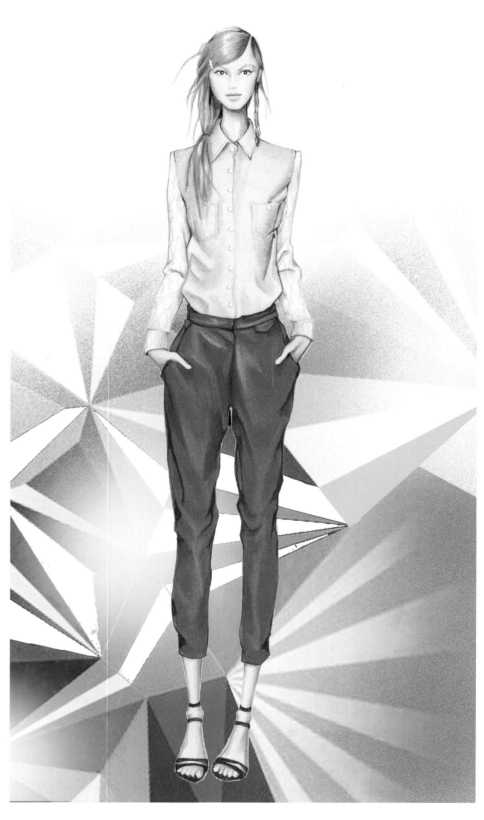

Figure based on nine-head croquis in a composed,
computer-generated full-color background setting.

Composition in Fashion Drawing

A fashion drawing is "composed" at a number of different levels and stages, and design decisions have to be made at each. In most instances, though, a number of decisions are "given" or already made, and others are made quickly and intuitively. These generally include the **design and colorways of the garments** to be included in the drawing ,the **combination of garments** and choice of **accessories**. Very often a drawing is made with reference to a swatch of the actual fabric the garment is to be made of.

The variables in the drawing that are usually within the sphere of decision of the artist/designer are: **(i) the pose, gestures and coloring of the basic figure drawing** of the croquis with the subject garments and **(ii) the composition of the figure or figures on the page,** the background elements, skin tone, make up and hair, objects and empty (or"negative") space. This chapter is concerned mainly with the type of decisions described in (i) and (ii)—the composition of the figure itself and the composition of the figure or figures on the page. These topics recur repeatedly throughout the various chapters of this book.

Principles of Design applied to Fashion Drawing

For those beginning to draw fashion, and particularly for those who have no formal training in art and design, it is useful to become familiar with the principles of design and to develop an awareness of how and when they can be applied in drawings. The following section of this chapter reviews both the principles and elements of design, with illustrations of how they are applied in fashion drawing.

composition

proximity/repetition

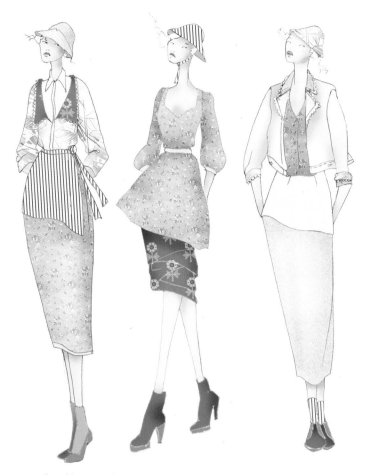

Repetition. These figures are unified in the composition by repetition of colors, patterns and shapes in the garments, poses and facial expressions.

Harmony/Unity Principle

The closest to a "**golden rule**" in design, as in art, is the concept of **harmony**, or—what is essentially the same idea—**unity**. Unless the individual parts of a drawing "fit together" in a unified, harmonious whole, it will appear awkward and disjointed.

Fashion drawings, as mentioned, incorporate design decisions on a number of different levels, covering many different elements. All these many elements should fit together so as to form a coherent, unified composition.

With so many variables in play, many of the decisions to be made regarding whether certain elements "fit together" in a drawing are subjective, and numerous situations arise where there are no hard and fast rules indicating how best to proceed. A number of graphic devices do exist, though, to help unify a drawing. These are particularly useful if the elements to be included in the drawing do not seem to fit together naturally. The main device that are employed for unifying drawings are the following:

Proximity

Elements placed close to each suggest unity. The eye does not have to travel large distances between the different elements and encompasses them all with ease.

Repetition

Repetition of shapes, colors or effects can suggest unifying links. The repetitive themes of a line of clothing, for example—which can be emphasized to ensure the theme is noticed—can often of themselves bring unity to a composition.

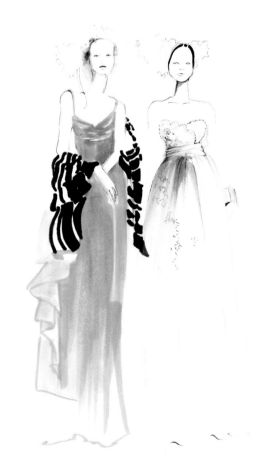

Proximity. This drawing is unified by the proximity of the two figures.

principles of design

demetrios psillos

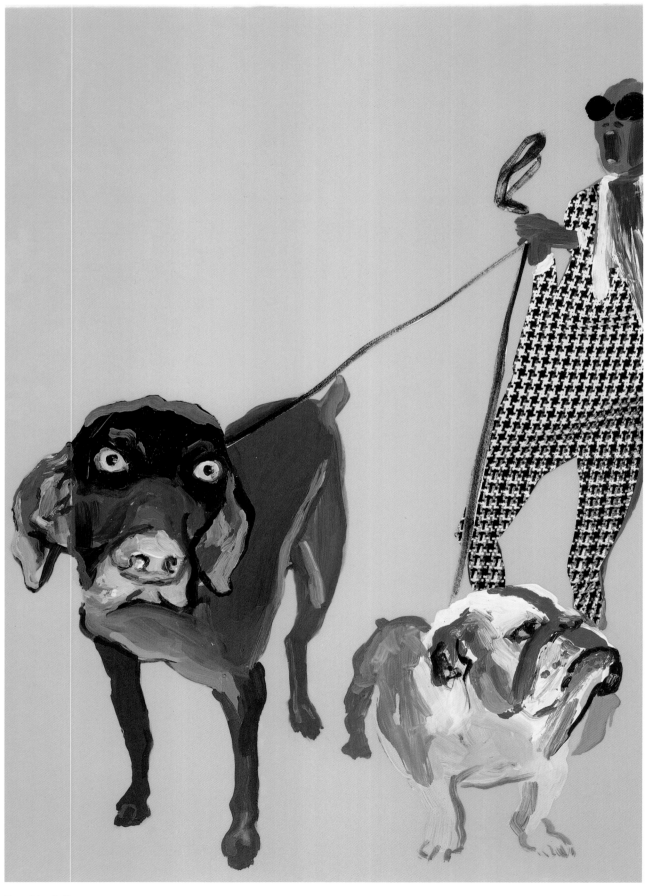

Demetrios Psillos
Breeds Apart

principles of design

continuity/ variety/ focal point/emphasis

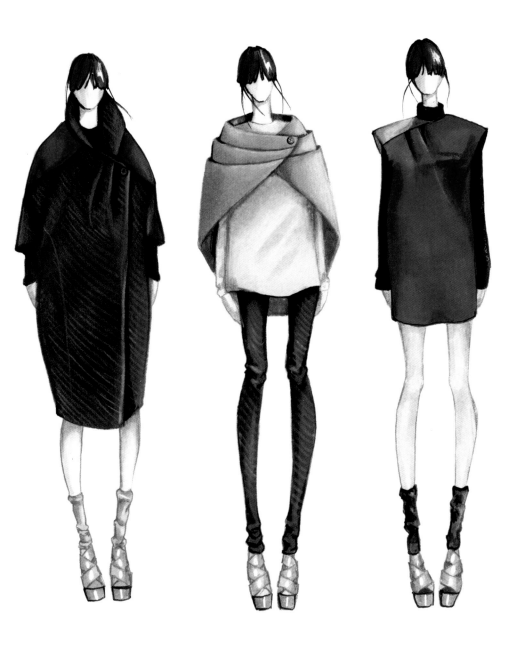

Continuity/Repetition. A number of repeated but varying elements in this composition give continuity to the line of figures: hair/hairstyle, skin-tone, fabric and color, accessories, shapes in the garments, accessories.

Continuity

Continuing a line or the direction of a line, a series or sequence, or placing objects in a line—"aligning them"—can unify elements that might be distant from each other and would not otherwise immediately appear to be similar or connected. In a fashion drawing, for example, a series of shoes or other accessories might appear unconnected; drawing them on croquis wearing similar clothes, though, can introduce a unifying continuity into the composition. In the drawing by **Demetrios Psillos** the elements are connected to each other by the lines of the dog leashes leading back to their master.

Variety

Adding variety—making subtle differences among objects—can also draw attention to the similarities, and unity, between the same things. A drawing showing a number of different garments from a line will also display a number of common features that makes it feel like a unified line: garments with similar silhouettes, for example, might display a number of variations in lengths of the hem or sleeves or in other detailing.

Focal Point/Emphasis Principle

A drawing should catch the viewer's attention so the eye is attracted and encouraged to explore further. A device that helps achieve this is a **focal point**. A focal point is a point in a drawing to which the eye is drawn. Once the attention has been engaged the eye is led to the other parts of the drawing.

In fashion drawing the garments themselves are usually made the focal point so that the eye will immediately be led to them as the most important aspect of the drawing.

A focal point is usually created by emphasizing one or more elements in a drawing—creating a contrast by making them differ from the others. This contrast or emphasis is often as simple as including a noticeably different shape or color, but can also include value contrasts, differing textures, changing the size or scale of objects, changing the scale or directions of patterns, changing line weight, changing the angles of planes, adding abstraction into a naturalistic setting (or vice-versa) or switching from rectilinear (straight-lined) to curvilinear (and also vice-versa).

A further way of creating emphasis or a focal point is through the placement of the elements in the drawing: for example, particular elements can be emphasized by arranging them in a pattern, or one element can be placed in isolation from the others. In the drawing by **Demetrios Psillos**, the dog on the left serves as a focal point because of size and location. The lines of the dog leashes then lead the eye to the secondary focal points of the drawing.

It is not always essential to create a focal point in a fashion drawing, but there are a number of situations where it is a particularly useful device. If a drawing is complex, a focal point can create a point of entry, so simplifying the task of interpretation.

principles of design

balance/symmetry

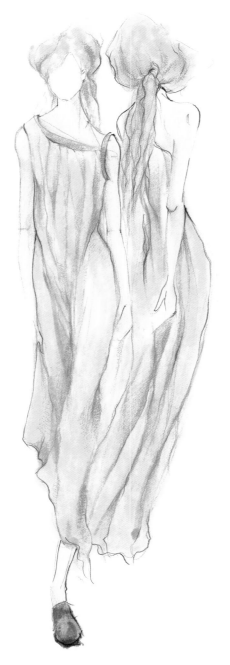

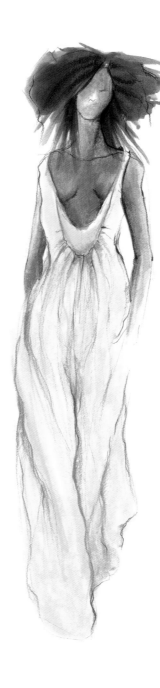

Asymmetrical balance. The two lighter-skin color figures on the left are in visual balance with the single darker skin color figure on the right.

(Focal point continued)

It is not always essential to create a focal point in a fashion drawing, but there are a number of situations where it is a particularly useful device. If a drawing is complex, a focal point can create a point of entry, so simplifying the task of interpretation. Another example is where a drawing has many similar repeated elements—a white wedding dress for example. The addition of a contrasting section or bright dash of color can serve to draw the eye into the picture to examine the different elements.

Balance/Symmetry Principle

Balance is the relative weight between the elements on the left and right sides (and sometimes between top and bottom) of a drawing. The eye quickly senses if a drawing is not in balance: balance occurs when the eye is equally attracted to the components on each side of a composition. A "balanced" picture appears graceful and pleasing to the eye, so unless there are good reasons not to do so (if a disturbing effect is intentionally sought, for example), then a drawing should appear balanced.

Balance/Symmetry

Balance can be achieved in a number of different ways. The most obvious form of balance in a drawing is **symmetrical balance**. This is where the two sides of the drawing are (in the extreme case) identical, or, more usually, contain similar elements of similar shapes and proportions. In a fashion drawing, for example, similar figures could be placed on either side of the page to create a satisfactory—though not necessarily interesting—sense of balance.

The human form is symmetrical. When the figure forms an asymmetrical pose—moving the hips to one side for example—there are offsetting moves both away from and back to the vertical center-axis line so that the figure always appears to maintain a "balance" (the eye also immediately senses if a figure is balanced or not). Just as with the actual human form, the left and right sides of the nine-head fashion figure are symmetrical—a hypothetical vertical center-axis line divides the drawing into two "mirror image" parts.

principles of design

asymmetry/balance

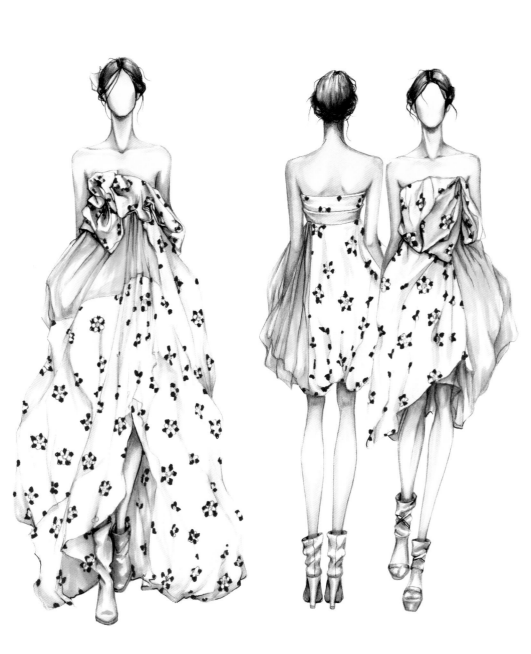

Asymmetrical composition. The two figures on the right with shorter dresses are balanced by the figure on the left with a longer and more voluminous dress.

Asymmetry/Balance

A drawing cannot always be symmetrical, containing an even number of elements distributed evenly between its left and right sides. Fashion drawings in particular will often contain uneven numbers of figures—one, three or higher—that cannot be placed symmetrically on either side of the page as with two or four figures. It is important, though, that even if a drawing cannot be balanced by symmetry, it nevertheless appears balanced; that although objects on either the side of a drawing are dissimilar they hold an equal attraction for the eye. This type of balance can be achieved in a number of different ways and is referred to as **"asymmetrical balance."**

If a single figure is to be drawn it is often placed in the middle of the page. To add interest the head or one of the other parts of the body can be placed to one side, or some other element—a different movement or drape in the clothing or hair, or a subtle gesture or shift in expression—might be included. This creates an asymmetry in the figure which could cause a feeling of imbalance. To restore the sense of balance in the drawing an off-setting gesture is added that leads the eye back to the figure.

In a drawing with more than one figure—three figures, for example— two might be placed together in relatively simple vertical poses while the third figure might have a more extended pose and occupy a space similar in area to the other two figures.

A drawing can be "balanced"—in the sense of "brought into balance"—by varying its main elements in a number of different ways. **Color** plays a major role in achieving balance and is discussed later in the chapter. **Value contrast**—the difference in value—darkness and lightness—between two or more colors is also an important device to achieve balance: the eye is attracted to dark-light contrasts and a strongly contrasting combination of colors in one part of a drawing can offset larger shapes with a lesser degree of contrast in another part (for example, a patent leather handbag with high contrast between the high value of the white highlights of the shine and deep black of the body, held out from the figure might be used to offset a combination of garments of a single, or similar colors without shine).

Textural Contrast—using an interesting or detailed texture over a relatively small area can offset larger shapes with less pronounced texture.

Leading the eye away from shapes concentrated in one part of a drawing (to which it is naturally attracted) **through the use of line or other means** is another device also frequently used to bring balance to an asymmetrical composition. This effect can also be seen in the drawing by Demetrios Psillos earlier in the chapter.

elements of design in fashion drawing

line/contour drawing

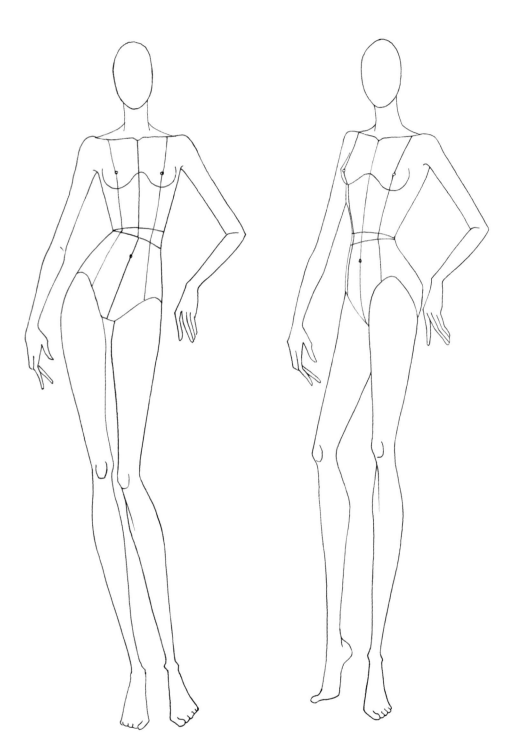

Nline-head croquis line drawing. The arrows highlight the three-dimensional cylindrical shapes on which the figure is based.

Elements of Design in Fashion Drawing

Line

Lines are the most familiar elements in art and design and are present with us all from an early age in the form of drawing and writing. LIne is also the most used element of design and very often plays a role in all the other elements of design: space, shape, value, texture and color.

In its purest form a line is the path traced by a point set in motion—it has length and no thickness. A line is also a physical mark on a surface—paper or some other substance —with a length greater than its width.

A line, by which we mean a line on paper or another surface, is defined by a number of different variables: **thickness, weight, location (or positioning), direction and quality.** The thickness of a line can vary greatly and is a most important variable in fashion drawing, as is line direction— whether a line is straight, curved, zig-zag or angled, to name but a few of the possibilities. The weight of the line, referred to as **Line Weight** refers to how dark or light the line is–whether a dark or light medium has been used and how it has been applied (for example, a dark 2B pencil naturally gives a heavier line weight than a light HB pencil but can be made darker or lighter by varying the pressure. **Line Quality** refers to thel way line is used in a drawing– the way it looks overall. This depends on the medium that is used to make the line, the weight, texture, consistency, speed and expressiveness of the line in that medium—the uniquely personal way different artists use line.

Importance of Line.

Line is important in art and design for a number of reasons, the principal reason being its ability to describe **shape**–the edges of objects. Drawings where lines are used to show the edges of objects are known as **contour drawings.** Contour drawings are particularly important in fashion drawing, where the outside edge—the silhouette or contour— of a garment is usually a defining feature, and the other edges of shapes within the garment—seams, pleats, details—are also important. Flats, for example (flats are technical line drawings that serve as blueprints and contain critical data on shape, size and structure of a garment, similar to an architectural drawing) are extreme examples of contour drawings.

Uses of Line

Line is also used in a number of other ways besides defining the shapes of objects: Line is used extensively to indicate the aspects of objects that make them appear three-dimensional. At the simplest level, for example, lines can be used in the form of **cross-hatching**—parallel lines of varying thickness and density—to create simple shading. In fashion drawing line is used in a number of ways to indicate the presence of the body under the garment, the curve of a garment around the body, different fabric types and more. These uses are discussed in detail

elements of design in fashion drawing

vik muniz

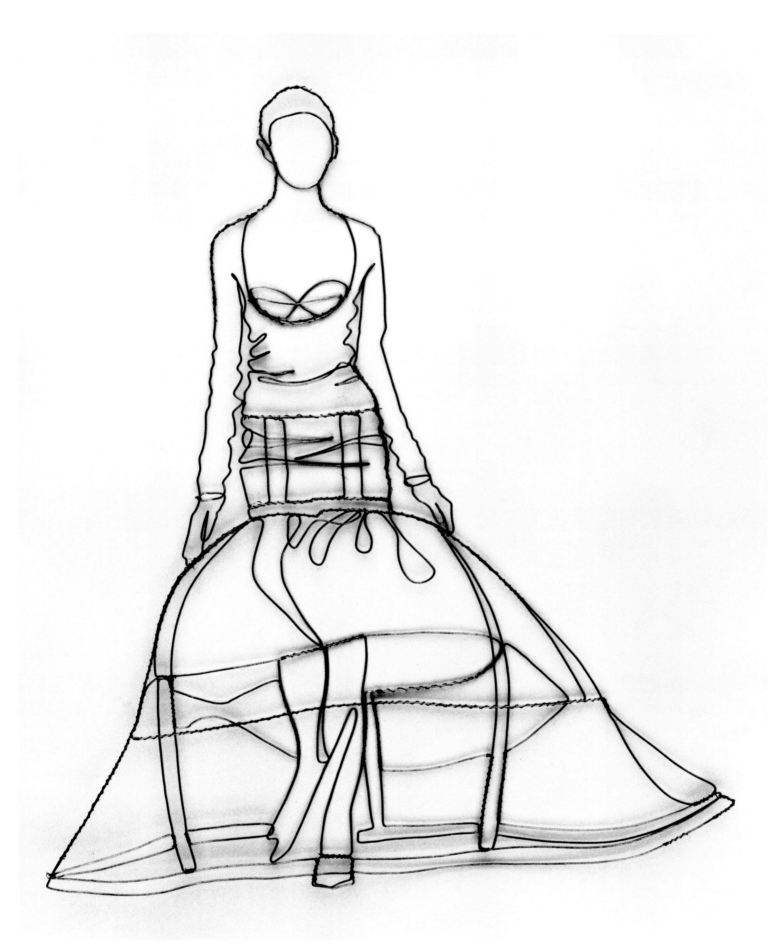

Vik Muniz
Rochas (Pictures of Wire), 2004

elements of design/line

use of line in fashion drawing/line thickness and weight

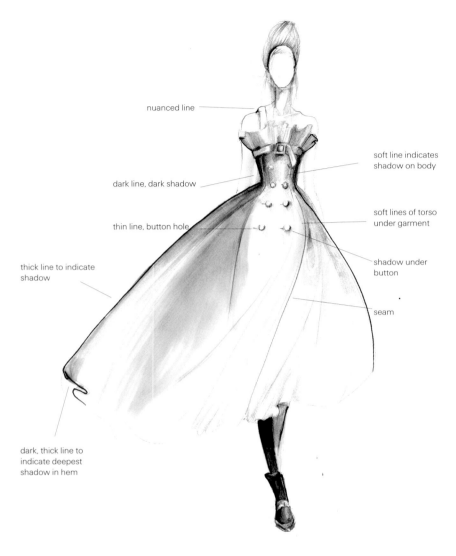

nuanced line

soft line indicates
shadow on body

dark line, dark shadow

soft lines of torso
under garment

thin line, button hole

shadow under
button

thick line to indicate
shadow

seam

dark, thick line to
indicate deepest
shadow in hem

Use of different types of lines to express different features of a garment (here a wedding-dress by Ray Kawakubo).

Use of Nuanced Line to show where fabric is flat against body and then bends away from body and casts a shadow. This is seen at both edges of the sash: the lower edge curves around the bust at the front and the top edge curves around the back under the arm.

Uses of Line (continued)

in this chapter and also in the chapter on fabrics; they are continually referred to in the explanations of drawings throughout the book.

Another type of line, important in art and design generally, and fashion drawing in particular, is the **implied line.** This is not an actual line but a line that is suggested by the continuation of a series of objects lined up in a drawing or the continuation of a gesture or glance. Implied lines can be useful for leading the eye around a drawing or, as mentioned, in balancing disparate elements.

Line Positioning

Lines are themselves the result of movement–the motion of the hand across the page– and, in turn, to the eye they can also suggest **movement.** This association of lines with movement is important for fashion drawing where it is often appropriate to show the appearance of a garment when the body is in motion. The direction and positioning of lines can lead the eye and reinforce the sense of movement and vitality in a drawing: horizontal lines suggest lack of movement, stability and equilibrium, but diagonal lines suggest movement and vitality.

Line and Color

In line drawing—drawings made with lines, usually created with a pen or pencil—the information in the drawing is conveyed solely by the use of line. As lines sometimes have to convey more than one type of information, the use of line has to be very precise in order to avoid confusion. When color is used, much of the information that is conveyed in a line drawing by line is conveyed instead purely through use of color: Shading, for example, is expressed through gradating color through shades and tints and not through cross-hatching. This means that line can be used more selectively to bring additional information to a drawing, such as the position and shape of seams, slits, pocket detailing, pleats, trims and so on- or for stylistic effect.

Use of Line in Fashion Drawing

Most of the information provided by line on **shape, size, proportion and detail** is conveyed using straight and curved lines of different lengths and locations. It is possible to communicate further types of information, though, by varying the **thickness and weight** of the lines used. This also makes drawings look more realistic.

Varying width and weight of line is a particularly useful device in fashion drawing, as it is well-suited to representing the differences between fabrics and the subtle visual effects of three-dimensional garments on the figure– where the fabric drapes, where the body sits under the garment and where it folds and creates areas of light and dark.
Lines can be categorized in a number of different ways but it is easiest to think of them according to their thickness: **thin lines, thick lines and nuanced lines. Nuanced lines** are lines that change in thickness and weight along their length, switching from

elements of design/line

conventions for line use

thin to thick, thick to thin, from light to dark, sometimes from crisp to soft-edged, sometimes disappearing and reappearing as the line moves into and out of areas of light.

Thin Lines

Thin lines in general suggest lightness, delicacy and detail and we use them when we wish to express any of those qualities in our fashion drawings.

Thin, light, crisp (clean-edged) lines drawn with a sharp, hard graphite or mechanical pencil are useful for indicating light, crisp fabrics such as linen, taffeta, laces, tulle, polished cottons. They are also used to draw straight or spiky hair.

Thin, light, soft (fuzzy-edged) lines drawn with the edge of a softer pencil are useful for indicating knits, bouclé, angora, furs with finer fibers, embroidery, ribbing.

Thin, dark, crisp (clean-edged) lines drawn with a softer pencil or black Micron pen are used to draw seams, shadows under buttons or other small details such as sequins, edges of jewelry, joints in accessories, shadows in crisp fabric, top-stitching and embroidery.

Thin, dark, soft (fuzzy-edged) lines, also drawn with a soft pencil or Micron pen are used when drawing tweed, zippers, cover stitches or indicating layers of fabrics.

Thick Lines

Thick lines in general suggest shadow, distance from the light source, weight and solidity.

Thick, light lines can be used to indicate the fit of a garment–the subtle shading indicating the position of the figure under the garment. Thick light lines are also used to shade drape where the fabric is light and well-lit.

Thick, dark lines are used to indicate deeper shadow, for example in the folds of heavier fabrics that are not close to the light source or cast shadows from thick fabrics and materials, such as that under a heavy belt buckle.

Thick, soft (fuzzy-edged) lines are used to depict thicker knits, such as cable, certain furs, fabrics with a 'pile' like velvet.

Variation in use of line

There is considerable variation in use of line and line quality: for example, some artists, fashion illustrators and caricaturists (or cartoonists) are often able to express a great deal about a facial expression or attitude, or the drape or line of a garment using little actual line–displaying what is referred to as an "economy of line." The opposite technique— a dense application of many lines—can also be used with excellent effect.

Despite these variations in style and usage, no single style of line is naturally superior to any other: the great fashion illustrators display a wide range of line quality and style. As with many other areas of art and design, the only requirements are that the final

Thin lines expressing lightness and delicacy. Thin, crisp lines are used to indicate lightweight fabric with crisp body.

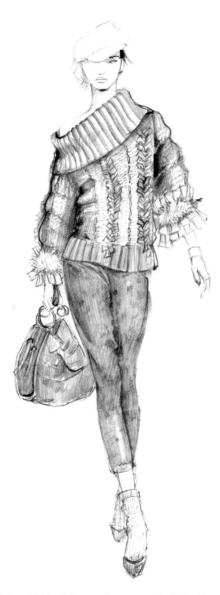

Thin and Thick soft lines used to represent the thick cable stitch and the curly filaments at the edges of the sweater. Thick and thick dark lines are used for shadows at the sides of the sweater and under the neckline.

elements of design/line/shape

use of line/shape/volume

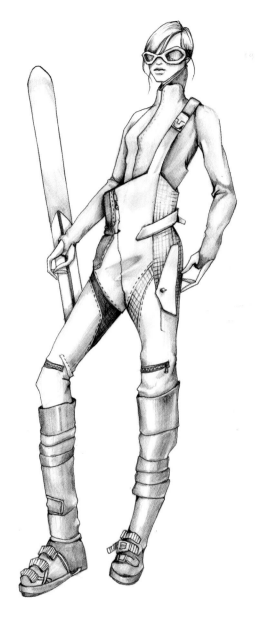

Thick soft lines are used for shading—along the side of the shoe, inside the thigh, and in the crotch area.

Variation in use of line (continued)

result is clear and aesthetically pleasing.

A line made with a single sweeping gesture is usually more elegant than a line made up of a series of small lines, sometimes referred to as "chicken scratches." Being able to draw elegant, expressive lines is a technique that requires practice to master. To draw graceful lines, it is important to *sit* gracefully, upright and perpendicular to the page. Keep the weight on the elbow and draw from the wrist. Focus on achieving precision and control—the qualities that need to be developed so that the lines of a garment can be drawn quickly and accurately. It is difficult to draw well when fatigued or upset.

Using line correctly

When used correctly line can make drawings look more realistic, accurately representing the appearance of surfaces and where light and shadows fall. If used incorrectly, however, line can be confusing, drawing attention to the way the drawing itself is made rather than to the subject of the drawing. Until skills in using line have been refined it is best, if in doubt, to make lines on the light side rather than risk a too-heavy appearance.

Shape/Volume

Shapes are areas with edges formed by either by lines, changes in color or changes in light and dark (value). **Shape is two-dimensional**—it exists on a flat two-dimensional surface, having height and width as opposed to **Volume** which has **three dimensions**, having depth as well as height and width. Three-dimensional objects are called **forms.**

We draw on a two-dimensional surface—the paper—and can express shapes easily by showing the edges with line, color or value change. We can, though, also create the **appearance of three-dimensional volume** on our paper. This is done by creating the shape of the object we are drawing accurately and then using **shading** to reproduce the pattern of light and dark that appears on the surface of a three-dimensional object. If parts of the object we wish to show are not parallel to the plane of the surface of the paper then those parts will appear **foreshortened** and the shapes that represent them also have to be foreshortened. For example, the drawing opposite is a three-quarter view figure. The side of the figure turned away from the plane of the paper is foreshortened. Shapes are very important in fashion drawing because shape is one of the most important things that changes between garments in fashion design: All garments have shape. They also have volume, which, as mentioned, we can show by shading, indicating where the garment folds and drapes and where the fabric is close the body and where it falls away from the body. **Shading of the body, garments and fabrics** in color is discussed throughout this book; a more complete introduction to shading in black and white can be found in the companion volume *9 Heads, a guide to drawing fashion.*

Shape. A number of shapes, some located within larger shapes, are shown in this "flat" line drawing of a blouse. Shapes are the outlines of objects shown on a flat–two-dimenssional surface.

elements of design

positive shapes/negative shapes

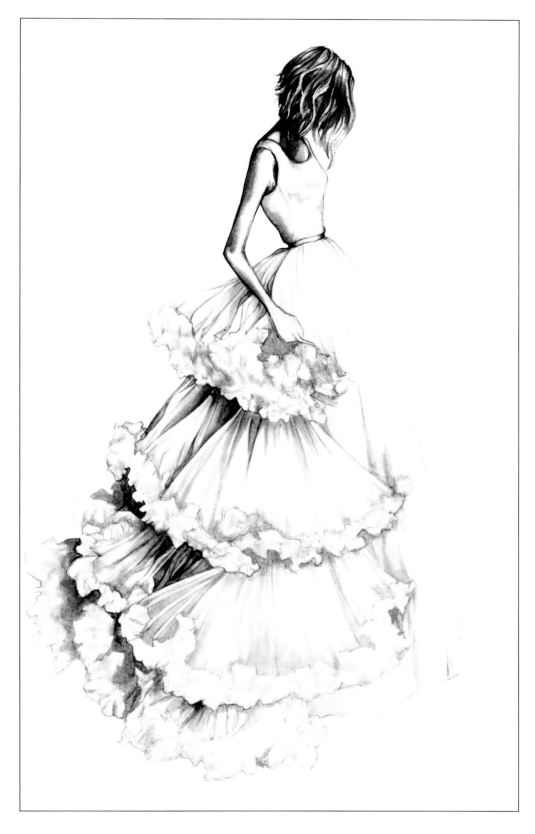

Positive shapes and negative shapes (negative space)

When we create shapes on the surface of the paper we also create shapes in the space *around* the shapes. These spaces around the shapes are referred to as **negative shapes** or **negative space**, and the shapes themselves are sometimes referred to as **positive shapes.** When composing a fashion drawing we must not only depict the basic shapes accurately but we must be aware of the negative space we are creating and make conscious design decisions about it. If the negative space is itself interesting we can draw attention to it through a variety of devices–outline, color, value variation, for example, and integrate it more fully into the overall composition.

Volume. Positive/Negative shapes. Objects are made to appear to have volume and depth by shading them to resemble the shadows that appear on them in real life, as seen in the shading of the numerous drapes and folds of this beautiful wedding dress. The shapes in the objects must also be drawn accurately, including the foreshortening of parts that are not parallel to the plane of the paper. This drawing is of a three-quarter view figure and the side turned away is foreshortened. An interestingly shaped **positive shape** (the silhouette of the gown) creates interesting **negative shape or space** (the shapes of the space outside the silhouette)¡.

elements of design

texture

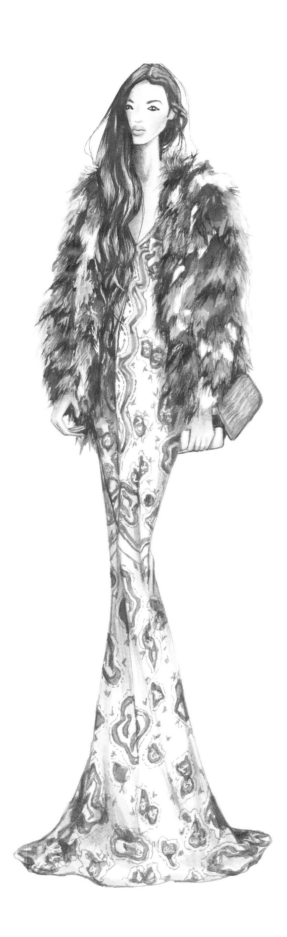

Texture

Texture refers to the quality of the surface of an object–how it feels, how our sense of touch experiences it. The "feel" of an object is usually accompanied by a particular way the object "looks", so we can often tell what the surface will feel like from the way it looks: a hard, smooth surface will often look "shiny"; a hard, rough surface, like tree bark, will usually look "matte" and "mottled". The differences between the "looks"–the appearances– of the surface of different objects are often very slight or non-existent and it is often difficult to tell exactly what the surface texture will be from its appearance. It is however important when drawing an object to show the appearance of the surface texture as accurately as possible.

In fashion drawing we wish to depict the fabric we intend our garment to be made of as realistically as possible. (We could simply show the color and shape of the garment we are drawing and include a swatch of the fabric to be used together with the drawing, but if we wish to show what the garment will look like in a variety of different fabrics it is easiest if we can draw them.) **We make the drawing of the fabric realistic by showing the thickness of the fabric, its weight and how it drapes and folds. We also need to clearly show what it looks like–whether it is a shiny leather, a matte suede, a crisp organza, a smooth cotton or a luxurious fur.** Even though the accurate drawing of the surface texture alone is sometimes not sufficient to identify the fabric beyond a doubt, when all the other pieces of information on folds, drape and thickness are considered then, if drawn well, the result is clear. If on the other hand we draw the folds, drape and thickness of the fabric accurately but do not draw the surface texture correctly the result is not clear.

When showing how to draw fabrics and garments in this book care is given to how to create realistic drawings of the surface texture as well as the other features of the fabric or garment.

Texture. A number of different textures are depicted realistically in this drawing and are immediately recognizeable: the smooth surface texture of the silk dress; the soft fibrous texture of the fur stole, the leather purse, the thickness of the hair and eyebrows and the smoothness of the skin and lips.

elements of design

space/motion

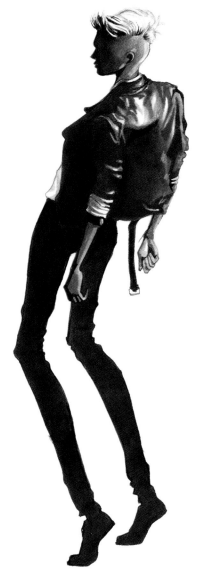

Space

To draw fashion realistically we must show space realistically in our drawings. As mentioned, we draw our garments with shading so they look as though they exist in three-dimensional space rather than on the two-dimensional surface of the paper. When we are designing a collection and show several garments in one drawing we have to make the nearer garments look as though they really are nearer than those that are further away. We do this using **perspective**, making the nearer figures larger than those further away. When one of the objects in our drawings overlaps another object we show only the front object where they overlap: the rear object sits in the space behind.

Motion

In fashion drawing we do not always wish to show garments in static poses. Sometimes we wish to show garments on figures that are in motion, either because we are showing **sportswear garments** that will be used in activities with a lot of movement, or we wish to show that the garments are designed for the young and energetic. We indicate that motion is present in our drawings by capturing the look of the figure in motion, walking, running, jumping, kicking or throwing a ball. In motion, the limbs are usually spread out, away from the body, creating diagonals in the figure. Figures with diagonals suggest motion and figures with arms and legs close to the body suggest rest and lack of motion.

Space. This back-threequarter view figure is drawn using perspective, making it appear three-dimensional and that it exists in space.

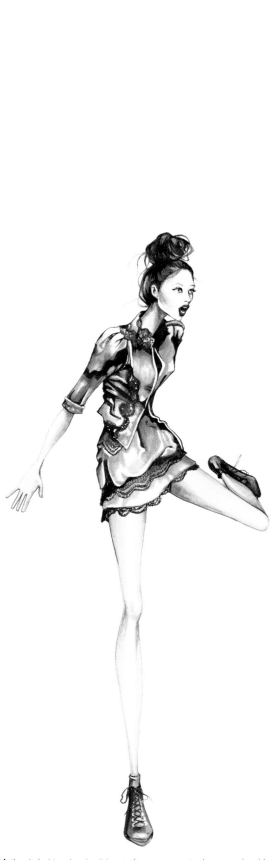

Motion. In fashion drawing it is not often necessary to show speed, so blurred edges are not necessary, but a pose showing the figure in the middle of a movement suggests motion and can be used when drawing active wear.

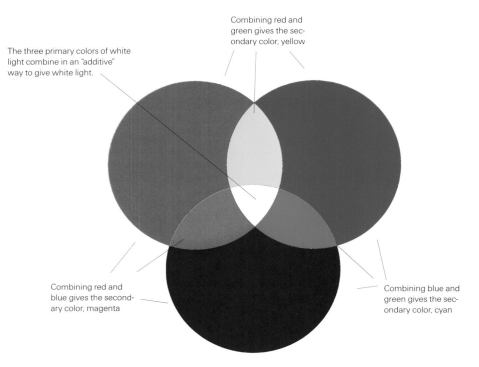

The three primary colors of white light combine in an "additive" way to give white light.

Combining red and green gives the secondary color, yellow

Combining red and blue gives the secondary color, magenta

Combining blue and green gives the secondary color, cyan

Primary colors of white light. Red, green, and blue (RGB) are known as the primary colors of white light. Combined together they form white, and when combined in pairs with each other they form the three secondary colors—**cyan, magenta and yellow (CMY)**. Note that the primary blue of white light almost appears more violet than blue.

The three secondary colors of white light—cyan, magenta and yellow— are also the primary colors of process color, the color system used in four-color printing (cyan, magenta, yellow and black—CMYK) to obtain a wide variety of colors.

Color

Color is one of the **elements of design,** one of the variables we use in the design of our drawings. Color is also, however, a major aspect of the world we live in and affects us in many ways every day. In fashion, color is one of the most important variables that are constantly changing according to shifts in tastes and trends.

This section of the book examines what exactly color is, its properties and how colors interact with each other. While this information is in parts complex and is not essential for good fashion drawing, given how important color is in fashion it can be very useful: Eventually our color tastes and decisions will become instinctive, but those instincts will be sounder if they are developed from within a body of knowledge. Knowing the terms used in describing color allows us to discuss technical color issues authoritatively; knowing the theory about how colors combine and interact gives us a framework with which to analyze our color options and make reasoned decisions, to cross-check our good choices or to help understand why some do not work.

Much of the information in this section of the chapter is recognized as fact, based on scientific observation and categorization. Other parts, however, especially in the area of relationships among different colors and how they interact with each other and the resulting schemes for color design, are, just like the **principles of design** themselves, based on informed judgment and opinion rather than scientific fact.

What is Color?

Natural white light is formed of rays of light of different colors, as can be demonstrated with a prism, which separates white light into its component hues, like a rainbow. (Note that "hues" is the term usually used to refer to colors in their "pure" state, though elsewhere in the book the terms "hues" and "colors" are used interchangeably.) The hues of light, often called **spectral hues**—the hues of the spectrum— are **red, orange, yellow, green, blue, indigo and violet** (though some color experts do not now consider that indigo is part of the spectrum and prefer to recognize only the other six hues).

When we talk about objects in our everyday speech we refer to them as "being" a particular color. **Color is in fact not a property of the objects themselves but is the way we perceive the light reflected from objects.** When white light falls on an object the object absorbs all the rays of white light except those corresponding to its "own color". Our eyes areceive the light waves reflected from the object and the object is then perceived by us as being of that color. For example, a red object absorbs all the rays of white light except red light; a blue object absorbs all the rays except blue and so on.

The types of surface also affect how light is reflected and how objects are seen. Objects of different textures—different types of fabrics for example—reflect light in different ways. A **shiny fabric**, no matter what its color, will tend to reflect all light at its highest points so that no rays of light are absorbed and all the white light is reflected, making it appear as white highlights. Matt fabrics such as wool absorb and reflect light uniformly and in consequence display a regularity of color across their surfaces, in contrast to the variations in color of shiny fabrics.. These are important points to bear in mind when drawing garments made of differing types of fabrics.

elements of design/color

additive color process/pigments/process colors/ subtractive color process

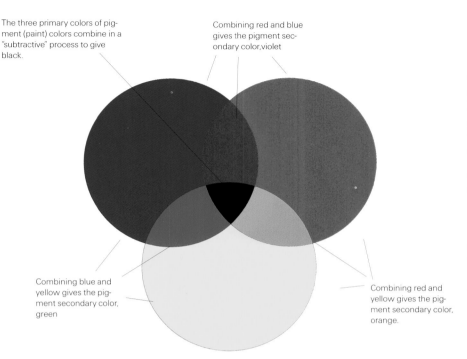

The three primary colors of pigment (paint) colors combine in a "subtractive" process to give black.

Combining red and blue gives the pigment secondary color, violet

Combining blue and yellow gives the pigment secondary color, green

Combining red and yellow gives the pigment secondary color, orange.

Mlixing the pigment primaries. The pigment (paint) primaries—**red, yellow and blue**, combine in pairs to form the pigment secondaries-orange, green and violet. Pigments combine in a "subtractive color process". The combination of all three pigment primaries, in theory, filters out all colors forming black. In practice, impurities bring about a result that is not pure black.

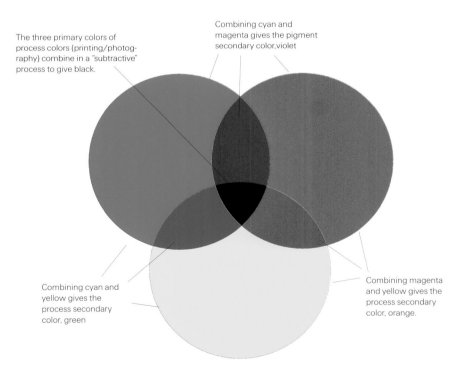

The three primary colors of process colors (printing/photography) combine in a "subtractive" process to give black.

Combining cyan and magenta gives the pigment secondary color, violet

Combining cyan and yellow gives the process secondary color, green

Combining magenta and yellow gives the process secondary color, orange.

Mixing the process primaries. Process colors are the colored inks and chemicals used in printing and film photography. The process primaries—**cyan, magenta and yellow (C,M,Y)**—combine in pairs to form the process secondaries—orange, green and violet—the same as the pigment secondaries. Process colors, like pigments, combine in a "subtractive color process." The combination of all three process primaries in theory filters out all colors forming black, but again in practice the result is not pure black but more mud-colored.

Primary Colors/Secondary Colors/Additive Color Processes

Primary colors are colors that cannot be obtained by mixing other colors. The primary colors of white light are **red, green and blue**. Secondary colors are obtained by mixing two primaries together—blue and green gives **cyan**, red and green gives **yellow** and blue and red gives **magenta**.

When light of different colors is mixed together it gives different results from when pigments (the material that gives paints, inks and dyes their "color") are mixed together. The primary colors of light—**red, blue and green**—can be "added" back to each other to re-create white light. This way in which colored rays of light combine is called an **"additive"** color process, or system, as shown in the illustration. TV, computer monitors and other visual projection technologies all generate ranges of colors through mixing of colored light according to the additive process (so called RGB—red, green and blue).

Pigments/Process Colors

Pigments, the material that is the colored ingredient of paint, markers and other color media, mix together in a different way to rays of colored light, as do the colored inks and chemicals used in printing and photography (printing and photography are referred to as **processes**, and the colors associated with them as **process colors**).

The primary hues of traditional pigments (paints, markers, pastels and so on) are **red, yellow and blue,** and the primary hues of processes (the process primaries) are **cyan, magenta and yellow**, referred to as **CMY (CMYK,** the four colors used in printing, is CMY + black, for which K is a symbol). **CMY** are also the **secondary colors** of the primary additive system of white light, that is, the secondary colors formed by mixing pairs of the primaries red, green and blue.

Subtractive Color Processes

Pigments and process colors combine in what is known as a **subtractive color process** (or **system)** and mixing pigment or process colors produces different results from those obtained by combining light of those same colors. The results of mixing the pigment and process primaries to give their secondaries is shown in the illustration. Note that the secondaries of both pigment and process primaries are the same—orange, green and violet. The process is known as subtractive because of the nature of pigments: their "color" comes from their properties of filtering out all the components of white light with the exception of their "own color". Combining two pigments is in effect the same as placing one set of filters on top of another—"subtracting" a further set of the components of white light from the first. This is why paints (in their many forms) lose intensity—or saturation, as it is often called—when mixed together, forming "neutrals"—browns or greys. Mixing all three primaries together filters out the whole spectrum of white light, leaving, in theory, black, though in practice pigment impurities and differing solvent concentrations mean the result is not pure black.

Mixing processes for markers

Mixing processes for markers, as for all other pigments, are subtractive, so as more colors are added mixes tend towards black, though in actuality they resemble mud more than coal.

properties of color

value/value keys

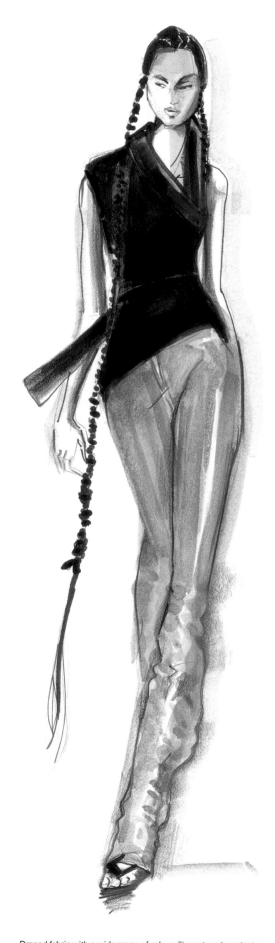

Draped fabric with a wide range of values. The value of a color is the term for referring to how dark or light a color is. In this illustration the extremes of value—black and white—are present and there are also a range of different values in the color of the pants.

Properties of Color

Value

Value is the technical term used to refer to the lightness or darkness of a color. Lighter versions of a color are said to have higher values, and darker versions lower values. Adding white to a color makes it lighter, increasing its value and producing what is known as a "tint." Adding black darkens a color, lowering its value and creating what is known as a "shade." Mixing colors will result in a new color somewhere between the original colors in value. "Blending" a color—diluting it with its solvent (colorless blender for markers)—makes it lighter, increasing the value. Examples of altering the value of a color are shown in the section on mixing colors in Chapter One: Materials and Techniques.

Value is an important characteristic of color for fashion drawing. Fabric, when made into garments that are then hung on the figure, drapes naturally, displaying a range of color values the breadth of which varies according to the type of fabric. A garment with a lot of drape, and deep folds, will display high color values on its flat surfaces and ridges, possibly even a shine or sheen, the highest value of the color—white; in the folds the color will decrease in value, often appearing black—the lowest value of the color—in the deepest recesses. This phenomenon, the gradual shift in value from high to low and low to high, is, referred to in this book as **gradation of tone**, as has already been seen in Chapter One. How gradation of tone appears in different fabrics and types of drape and how it is rendered in fashion drawing with markers is covered extensively in the chapter on fabrics.

Different colors have different intrinsic value levels, and are commonly known as light and dark colors. Yellow is light, higher in value than blue, which is dark, lower in value than yellow.

properties of color

saturation

Adding progressive amounts of grey to colors reduces the saturation of the colors, finally resulting in grey.

Value Keys

Value keys are groups of different colors of the same value—all with the same degree of lightness or darkness. Designs sometimes make use of colors of similar value and/or saturation levels, as described below in the section on color schemes.

Saturation/Intensity

One of the main properties of color is its "saturation," or "level of saturation." When used in describing color, "saturation" has the same meaning as "intensity" or "purity."

Saturation can be easily understood by visualizing the process of *lowering* **the saturation of a color:** Lowering saturation is achieved by adding grey of a similar value. As more grey is added the color loses saturation (though keeping the same value as we are adding a grey of the same value) eventually giving way to pure grey. Adding grey to a color results in what is called a **tone**—a less saturated version of the color. The saturation of a color can also be decreased by mixing it with its complementary color, resulting in an increasingly muddy, neutralized version.

Increasing **the saturation of a color,** on the other hand, is achieved by adding more of the same color, displacing greys and neutral elements, or adding an already more saturated version of the same color.

(A common misconception about colored markers is that they cannot create intense, saturated colors, such as those that can be achieved with oils, gouaches or acrylics. Highly saturated colors can in fact be created quite easily with markers as is shown in Chapter One: Materials and Technique.)

Increasing amounts of white added to base color. The value of the color increases as more white is added.

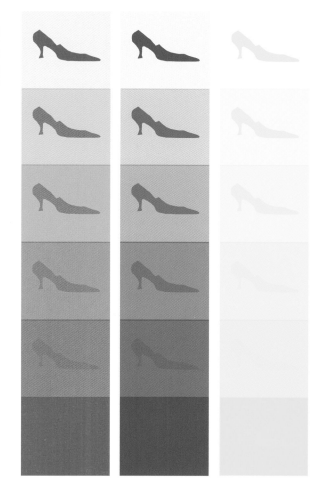

Adding white to red, blue and yellow. Red and blue are lower value colors and their values increase significantly and saturation decreases with the addition of white. Yellow is a high value color and its value changes less as saturation decreases with the addition of white. The shoes in each column are of the same value and saturation levels.

properties of color

shades and tints

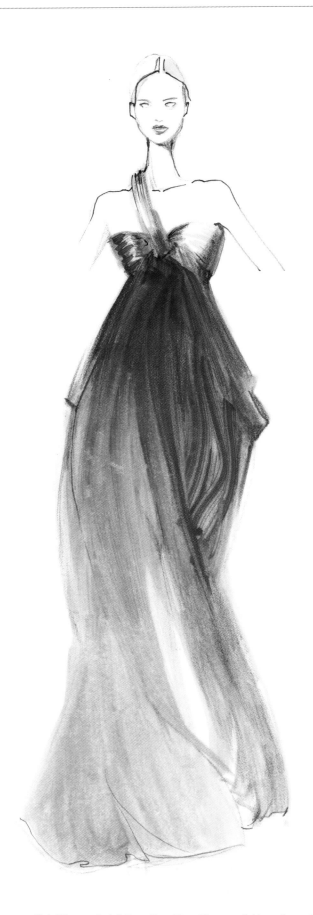

Shades. When a color is darkened by adding black or dark grey the result is known as a **shade** of the original color. In the figure above black is added to the original blue hue above the waist, resulting in a shade of the original color.

Tints. When a color is lightened by adding white or very light grey the result is known as a **tint** of the original color. In the figure above white is added to the original blue hue below the waist, resulting in a **tint** of the original color.

color wheels

additive/subtractive color wheels

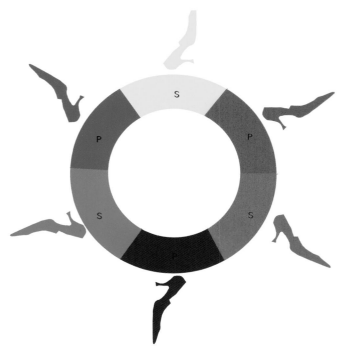

The **additive color wheel** showing the three primary colors of white light—red, green and blue (RGB)— and the three secondaries—cyan, magenta and yellow (CMY). (P = Primary color, S = Secondary color.)

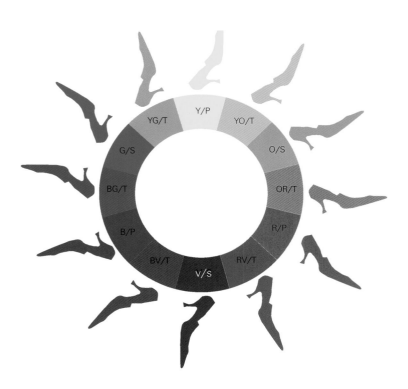

The **traditional subtractive system color wheel.** The wheel shows the position of the three primaries, red, yellow, blue, RYB, the three secondaries, OGV and the six tertiaries, RO, RV, YO, YG, BV and BG . (P = Primary color, S = Secondary color, T =Tertiary color.)

Primary, Secondary and Tertiary Colors of subtractive color wheel

Primary	Secondary	Tertiary
Red	Orange	Red-Orange
Yellow	Green	Red-Violet
Blue	Violet	Yellow-Orange
		Yellow-Green
		Blue-Violet
		Blue-Green

Color Wheels

Color wheels have been in use for several hundred years as tools showing the separation of the colors of the spectrum into distinct colors—or "hues" as the colors of the spectrum are known in their pure states. Color wheels are a way to display the spectrum of colors so that the relations among them become clearly apparent. Different color wheels exist to show color relations for both **pigment and process subtractive systems and** for **light-based additive systems.** The color wheel for additive systems—the component rays of white light—show the three additive primaries—red, green and blue—and the secondaries—cyan, magenta and yellow— as shown in the illustration.

The traditional subtractive system color wheel showing the effects of combining pigment and process colors has twelve segments representing the three primary hues, three secondaries and six tertiaries. The wheel shown here is based on that devised by **Johannes Itten** (1888–1967), an artist from the German **Bauhaus** school working in the second half of the twentieth century. The three subtractive primaries—red, yellow and blue—are shown as equi-distant segments with their secondaries, orange, green and violet lying mid-way between the primaries. The tertiaries—red-violet, red-orange, yellow-green, yellow-orange, blue-green and blue-violet— lie between their component primaries and econdaries.

Artists and designers are interested primarily in the **pigment subtractive wheel** as an aid in predicting the results of mixing colors of paints or inks. The **additive system wheel** is also directly relevant as it shows the relations among the component colors of white light, of use when considering the results of interactions among perceived colors, which reach the eye as rays of light, and how to combine colors harmoniously. Because both subtractive and additive mixing processes are of relevance to artists and designers, sometimes red, blue, green and yellow are all considered as primaries—the combination of the additive and subtractive primaries.

It is important to note that the traditional subtractive color wheels showing the primary and secondary subtractive are guides and do not usually give accurate predictions of the results of direct mixing of colored pigments, due to variations in pigments, the type of solvents they are used with and different concentrations. Constant experimentation is necessary and mixed colors should always be tested before being applied.

Subtractive mixing process of markers

As was seen in the demonstration of mixing marker colors in Chapter One, when the mixing process is a subtractive one, the results, particularly if the colors are distant from each other on the color spectrum, are usually muddy—the colors have tended to neutralize each other rather than produce vibrant new colors. Better results are obtained when mixing colors closer to each other in the spectrum, or by using blender, white or grey or black to achieve the effects of more transparent, more neutral, darker or lighter values or less saturated versions of a color. If budget permits then it is always best to use the marker with the pure pigment closest to the desired color. It will almost invariably be brighter and more saturated than a mixed color).

color wheels

color wheel relationships/color values/complementary colors

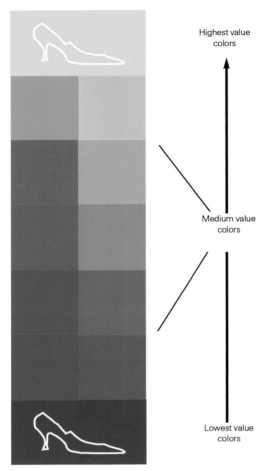

Inherent values of colors. Colors are arranged from the highest value—the-lightest— on top, to the lowest value— the darkest— at the bottom. The position of each color in this diagram is also equivalent in height to its position on the color wheel.

Color Wheel Relationships

Color Values

The different colors on the color wheel have different values—degrees of lightness and darkness. The color wheel is usually drawn with the highest value color—yellow—at the top. The colors on both sides of the wheel become progressively darker—lower in value—towards the bottom of the wheel, where the darkest hue, violet, is situated. In the diagram on the left the colors of the wheel have been re-arranged in two columns with the highest value colors at the top and the lowest at the bottom.

Complementary Colors

Colors opposite to each other on the color wheel are known as **complementary colors**, so called because they "complement"—or complete— each other. With additive, light-based color processes, when complementary colors are combined they form white. WIth subtractive, pigment-based processes complementary colors "neutralize" each other and tend to black.

The complementary color relationship is central to understanding color and making color decisions, in all areas of art and design as well as in fashion drawing and design.

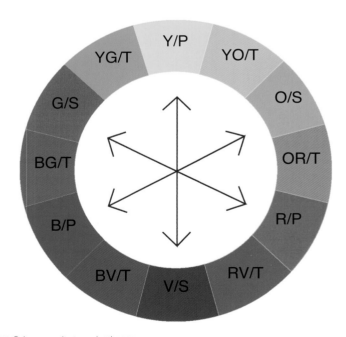

Complementary colors. Colors opposite to each other on the color wheel (here is shown the traditional subtractive system color wheel) are known as complementary colors. (P = Primary color, S = Secondary color, T =Tertiary color.) The primary colors are complementary with secondary colors and vice-versa. The tertiaries are complementary with their corresponding tertiaries.

Primary, Secondary and Tertiary
Colors of subtractive color wheel

Primary	Secondary	Tertiary
Red	Orange	Red-Orange
Yellow	Green	Red-Violet
Blue	Violet	Yellow-Orange
		Yellow-Green
		Blue-Violet
		Blue-Green

color wheels

analogous colors/color temperature

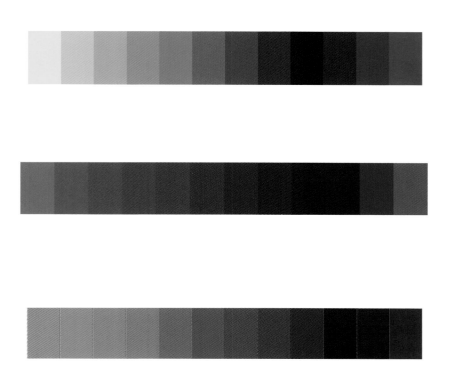

Adding complementary colors to each other in progressive amounts. At the point where almost equal amounts of each hue are mixed the colors are "neutralized" and the result is a "muddy" color. From top, yellow to purple, red to green and orange to blue.

Analogous colors

Analogous colors (or analogous hues), sometimes referred to as color families, are groups of two or three hues next to each other on the color wheel.

Color Temperature

The colors on the color wheel are almost equally divided between what are commonly referred to as warm colors and cool colors. **Warm colors**—those adjacent colors spanning from red to yellow—are supposedly associated with warmth and light. **Cool colors**—those from green to violet—are supposedly associated with cold and dark. Yellow-green and red-violet are on the borders between warm and cool, and can take on either characteristic depending on their context. Variations of the primary colors can appear either warm or cool depending on whether they are mixed with warm or cool colors. Whites, greys and neutrals are known as warm or cool if the colors they are mixed with are warm or cool.

Although referring to colors as warm and cool is a widely used convention in design, in both fashion and other areas, and is used extensively in this book, it should be noted that this classification into cool and warm is essentially psychologically and culturally based: the association is not in fact made in all cultures and its validity is questioned by some experts in color.

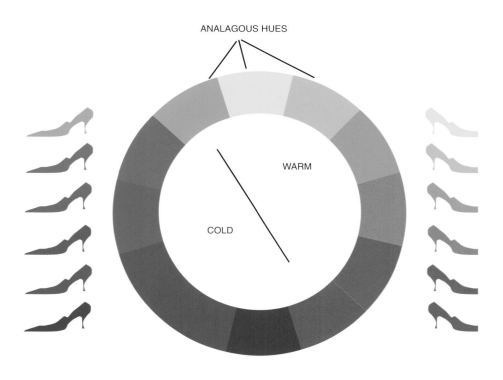

Color Temperature: Warm and Cold colors. The color wheel is almost equally divided between the so-called cold and warm colors. Not everyone agrees that these colors feel cold or warm, but the terms are frequently used in fashion and design.
Analagous hues are groups of any 2 or 3 colors adjacent to each other on the color wheel.

color wheel relationships

color chords

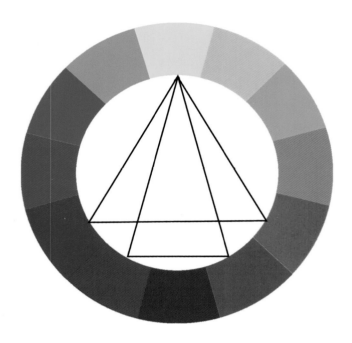

Triadic color chords, based on three colors. The chords are defined by either equilateral (all sides are equal) triangles, so are equal distances from each other on the wheel or isosceles (two sides are equal) triangles) so two are equally distanced from a third and closer to each other. The triangles can be rotated to any position on the wheel to indicate triads made up of other color groups.

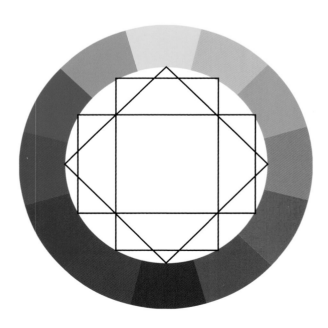

Tetradic color chords, based on four colors. The chords are defined by a square or rectangle inside the color wheel. Square tetrads are composed of two pairs of complementary colors.

Color Chords

Certain groups of colors spaced out on the color circle are known as color chords. These are groups of colors that, using the musical analogy, combine in a harmonious fashion, each with a different character.

Chords are formed of two, three, four or more colors, with each color in its group standing in a geometric relation to the other color. For two colors, chords are directly opposite each other on the color wheel, being pairs of complementary colors, for example yellow and violet. These pairs are known as complementry dyads, "dyad" meaning "two."

Three-color color chords (triads)

Color chords of three colors are known as triads (meaning "three"). Triads are either equidistant colors, in configurations of equilateral triangles (triangles with sides of equal lengths) for example red, green and blue—the additive primary triad—or form isosceles triangles (triangles with two sides of equal length). Triads that form the shape of an isosceles triangle are composed of a color at the apex of the triangle matched with the two colors lying on either side of its complementary color, known as "split complementaries."

Four-color color chords (tetrads)

Color chords of four colors form squares or rectangles called tetrads, for example orange, red, green and blue).

The geometric shapes of color chords can be rotated within the color wheel to give numerous color chord combinations.

Equi-distant saturation or value color chords

A similarly harmonious result to that of color chords, is also said to apply to colors of the same hue but different, equi-distant levels of saturation or value. These and harmonious color combinations in general are discussed later in the chapter in the section on color harmonies and schemes.

color relativity and contrast

interaction of colors

Color relativity. The shoes are all the same color but appear different against backgrounds of different colors.

Color Relativity and Contrast

Colors are rarely viewed alone, in isolation, but are generally seen together with other colors. The appearance of a color varies according to the conditions in which it is viewed—the conditions and direction of the light—and the colors that are adjacent to it. Artists have always been aware of this relativity of color and it has been commented on since the time of Leonardo da Vinci.

The French chemist **Michel Eugene Chevreul** (1786–1889) was one of the first to explore color relativity. Chevreul was the director of a factory that produced tapestries. He found that the color of a dye would often appear to change between the design stage and the actual printed fabric. Upon investigation he discovered that the problem was not related to the dyes but was optical, due to the influence of one color placed directly against another. Chevereul called this phenomenon **"simultaneous contrast."**

Interaction of Colors

The artist, educator and writer on color, **Josef Albers** (1888–1976) in his book *Interaction of Color* believed that it is rare to see a color that is not influenced by the presence of other colors. He compared the relative sensations received by the sense of sight with the relative sensations received by the sense of touch. As an illustration he suggested the experiment of placing the left hand in cold water, the right in hot, then moving both hands to a container of lukewarm water. To the left hand that had been in the cold water, the lukewarm water feels hot; to the right hand that had been in the hot water the lukewarm water feels cold. Albers claimed that colors interact with each other in a similar way and appear different depending on the colors to which they are adjacent.

The interaction of colors is highly relevant in fashion drawing, where often a number of colors will be present in the drawing and a large number of possible color combinations from which a unique selection has to be made are possible. Fabric colors and combinations of fabrics of different colors, skin tone, hair, facial skin tone, make-up, accents, background colors all have to be chosen with reference to each other and in such a way that everything appears to fit together.

To make effective and coherent choices about combining color, it is important to be aware of the principal ways that colors interact with each other. These ways in which colors interact are the basis of formal color "schemes", where specific combinations of colors are selected, as well as being present in any color composition, whether the colors are presented in a "scheme" or not.

Contrast of hue. All the colors contrast with their adjacent colors, the two with least contrast being the black and dark purple, those with most being the black and white.

Interaction of Colors (continued)

The interactions of color have been described and classified in a number of different ways, and the process is on-going, with new books about color and color interaction appearing with regularity. To provide a brief, explanatory framework for the different ways in which colors interact, the principal conclusions on the topic of Josef Albers and another great colorist, Johannes Itten, already referred to above, are summarized below.

Although Albers and Itten's views are their own personal opinions, and there is not clear supporting scientific evidence for them all (as is very often the case for theories that attempt to explain phenomena that are based on individual subjective perception) their views, nevertheless, do provide a clear, comprehensive and concise way of thinking about how colors interact. Albers' approach in the classroom was in fact to develop his students' sensitivity to colors through extensive experimentation before teaching about charts and tables. For those studying color in order to make more informed color decisions in fashion drawing and design, developing a direct sensitivity to color relations is as important, (or even more important) as an awareness of the scientific knowledge and theories of those relations.

In his book *The Art of Color* Johannes Itten lists seven types of color contrast. These are:

Contrast of Hue
Light-Dark Contrast
Cold-Warm Contrast
Complementary Contrast
Simulatanous Contrast
Contrast of Saturation
Contrast of Extension

Contrast of hue

Although the strongest contrast in colors is between black and white, black and white are not, strictly speaking, colors, but "achromatics"— meaning "without color". Among true colors (the "chromatics") the highest degrees of pure contrast of hue are between pairs of the additive primaries— red, green and blue—and pairs of the subtractive primaries—red, yellow and blue. This is because primaries are pure hues and do not contain color elements from the other primaries. Secondary colors also contrast, but less than primaries as they always have one primary color element in common. In general, the colors that contrast most with each other are those that are furthest apart on the color wheel—meaning they have fewer component colors in common.

Contrasting Hues. Outfit showing a wide range of contrasting hues.

interaction of colors/color contrast

light-dark value contrast/cold-warm contrast

Light–dark contrast. The pairs of shoes in each row are the same color but appear lighter against a dark background and darker against a light background. Note this effect also works for the achromatic grey in the bottom row.

Cold–warm contrast. The shoes and their respective backgrounds are all pairs of contrasting warm and cool colors.

Light-Dark Value Contrast

Light and dark colors contrast. The greatest light-dark value contrast, as for hue contrast, is that between black, the darkest color, and white, the lightest. Contrasts also exist among the chromatic colors , according to how far apart the colors are on the color wheel, as shown in the diagram of the ordering of colors by value.

If a color is placed against a darker background the contrast in values will make it appear lighter; if it is placed against a lighter background the contrrast in values will make it appear darker.

Cold-Warm Contrast

As discussed, some colors seem warm, suggesting warmth and light, and others seem cool, suggesting cold temperatures and darkness. On the color wheel approximately half the colors are warm and half are cool.

Warm and cool colors also influence other colors when placed together, warm primaries and second-aries making other colors warmer, cool primaries and secondaries making other colors coolers. Warm and cool colors can present interesting contrasts, accentuating the temperature of each other as well as the particular hues.

In fashion drawing a decision is often made to make the overall color scheme, or parts of it, cool or warm. If a cool color scheme is opted for, various elements can be made "cool": for example, light beige skin tone can be made cool by the addition of a small amount of blue. Conversely, red or another warm color can be added to the skin tone or to the shadows of a white garment if a warm color scheme is desired.

color relativity and contrast

complementary contrast/simultaneous contrast/contrast of saturation

Complementary contrast. The complementary colors in each pair accentuate each other and vibrate against each other.

Complementary Contrast

Complementary colors are "opposite" colors—those that are directly across from each other on opposite sides of the color wheel. For the subtractive color wheel, complementary colors are traditionally the pairs of the three primaries, red, blue and yellow, with their non related secondaries, green, orange and violet, and for the additive colors, red and cyan, blue and yellow, green and magenta.

Complementary color pairs accentuate each of the colors—a simultaneous contrast of colors—causing them to vibrate next to each other, sometimes an interesting effect for a drawing. A large area of background color with a small area of its comple- ment in the middle makes the complement seem brighter and more saturated.

Simultaneous Contrast

Chevereul used the term "simultaneous contrast" to refer to the general phenomenon of the interaction of colors. Itten developed this idea and related it to the "afterimage effect" noted with complementary colors: If the eye stares at an area of saturated color for a while and then looks away to a white wall or blank sheet of paper, the complementary color appears. The eye simultaneously "requires" the com- plementary color to appear and generates it sponta- neously if it is not present. Stated in another way, a color provides its own complementary color as a contrast even though that color is not actually pres- ent in a physical form on the surface.

Contrast of Saturation

Contrast of saturation is the contrast between satu- rated, highly intense colors and dull, neutralized colors. As mentioned, the saturation levels of colors can be changed by adding black, white, grey or the complementary color, resulting in shades, tints, or neutralized versions of the original color. These dif- ferent levels of saturation of the same hue provide an interesting contrast that is frequently used in fashion drawing.

Contrast of saturation. Colors of different saturation levels contrast. The more saturated colors here are also darker and so dark—light contrast is also present.

color relativity and contrast

contrast of extension/bezold effect/subtraction

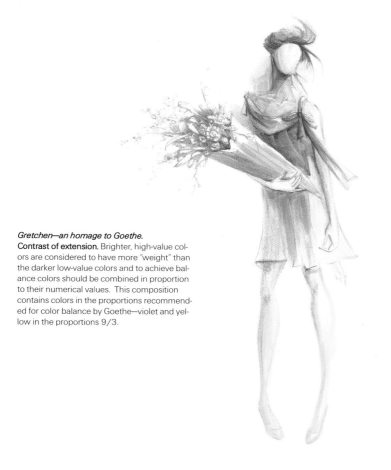

Gretchen—an homage to Goethe.
Contrast of extension. Brighter, high-value colors are considered to have more "weight" than the darker low-value colors and to achieve balance colors should be combined in proportion to their numerical values. This composition contains colors in the proportions recommended for color balance by Goethe—violet and yellow in the proportions 9/3.

Contrast of Extension ("weights" of different colors)

High value colors such as yellow are brighter, and according to some color theorists have more visual prominence or "**weight**" than low value colors like blue. To combine two colors of differing values so as to give a sense of balanced composition the proportions have to be varied. The numerical values recommended for combining colors by the famous German poet, playwright, novelist and philosopher **Johann Wolfgang von Goethe** (1749–1832) who also published a work on color theory—*The Theory of Colors*—are (as adapted by Johannes Itten):

Yellow	3
Orange	4
Red	6
Green	6
Blue	8
Violet	9

This weighting system would suggest that in order to achieve balance for an orange and blue composition, for example, the colors should appear in the proportion of 4/8—twice as much blue as orange; for green and violet 6/9 and so on. The drawing opposite is made using Goethe's proportions.

The Bezold Effect

The Bezold Effect, named after **Wilhelm von Bezold**, a nineteenth-century German textile chemist, is a color effect of great importance to the textile and fashion manufacturing industries and also relevant in fashion drawing. Bezold manufactured rugs, and discovered that changing one of the colors in a pattern in rugs changed the overall color appearance of the pattern. The effect is seen more strikingly when the dominant color is changed, particularly in patterns, where colors are directly adjacent to each other, than in composed drawings, but even in drawings the effect is important. The effect is particularly relevant when printing patterns on fabrics using different color variations.

The Bezold effect. Changing the dominant background color alters the relative appearance of the other colors in a composition. The shoes are the same colors in each of the pictures.

Subtraction

This effect, discussed, by **Josef Albers** in his book *Interaction of Color*, suggests that a dominant color—a color "ground," as he called it—will "subtract" itself from the less dominant color so the less dominant color appears different than it would against a neutral background. This concept can be understood by looking at the components of colors. For example, in the illustrations on the left, if green is the dominant color and yellow-green the less dominant, green (G) is subtracted from yellow-green (Y+G) to give the yellow-green more the appearance of yellow (Y). If red (R) is the dominant color and violet (V) is the less dominant, violet being a mixture of red (R) and blue (B), the red subtracts itself from the violet giving it a more blue appearance.

Subtraction. Top, according to Albers the dominant green background (G) "subtracts" itself from the yellow-green shoe (Y+G), making it appear closer to yellow. Below, the dominant red background (R) "subtracts" itself from the violet (composed of red and blue (R+B) shoe making it appear closer to blue.

color harmonies and schemes

simple harmony schemes/monochromatic/analogous/achromatic

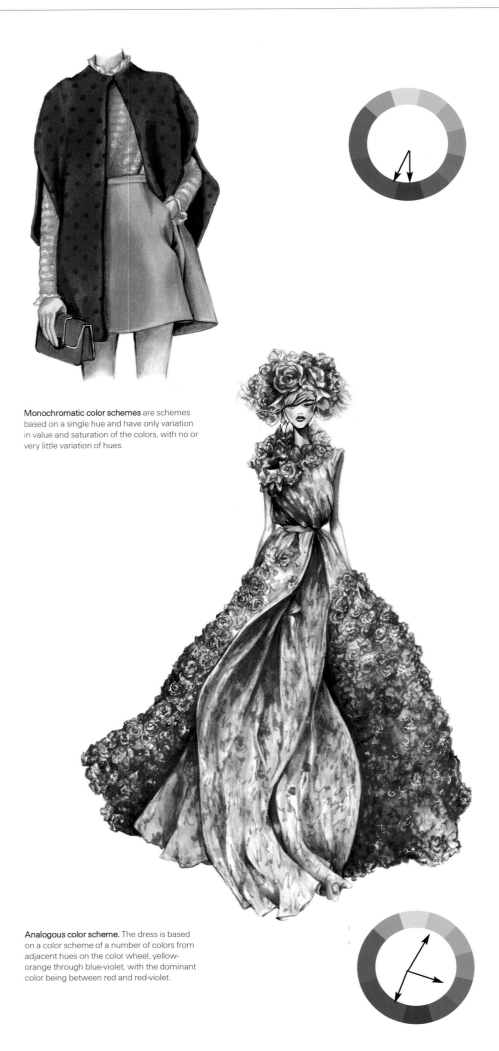

Monochromatic color schemes are schemes based on a single hue and have only variation in value and saturation of the colors, with no or very little variation of hues.

Analogous color scheme. The dress is based on a color scheme of a number of colors from adjacent hues on the color wheel, yellow-orange through blue-violet, with the dominant color being between red and red-violet.

Color Harmonies and Schemes

Color schemes are guidelines for choosing groups of colors that will harmonize, forming combinations that are pleasing to the eye. Formal color schemes are based on combinations of colors from the color wheel selected according to various rules.

There are three types of formal schemes: Schemes based on a limited number of colors or neutrals are often referred to as **Simple Harmony Schemes.**

Schemes based on opposite or contrasting harmonies, using colors from different sides of the color wheel or temperature contrasts, are often referred to as **Contrasting Harmony Schemes.**

Schemes based on **color chords**—equally-spaced colors on the color wheel—are referred to as **Balanced Color Harmony Schemes.** As balanced color harmony schemes often embrace colors distantly spaced on the wheel they are sometimes also in fact contrasting, as well as balanced harmonies.

Simple Color Harmony Schemes

Simple color harmony schemes group colors that are close together on the color wheel or of similar levels of value and saturation. A common simple color harmony scheme for example is neutrals of different hues but similar saturation levels. These schemes generally yield safe, predictable results, but can be wanting in range and excitement, though unusual uses can be striking. Sometimes the dominant color of a composition or design is referred to as its **"tonality."** Paintings of **Picasso**'s so-called **Blue Period**, for example, have a marked blue tonality. Both monochromatic and analogous color schemes, described below, usually display a particular color tonality.

Monochromatic Color Schemes

Monochromatic color schemes are schemes based on a single hue, e.g., red or blue. These schemes have only value and saturation contrast, no (or very little) hue contrast, and display a certain "tonality," as referred to above.

Analogous Color Schemes

Analogous schemes are based on analogous colors—colors from the same family of two or three neighboring hues on the color wheel. Analogous schemes are extensions of monochromatic color schemes, also displaying little hue contrast, with the exception of yellow-orange and yellow-green. Often with analogous color schemes one of the colors dominates the others, in which case these schemes also display particular "tonalities'.

color harmonies and schemes

achromatic/contrasting/cold-warm schemes

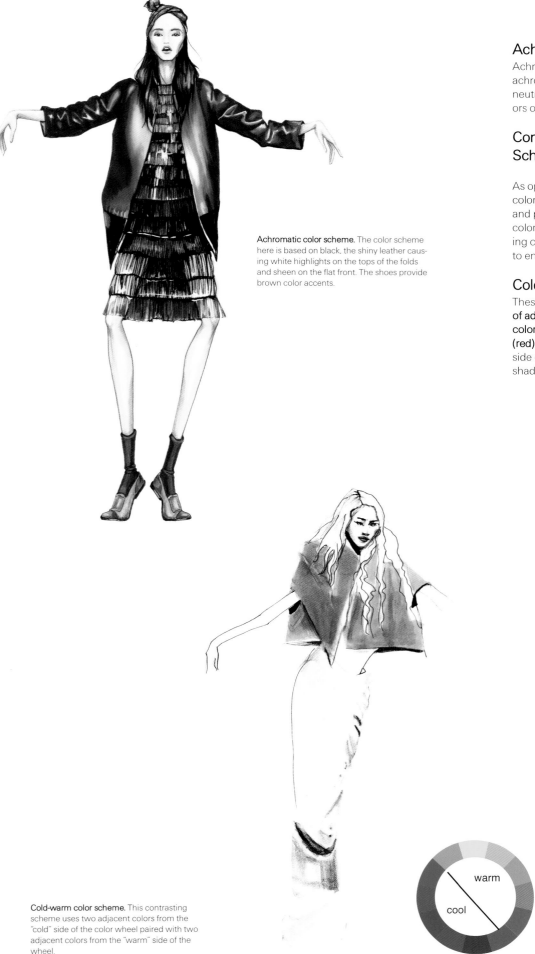

Achromatic color scheme. The color scheme here is based on black, the shiny leather causing white highlights on the tops of the folds and sheen on the flat front. The shoes provide brown color accents.

Cold-warm color scheme. This contrasting scheme uses two adjacent colors from the "cold" side of the color wheel paired with two adjacent colors from the "warm" side of the wheel.

Achromatic Schemes

Achromatic color schemes are based on pure achromatics—white, black and greys or chromatic neutrals resulting from mixing complementary colors or mixes of earth colors and black and/or white.

Contrasting Color Harmonies and Schemes

As opposed to simple color schemes where the colors are close to each other on the color wheel and provide little contrast of hue, when contrasting colors are used in schemes the potential for clashing colors is greater and more care has to be given to ensure the combinations are harmonious.

Cold-Warm Color Schemes

These schemes are based on combinations of a **pair of adjacent hues from the "cold" (blue) side of the color wheel and an adjacent pair from the "warm" (red) side**. The colors can be from anywhere on their side of the wheel, and can appear as tints and shades, so the scheme is quite flexible.

Split complementary color scheme. A color (here blue) is linked with the colors on either side of its complementary color orange, here yellow-orange and red-orange. Note also that this color scheme is a triadic color chord.

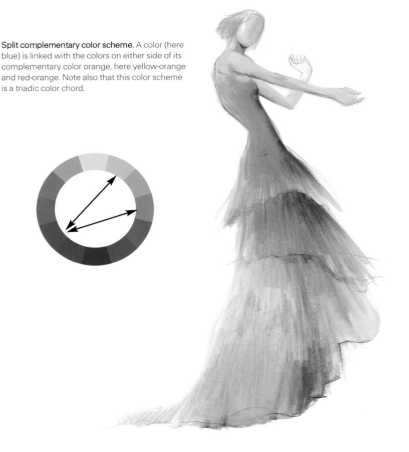

Split Complementaries

Split complementaries are schemes based on three colors where **a color is linked with the two colors adjacent to its complementary color** on the color wheel. For example, red, whose complementary color is green, could be linked with green's adjacent hues, yellow-green and blue-green. Split complementary schemes display color balance—equal distances between colors on the color wheel—as well as contrast of hues, an often pleasing combination.

Double Complementaries

These schemes use t**wo adjacent hues with their complementary pair.** As with cool-warm schemes, the hues can appear in varying levels of saturation and value. The expanded color range softens the stark contrast of saturated complementaries.

Complementary Dyad Schemes

These simple color schemes are based on **two contrasting complementary colors** on the color wheel—either one primary and the opposing secondary or two opposing tertiaries. Chromatic neutrals are also examples of complementary dyad schemes—they are groups of neutralized versions of pairs of complementary colors.

Double complementaries color scheme. This scheme uses two adjacent hues with their pair of complementaries. Here red and red-violet are paired with green and yellow-green.

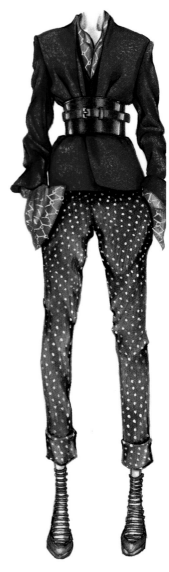

color harmonies and schemes/balanced

triad/tetrad schemes

Complementary dyad color scheme. These color schemes are based on single pairs of complementary colors–either a primary with its opposing secondary or two opposing tertiaries. Here yellow and violet are chosen. The *Homage to Goethe* drawing from the section on contrast of extension above is reproduced on the right. According to Goethe/Itten, yellow is the "heaviest" color and balances three times the area of violet, the "lightest" color.

Balanced Color Harmony Schemes
Balanced color harmony schemes are based on colors equidistant on the color wheel which harmonize (some say) like equidistant notes in a musical chord.

Triad Schemes
Balanced harmony triads are three equally spaced hues, forming equilateral (equal-sided) triangles based on the three primaries, three secondaries or two combinations of the six tertiaries. Each hue in a triad of this type lies equidistant from and exactly between the other two hues, so triads are always vibrant with maximum contrast of hue. Triads— groups of three colors—that are not of this type, such as split complementary triads, are contrasting, but not balanced harmonies.

A variation of a triadic scheme commonly used is to employ two of the three colors from a triad, for example red and yellow from the primary triad red, yellow and blue.

Tetrad Schemes
Tetrads have also been discussed in the section on color chords. Tetrad schemes are four-color schemes based on two pairs of colors where the distance between the colors in each pair is the same. In geometric terms, this means four hues which form a square or rectangular shape on the color wheel. Tetrads have a wide variation in hues and the best results are usually obtained by combining them with another scheme such as value or saturation keys.

A color scheme based on a triad— green, violet and orange.

A color scheme based on a tetrad— blue-green, violet, red-orange and yellow.

A triad color scheme based on the triad of primary colors—blue, red and yellow.

A triad color scheme based on the secondary triad of colors-green, violet and orange.

A color scheme based on a tetrad— blue-green, violet, red-orange and yellow.

Color Key Scheme. A scheme based on color keys: the colors are different but all have the same level of saturation.

Color Accents. Not strictly a color scheme, color accents are the use of relatively small amounts of color against a dominant color background, here whites and neutrals.

Color Keys

Color keys isolate one property of a color—hue, value or saturation. Keys based on one hue where the value or saturation is varied are also monochromatic schemes. Colors of similar value levels or saturation levels can also be grouped together in a unified manner, irrespective of their relative positions on the color wheel.

Color Accents

Color accents are not, strictly speaking, color schemes, but are uses of relatively small amounts of colors against dominant background colors. The accents usually contrast with the background in one of the color contrast ways discussed, and are also usually relatively higher value and/or colors of higher saturation than the background colors. A common use of color accents, for example, is dashes of a bright color against a muted, neutral or achromatic background. If the quantity of color used in the accent increases then the accents tend to lose their piquancy.

Other Color Schemes

Besides color schemes that fall within the three types of formal schemes where the combinations of colors are chosen according to rules, a number of informal harmonic schemes also exist where the rules are more flexible. The simplest schemes are based on varying a group of two to four colors by producing tints, shades and tones.

A number of schemes isolate one aspect of a color such as value or saturation, referred to above. Other schemes are based on tonal (value) gradations within one or more colors, gradation of saturation levels and gradation of hue. A number of these schemes are employed in the drawings throughout this book.

Color Order and Series

Color order and series—large topics in themselves—are schemes for ordering colors over ranges that extend beyond a single page. These schemes are more relevant to, for example, the ordering of pages in a portfolio or placement of colors on a presentation board than to individual compositions.

Color orders suggest logical ways to arrange objects of different colors. Colors can be ordered according to position on the color wheel, value, saturation and then distributed according to horizontal, vertical or diagonal grids.

color harmonies and schemes

subjective color and discord

Subjective Color and Discord

Color schemes are useful as guidelines for producing harmonious color combinations. The combining of colors to produce pleasing and striking effects is not an exact science. As there is a large number of variables involved in color composition and the ranges of values of each of those variables are great, it is quite possible to produce harmonious compositions outside of the guidelines of the formal color schemes. Once the artist/designer steps outside these color scheme guidelines, however, it is necessary to have a well developed sense of color, as there is a greater risk of committing mistakes and arriving at discordant color combinations.

Discordant Colors

Discordant colors are colors that have no real affinity to each other: they are not analogous, do not share similarity of value or saturation, nor do they balance each other as complementary contrasts or color chords. What is a discordant pair of colors in isolation, though, might not be discordant in a context where several other colors are present and the colors might be separately related to the other colors—or at least the discord might be offset by other effects.

Color discord is sometimes an intentional device in art and design, used in cases where the subject itself is unsettling or uncomfortable, and in fashion drawing too discord can also be employed to create an unsettled tone, of use, for example, for emphasizing the "edginess" of a particular garment.

Subjective color schemes are color combinations that do not conform to any of the formal color schemes but seem to work. Although there is no clear affinity between the hues there is however in this outfit similarity in saturation levels and values.

Discordant Colors are colors that have no real affinity to each other. They are not analogous, do not have similar values or saturation levels and do not balance each other as contrasts or color chords.

composition in color

putting the elements together

Grouping. The same dress styled for three different occasions, showing its versatility. This is an asymmetrical composition: the red color accents of the figure on the left balance the larger rendered areas of the two figures on the right, whose garments are in black and neutral colors.

Composition in Color

Up to this point in the chapter we have discussed the different aspects of the facts, theories, principles and practices underlying color and design. When making an actual fashion drawing all the decisions about color and design have to be made quickly and in rapid succession.

Color brings a new dimension to a drawing. Color can be used as a powerful tool for conveying information, expressing ideas, moods and emotions and as a way for unifying and enhancing the overall design. Color also adds an extra level of compositional complexity, however, and generates a further set of design decisions.

Intuition v. Method?

Although in many situations numerous outcomes are equally possible, it is almost always true that when making color and compositional decisions the more informed the decision-making and the greater the understanding of the principles of design and properties and behavior of color, then the better the final results will turn out. Many, and perhaps most, designers and artists *do* make decisions intuitively, but many of these intuitions were developed after a solid educational grounding in art and design and many years of practical experience.

Even though the design-decision process at some point becomes intuitive, however, there will still be times when a drawing has not turned out as hoped for but it is difficult to pinpoint exactly where the problem lies. In these cases, subjecting the work to a critical examination in the light of the principles of design and color combination often sheds light on how a problem can be solved.

This book contains many examples of fashion drawings in color ranging from simple to highly complex. Each drawing is accompanied by a detailed description of the techniques used and, in many cases, a comment or two about the compositional decisions regarding color and design. Studying the drawings and the accompanying descriptions, along with a familiarity with the contents of this chapter will assist in developing a skill in composition in color as well as in learning the techniques used to draw the particular garment or fabric being described. With constant practice and experimentation these skills will develop and improve and good design and color decisions will become second nature.

composition in color

initial compositional decisions/elements to include/grouping

Grouping. A group showing examples from a line of casual wear. Note the color combinations in each figure and across the group. The gestures of the hair, hand in the third figure and leg in the fourth figure lead the eye around the composition.

Putting the Elements Together

The remainder of this chapter looks at the sequence of design decisions involved in the composition of a fashion drawing, both the practical decisions relating to the presentation of the garments themselves and then the application of the principles of design and color combinations discussed in the first part of the chapter.

Initial Compositional Decisions

The fashion drawing is, first and foremost, an illustration. As mentioned at the beginning of this chapter, before considering the various issues of the overall composition of the drawing a number of initial decisions have to be made about the presentation of the subject matter. To recap, these initial decisions are:

1. **The design and colors of the garments** to be included in the drawing and the combination of garments and choice of accessories (many or all of these decisions will be givens from the start).
2. **The pose, gestures and coloring** of the basic figure drawing of the croquis with the subject garments.
3. **The composition of the figure** or figures on the page, the background elements, skin tone, make-up and hair, objects and empty (negative) space.

Once these decisions have been made, (or mostly made—for example, final decisions about hair, make-up, skin tone and accessories, or the background color can be left until later) the compositional design and color elements can be considered and the drawing planned out. These decisions are presented and discussed in the order in which they usually (but not always) occur.

Elements to include in the drawing—number of garments/figures

The first decision to be made about a drawing is what it is to include. If a number of garments are to be illustrated then the different ways the garments can be combined (whether on the same or on different figures) has to be considered, and decisions made as to which option would make for the best presentation. This often entails further decisions as to the number of figures to be included in the drawing.

Grouping

Decisions on how to group figures together (or not group them together) are based on whether the clothes are related to each other, and whether they are best shown together or separately. Clothes from coordinated collections can be placed together to reinforce their common design elements or to show the idea of a particular theme—a type of garment, fabric, or silhouette for example. Two figures are often used in a drawing when establishing a theme; three or more figures are used when a large number of garments are included in a collection, such as often happens in sportswear. How to create an attractive and balanced drawing with varying numbers of figures is discussed and illustrated later in the chapter.

composition in color/other elements to include

backgrounds/figure and pose/decisions on pose

Croquis against background. The addition of the abstract horizontal colored lines in the background enhances and unifies the drawing. The lines use the same color palette and similar color sequence to that used in the garment, emphasizing the dominant color striped theme of the wrap. The horizontal placement of the background stripes however contrasts with the vertical stripes of the wrap and the scale is much larger, so the background provides interesting contrast as well as closely mirroring the theme of the garment.

Other Elements to be included in the Drawing

Decisions concerning what other elements, in addition to the subject garments, should be included in or excluded from a drawing are made taking into consideration the number and complexity of the garments and what will create a pleasing and balanced final drawing.

If the subject garments are simple—bikinis for example—a decision might be made to include additional visual elements in order to give the drawing a more finished and balanced look—perhaps some accessories or relevant (sometimes irrelevant) props or backgrounds. If, on the other hand, the garments are complex and detailed, it might in fact be necessary to omit some inessential elements, such as the details of the features of the face, complicated accessories, or even parts of the figure, so that the drawing does not become cluttered and the attention stays on the garments themselves.

Figure and Pose

Once decisions have been made on the subject matter of a fashion drawing—the garments to be represented and the other elements to be included—many of the other decisions about the overall composition often (though not always) fall easily into place.

The next set of decisions to be made concerns how best to depict the garments in the drawing for the given purpose and audience in mind. This will depend on the type of garment being presented, its function, its intended market and sex/age range as well as whether it is to be presented alone or grouped with other garments.

Decisions on Pose

The first aspect of this overall depiction of the garments to be considered is the pose or poses of the figure or figures. There are three main considerations when deciding on the pose of the figure:

First, the pose should be appropriate to the type of garment, either its function or "mood". For example, an active sportswear garment, or range of garments, might be drawn in an action pose to show how they fit when being used as intended; a "street" garment might be drawn with a relaxed pose typical of the body language associated with the street; evening wear might be depicted using figures with elegant, interesting poses.

Second, it is important always to consider the basic silhouette and construction of the garment and to choose a pose that emphasizes the key areas of the garment. For example, pants should be drawn with the legs apart so the garment is not confused with a skirt; a wide sleeve is best shown with the arm held out from the body so the full extent of the fabric can be appreciated; heads should not cover a structured collar; with a full skirt the pose should reveal the extent of the drape.

Third, the choice of pose should suit the elements of the garment to be emphasized in the drawing. To draw attention to a detail at the hip, for example, a hand can be placed there.

composition in color

figure and pose

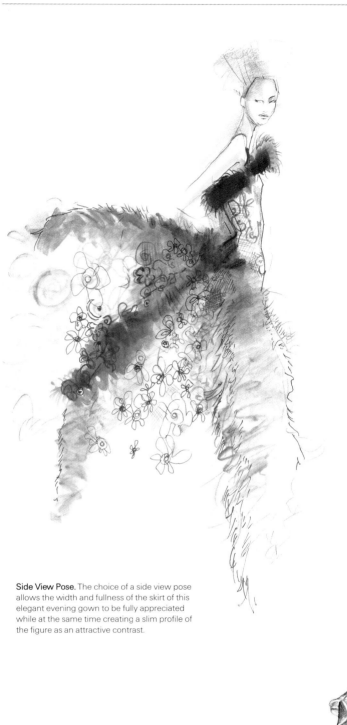

Side View Pose. The choice of a side view pose allows the width and fullness of the skirt of this elegant evening gown to be fully appreciated while at the same time creating a slim profile of the figure as an attractive contrast.

Static Pose. This static pose allows the quiet elegance of this silk chiffon party dress with beaded ornamentation to speak for itself.

Note that for most poses, **symmetry and balance** in the pose will tend to make a figure appear at rest and peaceful; shifting the weight to one side of the body gives more sense of movement and energy; stretching the arm above the head elongates the figure if a slim silhouette is to be emphasized.

Poses and gestures should be chosen also so that there is a natural movement of the eye from one element to another inside the drawing and the eye is not led outside the composition. Gestures or faces pointing or looking off the page should be avoided, as they draw the attention away from content of the drawing.

Another important consideration in deciding on the pose for a figure is a practical one: whether drawing skills are sufficiently developed for the task in hand. It is necessary to assess this realistically: for example, three-quarter views of the body, with limbs bending and extending in different directions usually involve perspective and foreshortening and can be tricky to draw. If drawing experience is limited it is usually best to choose a less ambitious pose than risk an awkward-looking, technically incorrect drawing.

Once the pose of the figure or figures has been chosen the next decisions to be made include positioning on the page, scale/consistency of scale, lighting, skin tone, hair, accessories and accents. Most of these decisions are interrelated and should always be made with an eye to the main visual themes of the drawing and with consideration given to what interaction they will have with the other elements.

Decisions at all stages, particularly if the drawing is not progressing smoothly, should be subjected to a test of whether they conform with the basic principles of good design, a process that becomes intuitive with practice and experience.

composition in color

position on page/scale do not do's/dynamic pose/negative space

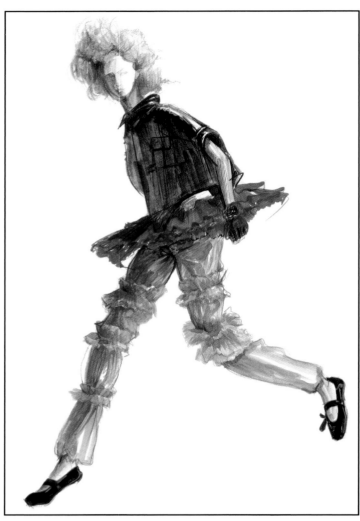

Dynamic Pose/Interesting negative space. A pose should be chosen that shows off the garments as well as capturing their mood and indicating the market they are designed for. Facial expression, body language and styling provide further information that reinforces the drawing of the garments on the figure. The figure placed on a diagonal across the page creates a feeling of movement and breaks up the page into interesting variations of negative space which forms a spiral shape around the figure.

Position on the Page/Negative Space

If there is a limited amount of space on the paper—if, for example, the drawing is to be placed on a presentation board together with flats, fabric samples, colorways and other information, then the choices regarding positioning may be limited; in some instances limitations of space may in fact dictate a simpler pose than the one that was originally considered.

If garments are being shown on a single figure, it is important that the figure fill as much of the available space as possible, allowing for an inch to an inch and a half on top and a little more beneath. Small drawings make it seem as though ideas are being explained in a whisper: to make sure drawings receive the attention they deserve it is best to make sure they are sufficiently large.

The positioning of the figure on the page determines the way the eye moves around the page. The figure should be placed so that the eye is not led away from the page and remains viewing the subject matter of the drawing. Thought should be given to the shapes created in the drawing by the subject matter and its surrounding space: varying the size and shapes of the negative spaces (the spaces around the figure) can be more interesting than making symmetrical or similarly-shaped negative space and can contribute to the balance, rhythm and unity of a drawing. Background color and other elements can be added to the negative space to help further unify the drawing, as is discussed further below.

Scale/Consistency of Scale

Thought has to be given to the relative scale of different drawings, both on the same page and on different pages. If figures are being placed on a number of pages of similar size—a portfolio or book for example—then an effort should be made to keep the sizes of the figures as close as possible, while, as mentioned, at the same time filling as much of

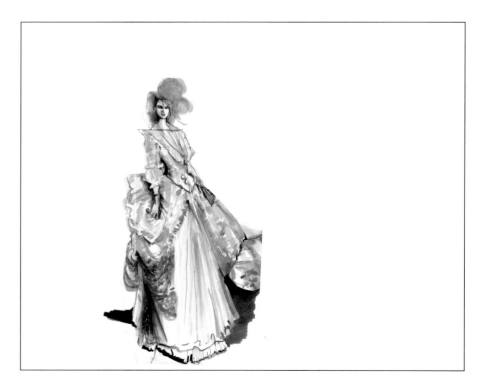

Do Not Do. The figure occupies too small a portion of the page. The drawing has to be appropriately scaled to the size of the paper.

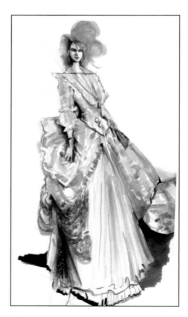

Do Not Do. The figure occupies too large a portion of the page. The drawing has to be appropriately scaled to the size of the paper.

composition in color

lighting position/color

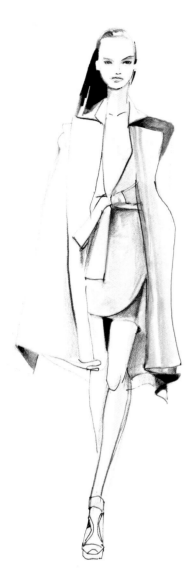

the page as possible. If it is necessary for reasons of space or layout to include figures on a different scale it is best to keep the variation in scales to a minimum. Varying scales can cause confusion, appropriate in Surrealist paintings but not as a rule in fashion drawing.

Lighting Position/Color

A decision should be made as to the lighting treatment to be used. A simple "neutral" frontal lighting is often sufficient when drawing simple garments. Single-source lighting from the side or below can create dramatic effects of shading and highlights revealing a full range of color values and the complexities of the drape (shading is covered at length in the next two chapters). When making a decision about the *color* of the lighting, the color to be used in the various parts of the drawing has to be considered—the skin tone of the figure, the hair and background objects included as accents to the drawing. If the actual colors of the garments themselves need to be clearly identified in the drawing, a lighting treatment should be selected that avoids confusion.

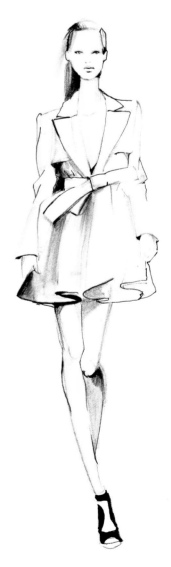

Figure with light source on left side. The left side of the figure appears bright and without shadow except where the fabric turns away from the light into the folds. The right side is in shadow and is shaded accordingly.

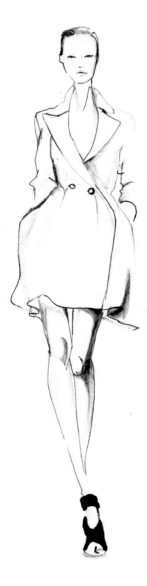

Figure lit from front. The front section of the figure appears bright and unshaded. Shadows form as the fabric begins to bend away from the light source towards the left and right edges of the outfit.

Figure with light source on right side. The right side of the figure appears bright and without shadow except where the fabric turns away from the light into the folds. The left side is in shadow and is shaded accordingly.

composition in color/planning out the drawing

skin tone, hair, accessories, accents/application of design principles and elements

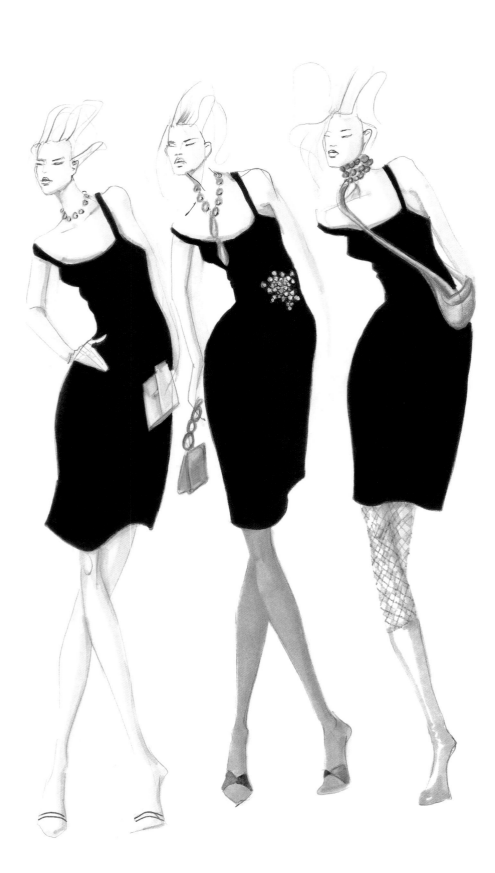

Repetition and accessories . The repetition of the same garment unifies the drawing and at the same time provides a convenient way to draw attention to the different accessories. The accessories in turn provide additional information about the garments: In the figure on the left the garment is accented with classic accessories; the accessories with the center figure are for a more contemporary look and the figure on the right has artistic and distinctive accessories that suggest bold, designer-market styling.

Skin tone, hair, Accessories,

In fashion drawing everything other than the garments is secondary in importance and is present in the drawing solely to enhance the appearance of the garments. This applies to the skin tone, hair, accessories (except in cases where they themselves are the subject of the drawing) as well as to the other unrelated elements that show up from time to time.

Skin tone is an important topic in itself, covered in the next chapter. Skin tone can be treated in effect as an accent of color in the drawing, and broad license taken in the colors chosen to represent it, both natural and artificial, or, alternatively, a color can be chosen that is naturalistic or part of the overall color scheme of the drawing.

Hair should be treated as an accessory to the clothes and the decisions regarding its shape and color made to reinforce the shapes and colors in the garments.

Accessories are useful in adding information about a garment—for example, a tennis racquet is an easy device to show that a skirt is a tennis skirt. Accessories can also be used to highlight a color or shape, but again should never overpower the figure and garment, except, as mentioned, where they are themselves the subject of the drawing.

Color Accents can be used to unify a composition— for example a particular color of reflected light used throughout the drawing can pull together garments of disparate shapes and colors, and can also be added when a drawing is in need of dash of spice.

Planning out the drawing: application of design principles and elements

Once the decisions about content and layout of the drawing have been made, the overall composition should be thought through in terms of its own design integrity and effectiveness, and decisions made as to how best to apply the principles of design and how to choose the elements of design in order to execute the drawing. The purpose of the drawing is to represent the garments realistically and make them appear as attractive as possible. Unless all the other elements in the drawing are "just right" and the overall composition is harmonious and balanced, the garments will not appear at their best.

In general, the same design principles should be applied to a drawing in color as to a black and white drawing, and then, as a second stage, the principles for color composition applied as an additional set of guidelines. Although there are some differences in the ways they are used and the ways they are executed between color and black and white line drawings, line type and quality, value contrast, symmetry, asymmetry, balance, repetition, focal point and emphasis are equally important for both.

composition in color

applying design principles/repetition/value contrast/symmetry and asymmetry

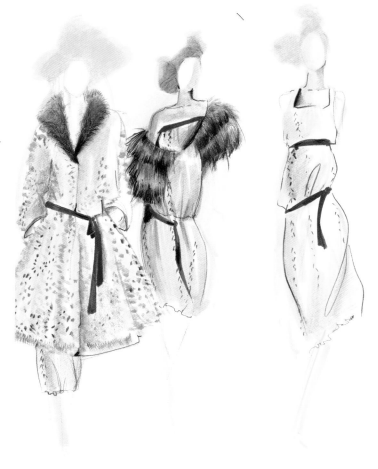

Repetition. This group of figures is wearing garments from a line that features a blue ribbon motif. The blue ribbon contrasts with the other muted colors of the garments (the overall color scheme is one of colored accents against neutral backrounds) and acts as a strong unifying device in the composition.

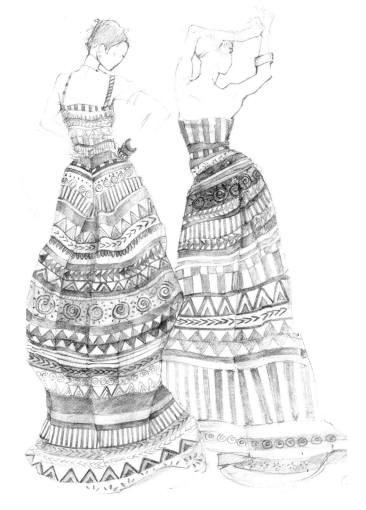

Different Line Weights. The croquis and the intricate patterns in these flamenco dresses are drawn using a wide range of different types and weights of line.

Repetition

In black and white drawing repetition is of similar shapes or patterns, or, sometimes. similar value levels or value contrasts. In color, repetition can be introduced independently of shape or pattern, and used in addition to or as an alternative to those elements.

Repetition in color can be achieved in a number of different ways, ranging from repetition of exactly the same color to repeated occurrences of different tints, shades and tones of the same hue. Repetition of the same color in a composition can serve to unify disparate elements in a composition. If a large proportion of the colors in a drawing consist of the repeated color then the drawing may begin to appear as though it has a monochromatic color scheme. If this is not the intention then use of the repeated color should be limited.

Value Contrast

As a compositional device value contrast is as important in color drawing as in black and white. When drawing with color, however, value contrasts occur within the variations of a single hue—particularly in fabric—as well as between different hues, so value contrast occurs across a wide range of colors and color combinations.

Value contrast in color is used in a very precise way when showing variations of value within a small color range, as often happens when rendering draped fabric three-dimensionally. These value contrast effects are usually localized, occupying a relatively small area, and limited to the fabric color and a range of shades and tints of that color. When value contrast in color takes place on a larger scale in the drawing, and between different colors, then in planning the drawing its effect also has to be weighed in the context of the overall color scheme. In these cases the other types of color contrast and interactions that are present have all to be taken into consideration.

Symmetry and Asymmetry

Symmetry and asymmetry have to be considered for achieving balance in color drawings as well as black and white, but color is a powerful tool that can be used to balance an asymmetrical composition. High value and/or saturated applications of color on one side of a composition can balance larger shapes of lower values and/or saturations on the other, as is mentioned in the description above of the weightings given to different colors by Goethe, and is discussed below in the section on color proportions and dominance.

Types of line/line quality

Line is an important element of all fashion drawings and in planning the drawing thought should be given to how line will be used and what tools will be required.

As has been discussed, when using color, shading can be indicated without the use of line, so line can be conveniently used to show construction, detailing and drape. The type of line to be used in the drawing will depend on the fabrics of the garments and the type and quantity of detailing to be included. The rendering of different fabrics and the particular use of line in each is covered in detail in the chapter on fabrics.

composition in color

fashion drawing and composition

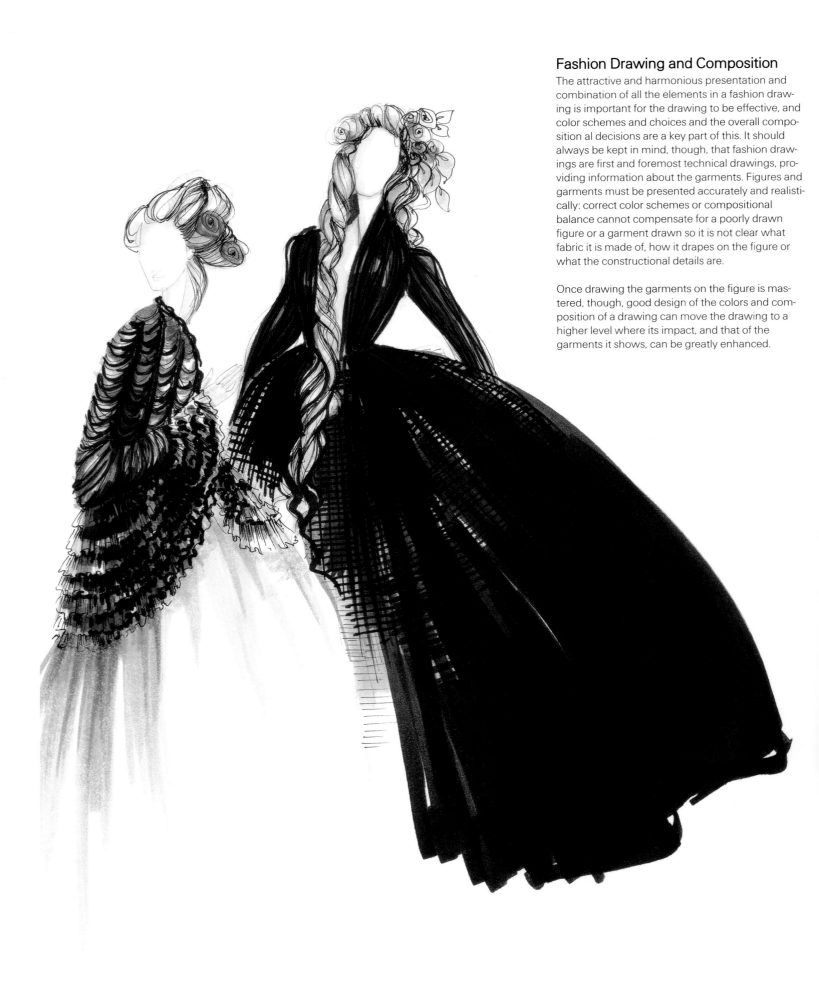

Fashion Drawing and Composition

The attractive and harmonious presentation and combination of all the elements in a fashion drawing is important for the drawing to be effective, and color schemes and choices and the overall compositional decisions are a key part of this. It should always be kept in mind, though, that fashion drawings are first and foremost technical drawings, providing information about the garments. Figures and garments must be presented accurately and realistically: correct color schemes or compositional balance cannot compensate for a poorly drawn figure or a garment drawn so it is not clear what fabric it is made of, how it drapes on the figure or what the constructional details are.

Once drawing the garments on the figure is mastered, though, good design of the colors and composition of a drawing can move the drawing to a higher level where its impact, and that of the garments it shows, can be greatly enhanced.

composition in color

fashion drawing and composition

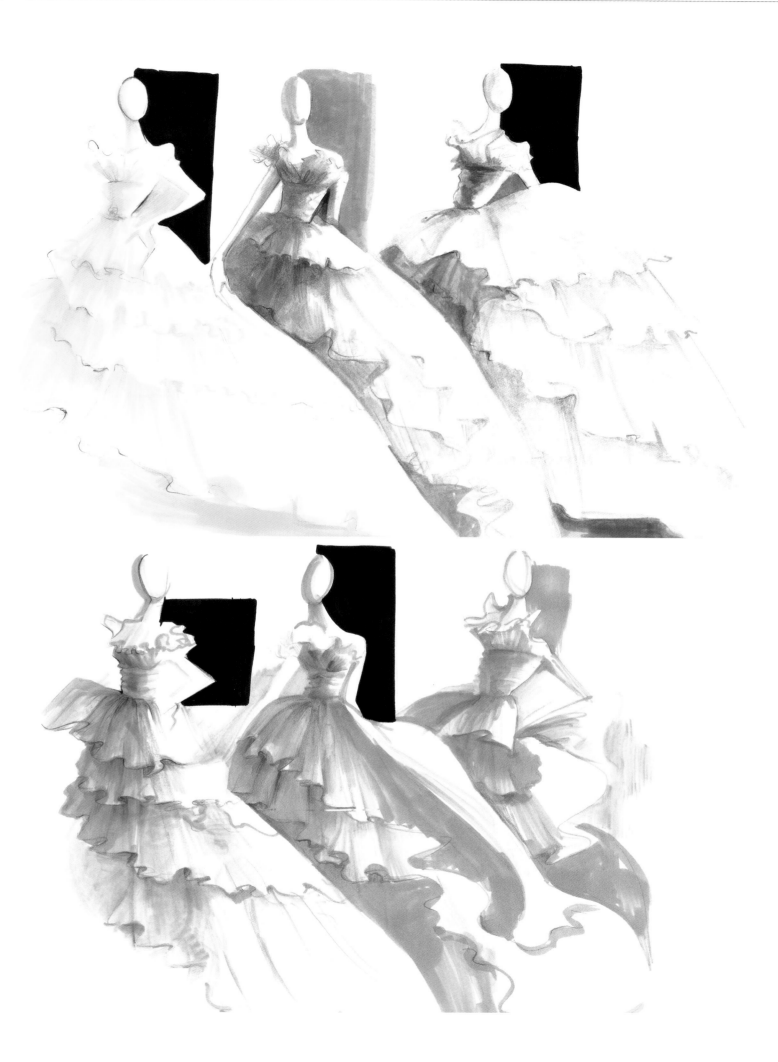

composition in color

practice and exercises

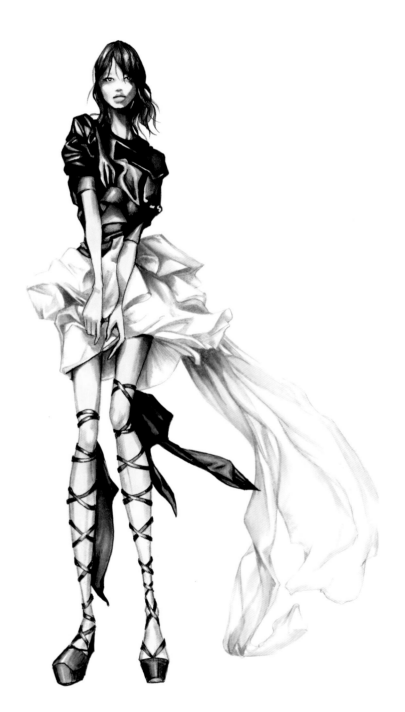

Beginners

1. Draw a front view croquis using a nuanced line.

2. Select a croquis with clothes from Chapter Three or Six. Copy this croquis using (i) a light line and (ii) a heavy line.

3. Draw a figure and garment using five different types of line. The lines can represent shading, cast shadow, crisp fabric, soft fabric, seams, details, hems, the figure under the garment or other aspects of the clothing and figure.

4. Draw the silhouette of a blouse made of (i) linen and (ii) silk. Refer to the chapter on fabrics for the characteristics of these fabrics.

5. Draw a croquis. Create a background for the croquis by pasting objects cut out of magazines. Put a simple garment on the figure that relates to the background.

6. Draw two figures wearing dissimilar outfits and add (i) accessories, (ii) make-up and (iii) hair to create continuity between the two.

7. Draw three figures with overlapping arms or legs.

8. Draw two figures. Fill in the top of one and the bottom of the other with saturated colors. Fill in the unfilled bottom with a tint of the saturated color of the top; fill in the unfilled top with a shade of the saturated color of the bottom.

9. Draw a tee-shirt and a skirt on a croquis. First fill in the t-shirt with a low-value color and the skirt with a high-value color and then repeat switching the t-shirt to high value and skirt to low value.

10. Draw a t-shirt and skirt on a croquis. Fill in the t-shirt with horizontal stripes using a saturated color for the uppermost stripes, making them progressively less saturated lower on the garment. Make the color less saturated by mixing in grey.

11. Draw three croquis and silhouettes of garments. Fill in the first croquis with a pattern based on complementary colors; the second croquis with a pattern based on secondary colors and the third based on tertiary colors.

composition in color

practice and exercises

Advanced

12. Draw a croquis in an active pose using (i) a fine line, (ii) a dark line and (iii) a light line nuancing to a dark line where the figure bends.

13. Draw a group of three figures with some limbs overlapping, wearing black, white and grey garments. Unify the group using (i) colorful accessories and (ii) different garment design details such as buttons, fringe, pockets, shirring and so on.

14. Make a balanced composition consisting of three figures wearing dresses of different lengths. Balance the composition by varying (i) sizes (e.g., two short and one long skirt), (ii) value (e.g., two light skin tone figures and one dark), and (iii) position and gesture.

15. Draw two or more figures wearing active sportswear garments. Create a focal point for the composition using (i) a graphic device (e.g., a cartoon character, image from nature, symbols) on one of the garments, (ii) a design element on one of the garments, (iii) an accessory and (iv) an element related to but not on the figures (e.g., clouds reflecting the colors or shapes in the clothing).

16. Draw three croquis with silhouettes of full skirts. Fill in the garments with a leaf pattern using warm and cool colors.

17. Draw three figures wearing dresses. Fill in the first dress with a print based on a complementary dyad, the second with a print based on a triad and the third with a tetrad.

18. Draw a blue evening gown and add color accents in lavender or red, (i) where they are integrated into the outfit (e.g., appliqués, trim, embroidery), (ii) in the hair and skin tone, and (iii) as accessories.

19. Draw two croquis wearing tops and pants, facing each other. Fill in one of the croquis with a color scheme based on analagous colors and the other with a scheme based on split complements.

20. Draw a grid of 100 squares of 1˝ on marker paper. Fill in the first two columns with variations of warm colors using marker and colored pencil. Fill in the next two columns with cool colors, the next two with neutrals, the next two with pastels, the next two with pretty colors and the last two with ugly colors. Practice drawing some patterns in the squares with colored pencils in contrasting colors, making the colors as saturated as those of the backgrounds. The grid at the left is an example of a completed exercise.

21. Draw a skirt and top with a palette of colors based on those taken from any diagonal of boxes in the grid made in the last exercise.

22. Draw groups of three figures united by pose and gestures (i) in a beach setting, (ii) at a party, and (iii) practicing a sport. The group of figures on this page is an example of such a group.

CHAPTER THREE

FABRICS

fashion drawing and design

accuracy and realism in fashion drawing

Fashion design drawing. Fashion design drawings should give as accurate and realistic appearance of the finished garment as possible. To understand the three-dimensional shapes of the garment it is necessary to draw it to appear three-dimensional. To understand the fabric–its volume, weight, surface appearance and how it drapes and falls it is necessary to draw it accurately so those aspects can be clearly seen.

Two-dimensional drawing is used for flats–technical drawings used mainly to show how to manufacture mass-produced garments.

Fashion Drawing and Design

Drawing is the easiest, most efficient, most economical and most effective way to show our fashion designs. Making a fashion drawing allows us to quickly jot down our designs, make adjustments to them, refine them, produce a final version and, using digital technology, immediately share them with whomever we wish.

Drawing is an easy, quick and almost cost-free way to develop and finalize our designs and can produce superb results. This is why it is worth investing the time and effort to learn to draw well. If we can draw well we are able to express our design ideas accurately and effectively so they are easily understood and make the best possible impact on others. If we are serious about fashion and fashion design the investment of time and effort in learning to draw to the best of our ability will repay itself many times over.

Accuracy and Realism in Design Drawing

When new designs are created in other areas of design, for example architecture, product design or automobile design, (in fact **all areas of design),** they are based on drawings that are usually accurate and realistic to a degree such that a very clear and accurate impression of the new building, car or other new object is obtained well before it is built. Unfortunately these standards of accuracy and realism present in other areas of design have never been standard practice in fashion design drawing. This has had a number of consequences, one of them being that when making up new garment designs based on drawings further discussion and clarification is often necessary.

Underlying the teaching in this book is the belief that fashion drawing should be as accurate and realistic as possible, and strive to be as much so as the types of drawing used in other areas of design. If we can achieve accuracy and realism in our fashion design drawings this will yield numerous benefits: we will be able to express our design thoughts more accurately; our designs will be clear to and immediately understood by our colleagues, particularly as those who work in fashion have highly developed visual sensibilities; the process of constructing the final garments will be made much easier and the likelihood of costly mistakes reduced.

Accuracy and Realism in Fashion Drawing

In this chapter of the book we start to learn the drawing techniques– in color–that are the foundation for drawing any garment to a degree of accuracy and realism where **we can immediately recognize the type of garment, the type of fabric it is made from and the cut and fit and other details.**

Drawing the three-dimensional form

Garments have little **form** (three-dimensional shape) of their own: when they are in the closet they hang as lifeless shapes. They take on **form** when we wear them, forming a separate layer over our bodies.

When we design garments we design them for **how they will appear on our bodies,** not for how they look in the closet. **To show our designs accurately in drawings, then, in order to give a realistic impression of how the garments will look, we need to show them as they appear on the body.** This means drawing them to appear **three-dimensionally,** like our bodies, with height, width and depth, so they look as though there is a real body underneath! Although when we make our design drawings we make them to appear **three-dimensional** in order to give as clear idea as possible of what the finished garments would like lie on the figure,

fashion drawing and design

shading

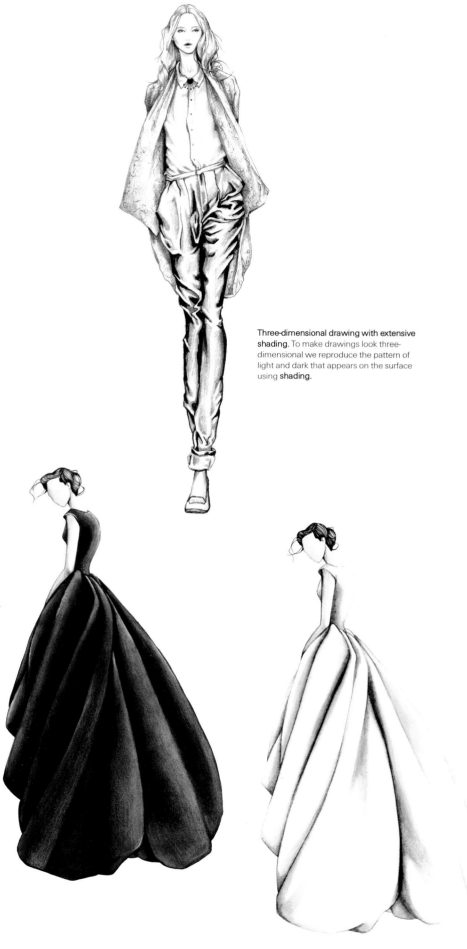

Three-dimensional drawing with extensive shading. To make drawings look three-dimensional we reproduce the pattern of light and dark that appears on the surface using **shading.**

it should also be noted that we *do* use **two-dimensional** drawings in fashion. These drawings are called **flats,** or **technical flats** and are used where we specifically wish to show garments by themselves, not on the figure. They are made mainly for showing how mass-produced garments are to be manufactured,

Shading

How then do we draw garments, or indeed any object, so that our drawings appear realistic, life-like and accurately show the form of the garment in three-dimensions? The answer is that we reproduce, in our drawing, the **pattern of light and shadow** that appears on the surface of real objects in normal lighting conditions. We do this by using **shading,** meaning that we use a range of different **values** (degrees of light and dark) to represent in our drawing the different areas of lightness and darkness that appear on the surface of any object. Our values will range from **white** in those parts of the object that are full-on to the light source, to **black** for those parts of the object where the light does not penetrate. For those parts that are between the lightest and darkest parts we use, if we are drawing in black and white, a range of **greys.** If we are drawing in color, as we are in this book, we use a **range of tints and shades– lighter and darker versions of the main color.** The gradual progression of different values of the color of an object from the parts seen full-on to the light and appearing **white** to those in shadow, and appearing **black** is referred to as **gradation of tone** and can be seen in the drawings opposite.

Remember, as we saw in **Chapter Two,** different colors themselves vary in terms of their darkness and lightness– they have different *intrinsic* **values** of their own, with **blue** the **darkest,** or lowest value color (next to black) and yellow the **lightest,** or highest value color (next to white); **red** lies between blue and yellow.

Shading objects of colors of different degrees of light and dark. Dark-colored objects–here a black dress– are shaded by making the darkest areas as dark as possible and showing where the object catches the light by applying white to show sheen or shine on the surface. **Light objects**–here we show a white dress–when shaded contain as much grey and black as white. The grey shows where the object is bending from the light and black is used to indicate the deepest folds hidden from the light. With **mid-range colors**–here a deep yellow, shading is made using darker and lighter versions of the color, becoming white on the tops of the folds and black in the deepest recesses of the folds.

purpose of chapter

drawing garments of different fabrics/how much detail?

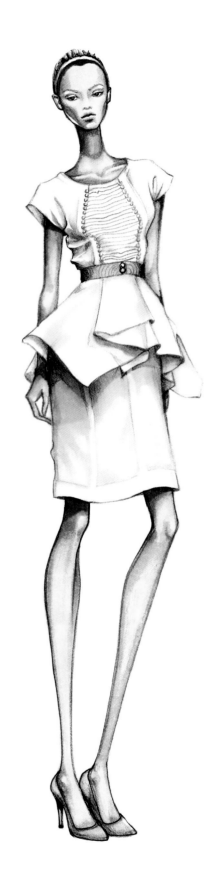

Design drawing. This drawing, which took about forty five minutes to complete, clearly shows the silhouette, fit, cut and constructional details of the garments. The fabric can be seen to be crisp, with body–either linen or wool crepe–with interfacing. Design drawings made to this standard of accuracy and realism also give a good feel for what the final garment will look like and whom it will appeal to.

Purpose /Organization of this Chapter: Drawing Garments of different Fabrics

Fabric is at the very heart of fashion. To draw fashion well it essential to draw fabrics well and to draw fabrics well means to capture their visual essence–what makes them look the way they do.

In this chapter we learn how to draw garments on the figure made of different fabrics. We learn to draw them with a degree of accuracy and realism that will allow those viewing the drawing immediately to understand the type of garment, its cut and fit and the type of fabric used in its construction: the garment will look very much like it would on the figure in real life.

Visual appearance of Fabrics

There are two aspects to the visual appearance of fabrics: First, the surface appearance—how the fabric "looks"; second, the way fabric appears on the figure– where it fits the shapes of the figure and where it drapes away from the figure.

The **surface appearances** of different fabrics vary greatly according to the fibers or filaments they have been made from as well as their intrinsic textures (which in turn also depend on what fibers or filaments the fabrics have been made from as well as the weight, weave and construction of the fabric)

Fabrics also **_drape_** differently according to weight, weave and the construction of the garment into which they are made. To draw fabrics so they can be immediately and unmistakably recognized it is essential to identify and clearly represent both these distinguishing visual characteristics, leaving no confusion as to what the fabric is and how it will look in the finished garment. If we can show realistically the _fabric_ the garment in our drawing is made from, as well as its other design aspects, then it will be easier immediately to understand the garment. Our design drawing will be taken seriously and command attention.

Shading the unclothed figure

To learn how to draw garments on the figure made of different fabrics we must first look at how to draw the figure itself.

To begin this chapter we review how the figure itself is drawn and shaded. The figure underneath gives garments most of their shape and appearance so we cannot understand and show how garments will look on the figure unless we understand how to draw the figure by itself, without clothes.

Drawing the fashion figure is one of the very first things we study when learning to draw fashion but as being able to draw the unclothed figure well is essential to being able to draw garments on the figure well we look at it again here. At this level though we are doing so in **color** and with a focus on correct **shading** to give the drawing a three-dimensional realism.

After looking at the unclothed figure we then look at how we draw clothes on the figure in the simplest form, beginning with clothes that are very similar in shape to

drawing garments of different fabrics

visual appearance of fabrics

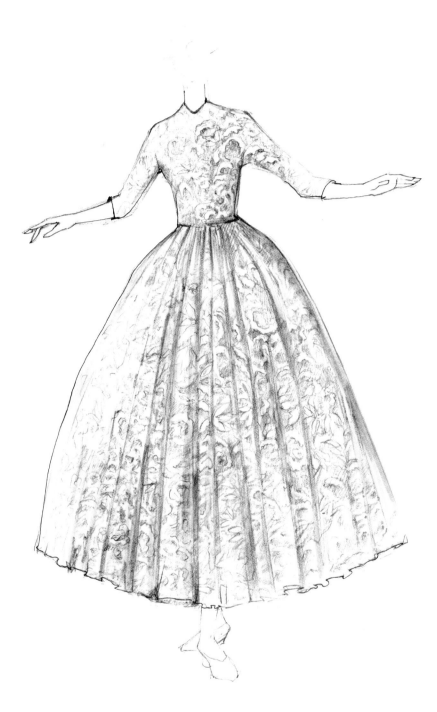

Visual appearance of fabrics: cotton lace. There are two aspects to the appearance of fabrics. One is the surface appearance which can be seen magnified in the lower image of the page of cotton lace. The other is the way the fabric falls and drapes, which can seen in the top drawing of a lace dress. The detail of the surface appearance of a fabric appears in varying degrees in fashion drawings that show the whole figure, depending on the type of fabric and the scale of the pattern or markings of its surface. The way it falls and drapes, though, is always clearly apparent in the drawing and must be shown accurately for the drawing to be believable.

the body underneath and progressing to clothes that have a structure of their own independent of the body.

Drape and Folds

Because the way a fabric *drapes* is one of the most important aspects of its appearance that we wish to show in our drawings we have to be able to draw drape well. Before looking at detail at different fabrics, then, we first look at how drape forms and how to draw it in a more general way. We look first in detail at how we shade folds of different types, how to shade sleeves and pant legs, how to show the folds that form at the waist and shoulders. We also look at how to draw a number of common fashion details that have folds built-in to their construction, and then how to draw a number of basic fashion garments. Once we have become familiar with how to draw drape and folds as they appear in garments in different locations on the body we can then move on to examine in detail the differences that appear in garments made of different fabrics. This is first done with an overview of different fabrics spread over two pages. These and the pages that precede contain some of the information that is most crucial to learning to draw fashion at an advanced level and should be carefully studied.

The final section of the chapter looks at a wide range of fashion garments made of different fabrics and shows in detail the elements used to make accurate and realistic drawings of the garments made of those fabrics. The emphasis here is not on the garment design as such but the *fabrics*; the garment designs are of secondary importance at this stage and have been chosen to illustrate clearly how the fabrics they are made of are drawn.

How much detail is needed?

This chapter shows how to render the fabric of a garment to a degree of realism where its texture, color, surface appearance and drape are all clearly shown. If we have taken our time and drawn well it will be possible to tell from the drawing, on appearance alone, what fabric has been used in the construction of a garment and how the fabric will look when made into the finished garment. Drawing at this level is appropriate for finished design drawings but doestake time, often more than is available in a work or study situation (for example, the finished design drawings in this book took from one to two hours to complete, depending on their complexity).

What if we only have a short amount of time—perhaps a minute or two—to record our ideas?

For quick concept drawings it is not practicable or necessary to make detailed renderings of the fabric of a garment (although it is necessary to be familiar with the physical properties of the fabric, as these are reflected in the silhouette and constructional detailing of even a quick concept drawing). In those cases where time is limited but it would be useful to show the type of fabric of the garment in the drawing, it is effective to render the fabric in detail in only a small part of the garment and show the type of folds and drape in one area. Although the drawing will not have the same immediate impact as one where the fabric is fully rendered, those with an eye for fashion will understand the "shorthand" being used and fill in the rest of the picture for themselves.

the body under the garment

body shadow map

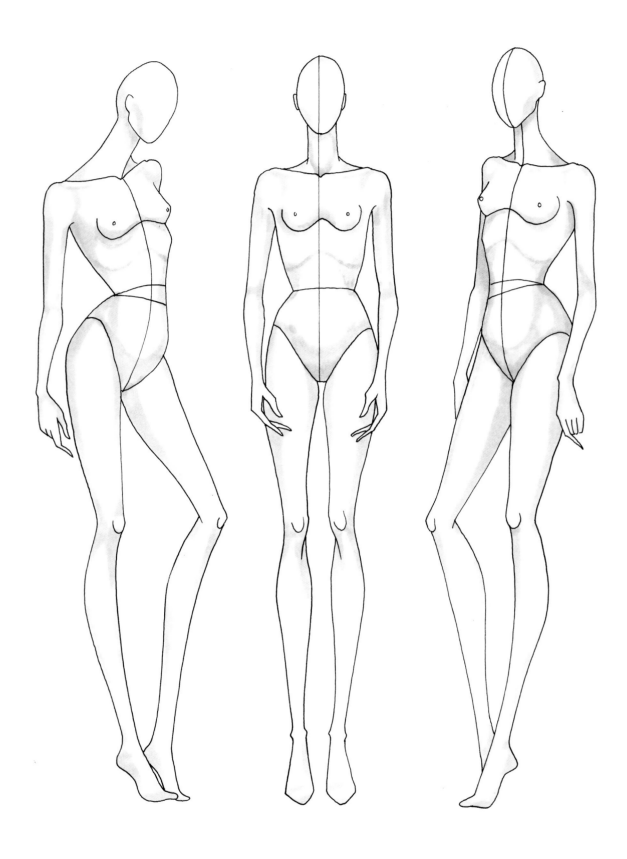

Body Shadow Map. Where shadows form on the unclothed body, here lit from **the center** (front).

the body under the garment

body shadow map

Body Shadow Map. Where shadows form on the unclothed body, here lit from **the left side** Note that the shadows are directly affected by the position of the light source and are longer on the opposite side from the light source.

Body Shadow Map. Where shadows form on the unclothed body, here lit from **the right side**. Note that the shadows are directly affected by the position of the light source and are longer on the opposite side from the light source.

The Body underneath the Garment

If we draw garments using a photograph as a reference it is easy to observe and copy the pattern of light and shadows on the garments. If, however, we are drawing from our **imagination,** as we often will do when designing new garments, we do not have a reference and need to be able to work out where light and shadow appear. So, **how do we know where light and shadows form on the surface of garments on the figure so that we can show this with shading?**

The answer is that just as garments mostly take their form from the body underneath, **the patterns of light and shadow that form on garments that are worn on the body are, in most cases, similar to the patterns of light and shadow that form on the body underneath.**

In other words, **in order to know where light and shadow falls on garments that are drawn on the figure and how we have to shade it,** it is easiest if we have a clear idea of where light and shadow fall on the *unclothed* figure.

Patterns of light and shadow on the unclothed figure.

Shadows start to form on the surface of an objecct when that surface starts to bend away from the plane that is straight on to the light source. This can be seen for the unclothed figure in the three series of drawings opposite: Where the **light source** is from the **center,** the parts of the body that are full-on to the light–and in a drawing are parallel to the surface of the paper–are not in shadow. Shadows form where the parts of the body start to **bend away** from the light source–around the neck and shoulders, under the breasts, around the arms, under the ribs, under and around the tummy, around the legs. When the light source is from the **left** the shadows shift over to the right, and when they are from the **right** they shift over to the left, as is seen in the drawings.

Garments-on-the-body are shaded in the same way as the unclothed body **except** when the garments do not follow the curves of the body, as we see in the next section. Study and practice making the drawings on these pages before moving on to garments on the body.

shading garments on the body

shading garments of different fits

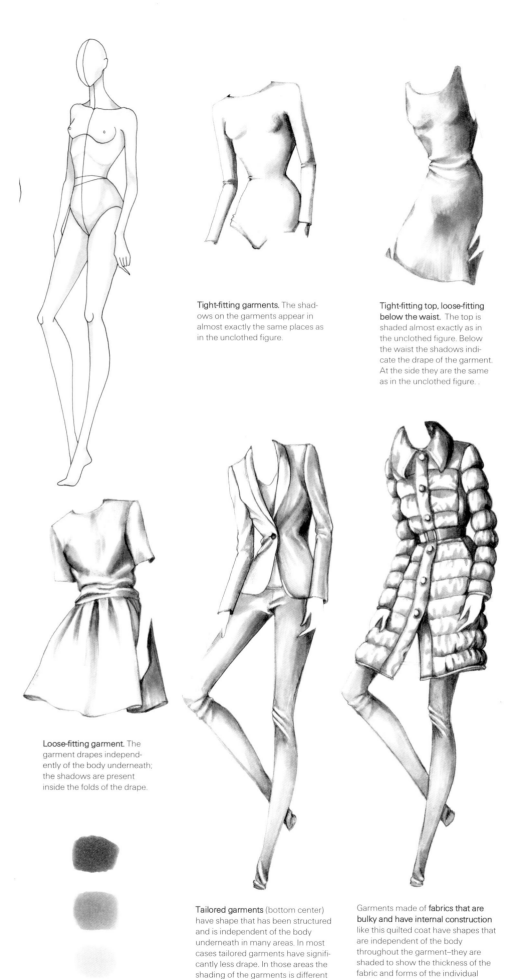

Tight-fitting garments. The shadows on the garments appear in almost exactly the same places as in the unclothed figure.

Tight-fitting top, loose-fitting below the waist. The top is shaded almost exactly as in the unclothed figure. Below the waist the shadows indicate the drape of the garment. At the side they are the same as in the unclothed figure. .

Loose-fitting garment. The garment drapes independently of the body underneath; the shadows are present inside the folds of the drape.

Tailored garments (bottom center) have shape that has been structured and is independent of the body underneath in many areas. In most cases tailored garments have significantly less drape. In those areas the shading of the garments is different from the body underneath.

Garments made of **fabrics that are bulky and have internal construction** like this quilted coat have shapes that are independent of the body throughout the garment–they are shaded to show the thickness of the fabric and forms of the individual panels. Note though that this is still shading at the edges of the body where it bends away from the light.

Shading Garments on the Body

Knowing the patterns of light and shadow that form on the *unclothed* body provides us with a good basis for knowing where light and shadow will form on the *clothed body* and how we should shade it. To know more precisely where light and shadow forms depends first on the fit **of the garments–how tightly or loosely the garments fit the figure.**

Tight-fitting garments

With **tight-fitting garments** the body underneath is in contact with the garment in almost every location. In the extreme case a tight-fitting body suit touches the body underneath in all parts, fitting it like a second skin. In these cases of tight-fitting garments the shadows that appear on the surface of the garment will be **almost exactly the same as those that appear on the unclothed figure** (which is why tight blouses or pants can raise eyebrows!). We shade tight-fitting garments -on-the-figure in the same way as we draw the unclothed figure: the parts of the garments that are full-on to the light source are fully lit and appear white or a light version of the color of the fabric. Those parts that are bending away from the light source are where the shadows form and appear as a darker version of the color of the fabric.

Loose-fitting garments

With **loose-fitting garments** the figure under the garment is in contact with the garment at **fewer points** than for tight-fitting garments. The shadows that form on the surface of the garment are the same as those that form on the unclothed figure in those places where the garments fit the figure **tightly.** In the parts where garments do **not** fit the figure but fall away, forming **drape**, the garments form shapes different from those of the figure underneath and will show a different set of light and shadows.

How we shade those parts of garments that are *not* supported by the body underneath and where the fabric forms drape depends on how the fabric of the garment drapes: If the fabric of the garment drapes in such a way that, rather than following the curves of the body, it falls straight down and is full on to the light source then it will appear well-lit, without shadow. An example of this would be the train of a wedding dress.

Drape and Folds

Whenever there is some **looseness**–usually called **fullness**– in a garment–which means that whenever there is more fabric in a garment than is required to form a tight-fitting skin, the excess fabric falls away, under the influence of gravity, from the parts where it **fits** the body underneath–called the **suspension points**– to form **drape**. Drape appears as **folds**, of different widths and depths–from bare ripples to deep tunnels–with the angle of the plane of the fabric often shifting between folds, curving away from or back towards the light.

Remember, especially when drawing from the imagination without visual reference material: Wherever it is not directly supported, either by the body underneath or construction devices, fabric will

shading garments on the body

shading folds/light and dark fabric

Shading folds, in light fabric 1.
The outline of the fold.

Shading folds, in light fabric 2.
Begin to indicate the dark edge of the fold with black or dark marker.

Shading folds, in light fabric 3
Widen the shadow.

Shading folds, in light fabric 4.
Lighter shading applied with diluted marker where fold emerges into light and in flatter parts of folds

Shading folds, light fabric

Shading folds, dark fabric 1.
The outline of the fold

Shading folds, dark fabric 2.
Indicate the thin white highlight running along the top of the fold with white gel pen.

Shading folds, dark fabric 3.
The area next to the highlight and where the fabric bends towards the light are indicated by applying white pencil over the color of the fabric

Shading folds, dark fabric 4.
Continue applying white pencil to achieve a continual gradation of tone between the dark and the lighter areas.

Shading folds, dark fabric

drape according to the laws of gravity. If these visual aspects of a fabric are successfully captured in a drawing, then it will be possible almost to feel the fabric in the drawing as well as to recognize it visually.

Drape forms in the fabrics of garments in different ways, depending on a number of factors: how much excess fabric is present, the type and thickness of the fabric, how and where the fabric is suspended and its other constructional aspects, including whether the fabric has been pressed or treated with chemicals to hold artificial folds and shapes or where other constructional details have been introduced into the garment by means of devices like tucks and darts, pleating, ruching, gathering and so on.

Drape affects the pattern of light and shadow on the surface of garments according to the different shapes it makes in the fabric—the folds and changes in angles of the planes in the fabric. Some of the main types of drape corresponding to the natural drape of different types of fabrics or to the artificially constructed drape of certain fashion details are shown in the illustrations included in the pages in this section.

Applying Shading

Shadows should be applied in the direction of the body shape to be defined: for example, *around* the bust rather than in a straight line. Long vertical strokes are used for the longer more vertical parts of the body such as the upper torso and the legs. The edges of shadows should be clean, clear and even. Note that shadows are directly affected by the position of the light source and will lengthen on the opposite side from the light source.

Common Mistakes

One of the most common mistakes in shading the fashion figure is to use a black or dark line to indicate shadow under the bust-line. This usually reads incorrectly as a seam or scar—a definite **DO NOT DO**. The bust-line is soft and does not have a sharp edge; it is drawn with soft, diffused shadows.

shading garments on the body

drape at bust and shoulder/ waist/cylinder and sphere

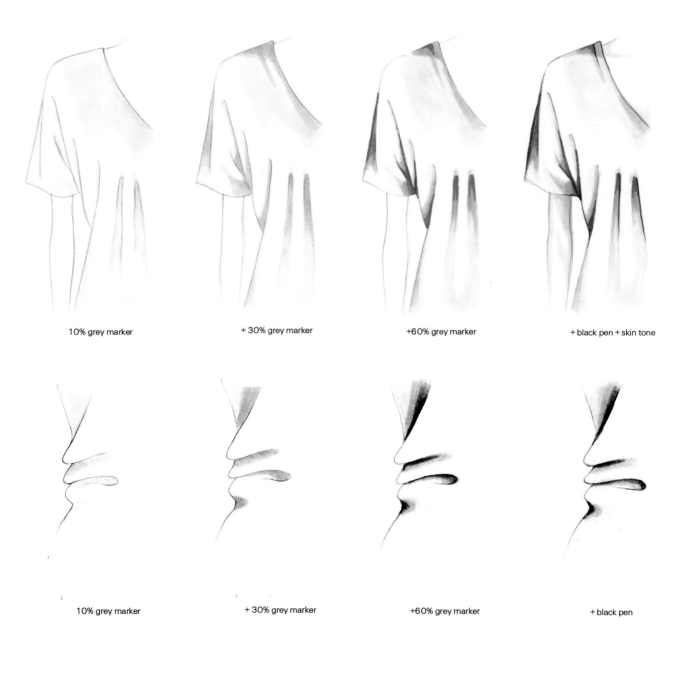

| 10% grey marker | + 30% grey marker | +60% grey marker | + black pen + skin tone |

| 10% grey marker | + 30% grey marker | +60% grey marker | + black pen |

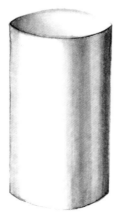
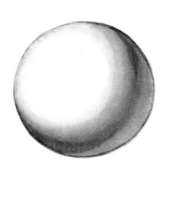

Cylinders and Spheres. Different parts of both the unclothed body and also the garments covering those parts of the body resemble cylinders and spheres and are shaded in similar ways. It is helpful when deciding how to shade a garment to think of the shapes of the different areas and whether they resemble cylinders or spheres and then to shade them in a similar fashion.

Drape on the upper parts of the body. In garments on the upper part of the body folds form where fabric is compressed, as it is at the waist, or where it falls away from a raised part of the body such as the bust. . It is important to shade these areas correctly so the garments appear three-dimensional. Succesive applications of darker marker are applied as shown above to build up the realistic appearance of the folds.

shading garments on the body

shading fashion details/different drape

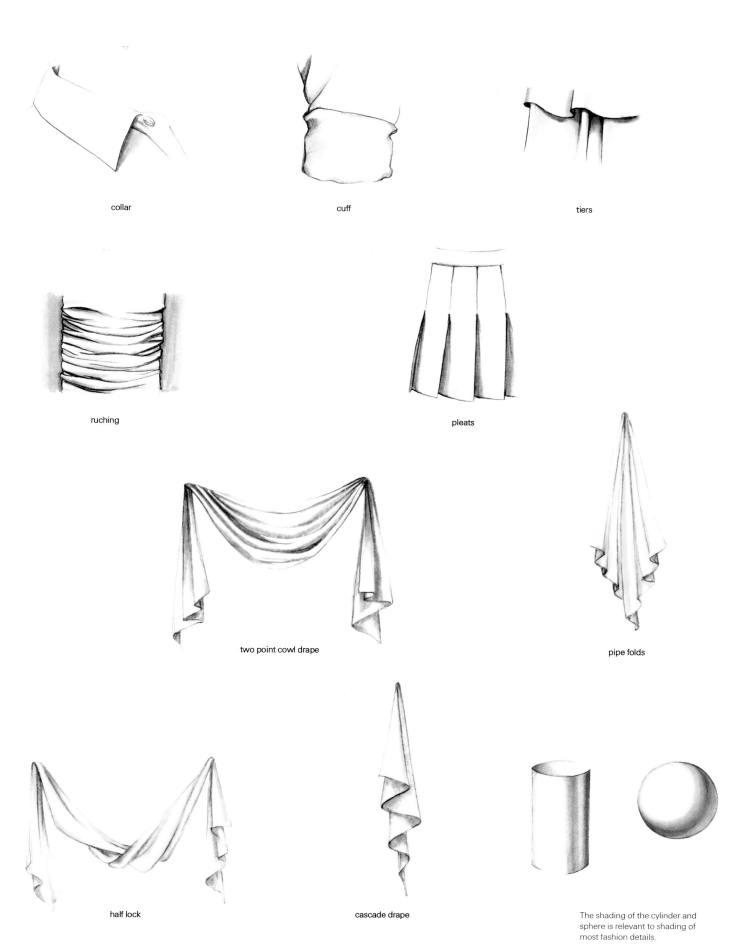

collar

cuff

tiers

ruching

pleats

two point cowl drape

pipe folds

half lock

cascade drape

The shading of the cylinder and sphere is relevant to shading of most fashion details.

Shading of various fashion details and types of folds/drape.

shading garments on the body

shine/sheen/folds of different widths/shading leg

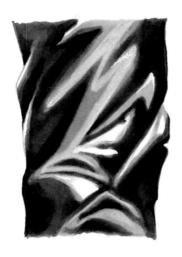

Shine. Shiny fabrics, like certain leathers and vinyl, reflect almost all the light from their surfaces. They are drawn using bright white gel pen to create thin, angular highlights on the tops of the crisp folds placed immediately adjacent to saturated black to show the dark interiors of the folds.

Sheen. Certain fabrics, like velvet and suede, reflect a lot of light from their surfaces but are soft and form folds that have wider tops than those of crisp shiny fabrics. The light is reflected from a wider area and the fabric appears to have a 'sheen'. This is drawn using a white pencil to give a less saturated white and more textured effect over wider areas. The folds do not slope as steeply to their interiors and there are more gradations of tones on the sides of the folds.

Narrow, thinner folds (thin fabrics like chiffon)

Wide folds (thicker fabrics)

Knife pleat

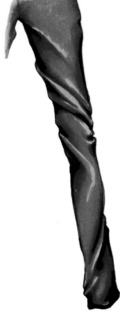

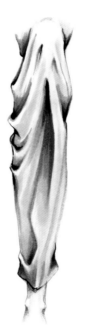

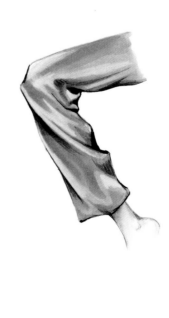

Shading pant legs.. Folds tend to form beneath the crotch, at, above and below the knee and above the ankle. Outline the silhouette and where the folds form, planning where the darkest interiors will appear. Fill in the base color, apply highlights on the tops and deeper shading in the interiors.

shading garments on the body

various garments

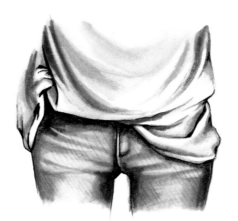

Half lock drape at hem of top

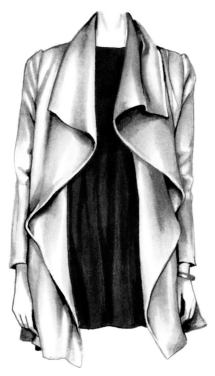

Cascade drape in one piece collar
and body of jacket

Cowl drape neckline in top.

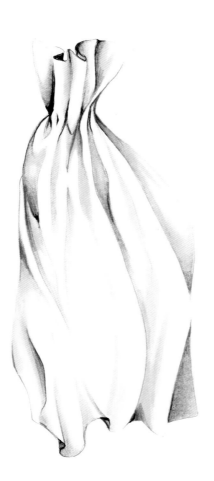

Drape at waist.

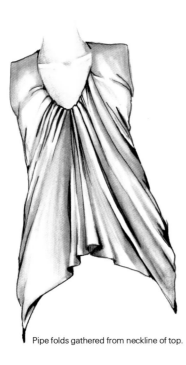

Pipe folds gathered from neckline of top.

Drape in sleeve. In sleeves a succession
of cylindrical folds spiral around the shape
of the arm. Some folds do not bend com-
pletely around the arm and are form half
locks and zig zags.

shading simple garments step-by-step

circle skirt/trenchcoat

Circle Skirt Step 1. Draw the silhouette making sure that the hem and waistband tilt in the same direction. Note that the folds are denser on the right hand side because of gravity.

Circle Skirt Step 2. Darken the line of the silhouette where it bends away from the light and where the folds curve.

Circle Skirt Step 3. Map out the shadows. Shadows will appear on the sides and interiors of each fold on the opposite side from the light source. Note that shadows are of different sizes. This step can either be done very lightly in pencil and then erased or can be drawn on white paper and placed under the marker paper to act as a guide.

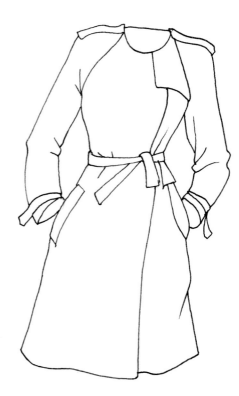

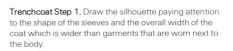

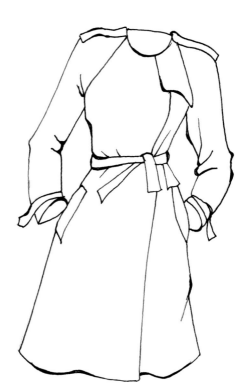

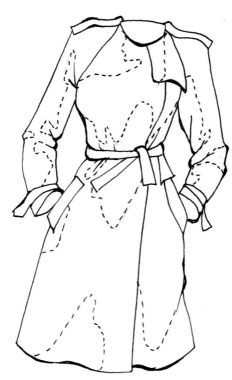

Trenchcoat Step 1. Draw the silhouette paying attention to the shape of the sleeves and the overall width of the coat which is wider than garments that are worn next to the body.

Trenchcoat Step 2. Darken the line of the silhouette where shadows occur: under the epaulettes, trench flap on right, belt and at the curves of the hem.

Trenchcoat Step 3. Map out the shadows. Shadows will appear around the neckline, under the trench flap, at the sleeves, elbows, waist and in the folds above the hem where it bends around the legs.

shading simple garments step-by-step

circle skirt/trenchcoat

Circle Skirt Step 4. First application of shadows is made with a light grey marke.r

Circle Skirt. Step 5. Second application of marker is made either with the same color marker or a slightly darker value which will accentuate the darker shadows in the deeper parts of the folds.

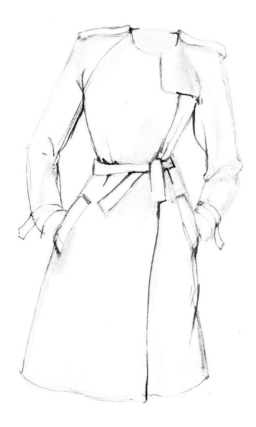

Trenchcoat Step 4. First application of shadows is made with a light grey marker.

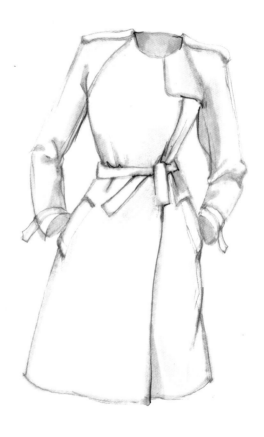

Trenchcoat Step 5. Second application of marker is made either with the same color marker or a slightly darker value which will accentuate the darker shadows in the deeper parts of the folds.

shading simple garments step-by-step

tee-shirt/pants

Tee-shirt Step 1. Draw the silhouette showing the fabric bending around the arms and hips and with gathered drape at the hips.

Tee-shirt Step 2. Darken the line of the silhouette where shadows occur around the arms, in the folds and where the silhouette curves away from the light.

Tee-shirt Step 3. Map out the shadows. Shadows will appear under the bust, at the sides of the sleeves, on the torso between bust and waist and in the folds at the hip.

Pants Step 1. Draw the silhouette taking care to place the center-front seam in the hip area below the waist correctly. The waistband must bend around the waist (it is not horizontal!). Note there is some drape at the knee and the hems bend around the bottom of the legs.

Pants Step 2. Darken the line of the silhouette where shadows occur in the edges of the waistband, the crotch, the hips, knees and hems.

Pants Step 3. Map out the shadows. Shadows will appear in the inside of the left leg, at the crotch and the folds that extend down from the knees

shading simple garments step-by-step

tee-shirt/pants

Tee-shirt Step 4. First application of shadows is made with a light grey marker

Tee-shirt Step 5. Second application of marker is made either with the same color marker or a slightly darker value which will accentuate the darker shadows in the deeper parts of the folds.

Pants Step 4. First application of shadows is made with a light grey marker

Pants Step 5. Second application of marker is made either with the same color marker or a slightly darker value which will accentuate the darker shadows in the deeper parts of the folds.

shading of different fabrics/comparison of main fabric types

silk jersey/chiffon/organza/cotton

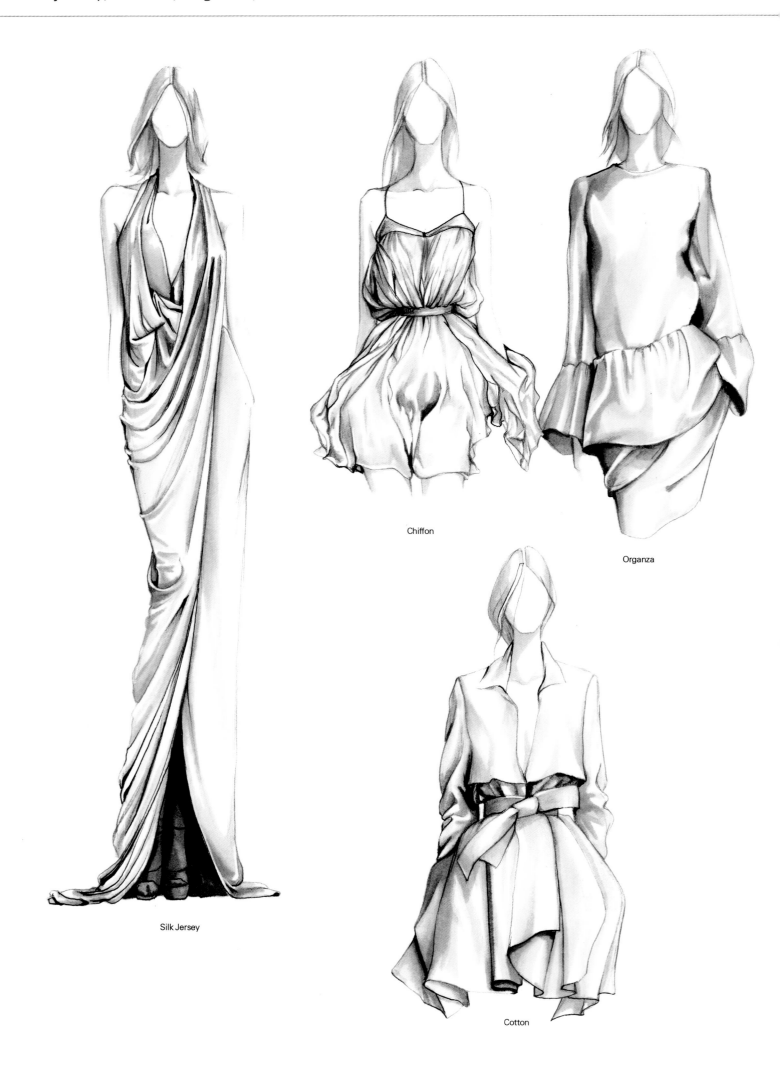

Chiffon

Organza

Silk Jersey

Cotton

shading of different fabrics/comparison of main fabric types

heavy satin/leather/vinyl

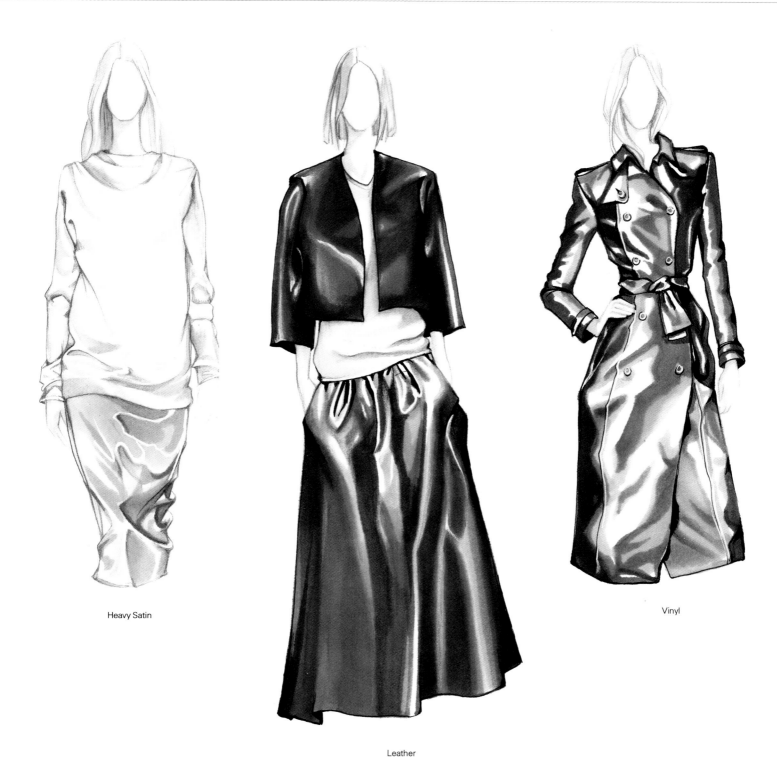

Heavy Satin

Leather

Vinyl

garments of different fabrics

fringe/feathers/brading

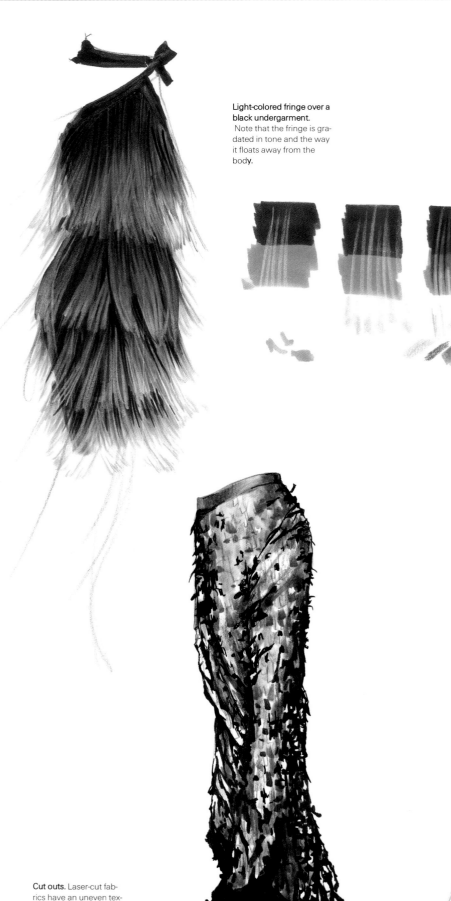

Light-colored fringe over a black undergarment. Note that the fringe is gradated in tone and the way it floats away from the body.

Cut outs. Laser-cut fabrics have an uneven textured surface that appears like an uneven pattern except at the edges of the silhouette where the cut-out pieces of fabric stick out and should be clearly defined with marker.

Drawing garments of different fabrics

This section shows how to draw garments made of a wide range of different fabrics so they appear realistic and three-dimensional.

As with any type of fashion drawing it is important first to make sure the croquis and the silhouette of the garment are drawn as accurately as possible, with correct proportions and scale. Next, the shadows in the drape of the folds have to be planned out: these will vary according to the type of fabric the garment is made of. As we have seen, generally speaking, **heavier fabrics** tend to have wider areas of drape and cast wider shadows; **lightweight fabrics** have narrow areas of drape and cast thinner shadows. Look carefully at the type of fabric being drawn and the qualities it displays and try to create that appearance with markers: For **softer-looking or more textured fabrics, such as wool, cashmere, velvet, corduroy and others** the appearance is best drawn using a combination of marker and colored pencil; the pencil helps create the soft texture. Markers are used to create broad areas of color. **Fabrics that are smooth or crisp are best rendered by adding successive layers of markers of the same and different values** to build up a range of values that give a realistic representation of how light is reflected from the surface.

Fringe is the term used for any fabric with loose threads, either bunched into tassles or twists, or separated. Fringe can be made from practically any fabric, including leather, beads, silk, chiffon, yarn wools, lace or linen. . Fringe is usually drawn with colored pencil to capture the stringy quality, but can also be drawn with the fine tip of a marker. Make sure fringe is drawn with a swing! Shadows can be applied to show the deeper parts of the fringe.

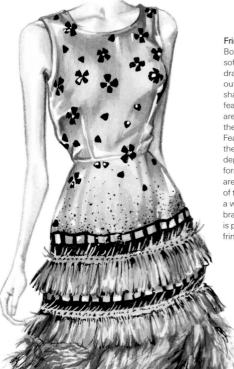

Fringe, feathers, brading. Both fringe and feathers are soft materials and when drawn should not be heavily outlined. The strokes for the shapes of the fringe and the feathers are made in rows but are not parallel to each other— they fall in random directions. Feathers are not flat fabric— they have substance and depth, so deeper shadows form in the interior parts and are made with a darker shade of the main feather color and a wider mark. A trim made of braided black and blue ribbon is placed above the rows of fringe and feathers.

garments of different fabrics

feathers/tiered fringe

Feathers. Uncolored and dyed feathers are extensively used in fashion garments. Feathers are light and delicate and are defined by drawing in the shadows. If the feathers are white the shadows can be defined with a cool or warm white and a darker version for the darker shadows. If feathers are colored an overall application can be made of the lightest base feather color and shadows defined with a slightly darker version of the color.

Feathers. This dress is made of white feathers sewn onto a white undergarment. The white color of the feathers is created by leaving the paper unmarked; highly diluted colors are used to create the shadows under the feathers that give them volume. The pointed edges of the feathers are best created using the point of a colored pencil.

Tiered fringe. First each tier has to be mapped out as an ellipse curving around the legs. Note that the fringe is of different lengths inside each tier and the edge of the tiers are uneven. Fill in the color of the fabric then use a darker marker to define the individual strands and under the edge of each tier.

Floral/sequins/tiers. Where there are several distinct textures and patterns in a garment it is usually easier to work from light to dark so that any mistakes are easier to correct. Draw in the print of the top using pink and blue marker and define the numerous shadows with lighter value pencil and marker. The skirt has three elements–the print, the sequins and the tiers. The print is drawn with markers, some of them, such as the blue and grey, diluted and mixed, others, such as the red, made with a first application of the color and then an application of grey on top. The black in the print is drawn with undiluted marker. The sequins are drawn on top of the print with a white gel pen making circles that are scattered unevenly across the surface. The tiers of gathered rows must be drawn and filled in separately with black marker. The edges at the silhouette must be broken to show each tier. White pencil is applied on top of each tier to show the sheen and the unmarked black marker is left to shwo the shadow at the edge of each tier.

garments of different fabrics

paillettes/pearls/stone beads

Paillettes (over-size sequins) beads, jewels and other adornments are drawn unevenly in scattered patterns as, even if they are placed regularly on the actual garment, they appear to disperse in the folds of the fabric. Each bead is drawn by filling in with a blended color, leaving some white visible for the highlights and a cast shadow is added underneath. It is important to show the beads appearing in profile at the sides of the garment to indicate the beads continue all the way around the fabric.

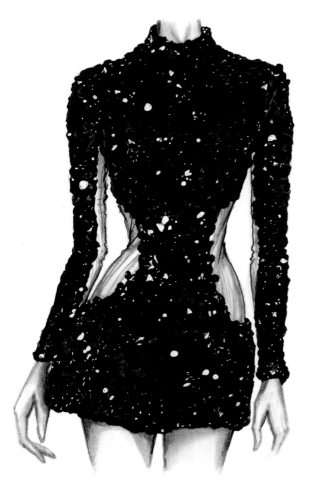

Pearls are spheres and must be shaded like spheres: round shadows are drawn on the surface of each pearl and the edges are defined by darker shadows. Note that the places where the pearls touch are the darkest–light is excluded at those points.

Stone beads. This stunning, densely-beaded garment is drawn using two techniques: First the base color is used to define the beading area on the exterior of the garment, making sure that the edges are jagged. The highlights are white shapes scattered unevenly across the beads, created using a white gel pen or using an eraser tool in Photoshop.

Paillettes. This textured fabric dress is decorated with paillettes of a variety of shapes and sizes. First the body of the dress is drawn and completely shaded. The garment is transparent and the skin tone color is applied from the reverse side of the paper. The fabric is lightweight and the folds are small and dense. The outline of each paillette is drawn with a colored pencil of a darker value than the garment. The hole where the paillette is sewn onto the garment is then defined with the same pencil and the interior of the paillette is drawn in—here it is white—with a pencil of the appropriate color. Note that the half circle at the bottom of each paillette represents the shadow it casts on the body of the garment.

garments of different fabrics

fur/suede

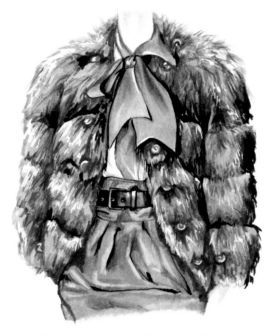

Fur is drawn with short, parallel strokes working from light to dark with darker values where shadows form under the fur. In this dyed fur jacket the pelts are sewn together to create rounded panels almost like quilting. Shadows are wide and rounded and are drawn in with black pencil. Highlights are created on the tops of each pelt with white pencil.

Fur is used extensively in garments, both in the main body of the garment (coats and jackets) and in trims for collars, cuffs and hems. It is also often used in accessories. Numerous types of animal fur are employed including fox, rabbit, mink, beaver, ermine sable, seals, chinchilla and others as well as some exotic animal skins (leopard, bear, for example). The growth of anti-fur sentiment has led to less use of fur in fashion and the rise of imitation furs–*faux furs*–made of man-made fibers. Different furs vary in appearance according to the length of the fibers, whether they lie smooth and flat or are more bristly and have spiky silhouettes. The **nap** of a fur is the direction that the hairs grown in. When garments are made from different pelts they are cut and placed so that the nap will appear to run in the same direction in the same part of the garment, or between the two arms or legs, for example. Furs can be dyed in a range of colors or left undyed.

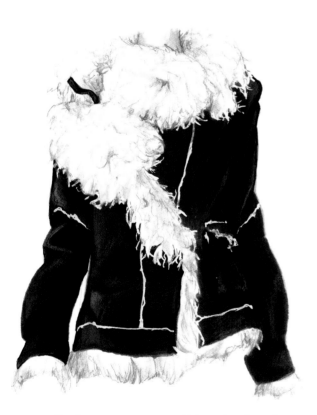

Shearling is the pelt of a one-year-old sheep where the wool is long and clipped to an even length. Draw shearling using multiple layers of warm grey leaving the white of the paper to show through in the lighter parts. Make sure the individual fibers are visible at the edges: draw them in with a white pencil. The shape of the fibers for shearling is more curly than other furs.

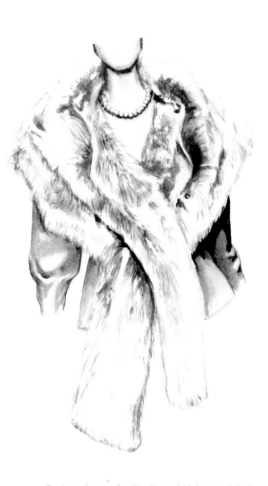

Ermine or faux ermine. The fibers of this fur are relatively short. The shadows form in the body of the pelts and are drawn using at least three values to show the depth of the fur. Shadows also form at the edges of the pelts. The darkest shadows form where the fur overlaps itself or the garment underneath. The lighter parts of the fur where it reflects the light are shown by leaving the white of the paper unmarked.

garments of different fabrics

corduroy/velvet

Corduroy is a distinctive soft fabric that has been cut and brushed to form vertical rows of pile called wales. Corduroy or ribbed fabric is drawn by first filling in the silhouette with an even application of the base color. The gaps between the wales of the fabric are then drawn in with a white pencil. A black pencil is used for shading.

Velvet is a medium-to-heavy weight fabric with a deep-cut pile that gives a fuzzy raised surface known as *nap*. The nap of velvet gives the surface appearance a luxurious sheen with soft shadows. Note that the reflection from velvet is "sheen", not "shine". Sheen is light reflected over a broader area than shine, which is light reflected from edges or points. Sheen is generally applied by using the side of white pencil on top of the marker color.

Velvet. To draw velvet first draw the silhouette of the subject garment and then fill in with many layers of color from both sides of the page so the color becomes very saturated. Fill in shadows in folds using a black pencil with an even application and light touch. Shadows are darkest at the inner edge of each fold where the fabric disappears into the fold. The sheen is added on the ridge of each fold with a white pencil.

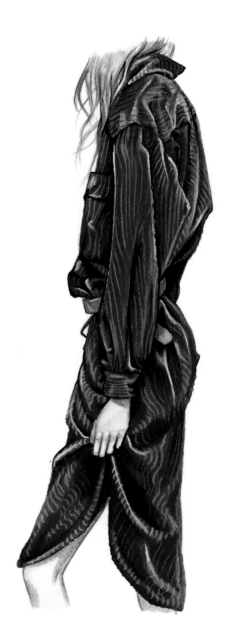

Corduroy. Most corduroy fabrics appear flat and rich so marker is applied from both sides of the page to achieve saturated color. The "wales"– the rows– of the corduroy are drawn with a black pencil and alternate with white highlights on the top of the ribs, drawn with white pencil.

fabrics

suede/metalic leather

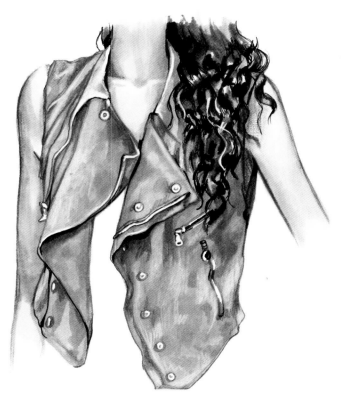

Suede is a fabric created by brushing the underside of lamb, pig or goat skins to create a soft "napped" surface. It is soft and pliable and used extensively in fashion garments and accessories. The soft napped surface produces very soft folds with "sheen" rather than shine on the tops of the folds, drawn using the side of a white pencil. Suede is drawn with the wide tip of the marker. The background color is applied from the reverse side to give a soft, even application. Shadows are defined by using the side of a black or dark–colored pencil. Shadows are applied in wide, even strokes.

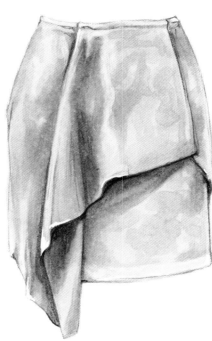

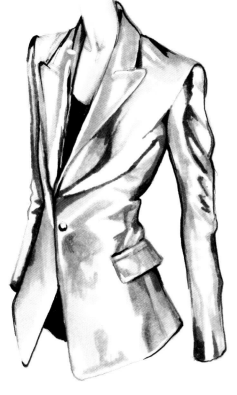

Suede. The design on the suede skirt is drawn with the thin point of colored markers. The background color is applied from the reverse side to give an even application. Shadows are defined by using the side of a black or dark-colored pencil and are applied in wide, even strokes. White pencil is used throughout the surface to indicate the matt sheen; it is more defined on the tops of the folds.

Metalic leather jacket. Metalic leather has more drape than patent leather. Although shiny, metalic leather is not as shiny as patent leather and the highlights are broader and there are more intermediate values. In the jacket the purple color is a reflected light.

garments of different fabrics

leathers-metalic and patent/vinyl

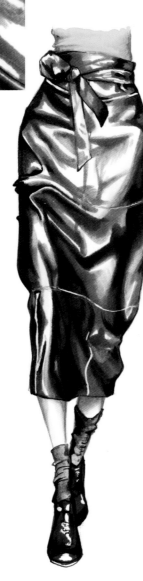

Metalic leather skirt

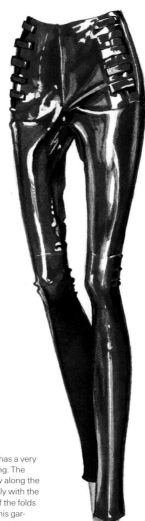

Shiny fabrics—metalic leather, patent leather, glacé leather, vinyl, taffeta and others (shown on this and the preceeding page) display a full range of values including variations of their intrinsic color to bright white and dark black, and should be drawn using at least three gradations of color. These garments have many folds, of different shapes and sizes that should not be drawn uniformly. Light is reflected from the top of each fold and the appearance of shine is created by placing a much darker value color directly next to the white of the top of the folds. The interiors of the folds are drawn in using a mid-range value of the color.

Transparent Fabrics Drawing transparent garments sounds like a contradiction: what is truly transparent has no appearance! To draw transparent garments is, in fact, to draw the parts that are not transparent—the shadows. Shadows form on the surface of the fabric where it bends away from the light and forms folds, where fabrics overlap, and where the shadows of the figure appear under the garment.

With transparent fabrics the shadows are darkest where the body underneath shows through the garment (as opposed to garments made from most other types of fabrics, which are non-transparent and where the shadows are darker where the fabric falls away from the body).

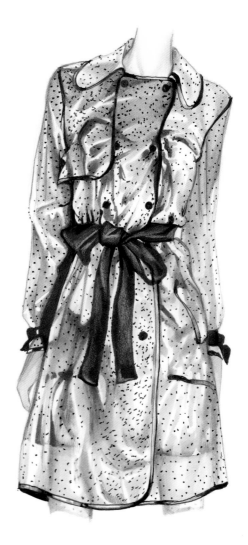

Patent leather pants. Patent leather has a very glossy surface due to a plastic coating. The highlights are very sharp and narrow along the tops of the folds and contrast strongly with the darker valued color in the interiors of the folds immediately adjacent to them. As this garment is lit from the front a bright core light is also seen down its whole length in addition to the highlights on the folds.

Vinyl. To draw this transparent vinyl raincoat, begin by drawing the croquis. In this drawing the raincoat is worn over a silver-grey strapless minidress and dress, arms, legs and shoulders are all clearly visible under the coat. Carefully draw the silhouette of the garment using a thin line to indicate crispness. Begin by adding skin tone to the figure. This is done best from the reverse side of the paper, enhancing the effect of seeing it through the fabric. Add shadows in the interior of the rigid folds creating thin lines of light on the top surface of the folds using a light grey marker. Add a second application of grey marker in the deeper areas of the shadows. Use a black marker to outline seams/trims and add, very carefully, polka dots throughout the garment. Note how the dots are compressed and change direction in the wrinkles and folds of the fabric. The black bow at the waist and cuffs are filled in and highlights are added with grey pencil.

garments of different fabrics

leather/embossed leather

Leather. There are numerous types of leather, which is formed by subjecting **animal skins** (called **hides** for larger animals like bulls or buffalo) to a process known as **tanning**. The different types of tanning and the post-tanning processes including sanding and coating result in a wide range of different types of leather including **full-grain leather, top-grain leather,** most common in high-end fashion, **embossed leather, patent leather. glacé leather and fish leathers** (such as **shark**). Leather garments are made from individual skins, which are not always of uniform size, so many seams are often required in the construction.

All leathers have a grainy finish but this is less apparent in the shiny leathers.

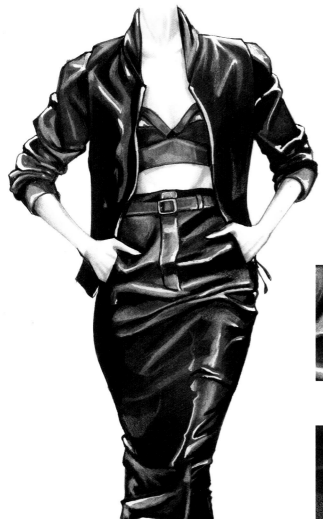

Leather has numerous folds of different shapes and sizes which create both areas of sheen and fine shiny highlights. For this reason it would be difficult to leave the white of the paper unmarked and draw the black leather around it–it is easier to apply a full application of black to the whole garment and then to draw the sheen and shine on top using white gel pen on the tops of the folds and white pencil for the sheen on the core lights on the legs.

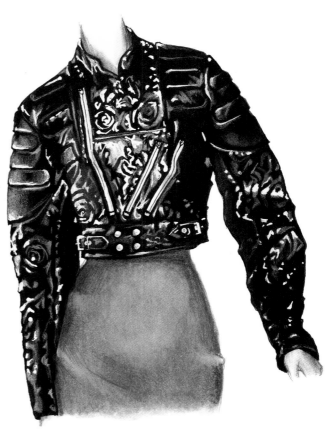

Embossed leather jacket. The base color of the garment is filled in from front and back of the paper so it becomes very saturated. When it is completely dry the embossed pattern is defined using a white pencil and white gel pen. Define lighter areas and shine with the side of a white pencil.

113

garments of different fabrics

horizontal and vertical stripes

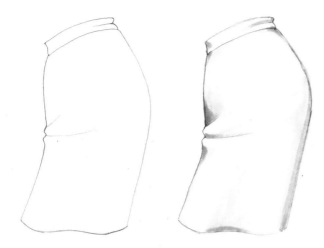

Drawing horizontal and vertical stripes. Steps 1. and 2.
Draw the silhouette. Plot the position of the folds and
where the shadows will appear and apply shading.

Drawing horizontal and vertical stripes. Step 3. Plot the position of the
stripes. The folds of the skirt are horizontal so vertical stripes distort more as
they cross the tops of the folds. Horizontal stripes bend into the folds. Note
how vertical stripes follow the shape of the S curve of the hip and legs. The
horizontal stripes bend around the body.

Drawing horizontal and vertical stripes. Step 4. Fill in the stripes.

Stripes are drawn to curve around the body and in
and out of the folds of the drape. Note that for
woven fabrics which do not stretch or change
shape the stripes maintain their shape, location and
direction except where cut into a seam. For **knitted
fabrics** which stretch and twist around the body the
stripes will change dimension, placement and direc-
tion. For both horizontal and vertical stripes, first
plan the locations of the stripes, bending around the
contours of the body, add shadows and then fill in
the stripes. For plotting horizontal stripes with
woven fabrics it is helpful to use the hem as a guide
and make the stripes above it parallel to each other.
For vertical stripes it is easiest to use the edges of
the garment and plot vertical lines parallel to them.

Vertical stripe pants. These pants are made of
a woven fabric which does not stretch or com-
press significantly in the drape so the stripes
maintain their shape, location and direction
except where gathered at the crotch.

garments of different fabrics

horizontal stripes/prints

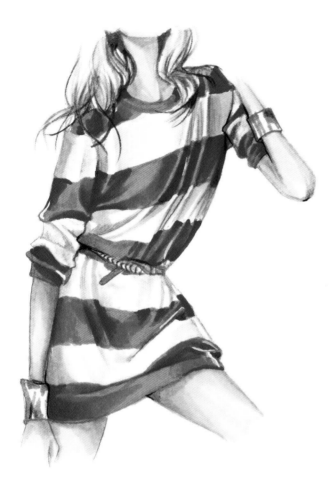

Horizontal Stripes. This dress is made of a stretchy, highly compressible knitted fabric that changes shape with the contours of the body underneath. As a result the stripes change shape, location and direction as the body moves.

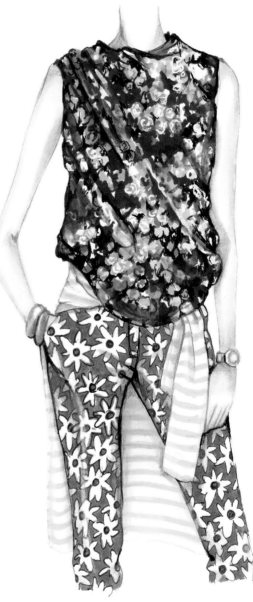

Floral Prints. The top is made of a cotton knit fabric which has more folds than woven fabrics. To reduce the scale of the repeat of the print in a drawing hold the fabric against the body and count the number of repeats. Choose markers and mix colors before coloring in. First draw in the colored flower pattern and then fill in the black background carefully. Less black is applied on the tops of the folds so they appear lighter.
The pants are made of a woven cotton, with fewer folds than the top. The same technique is used to scale the print down for the drawing.

garments of different fabrics

stripes in complex drape

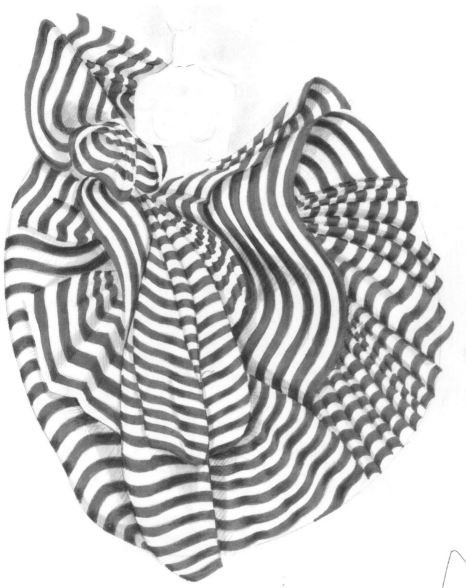

Stripes in complex cylindrical drap. This drawing shows how to draw stripes accurately on complex drape without getting dizzy. The folds of this fabric are cylindrical and fall in a variety of directions, which is what makes the skirt visually intriguing.

The key to drawing this type of garment successfully is to plan out each segment of drape as a cylindrical form, with the large primary fold originating at the center of the skirt and secondary folds originating from two other points. In this drawing there is a second radiation point to the right of the principal radiation point from which a single section of folds also extend, appearing to originate under the skirt, and a third radiation point originating near the knee. Plan out triangular shapes that define the different sections of folds. The accompanying drawing shows how the triangular shapes that define the different sections of folds is planned out. Divide up each triangle into the folds with a light colored pencil. To plan out the direction of the pattern begin by looking at the direction of the curve at the bottom of the fold and observing if it is convex (bends out) or concave (bends in)

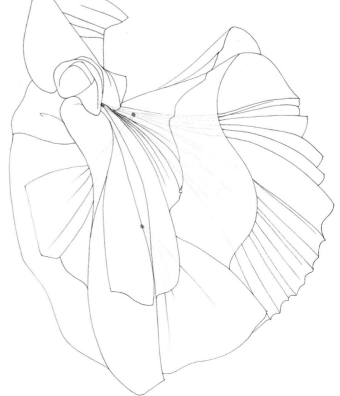

garments of different fabrics

diagonal stripes/plaids

Diagonal stripes often occur when fabric printed with horizontal or vertical stripes is cut and sewn in on the bias. As a result the garment often fits closer to the figure than conventional-cut garments. The stripes follow the contours of the body and have to be carefully planned out to be parallel and the correct width. If right-handed it is easiest to start from the left, if left-handed, from the right. Place dots to show the position of each stripe at the silhouette and then, working left to right, one fold at a time, draw in each stripe with a colored pencil to the edge of the next fold. Repeat this through each fold of the garment, remembering that stripes are alternately concave (bend inwards) and convex (bend outwards) as they follow the undulations of the folds of the fabric. Note that the fabric bends around the bust line.

Plaid can be drawn using a number of methods. One of the easiest is to first draw in the widest horizontal and vertical bands with marker then to apply the thinner horizontal lines of the plaid pattern and then the thinner vertical lines of the pattern using colored pencil or gel pen. Note that with plaids and stripes the widest or most prominent stripe falls on the center front of the garment (or c-f of each pant leg). This prominent stripe is also placed on the edges of cuffs, collars, hems, pockets or other design details.

Plaid flannel shirt. Because this is a woven fabric it does not stretch so the printed stripes do not distort in the folds

garments of different fabrics

knits

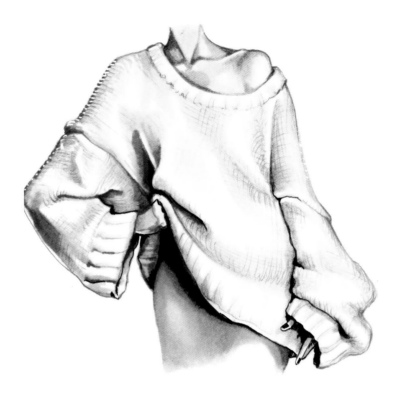

Knits are drawn by first making an even application of the color of the garment as a background. The rows of stitches are then lightly sketched in using the side of a pencil. The lines break when they move into a fold or into an area of sheen. White pencil is used on the top of the folds to show sheen and soften the look of the stitches and shadows are applied under the stitch patterns to create the appearance of depth. Note that the folds are very wide and the silhouettes of the garments are, bulky and sit far from the body. For heavy rib cuffs, collars or hems indicate the depth of the ribs by using dark shadow in between.

These hand-knit sweaters show a variety of stitch patterns and yarns. When drawing knits under time constraints it is not necessary to render every stitch in the garment: show a few stitches and if necessary include a separate side drawing of a close up of the pattern of the stitches.

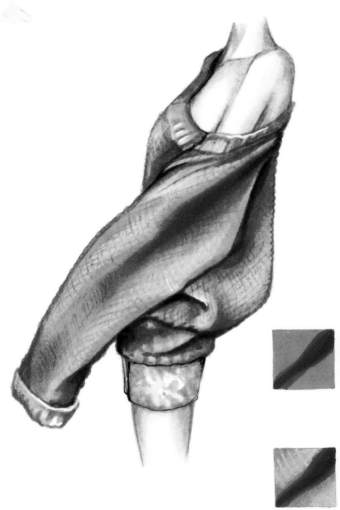

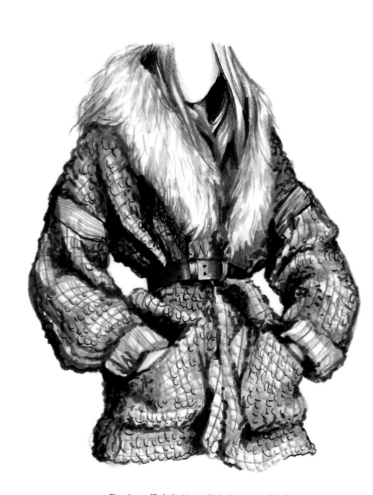

Chunky waffle knit. Also called a honeycomb knit, this grid pattern is plotted using the silhouette of the garment as reference, curving around the cylinders of the arms and following the drape of the lapels. The pockets are kangaroo pockets sewn in on a diagonal.

garments of different fabrics

cable knits

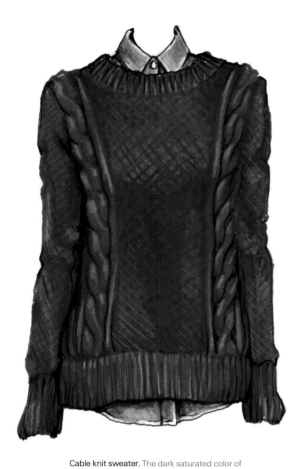

Cable knits are knits where cables are created with a knit stitch usually against a purl background. Various crossing patterns are possible using from one to four cables. One cable looks like a snake. two cable braids look like rope. Cables usually run vertically but can also be made into lattices; distance between repeats varies as does the volume of the cable–how chunky it appears.

When drawing cable knits first sketch out the pattern with the correct number of repeats. Draw in the cables with heavy shading at the edges and sheen on the tops. These knits are usually heavy and bulky and form wide folds.

Cable knit sweater. The dark saturated color of the yarn is achieved by applying marker from both sides of the paper. Black pencil is used on top to show shading. Note that for all soft-textured fabrics shading is applied to the surface over the base color with colored pencil.

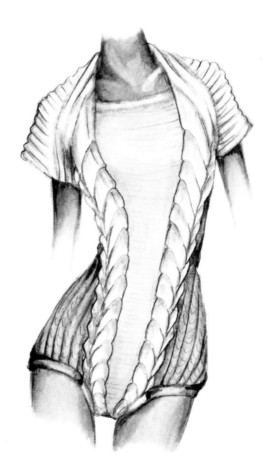

High fashion jump suit. A combination of wide ribbing and cable knit trim. Each rib and panel has to be shaded individually to indicate its depth.

garments of different fabrics

cable knit/casual knit/lightweight knit

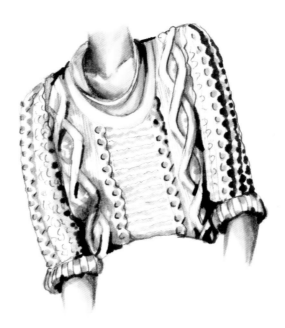

An Aran sweater made by combining panels of different cable and other stitches. All the patterns have a lot of volume and stand out from the surface of the sweater. Shadows have to be wide and dark to give the patterns their chunky appearance.

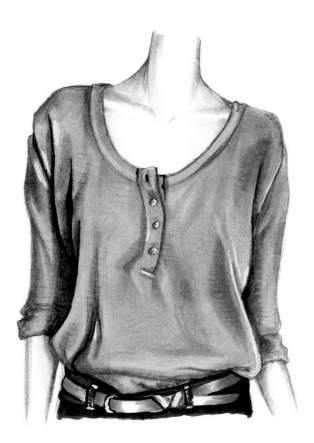

Casual knit Henley shirt. The knit stretches so the fabric clings to the body and forms multiple folds where it falls away from the body. Note the folds that curve around the arm and that the fabric clings to the shoulders and bust. Shadows are drawn using multiple layers of marker of the same color as the garment.

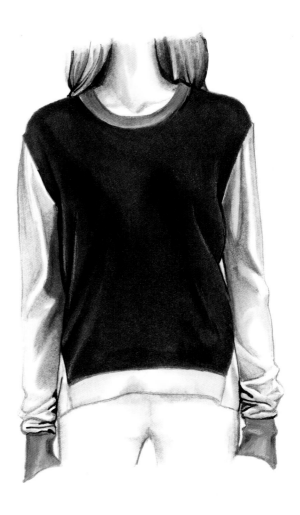

Lightweight knit. This fabric clings where the body is present underneath and forms numerous soft small folds where it falls away from the body.

garments of different fabrics

quilting/polyester

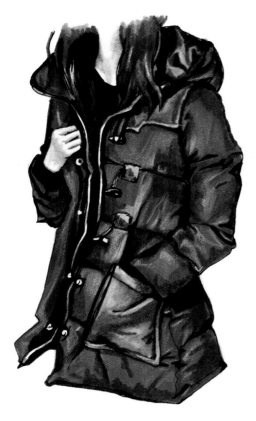

Quilting. Quilting is formed by enclosing a bulky insulating fiber–typically down, feathers or an artificial substitute–between two layers of fabric and sewing into sections to keep the fiber in position. Quilting is designed for warmth but also to expand the silhouette which becomes structured and quite separate from the body underneath. Quilting comes in different thicknesses–called "loft"– from minimum loft which is almost flat to high-loft which is puffy and bulky.

High density fabrics are made from polyester microfibers in very dense weaves and are used extensively in outdoor apparel because of their lightness, durability and wind- and waterproof qualities. HD fabrics have smooth, lustrous surfaces and the lighter weight ones form many folds.

Quilting. As with stripes or plaids, begin by planning the pattern of the surface stitching with a pencil, taking into consideration the small amount of drape at the waist and elbow (or knee in pants). Next make an even application of the base marker color from the reverse side of the fabric. If the fabric is shiny leave rounded areas of paper unmarked to show highlights on the high points of each quilt panel. Each panel is a separate section in the silhouette and because it contains filling it pushes out the edges of its panel so they appear rounded. The panels are drawn with a rounded highlight and shaded where gathered into the seams using a dark grey or black pencil. Pay close attention to the light source in the placing of the highlights. Note that these cold-weather garments are designed to fit over sweaters so have large armholes; as this is a puffy fabric the silhouette of the garment appears rounded.

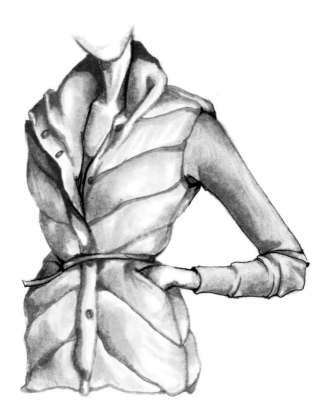

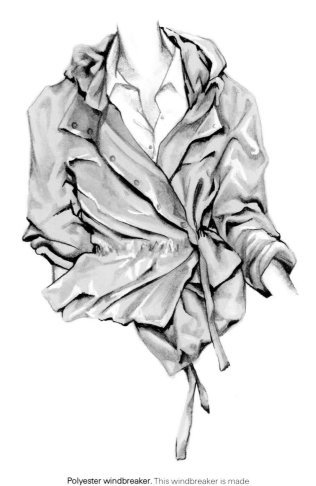

Polyester windbreaker. This windbreaker is made from a lightweight fabric and has folds throughout. Draw using the lightest to fill in the whole garment and then show the shadows using two darker values of the same color and black marker.

garments of different fabrics

embroidery/denim

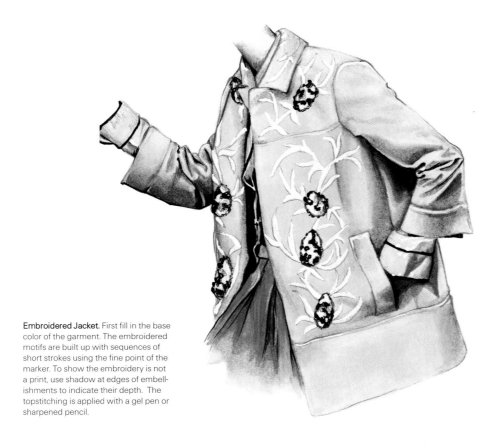

Embroidered Jacket. First fill in the base color of the garment. The embroidered motifs are built up with sequences of short strokes using the fine point of the marker. To show the embroidery is not a print, use shadow at edges of embellishments to indicate their depth. The topstitching is applied with a gel pen or sharpened pencil.

Embroidery created for specific garments as an embellishment gives an elegant and distinctive look. As opposed to embroidered fabrics where the embroidery is sewn onto the full extent of the fabric, embroidery applied to individual garments is applied to specific areas of the garment.

Denim is one of the most popular of fabrics. Although originally intended as a durable, hard-wearing fabric and popularized by cowboys in the American West, denim is now used in a wide range of fashion garments. Denim is produced from three or more yarns, one of which is the white diagonal twill and the others blue and indigo, meaning that denim never appears as uniform blue in color. Indigo dye is not fast so denim fades with washing; different fashion looks are created purposely by washing for varying periods of time and with different treaments. The twill yarn runs bottom left to top right or bottom right to top left which can be indicated in drawings, although it is sometimes positioned on the horizontal or vertical.

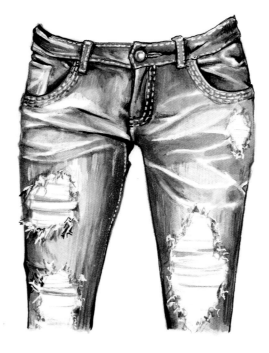

Blue denim. Fill in the pants—or whatever garment is being drawn—with a blue marker (indigo, navy or grey marker with blue pencil) and, with the side of a white pencil, make long strokes to indicate the areas of the pants where the twill—the white threads–of the denim show through. Indicate the areas of the pants where shadows fall with a grey or black pencil. Show top-stitching along seams with a white gel pen. Denim is usually thick so the shadows in the interiors of the folds are wide and the drape can alsobe wide. To show the frayed edges of distressed denim as seen in the drawing on the left leave the white of the page to indicate the fabric, add a little skin tone to show where the skin is visible underneath. The frayed edges that overlap the blue of the pant can be drawn in with gel pen.

garments of different fabrics

organza/black lace

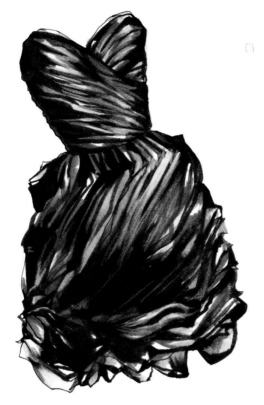

Organza is a crisp, transparent fabric that has a lustrous sheen. It has volume and buoyancy and the drape is more angular than other transparent fabrics. Make sure to show the angular drape in the drawing, using irregularly placed white highlights to emphasize this.

Lace. Once exclusively hand-made, lace is now machine-made to a high standard and commonly used in fashion garments. Lace can be used in a number of ways: unlined, it is transparent or semi-transparent depending on the density of the pattern; lined it appears as a delicate pattern against the lining background. It can also be placed over an opaque structured garment or over another transparent garment, in which case the overall effect becomes semi-transparency. The fabric is lightweight and drapes in numerous floating folds.

Organza dress. This dress has many layers of fabric gathered at the waist and appears less transparent than single layer organza. Note that the drape is diagonal and that the highlights follow the curve of the fabric bending around the body.

Organza has a distinctive angular drape

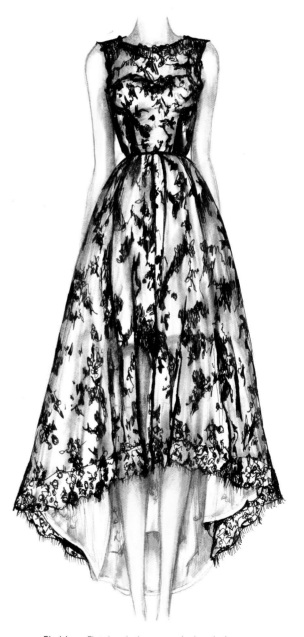

Organza skirt. The fabric is gathered at the wiast and flairs out in a wide, rounded drape. This skirt is transparent: the skin tone of the legs can be drawn in last from the reverse side of the paper.

Black Lace. First draw in the narrow shadows in the numerous folds with a black marker diluted down to grey, leaving the tops of the folds as the unmarked white paper and then draw the pattern on top. When the scale of the pattern of the lace is such that the details of the pattern can be seen in the drawing it has to be drawn in delicately using the fine tip of a marker. If the pattern is not noticeable create the effect of lace by stippling–making numerous light vertical stabs with the point of the marker.

garments of different fabrics

tulle/linen/cotton

Tulle is a fine lightweight netting that, being more air than fabric, appears transparent. It is drawn by first outlining the shape of the garment and then filling in the body with many thin strokes of very diluted marker. The marker strokes are more closely grouped together, so becoming more opaque, where either there are more layers of fabric or the body is present underneath. The crisp folds at the hem can be defined with a very sharp pencil point.

Cotton is one of the most popular and versatile natural fabrics in fashion used in a wide range of fabrics and garments.

Linen is a crisp, slightly stiff fabric, made from flax fiber, best represented using pencils. First an even application of the base color is made throughout the garment and the texture is created over this by drawing closely spaced thin lines bending around the figure using a sharp-pointed pencil with one of the colors of the fabric. If the fabric has a sheen this can be brought out by applying several different colors to represent the rough surface of the fabric and the unevenness of the color.

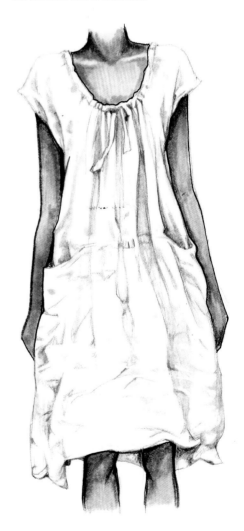

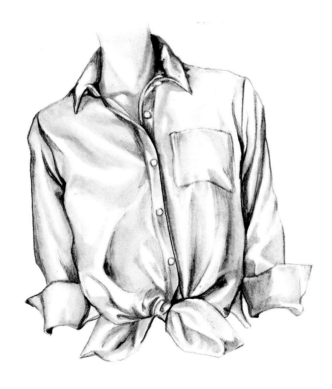

Cotton. This is a crisp cotton broadcloth shirt, the crispness created by fine horizontal ribs which are not noticeable in a drawing. This is a cool white shirt, so is drawn by filling in the shadows using a light blue marker and leaving the white of the paper on the tops of the folds. The folds pull from the shoulder line towards the bust and then from the bust to the knot at the waist. Note that the collar stands high above the shoulder line and the cuffs flare out from the arms.

Linen dress. In its natural state the drape of linen has wrinkles as well as folds, and tends to hold its wrinkles, which are often part of the look of the garment. This is shown in a drawing by having many small irregular-shaped shadows throughout the surface of the garment.

garments of different fabrics

chiffon

Chiffon is a lightweight, transparent fabric that is softer than organza or tulle and so has less buoyancy, draping closer to the body. Because of its loose weave and lightness it is usually made over a lining. Chiffon is drawn with a light application of blended color. A second application of the same color is used to show shading. The shading has to be rounded–chiffon does not have crisp edges.

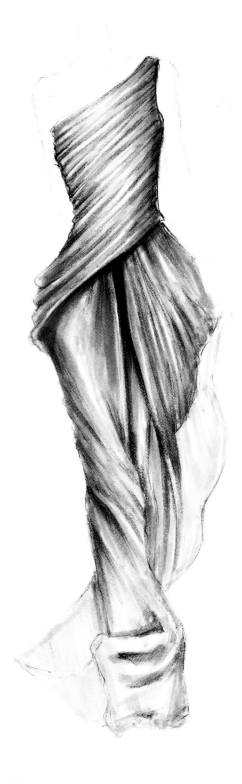

Chiffon. This lightweight chiffon evening dress is made of layers of fabric. In the bodice the fabric is gathered into fine folds from the side seams. The section at the hip is sewn at the waist and pulled over the hip to the back of the garment, creating fine diagonal folds. The lower part of the dress on the other side is not gathered and clings to the body. The dress can be thought of and shaded as four individual cylinders of different alignments.

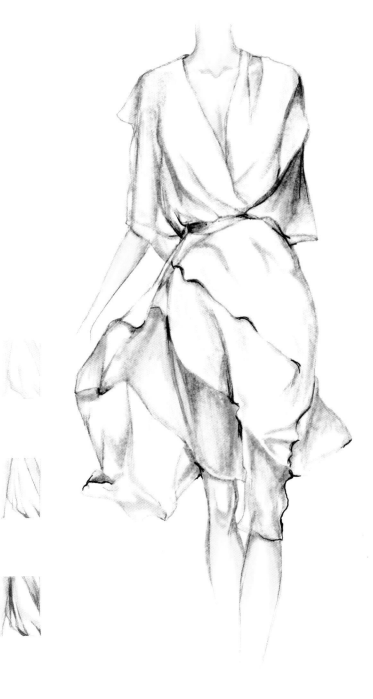

Chiffon. This dress is a lightweight transparent blue-tinged chiffon, draped on the bias, sewn over white silk. The shadows under each of the tiers of white silk are drawn using a very light application of diluted blue reflecting the color of the chiffon outer layer.

garments of different fabrics

silk jersey/graphic/geometric prints

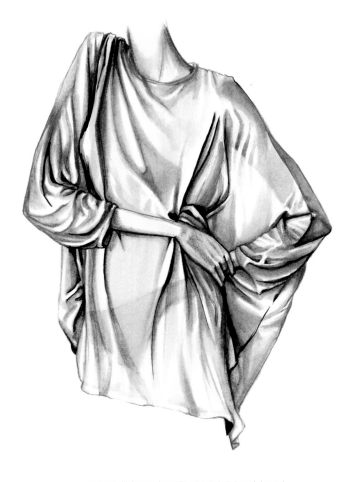

Knitted silk jersey dress. The fabric is lightweight and forms dense voluminous folds. It often has a sheen so is drawn with value contrast between the tops and interiors of the folds, using four values of the same color.

Cotton. This is a knitted cotton tee-shirt with a graphic print. The fabric is soft and creates many densely grouped clinging folds. The letters are applied last after the shading and distorted to follow the curves of the folds. To get an idea of how the letters will distort draw them on a separate piece of paper and bend.

Geometric print. This complex print has to be drawn carefully before any color is applied as the pattern bends in each of the folds. After the pattern of the print has been carefully drawn color is applied from light to dark. Two or three layers of shadows are applied after the base colors have been applied, using two or three shades of the base colors.

garments of different fabrics

shiny fabrics/medium shine

Silk has a special shine or sheen because of the flat surfaces of the silk threads that reflect light in many directions. The fabric is best rendered using thin layers of blended color to reproduce the special way it reflects light.

Duchess silk is a lustrous, luxurious heavyweight type of silk often used in wedding gowns. It has more body than other silks which allows it to be constructed into shapes that stand away from the body, like the large bow seen on this dress. Note the wider folds of the drape with wider flat expanses on top.

garments of different fabrics

taffeta/brocade

Tafetta is a crisp fabric often used in dresses, skirts, bridal and formal wear. It is lustrous, with a shine or sheen. Its cross-grain ribbed texture creates angular folds that hold their shape: the silhouette sits away from the body and shows the angularity of the drape. It is often made in bright iridescent colors that appear to change color when the fabric moves.

Brocade is a woven fabric with a raised design woven on top, sometimes with a metalic thread, usually floral or figurative, made to resemble embroidery. It is drawn in a similar way to a print, first applying the background color and drawing in the pattern of the print on top with colored pencil, which will give it the appearance of texture.

Satin is produced using multifilament yarns that yield a smooth and lustrous surface with luxurious drape.

Taffeta. Note that the diagonal stripes in this plaid pattern do not curve around the folds but because the folds are angular bend at sharp angles.

Satin. Because satin is shiny and the surface is very smooth it forms deep shadows. The smooth surface is obtained by an initial application of the base color marker and then further applications of the same marker to indicate the shading on the sides and interiors of the folds. Some marker brands do not have sufficient pigment to significantly darken the color with multiple applications so in those cases it is necessary to use a darker marker for the second application.

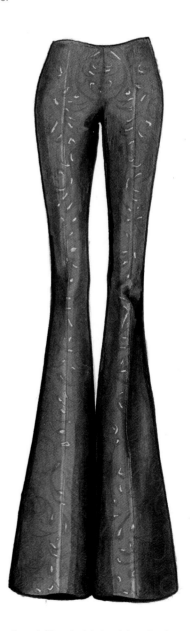

Brocade. The raised design of these flared pants is created with metalic threads which are shown by applying a scattering of slim marks with a white gel pen. Note that the fabric is heavy and relatively stiff with little drape except at the knee.

garments of different fabrics

felt/herringbone tweed/flannel

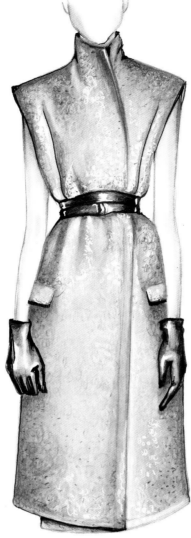

Felt. This funnel-collared wrap dress has very little drape except where cinched at the waist with the belt. Apply a flat application of light grey and add shadows where the wrap of the fabric overlaps at the collar and hem, under the pockets and in the seams. The elegant pattern is drawn in using a slightly darker value than the base color of the garment and a subtle application of white gel pen in the lighter areas. Avoid drawing hard outlines around the silhouette of this fabric.

Felt is made in the same way as paper, without use of yarn, by compressing fibers–usually wool– under conditions of heat and dampness. The resulting fabric is very stiff and bulky with little drape.
Flannel is a soft woven fabric with a fuzzy surface often used in tailored garments. The drape is soft, wide and round drapes. The surface is matt so there is little contrast in values in the drape.
Tweed is a rough, unfinished woolen fabric made with plain or twill weave and often with a herringbone or other well-known check patterns such as houndstooth or Prince of Wales.

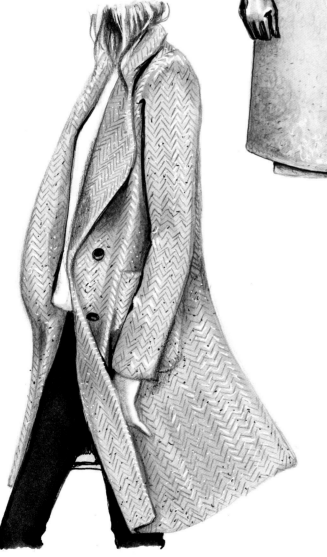

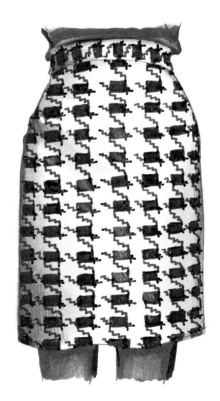

Herringbone is a tweed–a woven untreated-wool fabric with a distinctive chevron pattner. The base color of the fabric is filled in and the pattern is drawn in with colored pencil. Sheen is added to the tops of the folds with the side of a white pencil.

This houndstooth wool tweed skirt has to be planned and drawn very carefully before any marker is applied otherwise the pattern might not appear uniform and not line up with the sides of the skirt. First plan the direction of the pattern, following the hem, drawing it in first with grey pencil. Draw in the shadows that occur in the drape at the hip and around the sides of the legs. The pattern repeat is drawn with the thin point of a black marker and bends around the skirt.

garments of different fabrics

black and white with voluminous fabrics

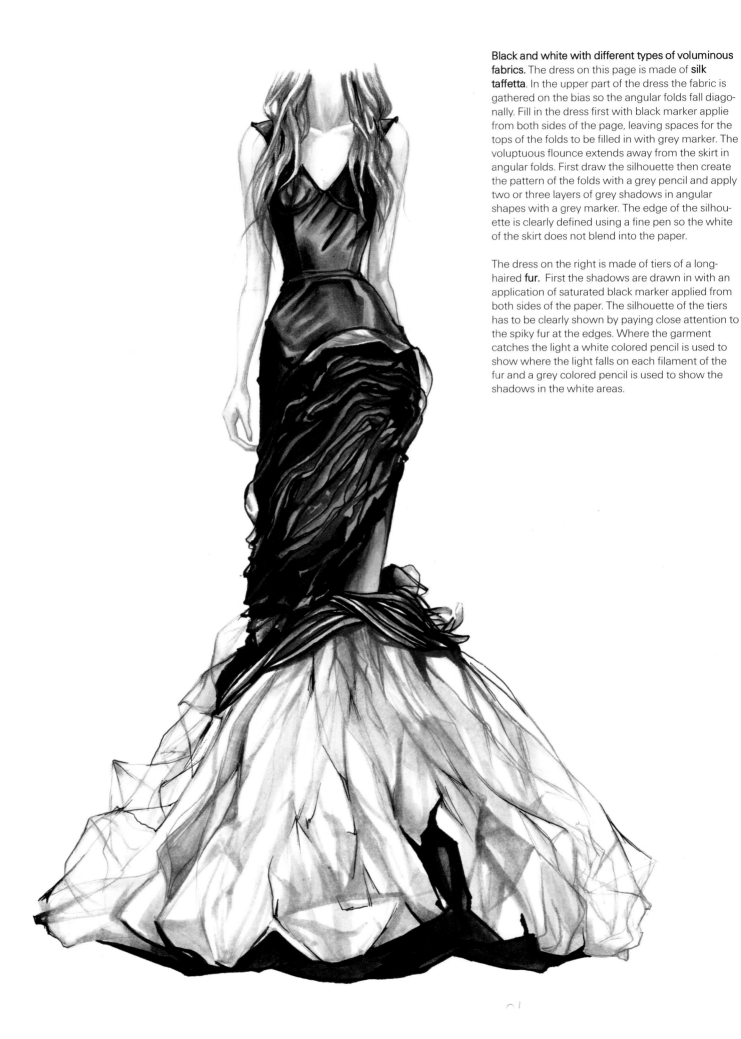

Black and white with different types of voluminous fabrics. The dress on this page is made of **silk taffetta**. In the upper part of the dress the fabric is gathered on the bias so the angular folds fall diagonally. Fill in the dress first with black marker applie from both sides of the page, leaving spaces for the tops of the folds to be filled in with grey marker. The voluptuous flounce extends away from the skirt in angular folds. First draw the silhouette then create the pattern of the folds with a grey pencil and apply two or three layers of grey shadows in angular shapes with a grey marker. The edge of the silhouette is clearly defined using a fine pen so the white of the skirt does not blend into the paper.

The dress on the right is made of tiers of a long-haired **fur.** First the shadows are drawn in with an application of saturated black marker applied from both sides of the paper. The silhouette of the tiers has to be clearly shown by paying close attention to the spiky fur at the edges. Where the garment catches the light a white colored pencil is used to show where the light falls on each filament of the fur and a grey colored pencil is used to show the shadows in the white areas.

garments of different fabrics

black and white with voluminous fabrics

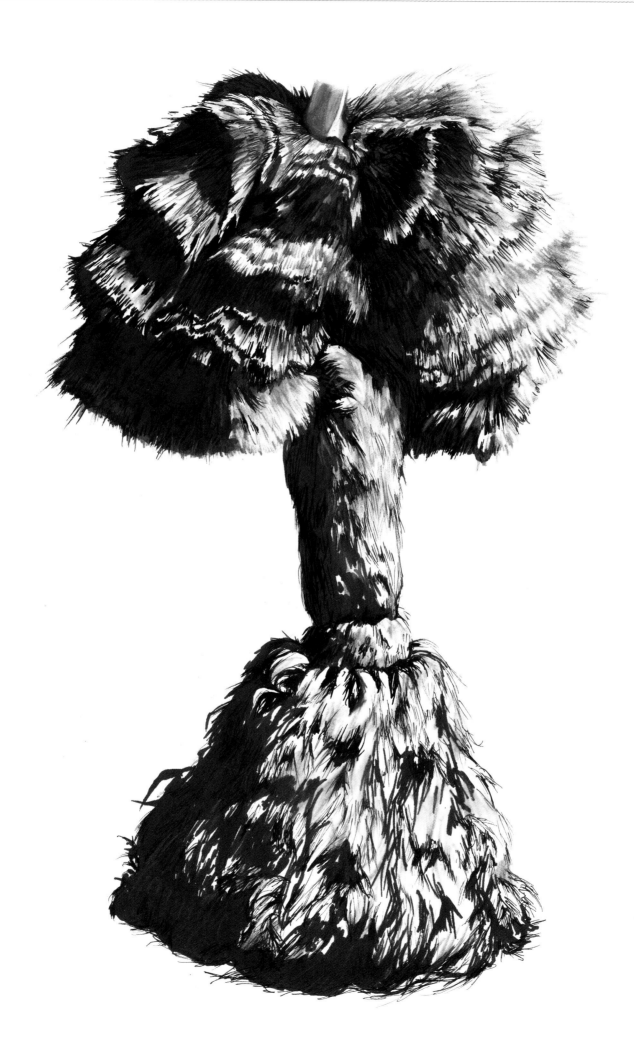

garments of different fabrics

magnified details

Fur

Quilting

Shiny

Shearling

Stitching

Feathers

Lace

Snakeskin

Velvet

fabrics/details

magnified details

aLong Fur

Knit

Fringe

Satin

Beading

Denim

Animal Print

Crocodile

Tapestry

garments of different fabrics

magnified details/flowers

Sunflower

Violet

Impatiens

Snapdragon

Wildflower

Rose

Calla lily

Hydrangea

Lace

garments of different fabrics

magnified details

Beading

Plaid

Paillettes on chiffon

Lace

Plaid

Tweed plaid

Cotton ribbing

Plaid

Floral Print

garments of different fabrics

flowers

garments of different fabrics

floral print

garments of different fabrics

practice and exercises

Beginners

1. Copy one of the croquis from the beginning of the chapter and add shading on the right side using a light colored marker. Copy another croquis and add shading on the left side and another shading it as though the light source is in front.

2. Draw the silhouette of any garment and add simple shading using a light blue marker.

3. Draw the same silhouette as for 2. and add two layers of shading using the same light blue marker.

4. Take a garment from the closet and lay on a table so its drape is visible. Practice drawing the shadows and light areas of a part of the garment—a sleeve or leg, for example—using markers and colored pencils.

5. Repeat exercise 4. using a photograph of a garment from a fashion magazine.

6. Copy the alligator fabric on the left.

7. Draw the silhouette of a bathing suit on a croquis using shiny fabric.

8. Draw the silhouette of a dress on a front view croquis. Fill in the garment with color and add shading so it represents (i) a transparent dress, (ii) a black dress, (iii) a white dress.

9. Draw two different flowers.

10. Copy the plaid print at lower left on this page.

garments of different fabrics

practice and exercises

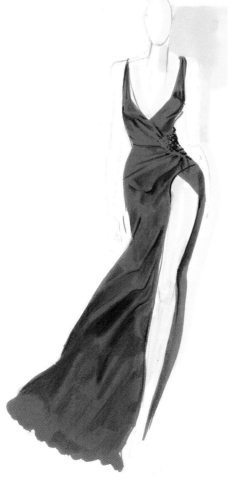

Advanced

11. Using a pose from the Chapter Five, add details and definition with markers and colored pencil to to make the garment appear to be made of (i) tweed, (ii) leather, (iii) velvet ,(iv) shearling and (v) plaid. Repeat this exercise with poses for men and children.

12. Draw a wedding dress front view made of any or any combinations of the following fabrics: lace, shiny satin, sequins, transparent chiffon.

13. Draw a nightclub outfit using leather, animal skin and fur.

14. (i) Draw a man wearing a tweed suit. (ii) Draw a woman wearing a tweed and suede suit.

15. Draw a child wearing a knitted sweater and a plaid skirt.

16. Draw a croquis and add the silhouette of a dress. Choose a fabric with a floral pattern and fill in the silhouette of the dress with the pattern on a reduced scale.

17. Take a a 4″x 5″ (approx.) swatch of a favorite fabric with pattern and trace the pattern onto tracing paper. Turn over and rub graphite pencil over the back. Re-draw the image from the top side with marker paper underneath and the image will transfer to the marker paper; this will take 45 minutes to an hour if done correctly. Using the original fabric as reference fill in the drawn pattern with marker and colored pencil to match the colors exactly to the original fabric. Start with light colors and work to dark. The images
on the left show an example of an original swatch of fabric and the copy.

18. Copy the dress on the left, starting with the croquis, adding the silhouette and shading in black and white. FIll in with a color from the reverse side of the paper.

19. Draw three different outfits using different knitting stitches.

20. Draw (i) a pair of lace nylons or tights, (ii) a lace camisole, (iii) a lace brassiere and (iv) a lace vest.
.

CHAPTER FOUR

SKIN TONE/FACE/MAKE UP/HAIR

choices—face/make up/hair/skin tone

basic croquis

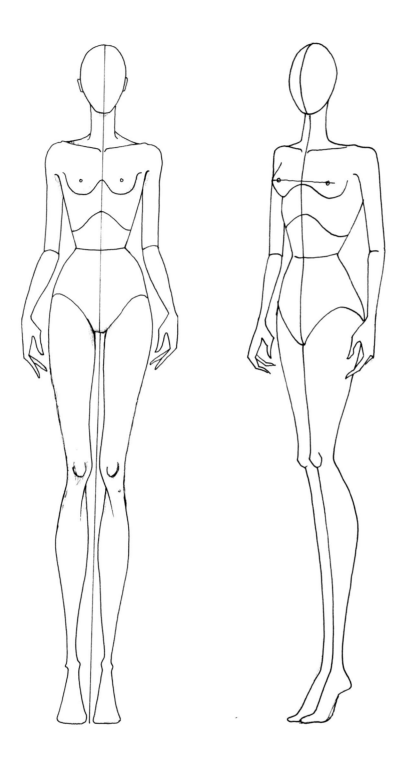

Making choices for the face, make up, hair and skin tone

The choices made in fashion drawing on makeup and hair are similar to the personal decisions we make everyday for make-up and hair to complement our clothes or the decisions made by the designer and stylist on styling a model for the runway. The treatment chosen for makeup and hair gives a drawing style and individuality: the face can be used as a canvas to extend or contrast with the overall effect of the garments. Along with choice of accessories that accompany garments, face, hair and skin tone are where choices can be made that affect the styling of the figure and provide important additional information about the garment.

The basic rule underlying choices for hair and makeup are the same as for most decisions on the content of a fashion drawing: the best choice is whatever makes the clothes look best and also whatever reinforces the way we wish the clothes to be interpreted. The same observation is usually true for decisions about skin tone on the body, though if a natural look is required it is necessary to ensure skin tone is as realistic as possible.

Skin tone

When drawing skin tone, as in fact with all drawing, it is important always to make the *intent* of the drawing clear. If the intent is that the skin tone look natural, it should be carefully drawn to look natural; if skin tone is a fantasy color chosen to fit with the garments and the overall composition of the drawing, it should be clear that this is the intention, that it is not intended to be a realistic color and the reason for the decision should be clear.

In general, if the intrinsic colors of a garment are important and feature prominently in a drawing, then making the skin tone/make up subtly reflect the colors of the garments can be an effective option. This can usually be achieved using a blended version of the garment color to create tints and tones on the face and make-up.

Hair

Decisions about hair involve shape as well as color, and in the fashion drawing hair is an important compositional element of balance and/or emphasis. The shape, type and color of the hair should be chosen to balance the shapes and colors of the garments. Hair can be used as an accent to the color scheme of the garments or to fit into the overall color scheme in some other way.

Basic nine-head croquis, ftont view and three-quarter view. These are the two-dimensional line drawings onto which simple shading is applied to give the figure a more realistic three-dimensional appearance.

skin tone

lighter skin tones

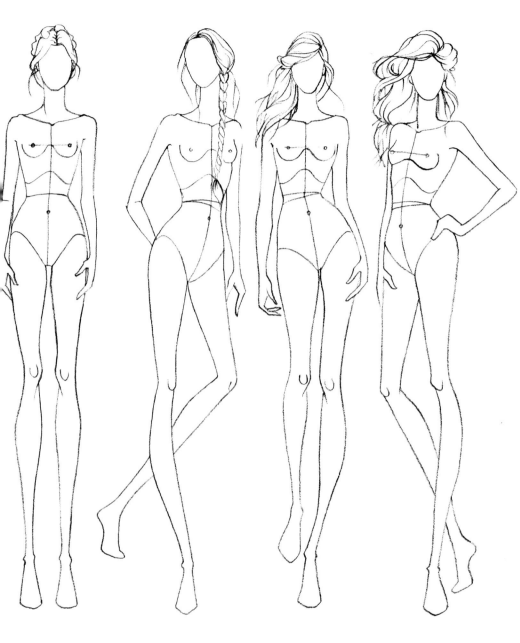

Rendering skin tone to look realistic using gradation of tone

To give the body a realistic, three-dimensional appearance the skin has to be shaded to resemble the way it appears in reality, with areas in light and areas in shadow. This rule applies for all different skin tones, both light and dark.

Although in actual light conditions there is a continuous gradation of shading on the skin from light to dark, in fashion drawing the convention is, in the interests of speed and simplicity, to reduce this gradation to three values—light, medium and dark (if time permits, however, as seen in many of the drawings in this book, many more levels of gradation can be added). When using markers, the light value is created by leaving the white surface of the paper unmarked; the medium value is the marker color chosen for the skin tone and the dark value is the marker color chosen for shading.

When drawing skin tone using shading, so it appears three-dimensional, the first decision to be made concerns the direction of the light source—whether it will appear from the front or side. If a decision is made to light the figure from the *front*, the *sides* of the figure will be in shadow; if from the *side* the shadows will appear on the opposite side from the light source.

If lit from the front a narrow strip of light appears down the center of the torso, legs and arms, which is shown by leaving a narrow strip of paper unmarked. The rest of the figure receives an application of skin tone color. On the upper body this is applied on either side of the strip of light using a careful vertical up-and-down stroke On the legs and arms, application is made with long, vertical strokes from the hips to the knees and knees to feet, and shoulders to elbows and elbows to wrists, running the marker along the contours of the figure, allowing a thin vertical strip of light, about an eighth of an inch wide, to remain in the center of the legs.

Streaking can occur in skin tone color if it is applied with short, jerky strokes. To avoid this it is best to apply the marker with smooth, continuous strokes, and not removing it from the surface of the paper in mid-action. This is a technique that has to be mastered, and it is useful to practice making long, continuous strokes on a separate piece of paper before beginning the drawing.

Lighter skin tones 1. Carefully draw the croquis and decide the direction of the light source.

skin tone

lighter skin tones

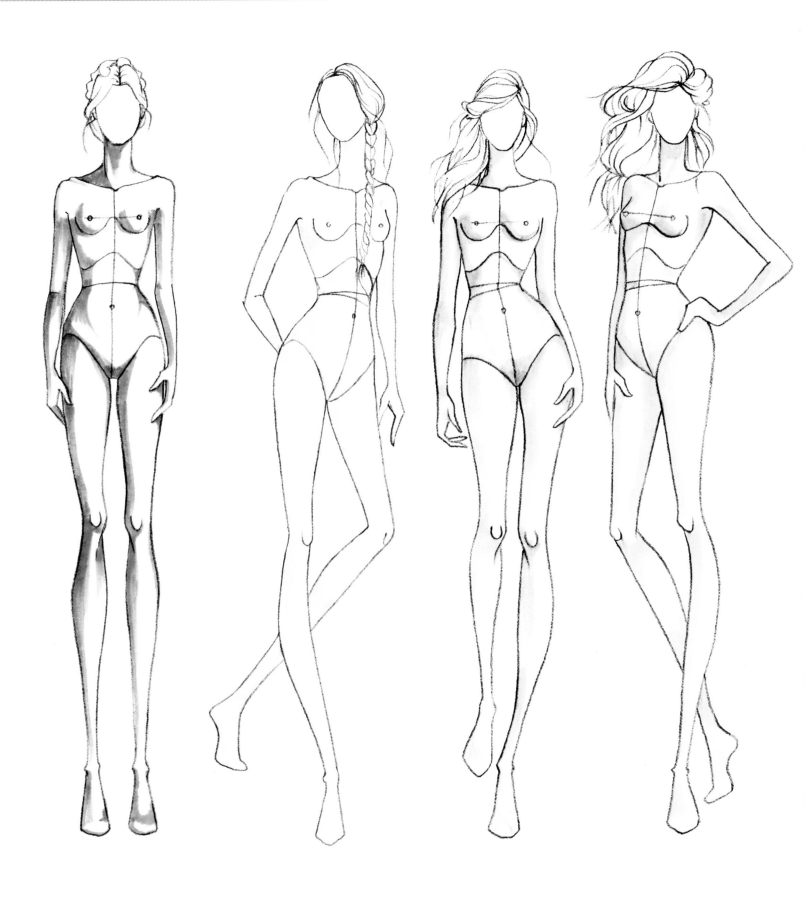

Lighter skin tones 2. The figures are lit from the right so shadows fall on the left and areas that recede from the light—the collar bone, side of the body and legs and undersides of limbs. A first application of the darkest color is made to the parts that are furthest from the light source or are bending away from the light. It is also possible to work from light to dark in which case the white of the paper is left for the lightest parts and the lightest shadows would be filled in first and will cover more of the surface.

skin tone

lighter skin tones

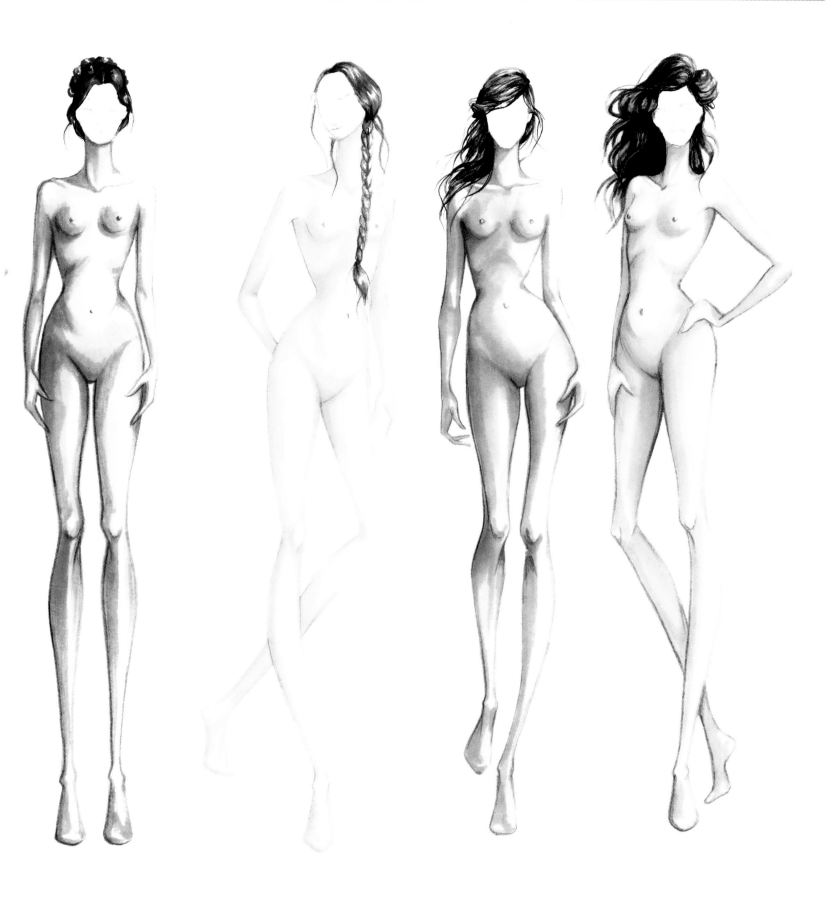

Lighter skin tones 3. The lighter shadows are added with a diluted version of the first application color or a similar color. These shadows define the form between the darker shadows and the lightest areas of the figure where the light hits which are left as the unmarked white of the paper. A second application of the color used for the darker shadows can be used to deepen the darkest shadows if necessary.

skin tone

darker skin tones

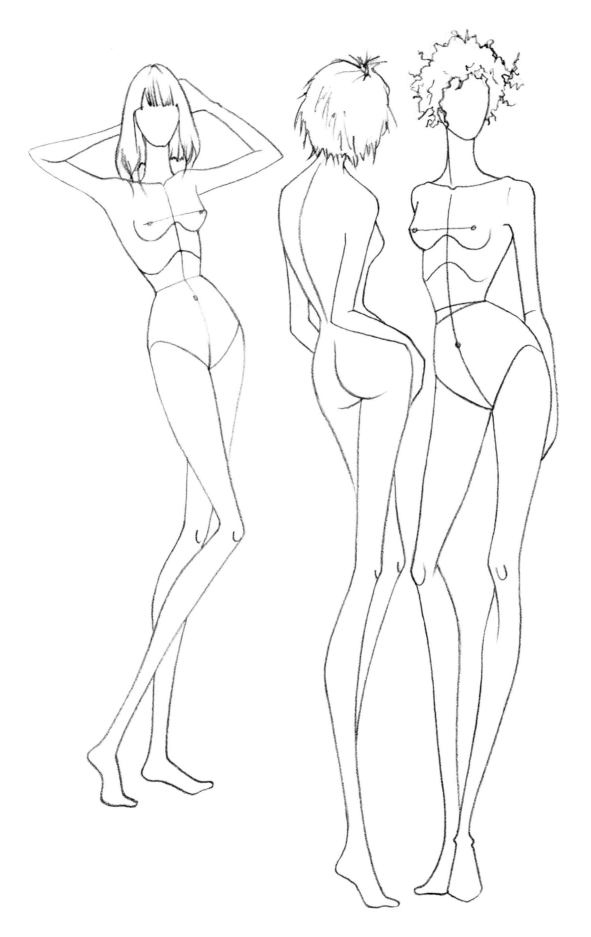

Darker Skin tones 1. Carefully draw the croquis and decide the direction of the light source.

skin tone

darker skin tones

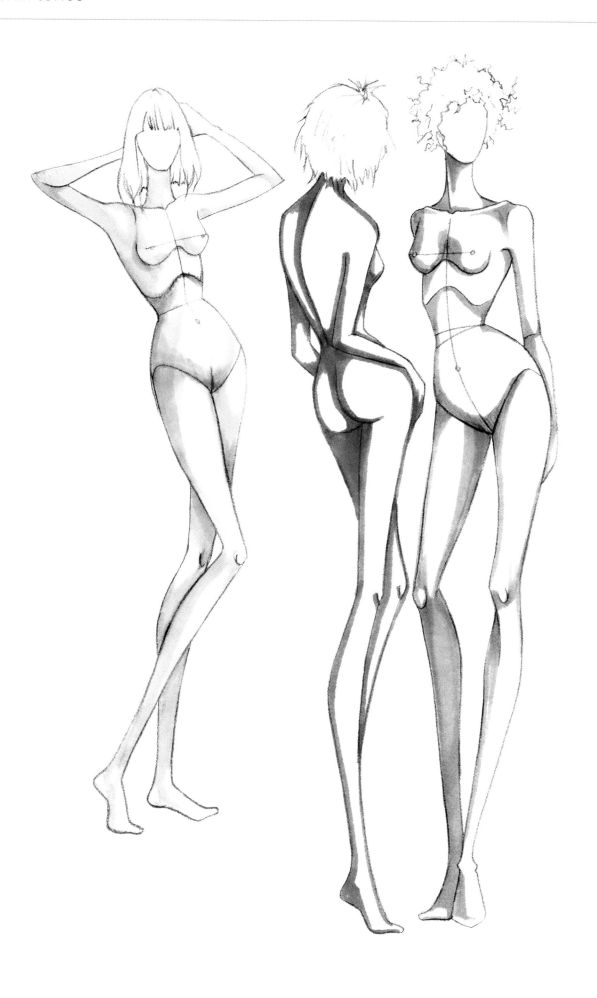

skin tone

darker skin tones

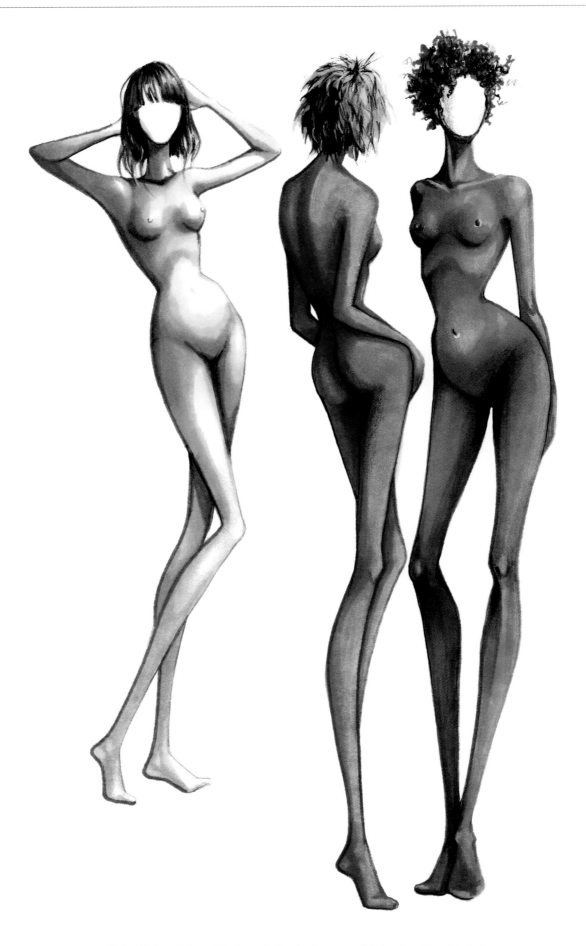

Darker Skin tones 3. Keep adding layers of color using the same or diluted versions of the original color to define the many tones and tints present on the skin. Richness and subtlety can be added to the skin by using olive or violet markers and lighter shades of colored pencil. Either the white of the paper can be left to show through as the highlights on the skin or color can be applied to the whole body and then highlights drawn on top with white pencil. The figure on the left has brighter highlights and is made of greys with three applications. Some darker-colored skins have a grey tint to them but as it is drawn here this is a fantasy color not representative of an actual skin tone.

face

drawing the face in color/shading the face/color choices

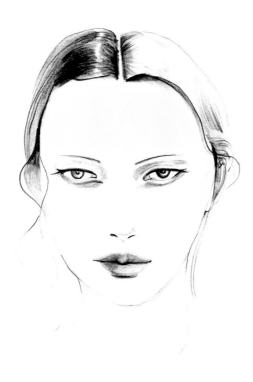

Blended rose and beige skin tone.

Dark skin tone face. Color is applied to define the features and planes of the face, giving a three-dimensional appearance. The face is filled in with walnut skin tone with further applications of color on the forehead and the left side of the face, and around the eyes.

Drawing the Face in color

Drawing the face, particularly when drawing it in color, requires a delicate touch and a sensitivity to the subtle, tiny shifts in the features that can result in dramatic changes in expression. In general the marker should be held close to the tip to exert a greater degree of control with shorter strokes. **It is easy to make mistakes when drawing the face, as it contains a large amount of information in a small area**: for example, an eye placed an eighth of an inch above the other will make the face appear hopelessly asymmetrical and distorted. Practice makes perfect, but if experiencing difficulty drawing the face, it is advisable to switch to colored pencil to draw the features, as it can be easily erased and corrected.

Keep in mind that all the main features of the face—the width of the eye, the length of thenose and the width of the mouth—are about the same size: a common error, for example, is to draw the mouth too low on the face; the mouth should be kept close to the nose, and as a result the face will look younger and more natural. The chin should always be included in the drawing—it is approximately the same size as the mouth!

Shading the Face

To draw the face realistically, to appear three-dimensional, it is necessary to show clearly the various planes of the face by indicating areas of light and shade. This can be achieved in two ways: the first involves defining the full range of values that make up the planes of the face, the second defines only the shaded areas of the face.

For the first method use a blended color to fill in the face in all areas except those where highlights usually appear, i.e., the bridge and tip of the nose, the cheekbones, the point of the chin and the line of the jaw. A second layer of color, slightly darker than the first, is then applied in the areas of the face that are in shadow: the eye sockets, along the side of the nose, under the nose, in the middle of the mouth, under the lips, along the side of the face and under the jaw-line. Blended color can be applied on the cheeks or along the side of the face to show reflected light and perhaps, particularly if a blended rose color is used, a healthy, vibrant skin (especially with children). When drawing the skin tones of darker-skinned races the highlights are applied afterwards using a white pencil.

With the second method of drawing the face naturalistically, the features of the face are first drawn in with a light-colored pencil and skin tone is applied only to the areas where shadows form, using blended color. Variations in value can be achieved by applying a second layer in areas where shadows are deeper.

Color Choices

Color choices can be used, of course, to represent natural skin colors, but they also are effective devices to create value contrast and dynamism in a drawing. As with the makeup used in fashion shows, license can also be taken when drawing fashion and colors chosen that are not naturalistic but dramatize and enhance the presentation of the garments.

The drawings on the previous and following pages show a wide range of skin colors and shading techniques, drawn on front view and three-quarter faces. The three-quarter face shows the planes of the face more dramatically so the dark and light areas can be clearly perceived.

face

drawing the face in color/skin tone colors

Pale skin tone, theatrical makeup, icy blonde hair.

Natural-look skin tone, freckles, simple auburn hair.

Simple shading with straight, brown hair.

Simple theatrical makeup with only partly-rendered wavy brown hair.

face

drawing the face in color/skin tone colors

Light application of beige marker leaving highlights on forehead, bridge of nose and chin.

Beige skin tone with subtle lavender shading at eye, bridge of nose, chin, under jaw and neck. This skin tone is suitable for combining with lightweight fabrics of warm hues.

Dark brown skin tone built up in three layers with white and lavender shading. This dark-race skin tone is suitable for combining with warm neutral or stark white fabrics.

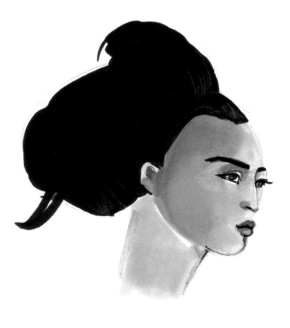

Blended walnut skin tone with second application around side of face. Suitable for a wide variety of lightweight fabrics with warm colors.

face

drawing the face in color/skin tone colors

Theatrical application of cool grey (10%) skin tone for high fashion.

Blended beige skin tone with blended rose around cheek bone. An excellent accent for any soft, lightweight fabric.

Blended beige skin tone leaving highlights on forehead and nose. Can be used in almost any application.

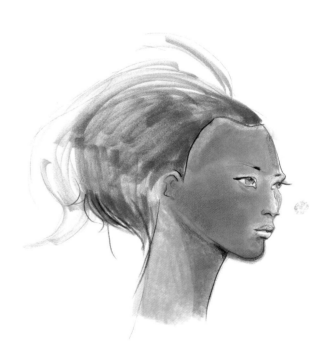

Blended brown applied over blended walnut. Excellent tone for a dramatic evening look for dark-race skin. White pencil is used to bring out highlights around the eyelid on the bridge of the nose, and on the lips.. Black pencil is used to define the eyebrows and eyeliner.

face

drawing the face in color/skin-tone colors

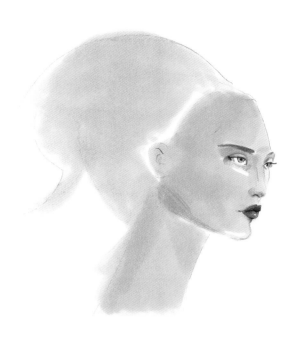

Peach skin-tone with highlights at jaw line and chin. This skin tone can be used with shiny fabrics: the contrast of values in the face echoes that which is present on shiny surfaces.

10% grey skin tone with blue highlights. This skin tone color will enhance any—but especially high fashion–cool-colored garments.

Blended blue colored pencil shading applied over 10% grey skin-tone. Excellent with cool-colored lightweight fabrics.

Blended beige skin tone with warm-brown and lavender-colored pencil shading and chartreuse shading at eye and chin. Can be used widely, especially where color is a dominant theme in the design.

face

drawing the face in color/skin tone colors

Blended walnut skin tone with second layer applied to increase contrast of value with the white of the cheekbone. Effective with shiny fabrics such as leather or velvet.

Single application of blended French grey leaving highlights at eye, cheekbone, nose and chin. Suitable for evening looks and soft lightweight fabrics.

Two applications of blended beige with highlight at cheekbone and blended brown colored pencil shading at eyesocket and around cheekbone. Excellent accent for Fall fabrics.

Dramatic makeup with strong contrast of values between skin tone, lips and eyes.

make-up

eyes/eye makeup

Dramatic tattooed eye-
brow for the catwalk.

Eyes and Make up

As in real life, make-up dramatizes the face and
adds accents to the clothing

When drawing eyes, note that they are always
lower on the inside and higher on the outside. The
line at the top of the eye represents the eyelashes
viewed from the front and is darker than the line
under the eye. Makeup is drawn in delicately with
either marker or blended marker depending on
how saturated the color of the makeup is. White
gel pen can be used to bring in reflections around
the eye–to the upper and lower lid, the iris, eye-
brow.

Grey marker used as a
halo around the eye has
a softening effect.

Sexy, sleepy eye with
extended mascara.

Warm color broadening
the eye gives it a more
sophisticated look.

Using grey in eyelid and
inner eye gives depth to
eye socket.Useful for
showing strong bone
structure.

Cool shadows add depth
to eyelid.

Warm, rose colors give a
healthy appearance.

Heavier use of rose col-
ors for more dramatic
effect.

Strong eyebrow and
eyeliner give dramatic
look for evening wear.

Warm and cool colors
–modern eye make-up.

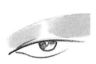

Shiny eye shadow shown
by leaving white area of
paper over the eyeball.

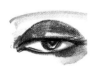

Fashionable smoky look.

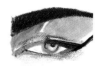

50's inspired make-up.

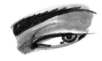

Eye shadow reflecting
an autumn or winter
palette.

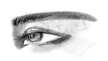

Grey shadow enhancing
natural eye color.

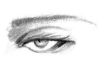

Adding color (here blue
pencil) to eyebrow and
around the eye gives a
dramatic effect.

make up

lips/lipstick

Lips and Lipstick

The base color of the lipstick is applied with blended marker and accents are added at the curve between the lips with colored pencils. Highlights are created in the center of the lips either by leaving the white of the paper unmarked or drawing in with white pencil (or, with dark lips, white gel pen).

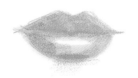
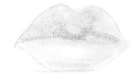

Soft colors.

Medium-intense colors.

Intense colors.

hair

exotic

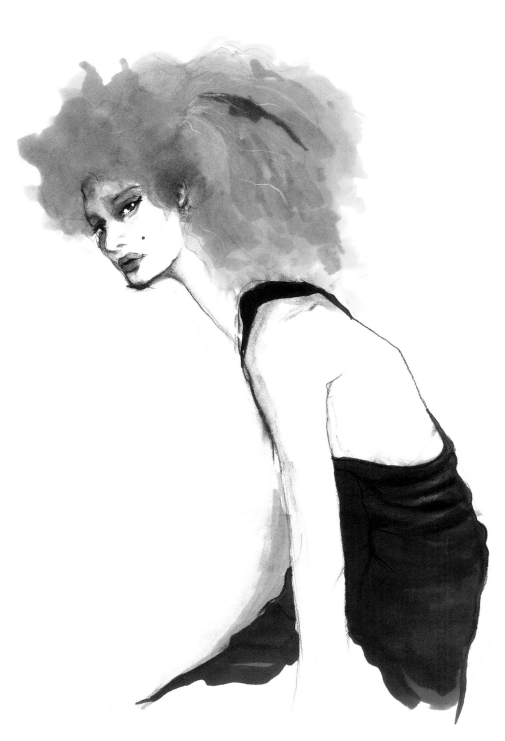

Hair

In fashion drawing hair frames the face, making it prettier, and accessorizes the garments. Hair can be treated in a number of ways, ranging from a natural look to highly artificial colors and shapes. Accessories can be added to the hair—bows, clips, tiaras, feathers, hair extensions for example—and hair styles on the runway have become wild and exuberant.

In drawing, the hair should be thought of as a series of shapes, sometimes simple, sometimes more complex. For beginners it is easiest to draw the outline of the hair and to fill it in with the desired color. The edges of the hair can then be broken up in a second easy step, using curved lines for wavy hair and straight lines for straight hair. Remember, hair frames the face, falling in at an angle towards the jaw-line. **It does not, unless you happen to closely resemble Cleopatra , end in a horizontal line**–the edges are always broken up and never horizontal.

In more advanced treatments of hair, to add depth and realism to the drawing, the more complex shapes that lie within the simple outline shapes each have to be identified and shaded from dark to light. Darker shadows often appear close to the face and under the chin, and hair further away from the face appears progressively lighter. It is best to avoid using too many lines to express hair: most of the detail should be added only at the outer edges of the silhouette so the drawing does not end up with the look of a bird's nest. Make sure the lines of the hair are parallel and drawn in the direction in which the hair falls. Use a photo of a face for reference and trace in the curve of the hair with a finger, for guidance. Note that with blonde hair, shadows appear darker than the shadows around red or dark hair as the value contrast is greater.

Highlights can be added to hair in one of two ways, either by allowing the white of the paper to show through the hair or by adding highlights with white pencil after the hair has been filled in. Light layers of color built up in the hair can give it a richness and beauty beyond a single application of color.

This **exotic hair style** is drawn by applying seven layers of blended color, starting with the lightest color, light beige. Blended light brown is added as a second layer close to the face and further layers added as accents.

hair

highlights/voluminous hair

Highlights. Step 1. Simple application of color allowing white of paper to show through for highlights. Marker is applied where the hairstyle originates at the crown and at the edges of the hair.

Highlights. Step 2. To complete, yellow and ochre are added over the first application.

Voluminous hair. Step 1. Outline the shape of the hair and indicate the direction of the styling with beige and pink marker.

Voluminous hair. Step 2. Fill in the hair with brown and orange marker to add depth and shading and finish off with violet and red pencil for nuance and detail.

hair

straight hair

Short, straight hair. Step 1. Outline hair and fill in with marker (here, orange, pink and beige). Indicate some shadow at the edge of the hair.

Short, straight hair. Step 2. Define shadows around the edge of face and sheen on side of hair with black and white pencil.

Long, straight hair. Step 1. Define shape of hair with beige marker, and break up with black pencil.

Long, straight hair. Step 2. Add shadows to interior of hair shape close to the skull.

hair

streaked/theatrical

Streaked hair. Step 1. For streaked hair first define shape with soft shading and add streaks with light-colored marker.

Streaked hair. Step 2. Fill in rest of hair with brown- and black–colored pencil.

Theatrical hair. Step 1. Define the direction with marker.

Theatrical hair. Step 2. Add additional layers of marker to give more saturated color and define shadows and highlights within the shapes of the hair using black- and white-colored pencils.

hair

curly

Curly hair. Step 1. Define shape of hair with light grey marker. Add lavender and black marker for shading. Leave the white of the paper to show through to indicate a broad highlight on the crown of the head.

Curly hair. Step 2. Darken the areas of the hair close to the face and on top of the head with black marker to increase the contrast with the white of the face and the white highlight of the hair, so accentuating the appearance of shine. Break up the edges of the hair with stippling strokes of the marker and indicate curls with half circles.

Long curly hair. Step 1. Define shape of hair with black marker and break up edges using a curled black line and thinner grey line.

Long curly hair. Step 2. Add white highlights and finish filling in the main body of the hair with black marker.

hair

straight with complex highlights/tousled look

Straight hair with complex highlights. Step 1. Draw outline of hair and fill in sheen and shadows with beige marker and brown pencil where the hair bends slightly away from the light.

Straight hair with complex highlights. Step 2. Add more brown marker and pencil for greater shading and depth.

Tousled-look hair. Step 1. Define swirl of hair using grey pencil. Add cream marker.

Tousled-look hair. Step 2. Add darker colored pencil close to eye level. Add more swirls with cream marker and make hair lighter at edges.

hair

black/blonde/braids

Black hair. Step 1. Define simple cap shape of hair closest to head with broad edge of a black marker. Break up hair into strands with medium tip of marker starting from the part of the hair at the crown and pulling lines around to neck, and again starting at jaw, moving away from the face.

Black hair. Step 2. Add further complexity to strands of hair and add white highlights with pencil.

Long blonde hair with pink highlights. Keep hair close to head until it reaches eye level, then open up to give volume. To show waves, turn wrist to both right and left. The interior of hair is defined with pink and brown shadows to add depth.

Braids. Braids are drawn with shapes like almonds or grapes using a light-colored marker. Fill in individual shapes from top and bottom using a beige marker and add layer of darker marker or blended colored pencil for more depth and shading at the points where the hair twists.

hair

wavy/curly/do not do's

Curly hair. Fill in the shape of the hair with beige marker using a scrubbing motion, allowing the individual strokes to show through to simulate the appearance of curly hair. Add a second application of brown marker and indicate ringlets at the edge of the hair with a twirling motion of the wrist. Colored pencil is used in some areas to show details of wisps of hair.

Do Not Do. Do not attempt to draw each strand of hair individually– it takes too long and usually ends in a mess.

Wavy hair in extended bun. Shadows fall in the waves and are darkest in the deepest recesses of the hair. Draw the silhouette of the hair so the line expresses the waves of the hair. Fill in the interior parts of the waves where the hair bends away from the light with blended color slightly darker than the main hair color.

Do Not Do. Do not randomly overlap the lines of the hair or it will begin to resemble a bird's nest.

hair

color alterations in photoshop

Experimenting with hair and make up color has become quite easy. A drawing is scanned and imported into Photoshop and the color varied.

hair

color alterations in photoshop

More variations in hair and make up color using Photoshop.

hair/skin tone/make up

putting it all together

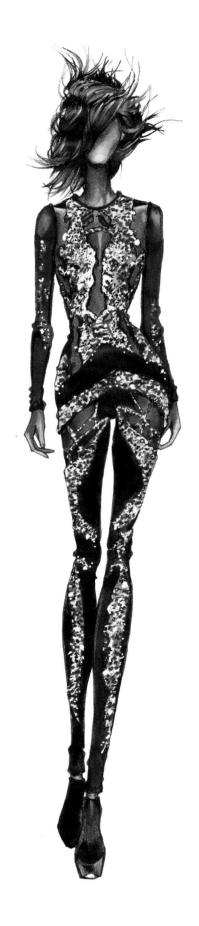

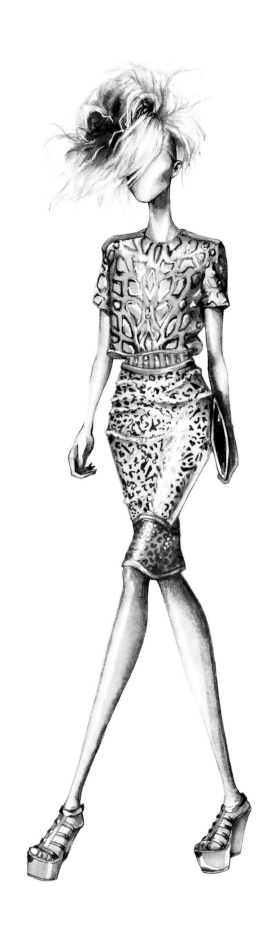

Putting it all together. The hair and the skin tones are designed specifically to emphasize the dramatic garments.

practice and exercises

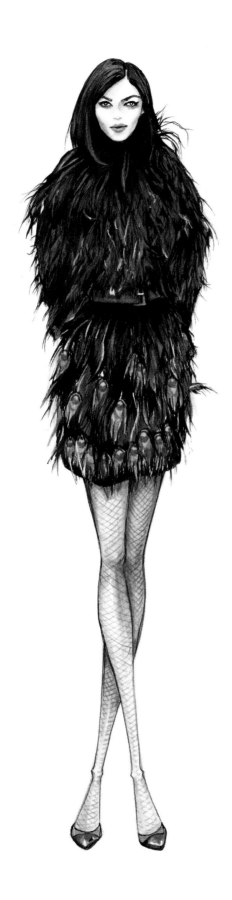

Beginners

1. Choose a croquis from the Chapter Three or Chapter Six and fill in completely with natural skin tone. Using a pencil add eye shadow.

2. Copy a face from this chapter. Fill in with lipstick.

3. Draw a simple front view croquis. Add skin tone to the face and body. Add the details of the face and hair using colored pencils.

4. (i) Draw a page of heads each with different make-up. (ii) Draw the same face ten times using different skin tones.

5. Draw a page of mouths with different lipsticks.

6. Using images from magazines or printing images from the internet of hairstyles you like, first trace them then copy them using markers.

7. Copy a face and hairstyle you like and change the color of the hair.

8. Copy a face and hairstyle you like and change the skintone, make up and hair color.

practice and exercises

Advanced

8 Draw a front view face. Add (i) curly hair,. (ii) straight hair; (iii) streaked hair,(iv) theatrical hair with artificial colors.

9. Draw a man with light skin tone. Draw the same man with dark skin tone.

10. Draw a three-quarter face with markers and colored pencils and create three types of skin tone representing different races.

11. Draw a made-up face for the following occasions: (i) a party, (ii) a dinner with the head of your company or school, (iii) a shopping trip

12. Draw a father and son or mother and daughter each with the same hair style.

13. Draw the same face with (i) natural lighting, (ii) theatrical lighting.

14. Draw a profile of a face with a hairstyle appropriate for a bride. Add hair ornaments or a veil.

15. Draw a three-quarter face with lighting from the left and then the same face lit from the light. Show how the shadows change on the hair and face.

16. Show a face with no make up; with make up for a job interview and with make up for an evening event.

beginning to draw/learning markers/short cuts

learning about fashion

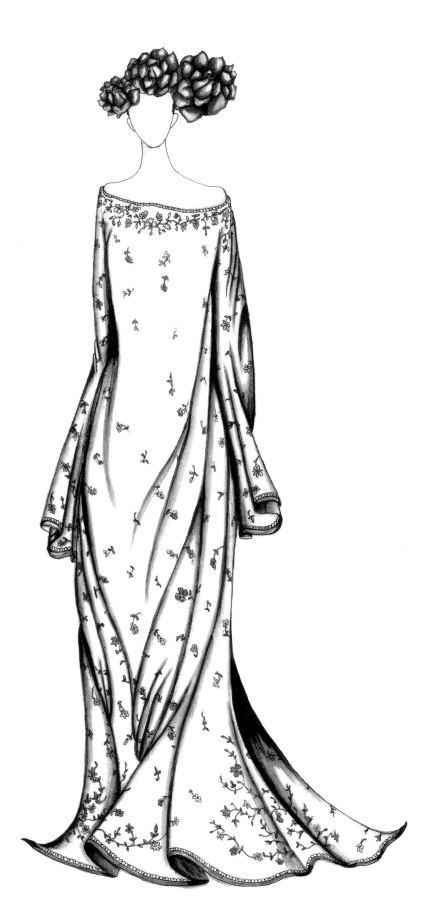

Beginning to draw/learning markers/ short cuts

This chapter is designed to be useful to more than one type of reader. **First,** as the title suggests, the chapter is principally for those who are new, or relatively new, to fashion drawing in color and who wish quickly to master both the basic concepts of the subject and the techniques for using colored markers. Acquiring these basic skills will create a strong foundation and allow readers to move on with confidence to the later chapters of the book that involve more advanced techniques.

Second, this chapter is designed for those who have some experience in drawing fashion, both line drawing and color, but whose experience with color is with watercolors or other media and not with colored markers. The techniques for using markers to draw fashion are not difficult but there are some significant differences in how they are applied when compared with other media. Reviewing this section as well as Chapter One: Materials and Technique, will allow the already-experienced reader quickly to attain competency in the new medium.

Third, the chapter is also relevant for those readers with more experience in fashion drawing, and who have quite possibly been using markers for some time but wish either to learn how to draw more quickly, or to improve the quality of work produced under conditions where time is limited (all too frequent in the fashion industry). In these situations, when a deadline is looming, often all that is required is a basic representation of a garment, one that can be fleshed out later if required. This basic representation should, however, be fully recognizable, accurate and attractive. Drawing quickly while making sure the drawing still meets those criteria involves developing the ability to identify the essential elements to be included in the drawing as well as those elements that are *not* essential and can be excluded. This process quickly becomes intuitive, but this chapter is designed to help to learn and speed up this process.

Those beginning to draw should keep in mind two points: first, that drawing with markers requires practice and study, like any other acquired skill, and the quality of the results depends, to a large extent, on the time and effort that is invested. Second, that fashion drawing is *technical* drawing, intended to convey detailed information about the appearance and construction of garments.

Fashion drawing is a wonderful instrument for expressing ideas about fashion, but those ideas are best expressed (and the resulting drawings will be most effective) if they are coherent, that the garments drawn "make sense" from a constructional point of view and that, if so desired, they could be actually fabricated from the drawings. Fashion drawing is a powerful *language* for communicating ideas about fashion, but, although it assists greatly in learning about fashion, it is important separately to build up a knowledge of fashion and garments so the ideas that are expressed are interesting and make sense from a fashion point of view. Knowledge of garments and their constructional

beginning to draw

four basic steps of fashion drawing

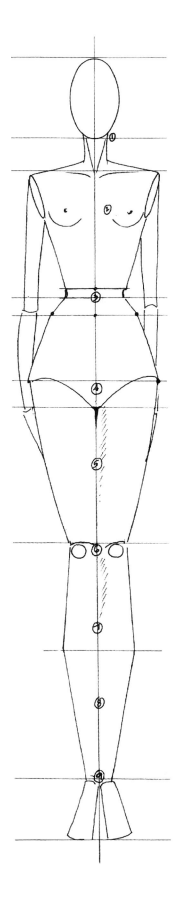

The nine-head croquis.

details—learning how fabric drapes and falls and about the properties of different fabrics—comes from continual observation and immersion in fashion and fashion images. To begin developing a deeper knowledge of fashion, take out favorite clothes from the closet and inspect closely how they are made; examine garments in the pages of fashion magazines and pull out the pictures that inspire most and keep them in a scrapbook. To be able to draw fashion well and to use it to design new garments it is necessary to build up a rich store of ideas about fashion itself so that the elements included in drawings have a basis in reality.

It must be stressed here that this is the chapter where most of the hard work is to be done; this is the chapter where basic skills are learned and developed and where, the more time and effort is invested, the more the results will be apparent. With practice, drawing will become quicker and more accurate, and with practice, drawings will become beautiful and will call attention to the ideas they contain. Drawing quickly becomes a source of pleasure and satisfaction. Hard work will bring abundant rewards!

Beginning to Draw: the Four Basic Steps

There are four basic steps that form the foundation of good fashion drawing. In order to develop the skills necessary to draw fashion well time should be devoted to developing proficiency in each of these steps. These four steps are as follows :

Step One: Understanding the proportions of the figure—the nine-head croquis.
Step Two: Learning to perceive and draw the basic shapes of garments—the silhouette.
Step Three: Showing the constructional details of garments.
Step Four: Shading.

Each of the drawings in this chapter is broken down into the different intermediate parts the four steps refer to. Sometimes more than one intermediate drawing relates to the same single step, for example when extra detailing requires more explanation. The reader can make practice drawings for each of the four steps by reviewing the corresponding break-down drawing and either copying it, using tracing paper, or using it as a reference to make a new drawing.

For beginners it is best to focus on each step in the drawings in turn and repeat each of them several times until satisfied with the result, and then to move on to the next step. This will not only give an understanding of the distinct steps involved in completing the final drawings but will also help develop the basic hand/eye coordination and detailed observational skills necessary for good fashion drawing. For those more experienced and interested in learning to draw more quickly, the series of drawings for the basic garment silhouettes of interest can be referred to for guidance on how to improve speed and accuracy.

four basic steps of fashion drawing

step one: proportions of the figure/step two: drawing the silhouette

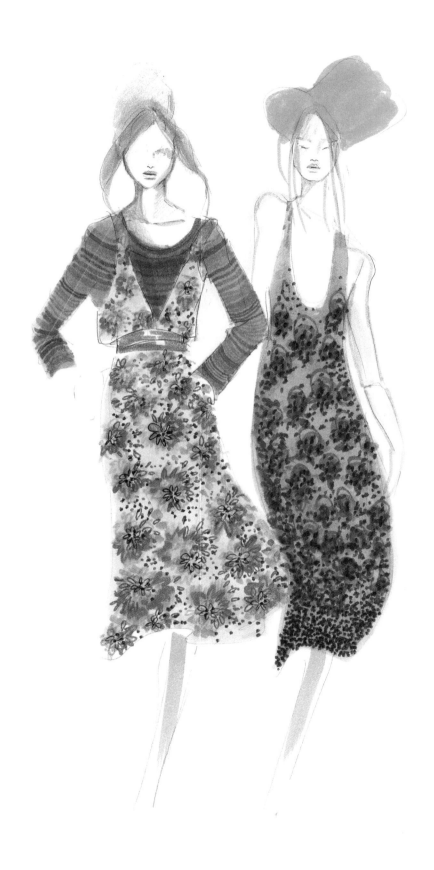

Step One: Understanding the proportions of the figure: the nine head croquis

When beginning to draw fashion figures the first step is to understand the structure of the figure and how its different parts fit together in a range of positions and poses.

The modern fashion figure is based on the nine-head croquis ("croquis" is the French word for "sketch") where the length of the figure is equivalent to the length of nine heads, and the relative proportions of the different parts of the body are also measured in relation to the length of the head. Once this basic structure of the figure is understood then almost any pose can be expressed with ease.

For beginners it is important to practice drawing different poses as much as time permits. If time is short then poses can be copied from the Appendix at the back of the book (tracing also aids the learning process) and used as the starting point for fashion drawing, but the aim should be to able to draw a croquis freehand as required Usually only four croquis have to be mastered in order to draw any type of garment, and if so wished these four croquis can be chosen from this chapter.

In the drawings in this chapter, and in a number of the more advanced drawings in later chapters, the underlying croquis is included for reference. The poses in this chapter are relatively simple and straightforward, but it should be noted that for poses where the figure is curved, rather than straight, the weight of the figure shifts from the center to one side of the body. For these poses "curve-of-the-body" lines have been included to show the "flow" of the pose.

Step Two: Learning to perceive and draw the basic shapes of garments— the silhouette

The next step in learning to draw is to develop the ability to perceive the basic shape of the outline of the garments, most commonly referred to as the "silhouette" of the garment (and also often referred to as the "edge" or "contours").

The ability to perceive the silhouette of an object correctly is the most important prerequisite of all types of drawing. Fashion drawing is the supreme example of this rule, as silhouette is the defining characteristic of practically every garment. Once the silhouette of the garment can be perceived correctly it is possible to start practising how to draw it on the croquis. Surprising as it may seem, for most garments the silhouette can be reduced to one or more simple geometric shapes—circles, triangles and/or rectangles, and thinking of the silhouette as composed of those shapes is often helpful in learning to perceive it clearly.

To begin learning how to draw the silhouette of garments on the figure it is often easiest to trace photographs or existing drawings of figures and garments. It is important to develop a sensitivity to

Silhouette. The silhouettes of these garments are easily identifiable from the drawing. The silhouettes are drawn so that hems, necklines and sleeves bend around the body so the garments appear three-dimensional and to actually fit the figure.

the four basic steps of fashion drawing

step three: constructional details

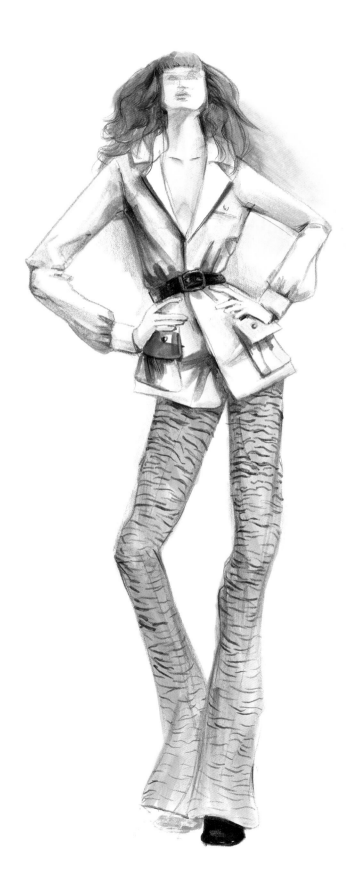

the details of the outlines of the garment, even to the extent of examing pictures of garments with a magnifying glass. For example, it is important to observe that fur forms round, wide shapes at the edge, as opposed to taffeta, which forms more angular contours, or that the silhouette of a loosely flowing dress appears distinctly different from that of a tailored suit.

It is also important to become sensitive to the way the different parts of the body and garments sit in relation to each other, the different planes and angles they form, and the shapes of the negative spaces (the space around the figure or between different parts of the figure) formed by those inter-related parts. An understanding this interaction between garment and figure is greatly assisted by drawing silhouettes of garments on the figure, and it is important to begin doing so from an early stage. Once the basic shape of a figure and garment can be drawn so that it is instantly recognizable and appears correctly proportioned then the most difficult part of learning to draw has been successfully accomplished; the other steps, though important, are relatively easy to master.

Each of the drawings in this chapter contains a break-down showing the silhouette of the garment or garments and how they fit with the croquis underneath. These should be studied at length and drawing the silhouette on the figure practiced as much as possible by making copies.

Step Three: Showing the constructional details of the garment

Once the structure of the body and the silhouette of the garment are understood and can be drawn competently—that point where, although the drawing might not be perfect, the type of garment, the basic drape of the silhouette and the correct relation between the figure underneath and the garment are instantly recognizable—then the next step is learning how to represent accurately the construction of the garment— where the seams lie, the placement of buttons, zippers, trims, darts, gathers and so on.

This step involves, first, at least a basic understanding of the construction of garments. For those who have never sewn a garment, insights into the construction of garments can be acquired, as already mentioned, through observation of fashion photographs and a close examination of the clothes in one's own closet.

Second, it is important to develop a sense of the correct placement of the constructional details of the garment when drawn on the croquis and how they appear in different poses of the figure as the position of the central axis of the figure shifts. Unless constructional details are correct the entire garment will appear awkward and confusing. Each of the drawings in this chapter includes a break-down that highlights the constructional and detailing elements of the garment.

Constructional details. In this drawing the constructional details of the garments are accurately drawn and positioned.

the four basic steps of fashion drawing

step four: shading/shading the unclothed figure

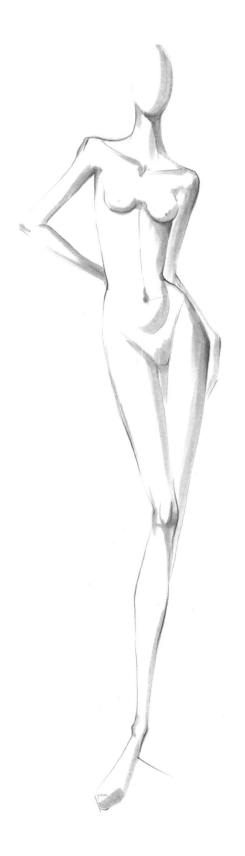

Step Four: Shading

The final step in drawing the fashion figure and garment is the application of shading. Shading is the depiction of shadow on the surface of a garment and the simultaneous depiction of light where shading is not present (generally speaking, areas that are closer to a light source will have no shadows and areas further away will appear darker and will be shaded). The accurate representation of light and shadow in a drawing is what makes a garment appear real and three-dimensional. Without a realistic application of shading, drawings will appear flat and two-dimensional.

At an advanced level shading techniques can be, if so desired, used to give near-photographic representation of the surface qualities of different fabrics, as is covered in Chapter Four: Fabrics. At this more elementary level, however, the focus is on learning the general rules for how to shade drape as fabric bends around and falls from the figure. These techniques are illustrated with reference to different garments of non-specified fabrics. Shading of different specific fabrics is not yet attempted in this chapter but features in detail in the next chapter, on women's fashion.

Each of the drawings in this chapter shows how basic shading is applied to figure and garments. Note that as a rule shading is added as a final step to accentuate the shape and surface appearance of the fabrics and to help differentiate separate garments where they are layered over each other. When working with lighter fabrics, however, it is quite common to make an initial outline application of marker to represent shading *before* applying the main colors of the garments: Adding the shading first indicates where the highlights will appear in the final drawing, and with light-colored garments highlights are shown by leaving the white of the paper unmarked. It is easier to tell where these highlights formed by unmarked paper will fall if the position of the darker, shaded, parts is known—if the main color of the garment is filled before indicating shading it is easy to apply erroneously over areas that should be left white.

Preparing to Draw

Before beginning to draw a number of preparatory tasks should be performed. These are listed on page 26 in Chapter One.

Shading. The drawing shows where shading is applied to indicate where shadows form on the unclothed figure, here lit from center-left.

the four basic steps of fashion drawing

step four: shading/shading the clothed figure

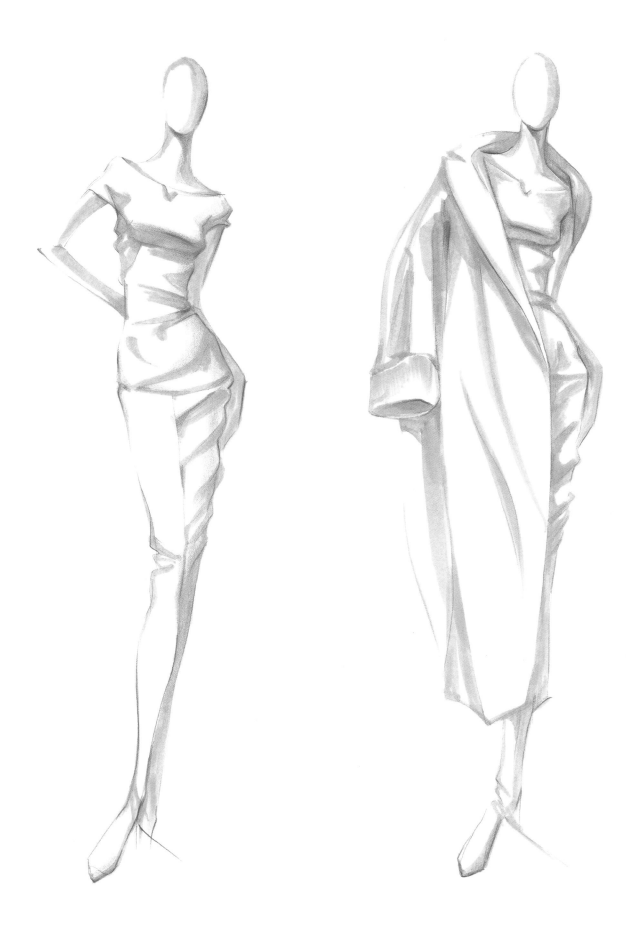

Shading. The drawings show where shading is applied to indicate where shadows form on the clothed figure.

beginning to draw

jacket/skirt separates

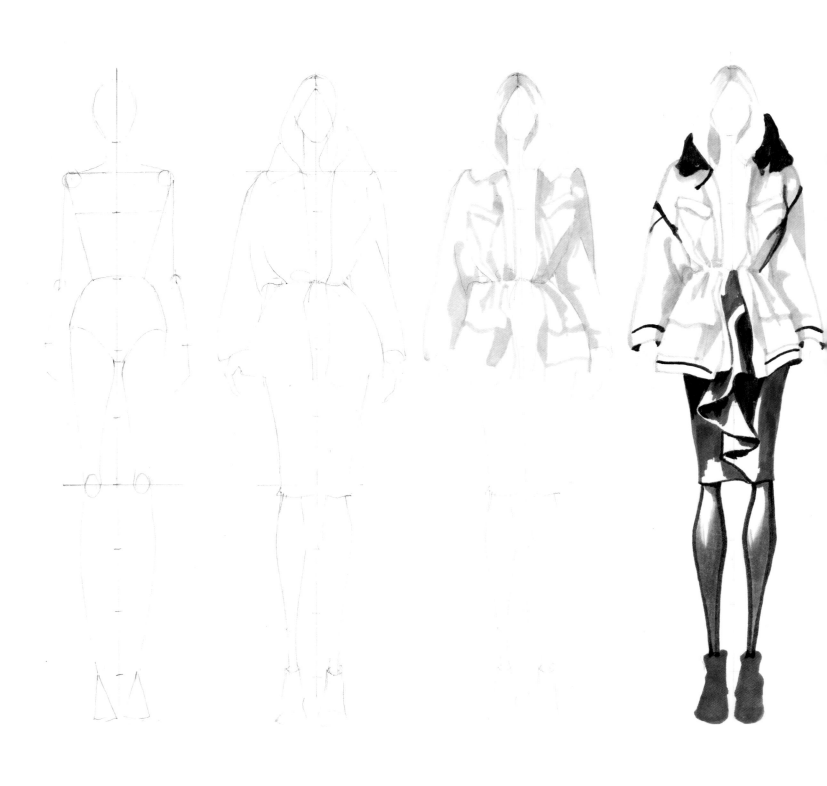

Step 1. Draw the croquis. A front view croquis is the easiest to draw of the different views and beginning symmetrical–each side of the vertical axis line is identical– it is also the best to use when showing a garment with symmetrical details. Draw in the croquis with a light touch using a sharp pointed pencil: we do not want the figure to be heavily outlined or show through under the garment. At this point the arms and lower legs can be drawn as single lines–often the garment will cover the arms and lower legs and they do not have to be drawn in.

Step 2. Draw in the silhouette of the figure and the outfit. Note that this jacket has bulk and thickness in the body and sleeves; the shoulder line is rounded and wide (typical of a dropped shoulder seam); the collar extends above the shoulder line and around the back of the neck and the jacket flares out at the hem. The tight skirt contrasts with the jacket giving a chic appearance to the overall outfit. Draw in the hair with a simple shape hugging the head to eye level then spreading out, reflecting the shape of the jacket. Finish the legs, adding simple, fashionable shoes.

Step 3. Add shading to the jacket. It is sometimes useful to add shadows before the base color of the garment because it develops the habit of drawing garments to appear three-dimensional, though this is not essential and it is equally effective to work from light to dark. The size and shape of the shadows depends on the type and thickness of the fabric (see the discussion in Chapter Three on shading different fabrics). Working from top to bottom, the lapel casts a wide shadow that extends across parts of the chest; the gathers at the waist have shadows extending both up and down; shadows extend around the patch pocket. The arms can be viewed as cylinders and have shadows at the sides.

Step 4. Here the darker colors of the skirt are added first. The base color of the skirt is filled in and then the deep shadows at the side of the skirt and in the deepest parts of the cascading ruffle. The collar of the jacket and trim is also filled in with black. The tights are filled in with grey marker leaving white areas for the lighter areas that catch the light. The shoes are also filled in.

beginning to draw

jacket/skirt separates

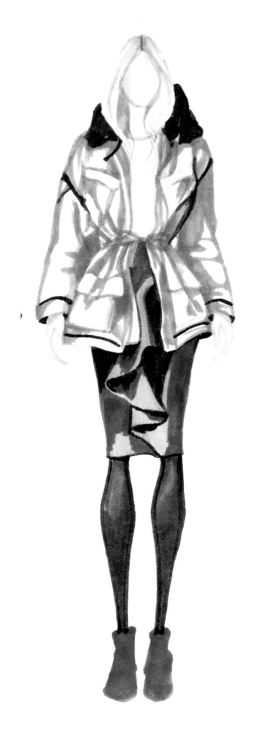 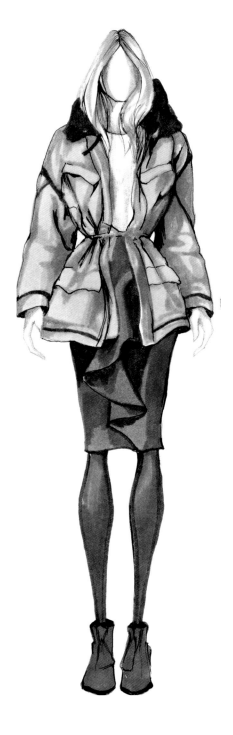 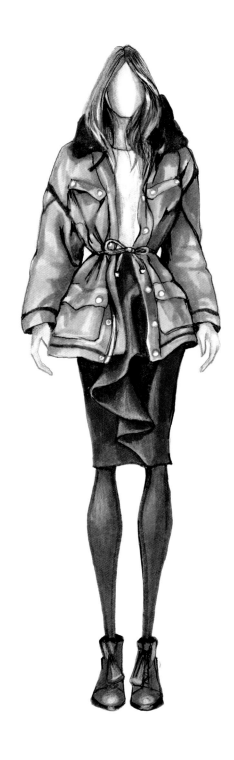

Step 5. Another layer of shadows is applied to the jacket using a medium value brown. A lighter grey is applied to the lighter areas of the tights.

Step 6. The base color of the jacket is applied. Because it is lighter than the shadow applied in the previous application -it can be applied from the reverse side of the paper without obscuring the shadow. Use blue pencil over the grey of the skirt in the lighter areas so it matches the rest of the skirt. Add detail to shoes and jacket with a thin black marker. Add a little grey marker to show the shadows in the top.

Step 7. To finish off the drawing, add white pencil for the snaps, on the tops of the folds and the toes of the shoes. Draw the details of the belt, shoes and snaps with a black micron .005 pen.

beginning to draw

tailored jacket/denim pants

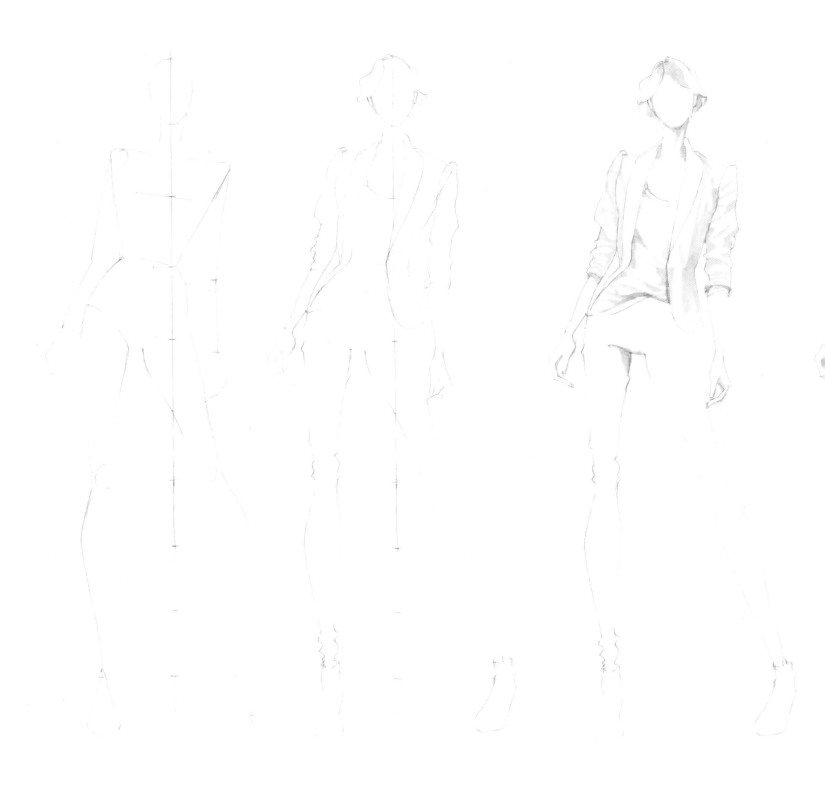

Step 1. Tailored jackets are staples of women's wardrobes. Draw the croquis. This S-curve pose with legs open was chosen because it helps show the shape of the pants and also gives the outfit a youthful appearance.

Step 2. Draw in the silhouette. The back of the collar extends around the back of the neck above the shoulder line. The shoulders are square and the caps of the sleeves are clearly drawn. Note that the sleeves have a large amount of drape as they have been pushed back to the elbow, compressing the fabric. The pants are tight but still show drape at the knee and ankle. The tee-shirt is drawn so that part of the hem is tucked into the pant top.

Step 3. The base color of the jacket is applied in the 'valleys' around the folds which are shown by leaving the white of the paper unmarked and on the flat front panels of the garment as they recede away from the light. In the tee-shirt the shadows are a cool grey.

beginning to draw

tailored jacket/denim pants

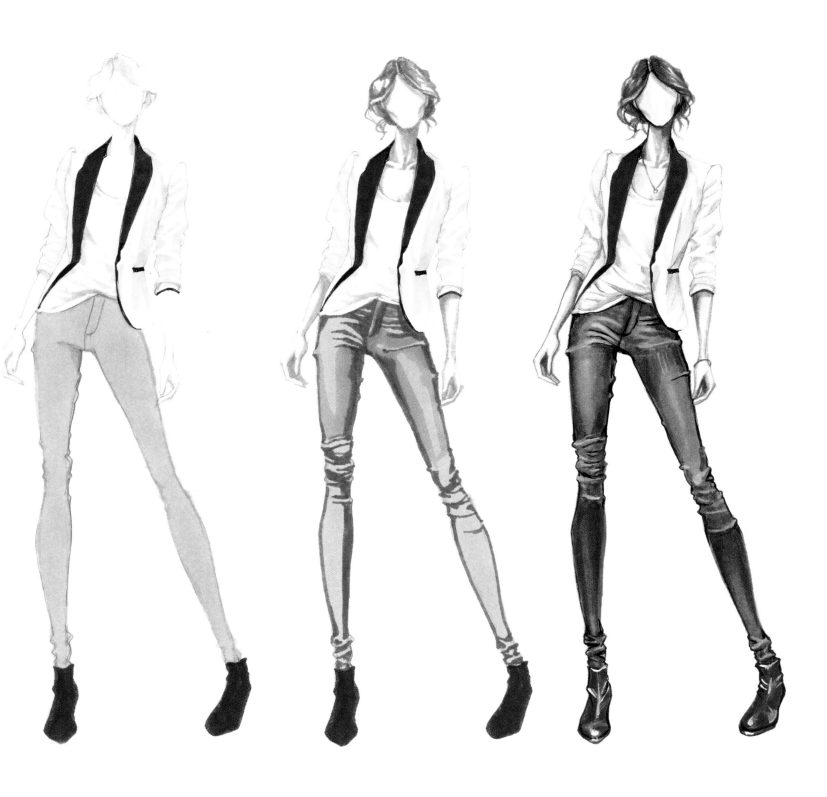

Step 4. Fill in the pants with a light blue marker and the lapel, trim and shoes with black marker.

Step 5. Make a first application of shadows using a diluted navy blue marker to the pants. Add the skin tone and hair.

Step 6. Add more diluted navy blue marker to the legs, black pencil on the deepest shadows and white pencil on the high areas of the folds and the core light running down the front of the thighs. Use white pencil also on the highlights of the shoes. Use another coat of grey to the shadows of the tee-shirt and jacket. Define the bracelet and necklace with a black Micron .005 pen.

beginning to draw

jean jacket/camisole/shorts separates

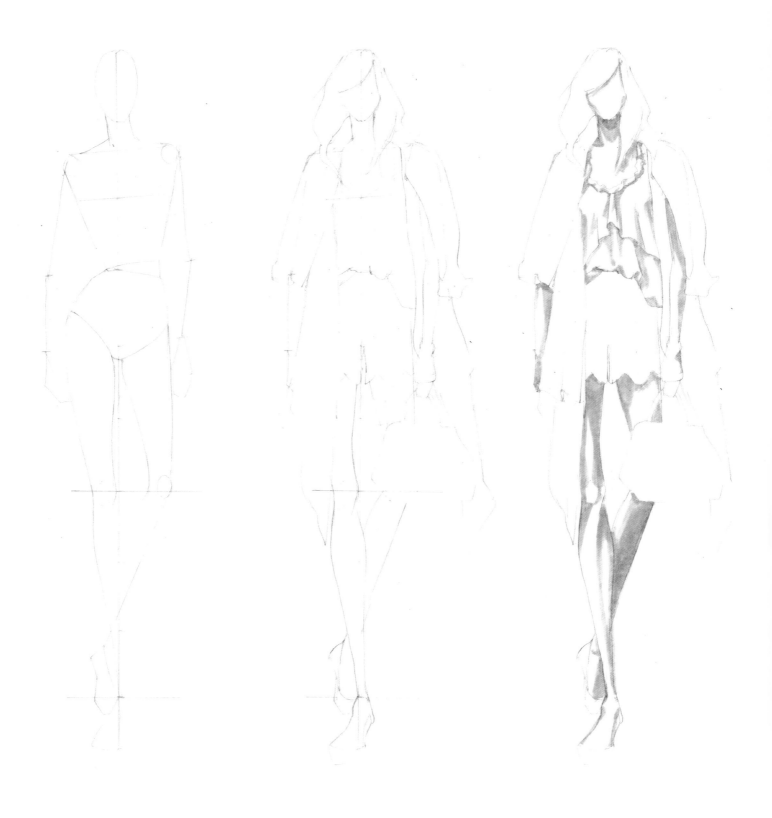

Step 1. Draw the croquis. This is an S-curve croquis with shoulder down and hip up on the left side. This pose accentuates the drape of the camisole and shorts.

Step 2. Draw in the silhouette of the garments, bag, shoes and hair. The shape of the hair is chosen to reflect the shapes of the garments in the outfit: a casual look with scalloped edges. These are layered separates and each layer has to be clearly defined so the garments can be clearly understood.

Step 3. Begin to add shadows to the camisole, the most draped and the interior garment of the outfit. A light walnut marker is used. The shadows fill in the drape that forms around the bustline. The bust itself catches the light and is left as the unmarked white of the paper. The skin is mostly in the shadow of the garments of the outfit; the chin also casts a shadow. The shadows on the skin are filled in, here using the same color as the shading of the camisole.

beginning to draw

jean jacket/camisole/shorts separates

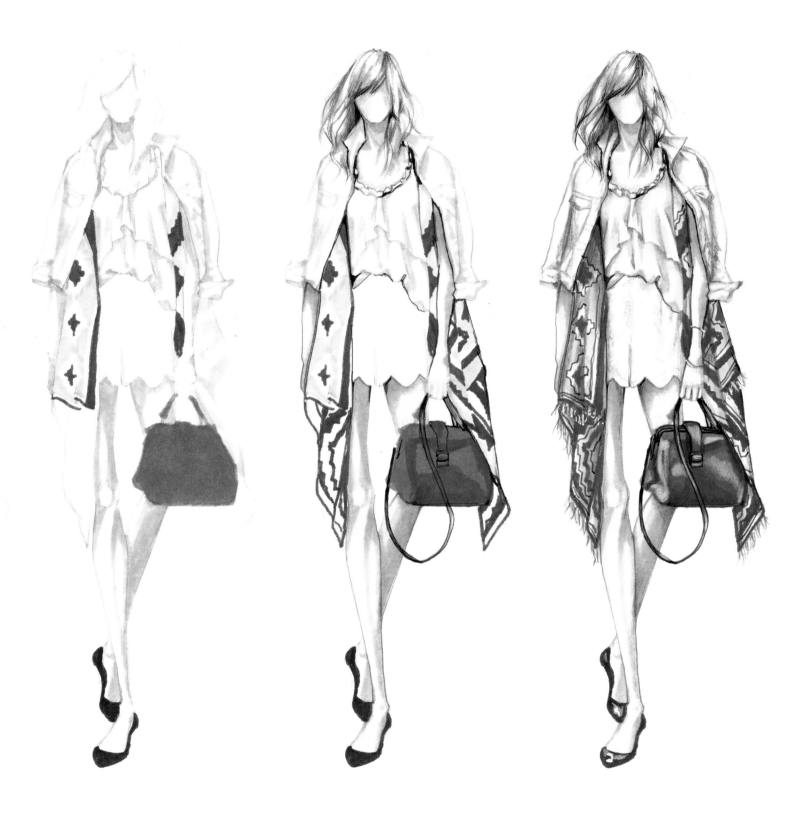

Step 4. The base colors of the purse, jacket and scarf are filled in with markers. Begin to draw in the pattern of the scarf with marker. Color the flat shoes with black marker.

Step 5. Complete the pattern of the scarf; make sure the pattern bends with the curve of the scarf. Make a second application of the same brown marker to the purse and fill in those details as well as the scalloped hem of the skirt and the necklace with a Micron .005 black pen. Fill in the hair with grey marker.

Step 6. Complete the pattern of the scarf with the fine point of a burgundy marker or colored pencil. Add fringe using a blue marker. When dry add grey shadow to all parts of the garments and outline the pattern of the lace. Add detail to the shoes with grey colored pencil.

beginning to draw

little black dress

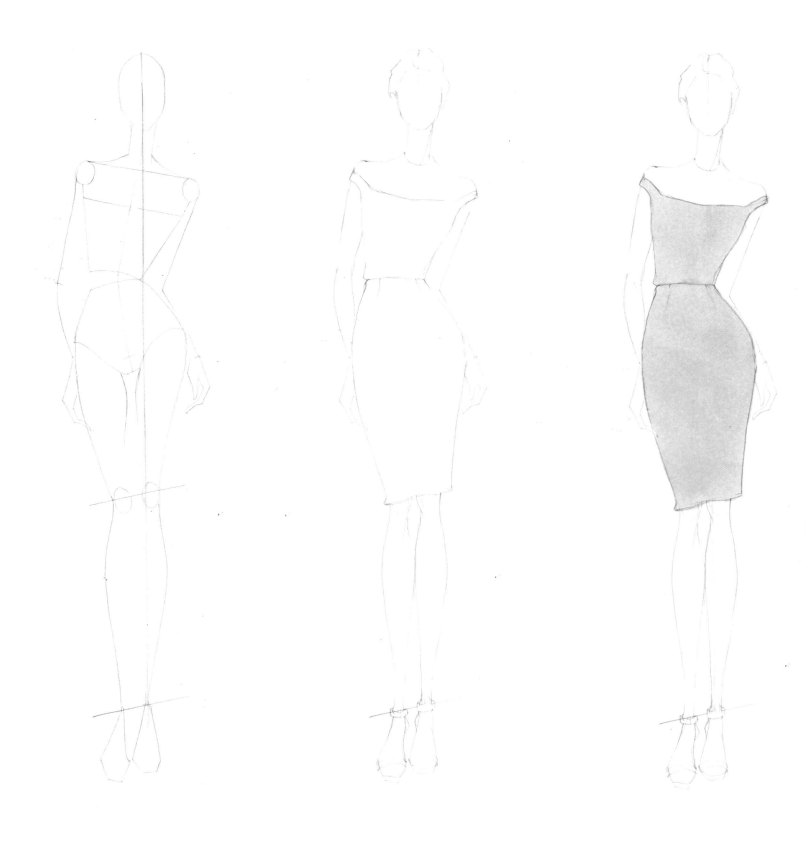

Step 1. Draw the croquis.
Front view croquis is drawn with weight on right side of figure, forcing the right hip up and right shoulder down. The garment has a slim silhouette so a croquis is chosen with the legs together so the slim profile will be maintained.

Step 2. Draw in the silhouette of the dress paying close attention to make sure the curve of the neckline bends all the way up to the back of the neck, the sleeves bend all the way to the edge of the arms and the hem tilts up to the right in the direction of the raised hip. (DO NOT DO: It is a common mistake to draw the hem horizontally even though the hip is up and lifts the hem in that direction). Draw in the outline of the hair and the shoes. The hair is simple and chic.

Step 3. Fill in the body of the dress with a first application of warm grey. This is going to form the highlights on the dress. Working from light to dark means that the darker parts of the dress can subsequently be drawn over the lighter grey–if done the other way round it is difficult to cover dark areas with lighter colors.

beginning to draw

little black dress

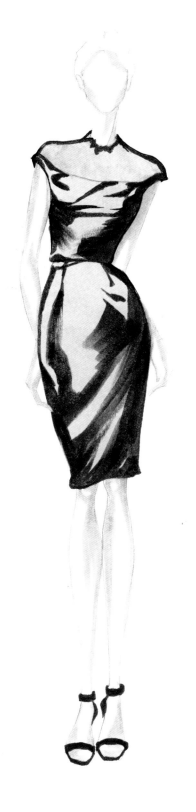

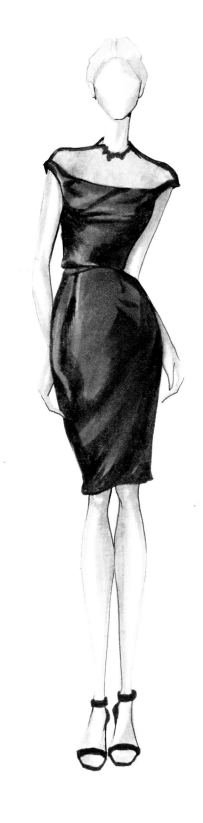

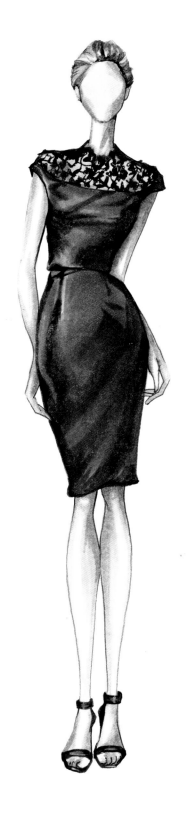

ep 4. Add the main color of this little black dress with
ndiluted black marker over the lighter grey first applica-
on. Use the same black marker for the trim at the neck-
ne and the shoes. The black parts of the dress are the
arker parts, the grey are the lighter parts. The folds
xtend from the right hip to the left knee and the warm
ey background is left to show through. There is also a
ore light running down the front of the dress from the
aist to mid-thigh. There are also a few folds at the bust-
ne from the pull of the tension point at the right shoulder.
dd skintone.

Step 5. Add a darker grey on top of the highlights to cre-
ate the effect of a soft sheen. Complete the skin tone with
a second application of beige marker and make a base
application for the hair with a light cream marker.

Step 6. Carefully draw in the pattern of the lace with the
fine point of a black marker. Add more shadows to the hair
and complete with a .005 pen.

beginning to draw

soft wool coat

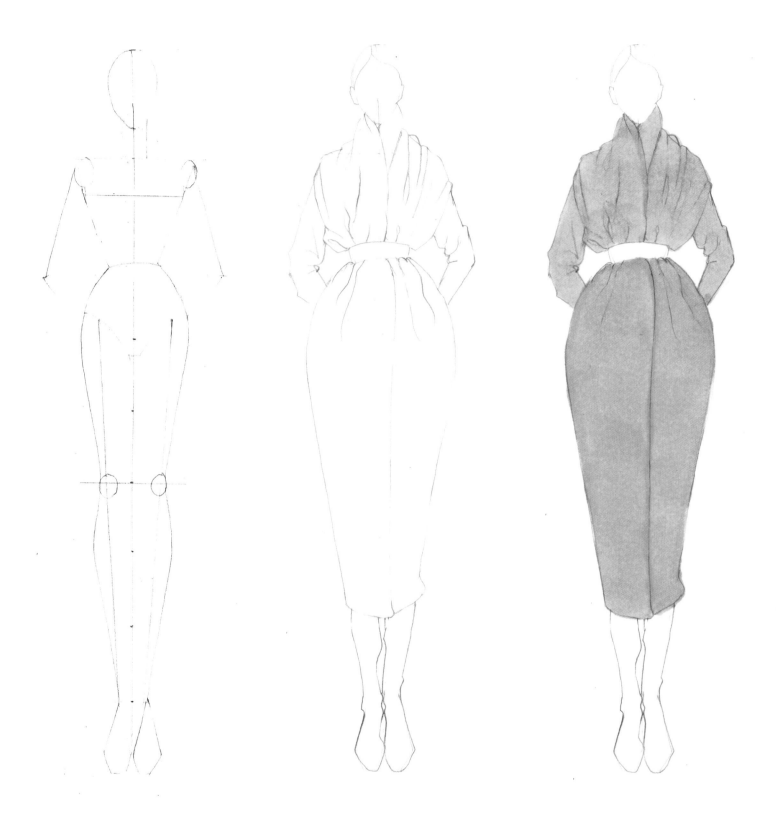

Step 1. Draw the croquis. A front view croquis is selected with the hands at the side in the pockets. This pose pulls the shoulders back and by moving the arms away from the body allows the silhouette at the sides of the garment to be more clearly visible.

Step 2. Draw in the silhouette of the coat showing multiple rounded folds at the raised neckline, curving around the shoulders, extending up and down from the belted waist and around the elbows. Note that the belt is cinched quite tightly to emphasize the chic silhouette. Draw in the simple hair and the boots.

Step 3. Add the base color of the garment.

beginning to draw

soft wool coat

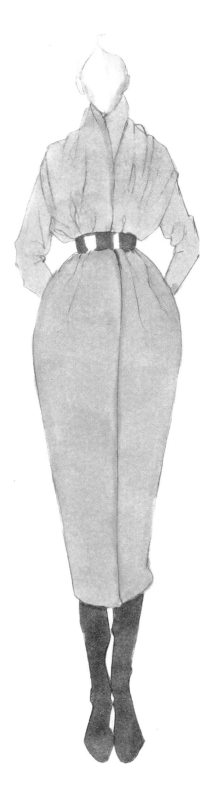
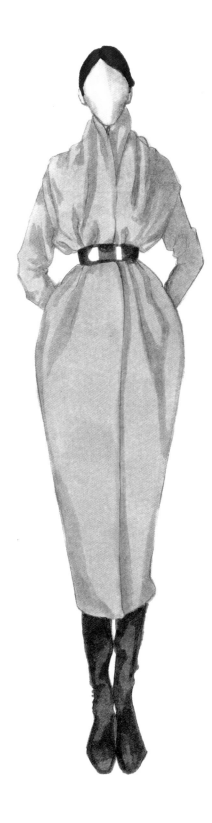
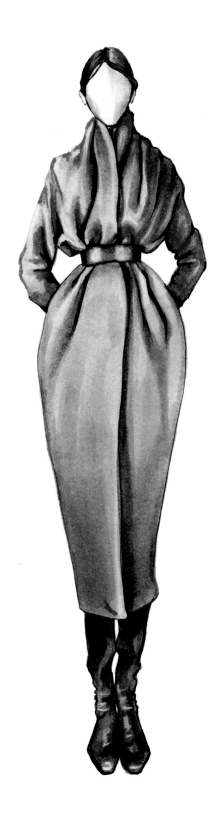

Step 4. Fill in the boots. The boots are a matt leather with little shine so it is not necessary to leave unmarked white on them. Fill in the belt. The belt has more shine so white is left where highlights will appear. Shading is applied to the right side of the face which will be in shadow.

Step 5. Add more shadows to the coat using a second application of the same color. The shadows are applied to the valleys on either side of each fold–the raised part of the fold in the middle is left a lighter color. Shad in the hair and make a second application of brown on the shoes. Fill in the left side of the face closest to the light source with a lighter skin tone color.

Step 6. The deepest shadows of the garment are drawn in by making a third application of the same color. Add a little black to the hair and shoes for deeper shadows and a little grey pencil to show highlights on the belt and shoes.

beginning to draw

practice and exercises

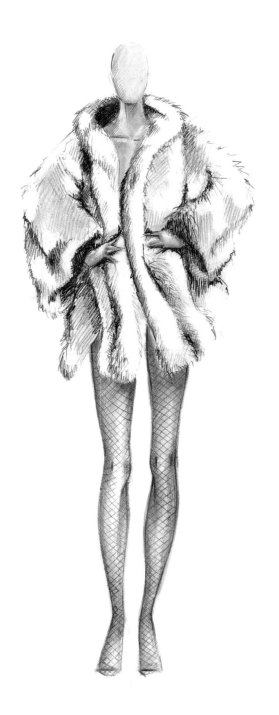

Beginners

1. Take any of the series of drawings of basic garments and copy every drawing in the series using black, white and greys rather than colored markers.

2. Repeat exercise 1. in color.

3. Draw a croquis, front view. Add the silhouette of a blouse and skirt. Fill in with blended color and shade in the folds of the drape. Take the same croquis with the silhouette of the blouse but replace the silhouette of the skirt with pants.

4. Draw a croquis. Add the silhouette of a coat and dress. Add a floral pattern to the coat and a plaid to the dress.

5. Draw the croquis and silhouette of each outfit in the chapter.

6. Draw a pleated skirt with a lace trim.

7. Draw a leather jacket with a satin trim.

8. Draw a jacket with a print—it can be floral, geometric, ethnic, plaid or some other—and add sequin detailing at the collar, cuffs or spread over the garment.

9. Draw a striped blouse and pants. Make sure the stripes follow the curves of the body underneath.

10. Draw (i) a jacket made of lightweight fabric such as wool challis or silk,. (ii) a coat using a medium to heavy-weight fabric such as leather or corduroy.

11. Draw three garments made from transparent fabrics.

12. Draw white t-shirts of different styles—sleeveless, long-sleeved and so on—and add graphic images to each.

beginning to draw

practice and exercises

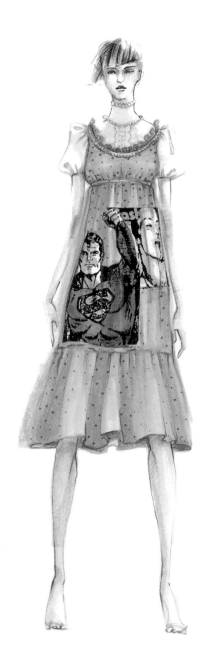

Advanced

13. Copy any of the final outfits in this chapter changing the colors.

14. Copy any of the final outfits changing accessories.

15. Copy two of the finished drawings in this chapter, changing the color of the fabrics.

16. Copy the croquis with the fur on the opposite page and add (i) a straight skirt, (ii) ankle-length pants and (iii) a chiffon full skirt.

17. Copy the figure on this page and change the color.

18. Draw a six-layered skirt using a different print pattern on each layer.

19. Draw two evening gowns, the first made of silk, the second of velvet (refer to the chapter on fabrics for how to draw silk and velvet).

20. Draw a group of three croquis with one of the croquis wearing one of the garments from this chapter and the other two with variations of the same garment. Make the figures overlap at at least one point.

21. Draw a croquis wearing a blouse, skirt and jacket and accessorize using the drawings of accessories in this chapter as references.

22. Take one of the figures in this book, changing it slightly to personalize it, and draw it in twenty minutes.

CHAPTER SIX

WOMEN'S FASHION

drawing women's fashion

Drawing Women's Fashion

"The last decade of womenswear is totally different to fashion of the past and yet it is the same. The same, because it remains a true reflection of the society that wears it. And because that society is undergoing tremendous change, fashion also is changing.

The impact of he internet and social networking has shaken the very infracture of the fashion systems. Bricks-and-mortar stores are no longer the kingpins of retailing. Established designers are racing to rein-vent themselves and their businesses to catch up to the young techno-savvy stylists. The advent of fast fashion with its quick turn-round and adoption of trends has spelled the end of traditional seasonal shifts in silhouette, textiles and color. Now all the components of fashion are subject to instantaneous communication.

Textile technology, 3-D printing and robotic innova-tions will be the driving forces of fashion in the decade to come, making obsolete the traditional systems of fashion design, manufacturing and distri-bution. A diverse global society, and therefore, all fashion consumers, faces the challenge of coping with rapid-fire change in their worlds. Therefore fashion is subject to constant reinterpretation in order to keep up with shifting interests and attitudes."

David Wolfe, Creative Director, Doneger Group

This accelerated process of change in all aspects of fashion, as highlighted above, makes the need to be able to communicate fashion ideas quickly and accurately all the more important. Quick adoption of trends and shorter turn-round times means narrow-er margins for error at all stages: communication of designs must be efficient and accurate; images can no longer be trite and clichéd, they must be clear and unambiguous and highly informative. In this chapter we show how the elements covered in the preceding chapters are brought together in order to create design drawings that fill those criteria.

Chapters Two, Three and Four covered the princi-ples of design and color theory as they relate to fashion drawing, along with the techniques required for drawing different types of fabric, skin tone, the face and hair. Chapter Five: Beginning to Draw explained the processes for making three-dimen-sionally realistic drawings of basic garments quickly and easily. The level of drawing shown in that chap-ter will be sufficient for most cases where a fashion drawing is required. Those drawings do not, howev-er, contain a high degree of detailing, and as our design evolve we will often wish to draw garments that are in some way or other highly detailed. . In this chapter, then, we arrive at the point where all the elements of the first four chapters are drawn upon in order to produce advanced drawings of a wide range of garments constructed of all types of fabrics and often with highly complex detailing. The fashion drawings shown in this chapter are exam-ples of advanced fashion drawing, drawing that ful-fills the criteria for accuracy and clarity discussed above. They are intended to serve as models for the standards to which drawings intended for inclusion in portfolios, for design presentations or for advertis-ing or editorial purposes should aspire.

In this chapter and the two that follow—Men's Fashion and Children's Fashion— all the information needed for the reader to be able to reproduce the final drawings of different garments made of differ-ent fabrics is provided. Responding to feedback from students of fashion drawing, all the drawings are presented in easy-to-follow progressive step-by-step forms.

The drawings are accompanied, in most cases, by a detailed textual description of the drawing process, indicating also materials and techniques used and-compositional and technical fashion considerations. The visual representations and textual descriptions are intended to complement and reinforce each other in order to achieve as clear and full an expla-nation as possible of how to execute the drawing and drawings of similar garments or similar fabrics. Different people learn to draw in different ways: while some learn almost completely from visual cues, others require the reinforcement of a clear tex-tual explanation, and yet others depend largely on the text. Studying and copying the drawings, or using them as starting points for new designs, will serve as excellent practice, helping to absorb the information they contain and aiding the learning process.

The main differences between the drawings in this chapter and those of the earlier chapters are that here more shading is used, more layers of color are applied (resulting in the appearance of greater depth and wider range of colors) and the clothes themselves are more complex and with more design details. If, even after studying the text and drawing break-downs, difficulty in understanding part of an explanation is still encountered, whether it is for a croquis, silhouette, application of color, shading, skin tone or hair, reference should be made to the corresponding sections in the Beginning to Draw chapter and the earlier chapters dedicated to those topics. The tasks to be completed before start-ing a drawing are listed in Chapter One: Materials and Technique and are the same for all drawings. If doubts arise about rendering the face or figure, or basic fashion details, or memory in a particular area needs to be refreshed then reference can also be made to *9 Heads–a guide to drawing fashion*.

The drawings in this chapter are designed to help develop skills to an advanced level. They range in difficulty from an intermediate to an advanced level. Many of the drawings will appear complicated and sometimes daunting to those relatively new to the field, but in fact they are all based on the techniques explained in the earlier chapters of this book: no technique is used that has not already been explained elsewhere. Once the drawings are stud-ied in conjunction with the explanations of how they are made they will soon become clear and appear less complicated.

drawing women's fashion

time constraints/organization of the chapter/useful tips

Drawing under time constraints

Very often, as has been discussed, in real life situations in fashion design time constraints will not allow for drawings to be made that are as complex as many of those included here. The best preparation for being able to draw well when working under strict time constraints, however, is to learn to draw to a higher level than will normally be required. If one learns to draw well then the shortcuts and simplifications that have to be made when drawing under time pressure will come quickly and naturally. This chapter provides the elements necessary for learning to draw fashion garments to the level of the drawings provided as examples, and with the right motivation, practice and application almost anyone can learn to draw to these standards.

How this chapter is organized

This chapter is divided into sections corresponding to garments made of different categories of fabrics and materials, either specific fabrics or materials, such as denim, lace or leather, or types such as black and white or shiny. The reason for this ordering is that one of the key elements in successful, advanced fashion drawing is being able to render garments in different fabrics and materials to a degree of realism such that the fabric/material is immediately identifiable (this is unfortunately frequently overlooked in courses and textbooks with the result that it is often difficult to tell from a drawing what fabric a garment is made from). As has been consistently emphasized in the preceding chapters, **fabric is always one of the major defining features and often *the* defining feature of a garment. Capturing the way a fabric looks when made into a garment: the drape, the texture, thickness, the way it holds its shape and the surface appearance are vital parts of a drawing. This is usually more difficult to execute than the drawing of the silhouette and details but is necessary if the drawing is to be successful.**

Each fabric section contains a cross-section of garments, ranging from simple to elaborate, with a wide variety of shapes and textures.The drawings parallel the garments in their range of complexity and difficulty, though it is not always the case that the most complex garments are the most difficult to draw, and vice-versa.

A separate section on accessories has been included as these (as they always have) play a vital role in women's fashion and continue to grow in relative importance.

Useful tips for drawing complex garments

Two tips that will often prove useful when drawing complex women's garments. First, when considering how a garment should be shaded—an important part of what makes a garment look realistic and three-dimensional—always remember that the silhouette itself, if drawn correctly, contains key information about how to shade. How the fabric of the garment drapes and where it bends—usually at the elbows, knees, armholes, bust, waist and crotch—give clear pointers as to where shadows will appear and shading should be applied. Second, when a drawing is complex and contains a number of spread-out and differing elements, such as when an outfit is made up of several layered garments, the composition can be unified by introducing a single, subtle color in different areas. Using a blended version of one of the principal colors from the garments and applying it to the hair and skin tone as a reflected color can be an effective way of doing this.

garments on the figure step-by-step

denim/fine lace appliquéed on denim

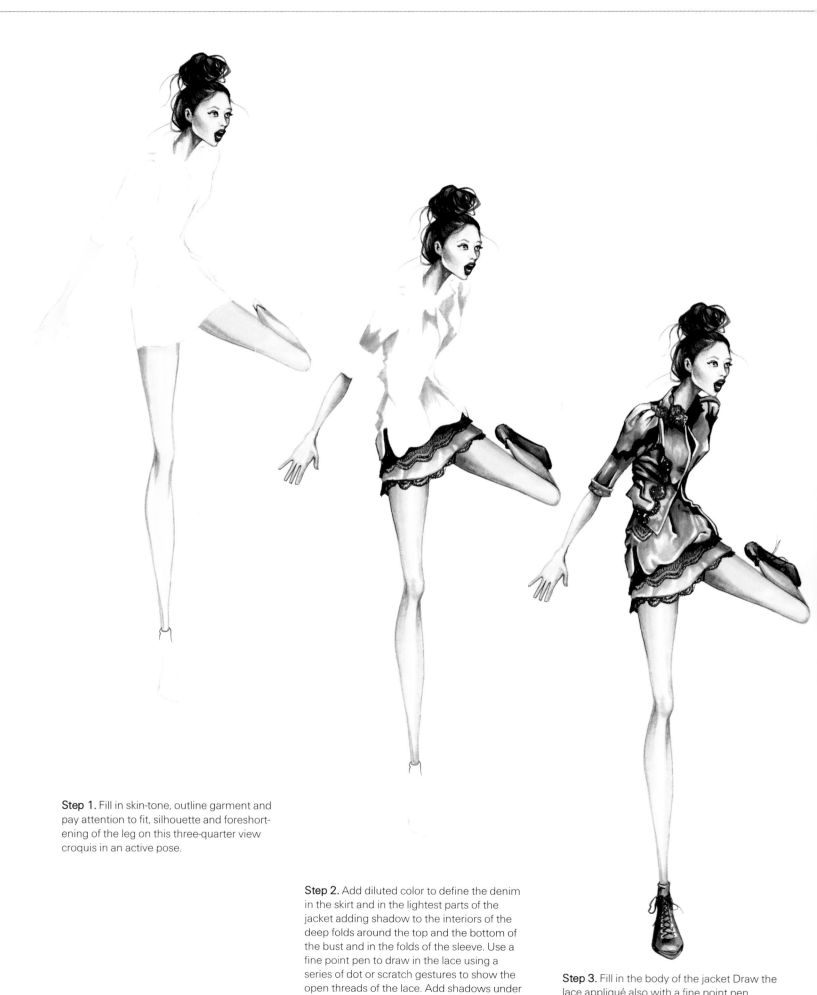

Step 1. Fill in skin-tone, outline garment and pay attention to fit, silhouette and foreshortening of the leg on this three-quarter view croquis in an active pose.

Step 2. Add diluted color to define the denim in the skirt and in the lightest parts of the jacket adding shadow to the interiors of the deep folds around the top and the bottom of the bust and in the folds of the sleeve. Use a fine point pen to draw in the lace using a series of dot or scratch gestures to show the open threads of the lace. Add shadows under the tiers of the skirt to create depth.

Step 3. Fill in the body of the jacket Draw the lace appliqué also with a fine point pen. Where threads are thicker in the lace use a medium point marker.

garments on the figure step-by-step

denim/stretch denim pants/sweater/full-knit top

Step 1. Fill in skin tone. Outline the sweater and top with soft, rounded contours. The pants are tight but still have drape at the knee and ankle. It is usually easier to draw in the garment closest to the body first. Make an application of the base color of the fabric and then create the folds using a colored pencil or slightly darker marker.

Step 2. Fill in the color of the pants using a white pencil to indicate the highlights on the folds at the knees and ankle.

Step 3. Shade in the sweater using a colored pencil. All the shadows are soft. Shadows extend behind the legs and in the interiors of the sleeves. The purse is filled in with marker and white pencil for highlights.

garments on the figure step-by-step

denim/classic denim jeans/layered jackets, top

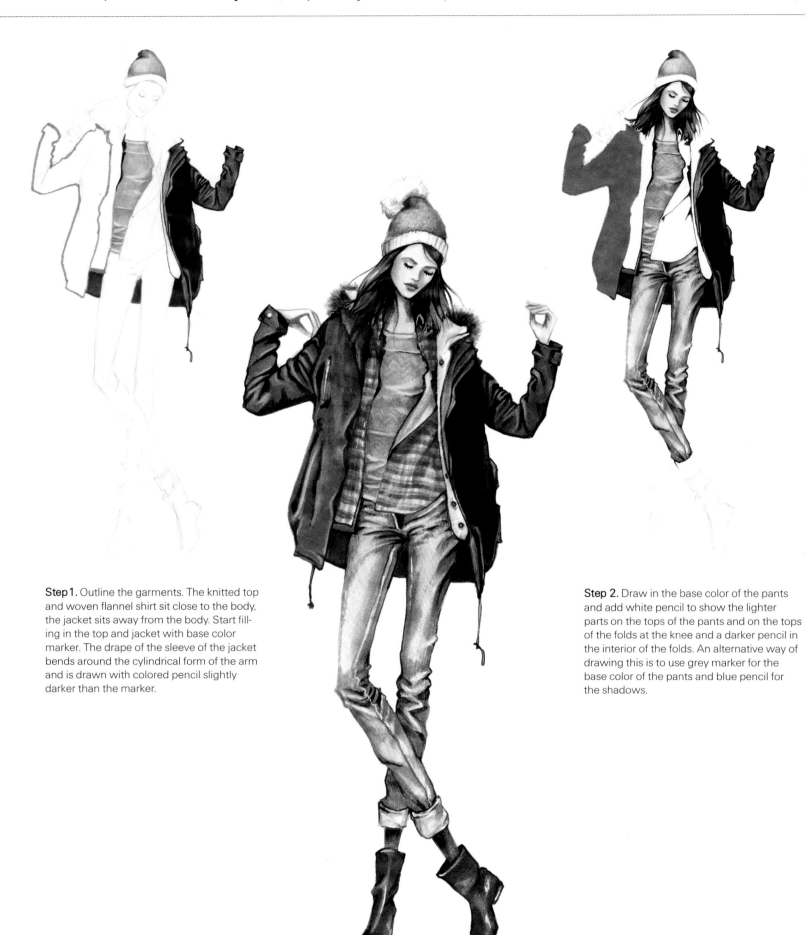

Step 1. Outline the garments. The knitted top and woven flannel shirt sit close to the body, the jacket sits away from the body. Start filling in the top and jacket with base color marker. The drape of the sleeve of the jacket bends around the cylindrical form of the arm and is drawn with colored pencil slightly darker than the marker.

Step 2. Draw in the base color of the pants and add white pencil to show the lighter parts on the tops of the pants and on the tops of the folds at the knee and a darker pencil in the interior of the folds. An alternative way of drawing this is to use grey marker for the base color of the pants and blue pencil for the shadows.

Step 3. All of these fabrics have a soft texture which is best achieved by drawing in the shadows with colored pencil.

garments on the figure step-by-step

denim/classic jeans/sweater

Step 1. Fill in skin tone, outline garment. The scarf has a wide cowl-like drape around the neck. Make an application of base color to the sweater. Fill in shoes.

Step 2. A second application of the grey marker is used to fill in the scarf and deepen the color of the sweater. White pencil is used on the surface of the folds of the sweater to soften the look.

Step 3. Blue pencil is used to define the texture and color of the pant. A light application of white pencil can be used to show the twill of the pant. The shadows are drawn in with black pencil.

garments on the figure step-by-step

cotton/tailored cotton shirt and pants

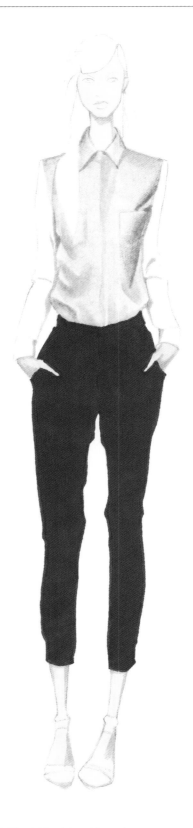

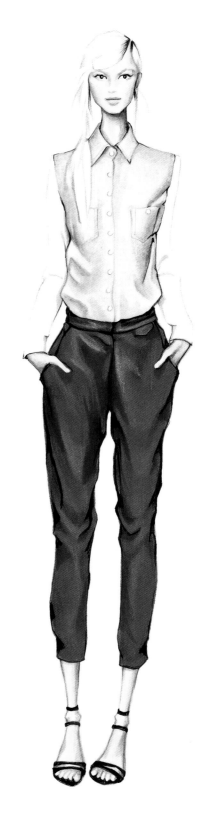

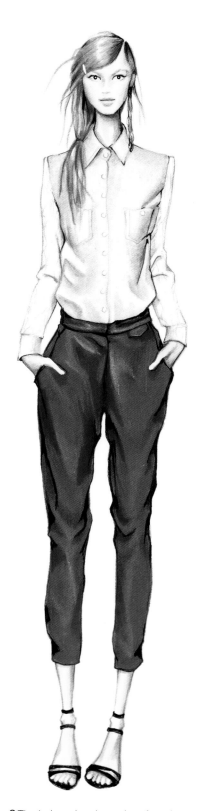

Step 1. The folds of the shirt and pants are medium in width and appear in the garment where the body underneath bends–at the elbows and knees–and where the fabric pulls–from the armhole and around the waist. Fill in skin-tone, outline garment and pay attention to fit and silhouette

Step 2. Choose a color for the shadows that is a darker value of the fabric color. In the pants black is used to define the shadow and light pencil is applied to the surface of the folds.

Step 3. The hair and make up is soft and youthful and gives an interesting contrast to the masculine appearance of the shirt.

garments on the figure step-by-step

black and white/stretch knit swimsuit/nylon jacket

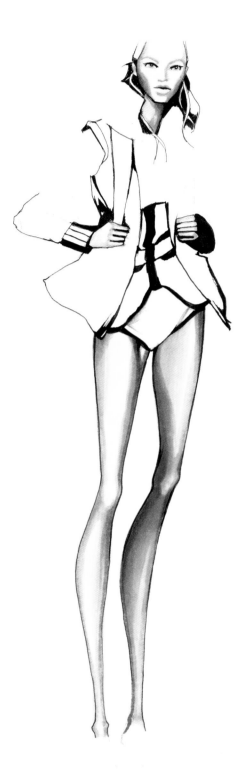

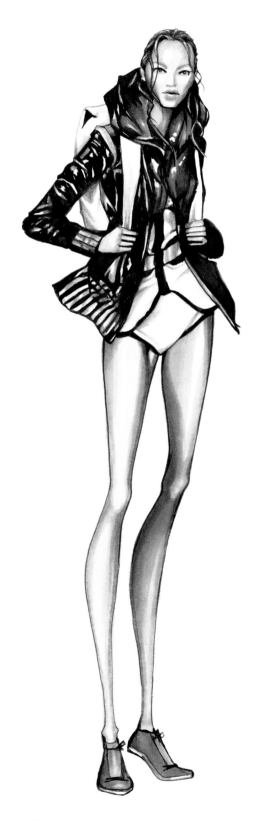

Step 2. Swimsuits will show multiple slim folds to indicate they are bending and stretching – drawn with light grey pencil or a cool grey (10%) marker. The shiny jacket has multiple folds and floats away from the body (the hood and the hem) because the fabric is a light nylon. The full silhouette of the jacket contrasts with the figure-hugging silhouette of the bathing suit.

Step 1. The jacket is a high density microfilm. Fill in skin-tone and outline the garments.

Step 3. Fill in the jacket with black marker and leave slim areas of the paper to show through on the tops of the folds and the rib trim at the wrist and hem to indicate shine. The backpack is shaded with grey pencil.

garments on the figure step-by-step

black and white/soft white blouse/black shorts/leather bag

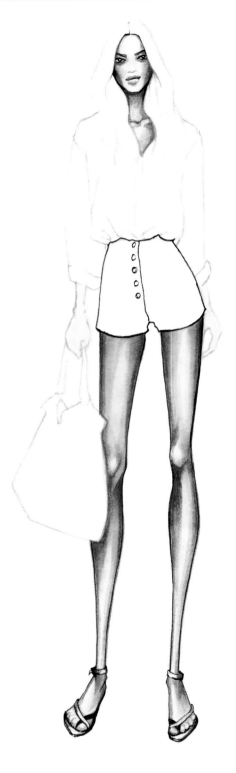

Step 1. Fill in skin tone, outline garment.

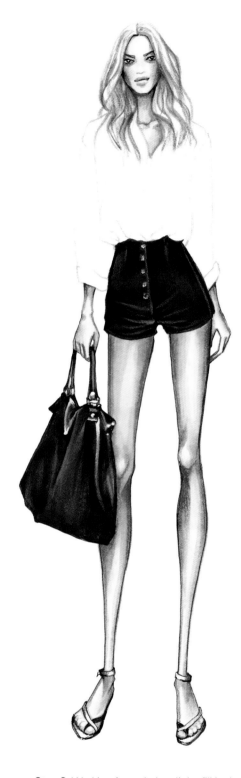

Step 2. Working from dark to light, fill in the shorts and bag with black marker; details and highlights can be drawn in with white gel pen.

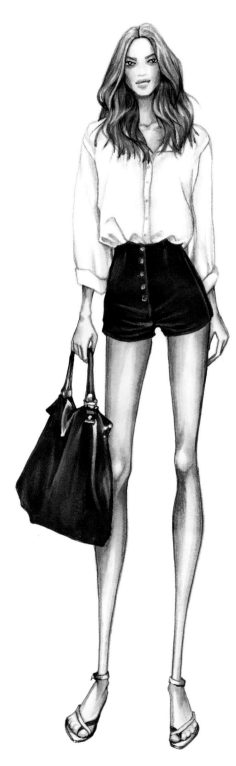

Step 3. 10% cool grey is used to fill in the drape and the rounded shadows that extend down from the shoulders to the bust and below the bust to the waist, in the curving fold at the waist, at the elbows and the cuff. The blouse is not fitted at the waist and has curving folds where it tucks into the shorts. The blouse should have a light look so do not outline

garments on the figure step-by-step

black and white/transparent white top/transparent black skirt

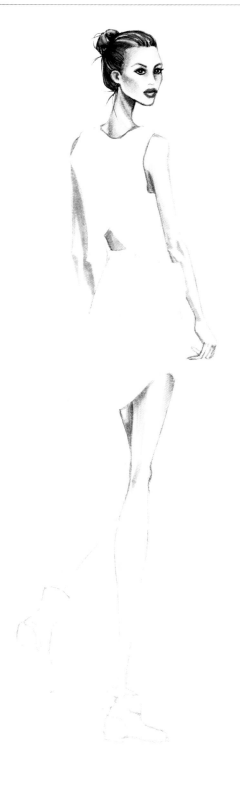

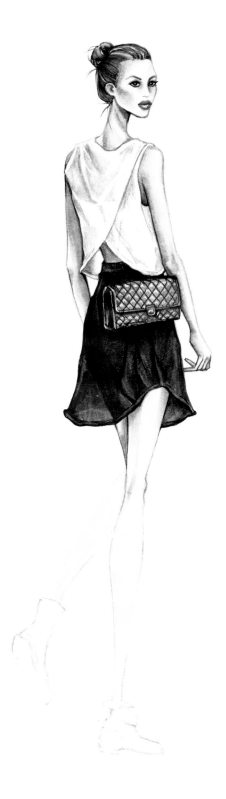

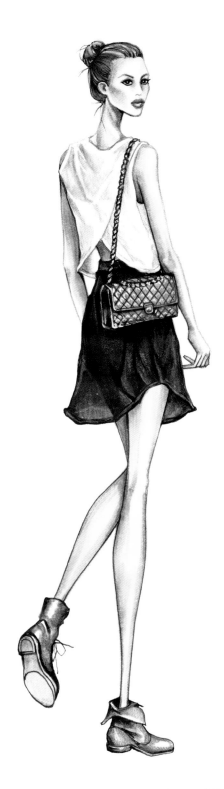

Step 1. This is a difficult three-quarter back pose. Fill in skin-tone, outline garment and purse. The arm and leg on the left are turned away from the light and have dark shadows. Note the fullness of the silhouette and that the cotton does not cling to the body.

Step 2. Fill in the skirt with a diluted black color and then make an application of undiluted black in the areas where the body is present underneath. The top is drawn by applying light grey marker as shading in the interiors of the folds. White pencil is applied to indicate sheen on the skirt. The bag has been left white and the black pattern is defined with the sharp point of a marker or a pen. Include a line for the hem, as it is visible through the transparent fabric.

Step 3. Add more shadow to the legs and fill in the shoes.

garments on the figure step-by-step

black and white/satin-faced cotton suit

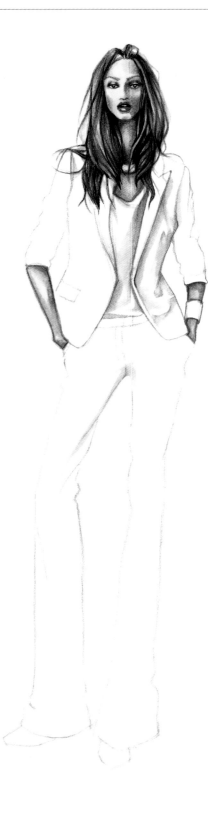

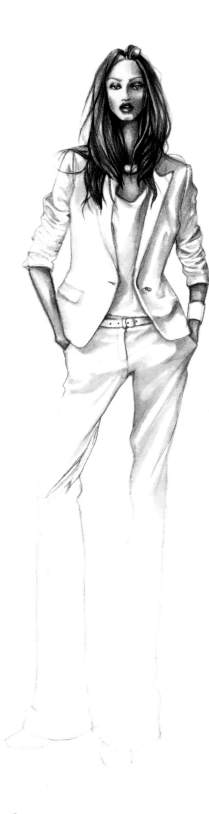

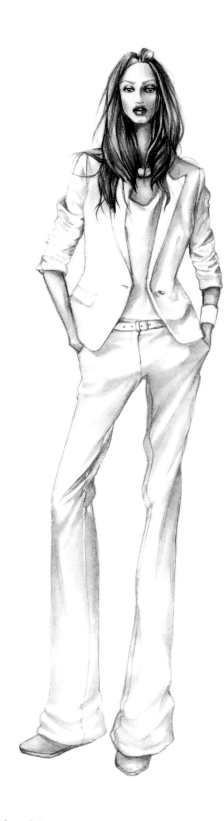

Step 1. This is a tailored garment with a clean silhouette and clearly defined construction details. Note the tailored set-in sleeves. The sleeves are pushed up and have formed multiple folds. Fill in skin-tone, outline garment and begin shading the tee shirt (which is closest to the body) with light grey marker.

Step 2. Add more shading to the jacket and pants on the right side, away from the light source. The shadows bend in spirals around the arm; longer shadows under the lapel. Shade also under the pocket and hem of the jacket. When drawing the pants the shadows will extend from the hip to the knee .

Step 3. Draw in the shadows in the pants, extending from the knee to the ankle. Note that the pant leg extends over the shoe.

garments on the figure step-by-step

black and white/white fur jacket/black leggings

Step 1. Fill in skin-tone and outline garments, using a light touch for the fur jacket.

Step 2. The essential thing in this drawing is to render the fur with fullness and bulk and the leggings so they closely fit the shape of the legs, a sexy contrast. The leggings drape only around the knees and the ankles.

Step 3. The filaments of the fur are drawn with a light grey pencil and a darker grey added at the hem to give it a rounded appearance. Make sure the fur fibers are clearly visible in the silhouette at the edge of the garment.

garments on the figure step-by-step

black and white/transparent white top/opaque black pants

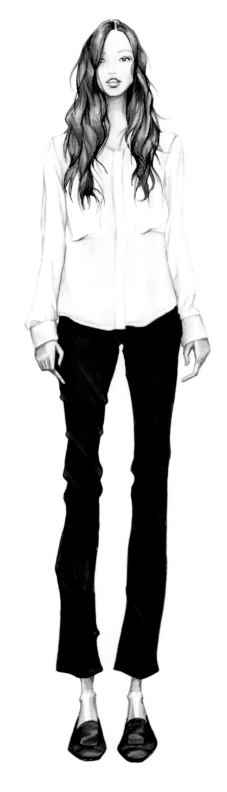

Step 1. Fill in skin-tone and outline garment. There are two contrasting silhouettes in this outfit: a boxy blouse and slim pants. Do not make the blouse tight.

Step 2. The white transparent blouse is drawn with a very light touch. The outer edge of the garment should appear as a light line – it should be drawn in very lightly and then blended into the garment with light grey marker. Skin tone under the top can be drawn very subtly from the reverse side of the paper using marker or Prisma (wax-based) colored pencil.

Step 3. Note the pockets and cuffs are defined with a stronger, darker shadow. FIll in hair and make-up.

garments on the figure step-by-step

black and white/knitted tee-shirt/black pants/leather jacket/bag

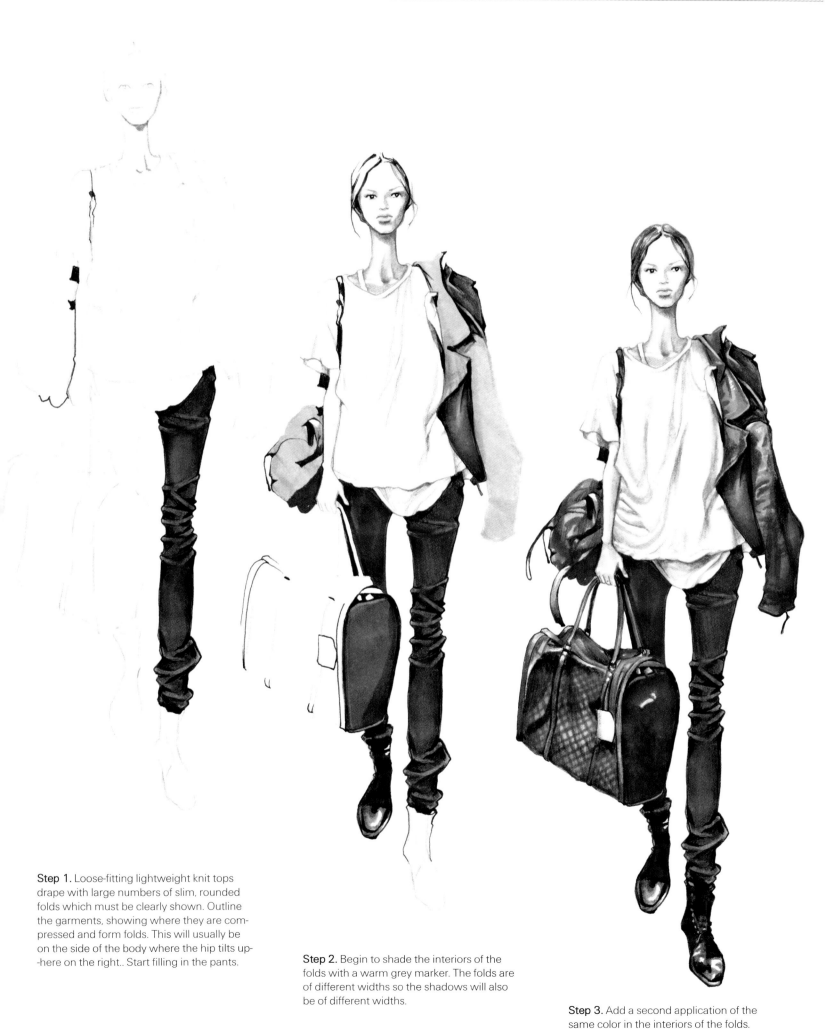

Step 1. Loose-fitting lightweight knit tops drape with large numbers of slim, rounded folds which must be clearly shown. Outline the garments, showing where they are compressed and form folds. This will usually be on the side of the body where the hip tilts up- -here on the right.. Start filling in the pants.

Step 2. Begin to shade the interiors of the folds with a warm grey marker. The folds are of different widths so the shadows will also be of different widths.

Step 3. Add a second application of the same color in the interiors of the folds.

garments on the figure step-by-step

lace/cotton lace woven into netting

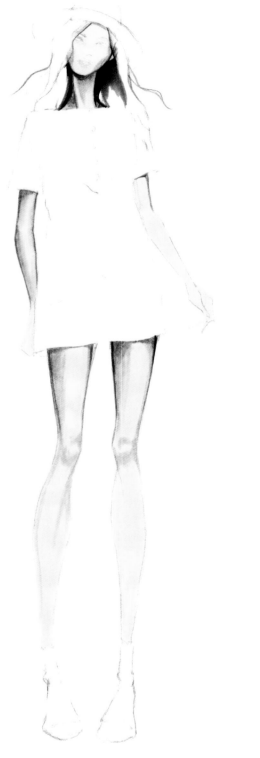

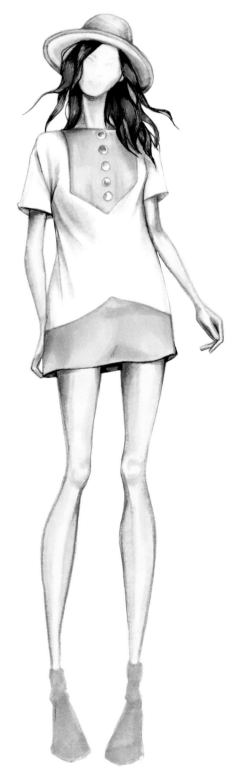

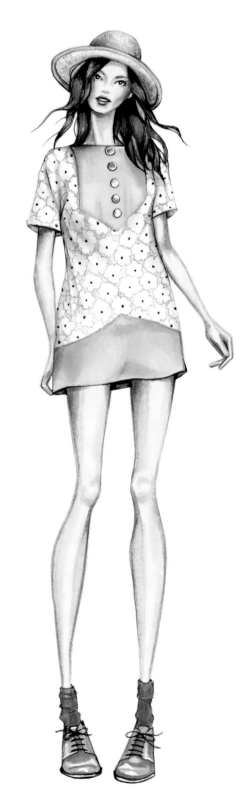

Step 1. Fill in skin-tone, outline garment and pay attention to fit and silhouette.

Step 2. Fill in the areas of the dress where the lace does not appear.

Step 3. A second coat of grey marker is applied to the shading on the dress; more shading is applied to the legs and the shoes are filled in. The lace is large enough to appear as a pattern. This is a thicker lace and has more depth which is indicated by shading around the repeated pattern. Draw in the pattern remembering to bend it around the croquis. Use a pencil to fill in the areas between the flowers. Gouache can be applied with a fine brush to give the flowers more depth. To show the netting that is the base of all lace use a fine tip pen and lightly render some of the lace with crisscross lines using a very light touch.

garments on the figure step-by-step

lace/silk-lined lace dress

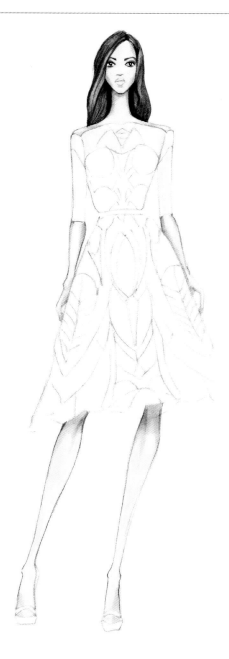

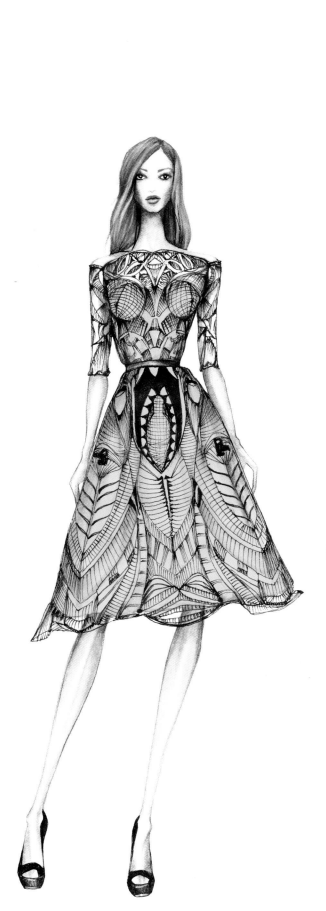

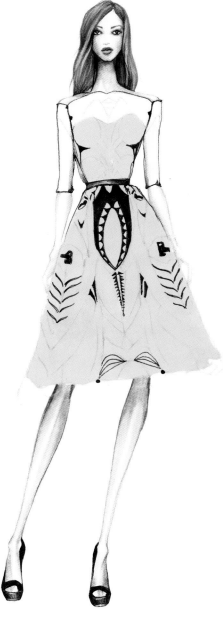

Step 1. Fill in skin-tone, outline garment. The pattern of the lace is symmetrical and should be drawn in using a French curve and/or ruler to create perfect curves.

Step 2. The color of the dress is filled in with a green marker from the reverse side. This allows the lace pattern to remain visible. The lace is drawn on top with an .005 micron pen taking great care to create symmetrical detail.

Step 3. This very fine lace is drawn exclusively with line: because it has little depth very limited shading is necessary. The pattern is drawn with a variety of line weights and different thicknesses of pens from .005 to .02 should be used. This is an extremely difficult drawing and should be attempted carefully and slowly.

garments on the figure step-by-step

transparency/semi-transparent voile summer skirt with denim trim

Step 1. This garment is made with spun cotton that has a matt, transparent surface. The garment has wide folds that bend around but do not cling to the body. Fill in skin-tone, outline garment and pay attention to fit and silhouette.

Step 2. The fabric is rendered with diluted marker or colored pencil so the shadows of the fabric are light and subtle. There is little variation of value within the shadows

Step 3. The leopard print panty can be rendered from the reverse side of the paper or with colored pencils as this area appears to have to be an opaque fabric. Note that the trim is light blue and the edge of the skirt can be drawn in pencil to show that it has a crisp edge.

garments on the figure step-by-step

shine/dress with feathers and sequins/wool jacket

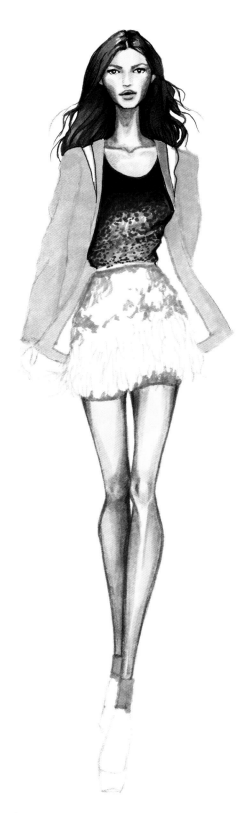

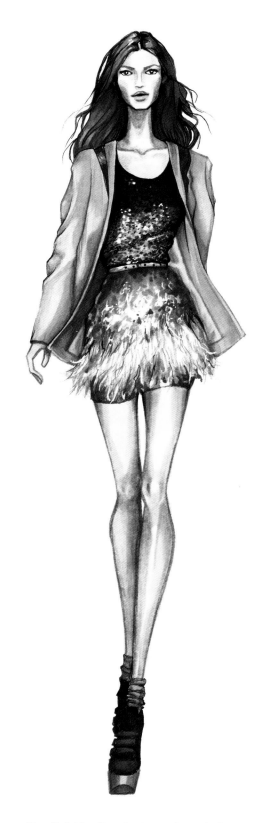

Step 1. Draw in skintone and define the silhouette of the garment.

Step 2. Be aware of the two quite different textures in the dress—sequins and feathers. Sequins are sharp edged and have to be clearly defined. Feathers appear soft and are drawn with a soft touch of diluted color. First draw the dress: Work from light to dark using a diluted version of color make a first application of grey leaving unmarked the shiny areas of sequins and the feathers that appear on the higher part of the folds and around the tummy. Black marker is applied in the interiors of the fold and the edges of shine to create contrast of value and enhance the shiny effect.

Step 3. Add a diluted color marker to indicate the broken edges of the feathers. Draw in the sequins as half circles to show their flat shape. Scatter them randomly across the garment so they do not look like a print.

garments on the figure step-by-step

shine/shiny minidress

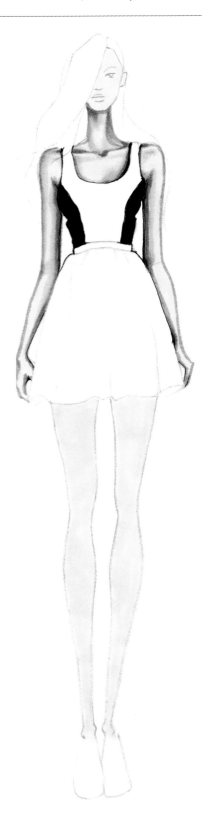

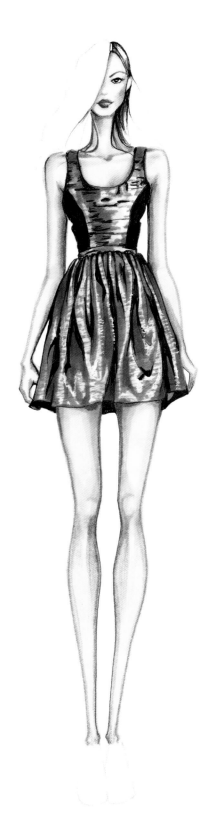

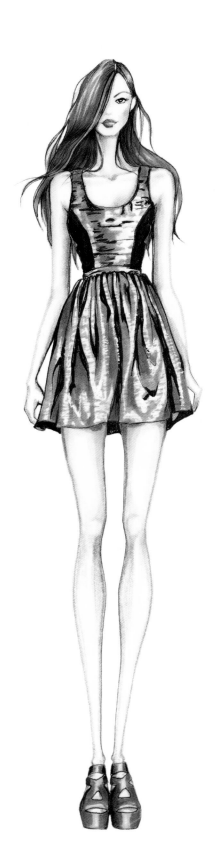

Step 1. Fill in skin tone, outline garments. The bodice fits tightly and the gathered skirt has volume and round drape. The side panels are filled in with black marker.

Step 2. Working from light to dark colors, first fill in the skirt and the center panel of the bodice with the lightest color—a very light beige, which will serve as the lightest part of the surface of the fabric. Add darker values of the beige in the interiors of the folds in the skirt with black in the very deepest parts. The bodice is lit from the right so shadows appear on the left side and are also created using applications of and brown and black marker. Make sure the gathers start at the waist with compressed folds which expand into wider folds towards the hem.

Step 3. Fill in the hair and shoes

garments on the figure step-by-step

shine/evening dress with paillettes

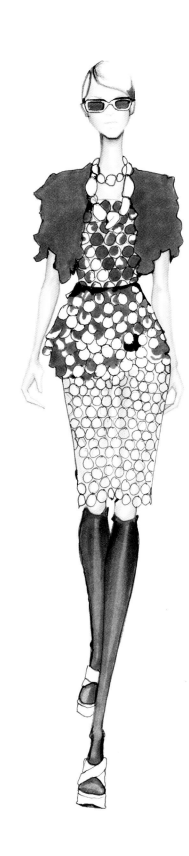

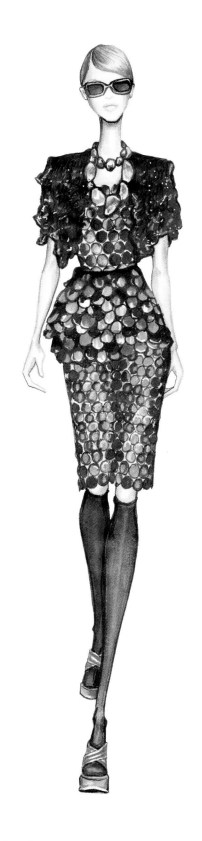

Step 1. Draw the silhouette of the dress. As part of the garment is semi-transparent fill in the skin tone in the thighs as well as arms, face and neck.

Step 2. Draw in the paillettes with grey pencil then randomly fill in some of those in the upper part of the dress with greys, blues and browns, leaving others white. Make an application of black marker to the sleeves and socks. Start to fill in the eyeglasses and hair.

Step 3. Fill in the paillettes with diluted color and add the subtle sheen with grey pencil. Define hair with two or three variations of diluted brown and the necklace with diluted marker.

garments on the figure step-by-step

leather/shiny leather minidress

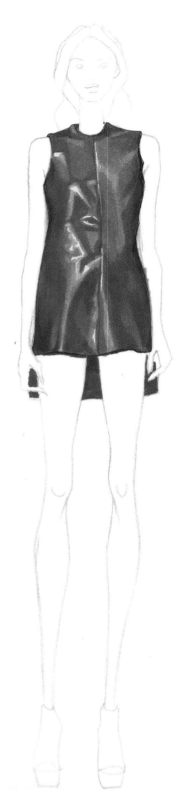

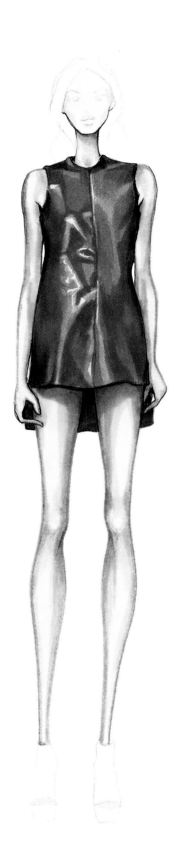

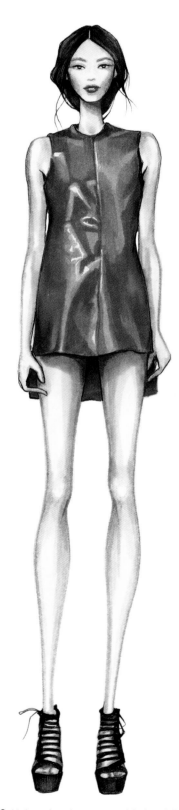

Step 1. Draw in the outline of the garment. This leather has a stiffer structure and so has a boxy silhouette. The depth of the fabric is indicated at the hem with a darker line. Fill in the dress with a medium tone and add a second layer of the same color for deeper shadows on the inside of the folds and along the sides of the figure. The sheen of the leather is created with a soft application of a Prismacolor pencil – blended at the top of the folds.

Step 2. Add skin tone.

Step 3. Hair and make up are added and the shoes are filled in.

garments on the figure step-by-step

leather/quilted leather jacket/knit top/silk skirt

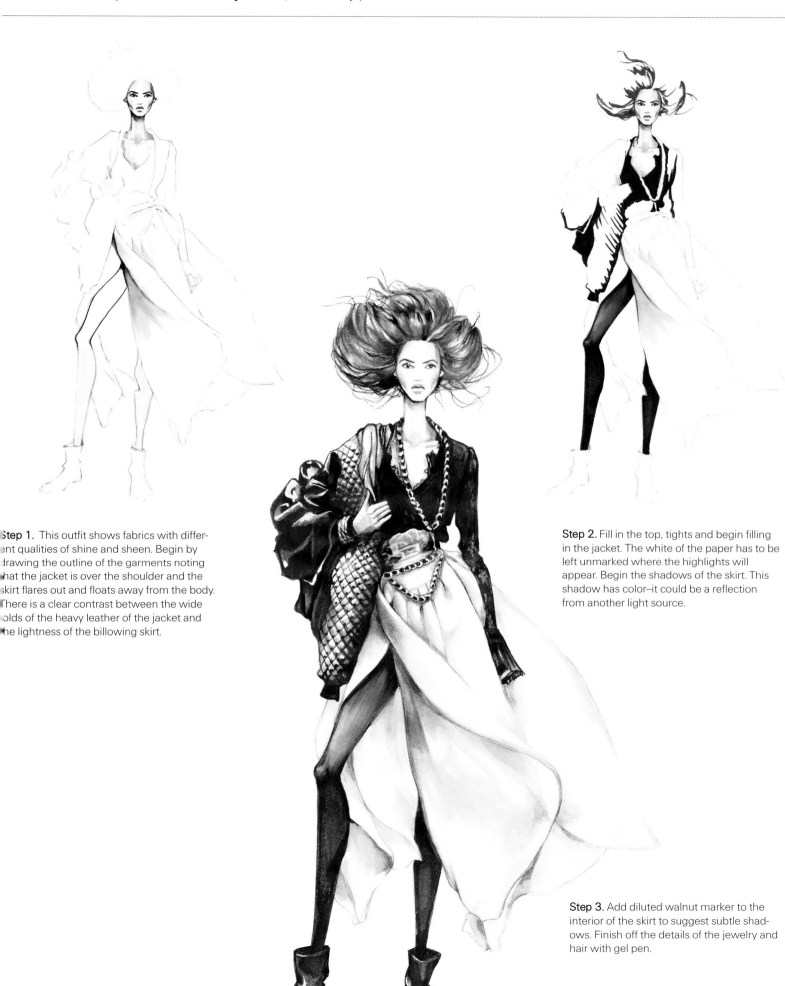

Step 1. This outfit shows fabrics with different qualities of shine and sheen. Begin by drawing the outline of the garments noting that the jacket is over the shoulder and the skirt flares out and floats away from the body. There is a clear contrast between the wide folds of the heavy leather of the jacket and the lightness of the billowing skirt.

Step 2. Fill in the top, tights and begin filling in the jacket. The white of the paper has to be left unmarked where the highlights will appear. Begin the shadows of the skirt. This shadow has color–it could be a reflection from another light source.

Step 3. Add diluted walnut marker to the interior of the skirt to suggest subtle shadows. Finish off the details of the jewelry and hair with gel pen.

garments on the figure step-by-step

leather/white leather skirt

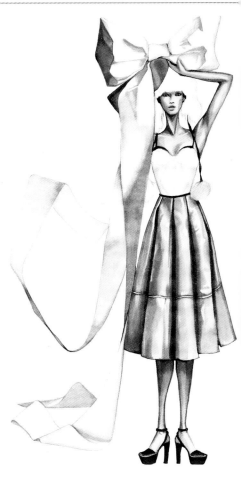

Step 1. Leather is stiffer than other fabrics and the tucks and folds hold their shapes—the shadows are uniform down the length of the garment. Draw the outline of the skirt, top and bow. Fill in the skirt with a light marker adding a second and third application in the shadows and leaving the white of the paper for highlights. Leather is a skin so often requires mutiple seams, which is the reason for the horizontal seam above knee level.

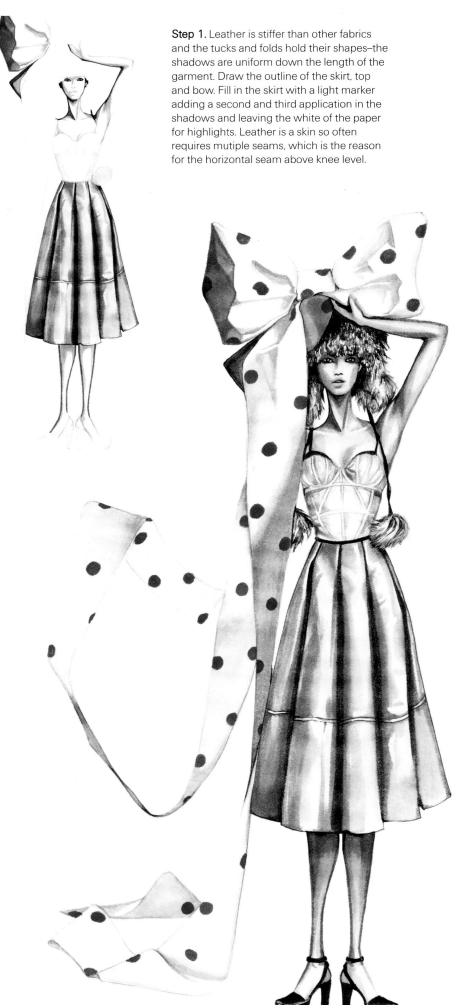

Step 2. Add shadows to the rest of the garment. Note the wide shadows on the upper part of the legs to indicate the depth of the skirt.

Step 3. Finish off the top, bow and hair. There is an interesting contrast between the warm grey of the skirt and the cool grey of the top and bow.

garments on the figure step-by-step

leather/soft leather jacket

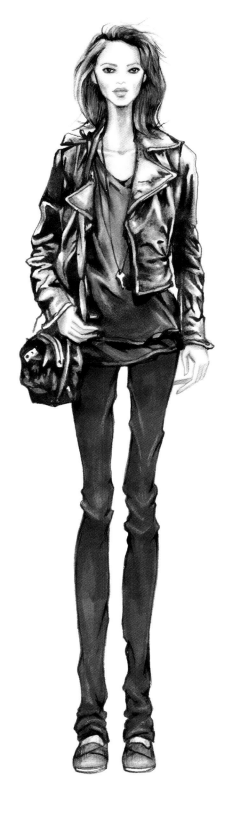

Step 1. This is a very soft calfskin leather that has much more drape than other stiffer leathers and forms numerous folds. Draw in the silhouette and the outlines of the folds, clearly showing the bends and curves of the leathers in the sleeves. lapel and body of the jacket. Draw in skin tone and pants.

Step 2. This jacket can be drawn in two ways: In this version the deeper shadows are drawn in with black marker and the white of the paper is left unmarked in the areas where the folds are shallower. Alternatively the whole garment can be filled in with black and white pencil used on the highlights on the tops of the folds..

Step 3. In this version grey marker is added to shade the lighter shadows leaving the white of the paper to show through as highlights. Fill in bag and shoes.

garments on the figure step-by-step

leather/leather jacket

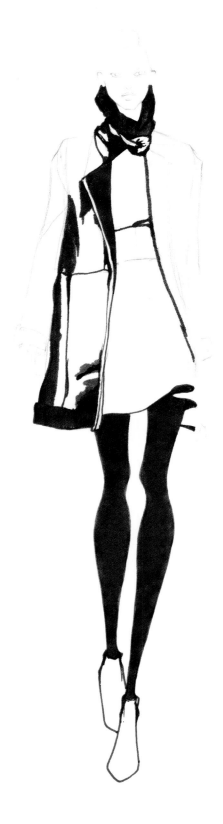 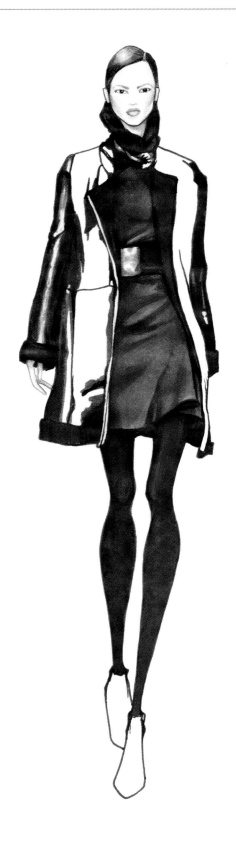 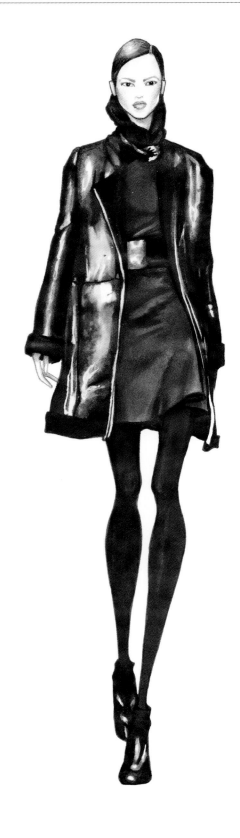

Step 1. This is a heavier leather jacket with straight edges and little drape. Black leather is drawn using black marker to show the color of the fabric and white for the highlights. The white highlights can be shown either by leaving the white of the paper unmarked, as in this drawing, or by filling the whole garment with black and then using grey marker and white pencil directly on top of the black.

Step 2. The matt dress contrasts with the shiny black jacket and is drawn using a medium value cool grey with a slightly darker grey pencil for the shadows.

Step 3. The zipper and details on the belt are drawn with white gel pen.

garments on the figure step-by-step

leather/fringed dress

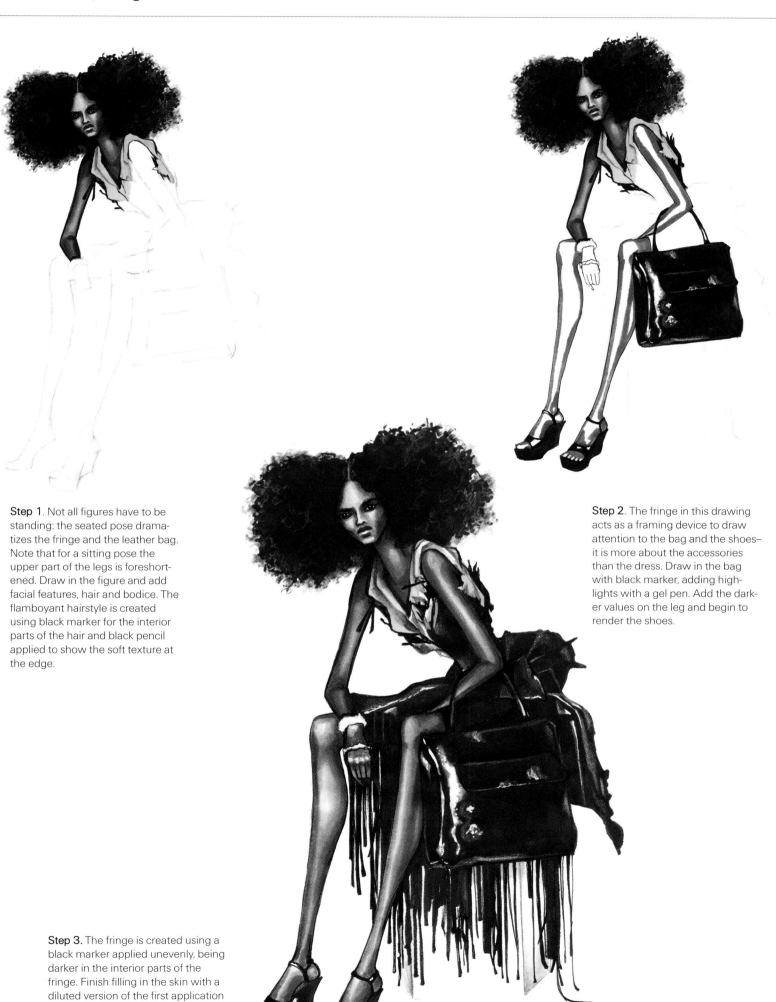

Step 1. Not all figures have to be standing: the seated pose dramatizes the fringe and the leather bag. Note that for a sitting pose the upper part of the legs is foreshortened. Draw in the figure and add facial features, hair and bodice. The flamboyant hairstyle is created using black marker for the interior parts of the hair and black pencil applied to show the soft texture at the edge.

Step 2. The fringe in this drawing acts as a framing device to draw attention to the bag and the shoes– it is more about the accessories than the dress. Draw in the bag with black marker, adding highlights with a gel pen. Add the darker values on the leg and begin to render the shoes.

Step 3. The fringe is created using a black marker applied unevenly, being darker in the interior parts of the fringe. Finish filling in the skin with a diluted version of the first application or a lighter brown marker.

garments on the figure step-by-step

fur/fox fur wrap

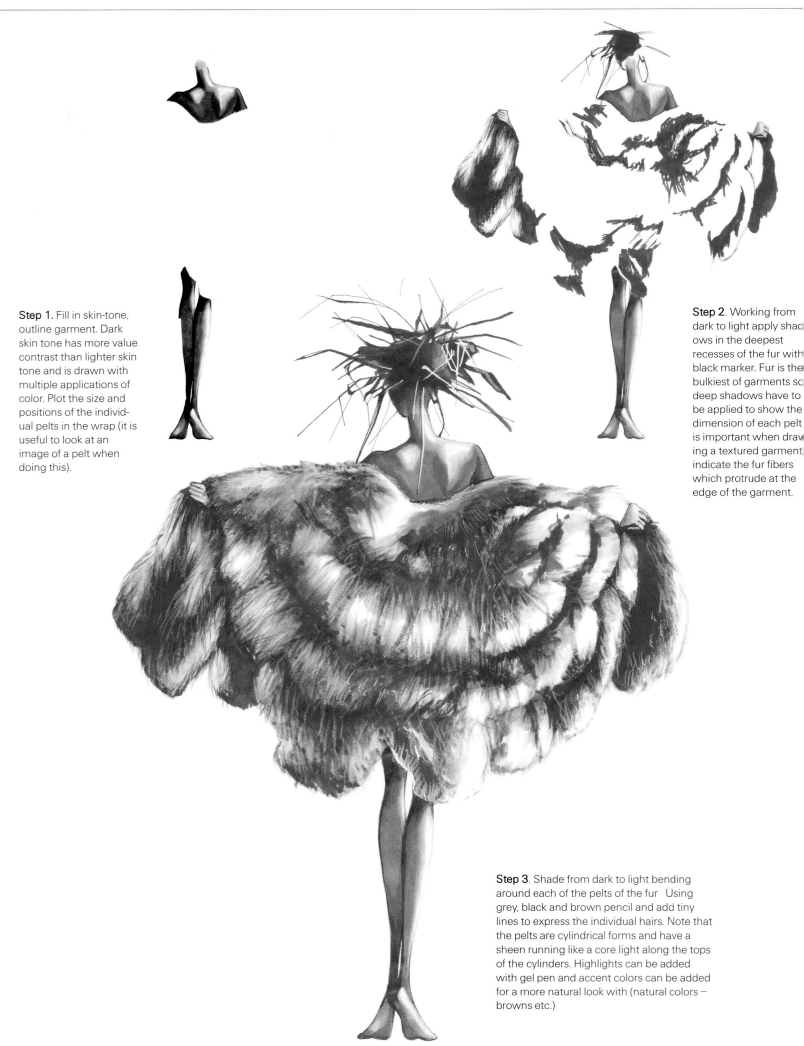

Step 1. Fill in skin-tone, outline garment. Dark skin tone has more value contrast than lighter skin tone and is drawn with multiple applications of color. Plot the size and positions of the individual pelts in the wrap (it is useful to look at an image of a pelt when doing this).

Step 2. Working from dark to light apply shadows in the deepest recesses of the fur with black marker. Fur is the bulkiest of garments so deep shadows have to be applied to show the dimension of each pelt is important when drawing a textured garment indicate the fur fibers which protrude at the edge of the garment.

Step 3. Shade from dark to light bending around each of the pelts of the fur Using grey, black and brown pencil and add tiny lines to express the individual hairs. Note that the pelts are cylindrical forms and have a sheen running like a core light along the tops of the cylinders. Highlights can be added with gel pen and accent colors can be added for a more natural look with (natural colors – browns etc.)

garments on the figure step-by-step

fur/dyed faux fur jacket and graphic print dress

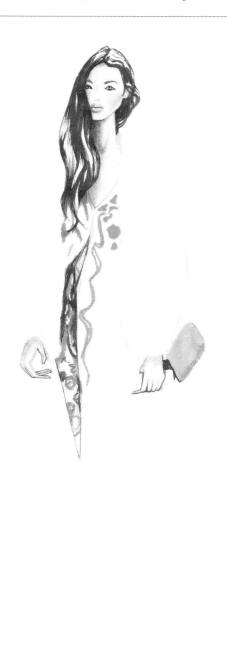

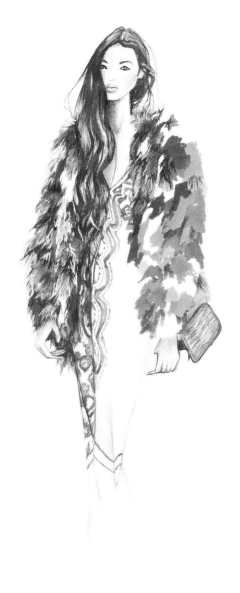

Step 1. Fill in skin-tone, outline garment and begin plotting the print on the dress.

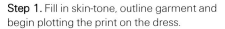

Step 2. There is a contrast between the flat graphic pattern of the print of the dress and the soft voluminous faux fur of the jacket. The faux fur is drawn by making successive applications of different colors with markers and adding colored pencils while the marker is still wet to create the soft effect. Make sure that individual lines can be seen at the silhouette of the garment. In the cotton dress add grey shadows following the form of the body vertically.

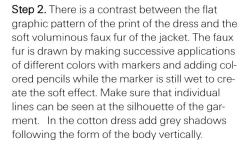

Step 3. Add print using the thin point of a red marker- breaking up the print inside the folds of fabric. Pay attention to variations of shapes on the dress. Add horizontal shading at the hem of the dress.

garments on the figure step-by-step

outerwear/tailored wool coat with leather lapel and purse

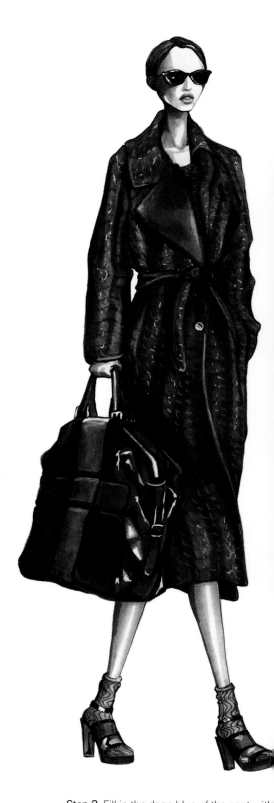

Step 1. This is a tailored coat with padded shoulders and a structured collar. It is a full silhouette that fits closely only at the waist. Outline the garment and bag and fill in the skin tone.

Step 2. Begin by drawing the bag completely and filling in the color of the leather lapel adding highlights with white pencil. This will define these areas clearly.

Step 3. Fill in the deep blue of the coat with an even application of the marker paying close attention to the tailored areas – shoulders, collars and lapel—and the fullness of the coat. Indicate the soft-edged texture and pattern of the wool fabric with white and grey colored pencils. Add shadows under the bag and lapel to indicate depth. Note the white highlight on the bag is much sharper than the white in the texture of the coat.

garments on the figure step-by-step

outerwear/loosely structured wool jacket

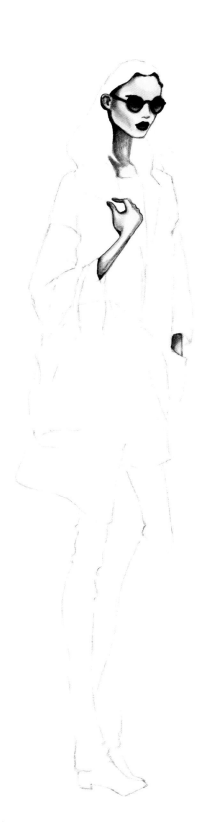

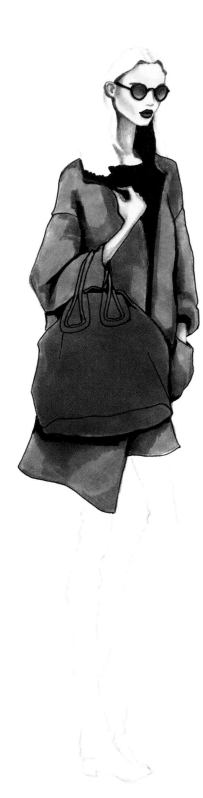

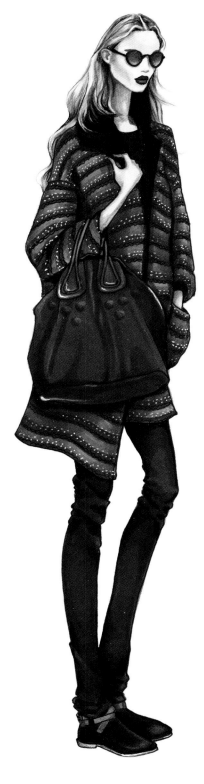

Step 3. Add the print of the jacket using black and white colored pencils. Make sure that the print bends around the folds.

Step 2. Fill in the color of the purse and the grey base color of the jacket.

Step 1. The folds are very wide so shadows are soft and close in value to the color of the garment. Fill in skin tone and outline the garment making sure the hem bends around the figure and the sleeves bend around the arms.

garments on the figure step-by-step

outerwear/layered/heavy canvas coat

Step 1. The bulk and width of the coat have to be clearly shown: the sleeves are wider and the hem flares slightly away from the body; leaving the coat open accentuates the fullness of the fit.

Step 2. Fill in the dress and hair and draw in the outline of the bag. Note that the bag is positioned to be seen in three-quarter view, allowing a clearer idea of the bag– its depth as well as its shape–to be seen.

Step 3. Fill in the base color of the coat with a marker and use grey pencil to show the soft, wide shadows at the elbow, under the collar, along the placket and in the fur. This is a flat matt fabric with little sheen but a soft texture–pencil is particularly effective for drawing this type of fabric.

garments on the figure step-by-step

outerwear/layered/tailored coat/tailored jacket

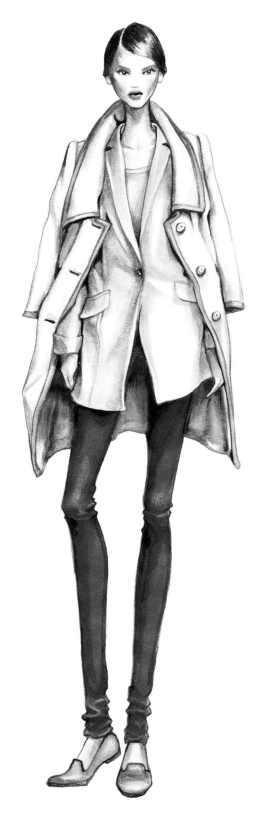

Step 1. Each garment is tailored, meaning it is structured and has a clearly defined shape that is independent of the body underneath. Draw in the silhouette of the garments. The shapes are symmetrical and wide: the collars sit well above the shoulder line, the shoulders sit outside the natural shoulder line. The drape is limited to the tension created by the pull of the jacket at the button.

Step 2. Shadows form under each successive layer. Draw in the shadows with pink pencil. Note that when drawing outfits with layered garments it is useful to show the outermost garments open so the detailing of the inner garments can be seen.

Step 3. Fill in the base color of the jacket from the reverse side of the paper, which results in a smooth, even application. Draw in the tailoring details adding cast shadows under the buttons and lapels.

garments on the figure step-by-step

outerwear/layered/quilted jacket

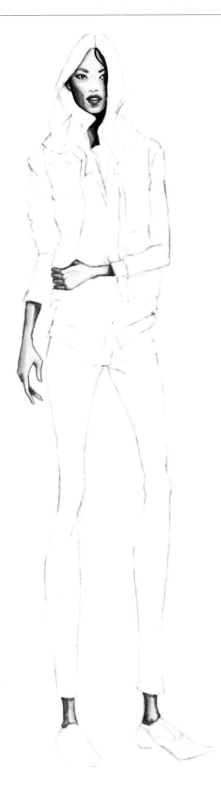

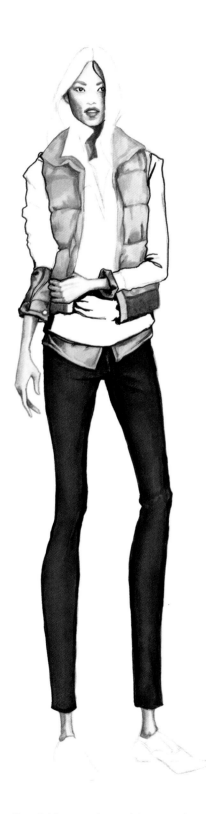

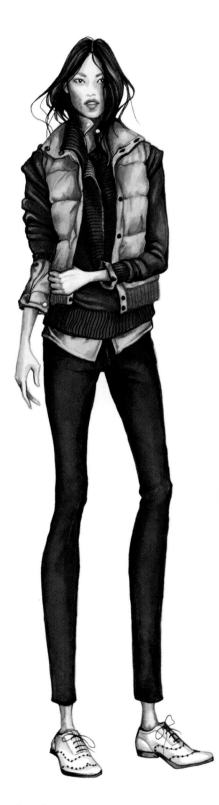

Step 1. Fill in skin tone, outline garment. This outfit consists of garments of different fabric types and attention must be paid to the width of each garment in the silhouette: each garment bends around the garment underneath it.

Step 2. The roundness of the smooth surface of the quilted fabric is shown by filling in the garment with multiple layers of marker that are close in value Define the sewn edge of the quilting sections with black pencil and add wide, rounded shadows that will indicate the puffiness of the fabric.

Step 3. It is usually easier to draw from ligh to dark, so draw in the sweater and denim shirt after drawing the quilted vest.

garments on the figure step-by-step

outerwear/layered/tailored wool jacket over blouse and skirt

Step 1. Outline the garments taking care to show that the silhouette of the jacket is not too close to the body and the skirt flares out from under the hem. Fill in coat with base application of beige marker; begin to define the other garments.

Step 2. Note that the shadows in this tailored melton wool garment are very subtle and close in value to the color of the fabric. Use a second application of the same color while it is still wet so it blends in. Add the first application of the skirt, using a diluted version of the same in the scarf. Add skirt details with cream colored pencil.

Step 3. Apply shadows to the skirt with the same color as the base color while it is still wet. This results in a smooth matt appearance for these non-lustrous fabrics.

garments on the figure step-by-step

outerwear/layered/multi-layered padded winter jacket ensemble

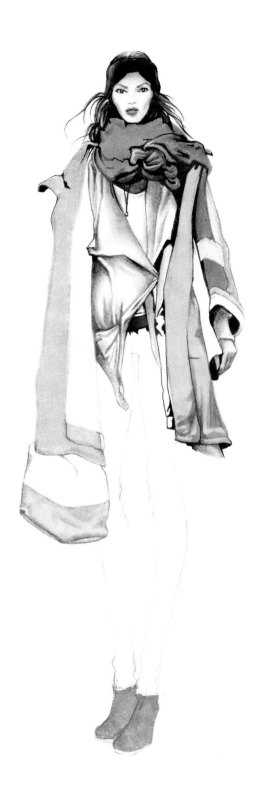

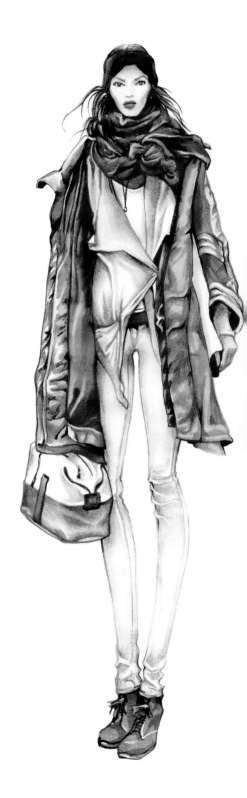

Step 1. As there are so many layers to this outfit it is necessary to make sure to draw the jacket sitting well away from the body. It is possible to begin drawing at almost any point but as teal is the most dominant color it is probably easiest to fill in that area first.

Step 2. The second dominant color is the blue of the scarf followed by the rose on the bag and the brown of the shoes. The other colors can be rendered using warm and cool greys.

Step 3. Continue layering greys into deeper folds and where garments cast shadows on those beneath.

garments on the figure step-by-step

outerwear/quilted jacket

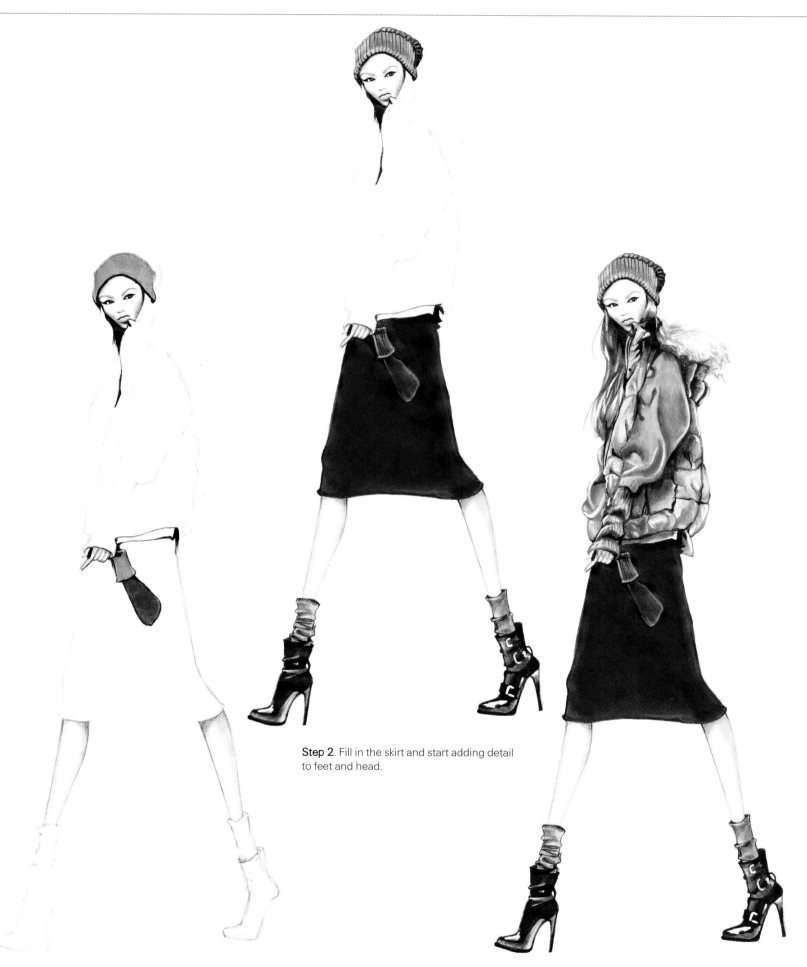

Step 2. Fill in the skirt and start adding detail to feet and head.

Step 1. Outline the garments. The jacket has a full fit and the skirt fits tightly to the legs. Showing the skirt with the legs apart helps indicate that it is a stretch fabric.

Step 3. The interiors of the quilt panels are built up using successive applcations of the same color marker while it is still wet. The shadows form under the arm and in the deeper folds of the jacket. The contrasting pink sleeve is also built up with successive applications of the same color, as is the fur, with grey marker.

garments on the figure step-by-step

evening/taffeta blouse and evening skirt with train

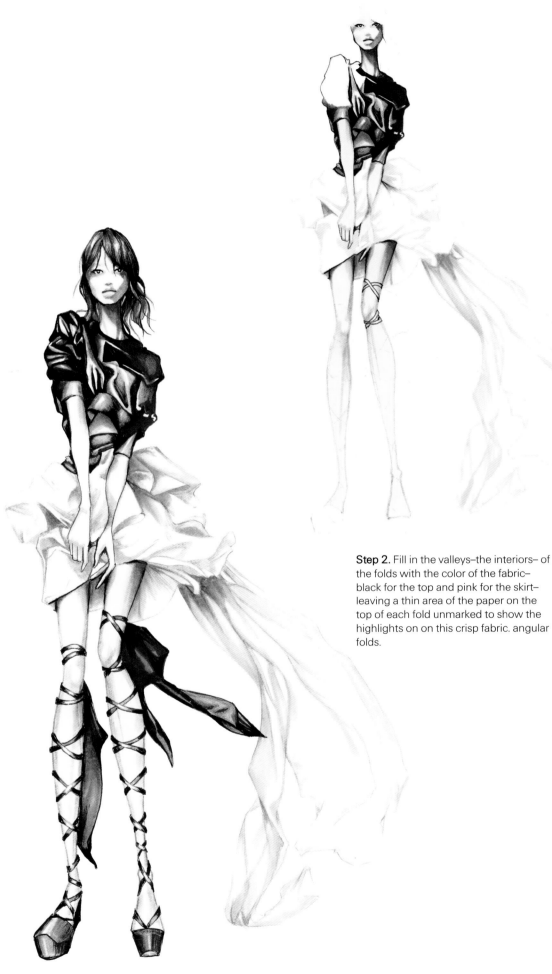

Step 1. Taffeta is a plain weave fabric that is very shiny and has a crisp feel, rustling as it moves on the body. Outline the garment paying attention to the fit and silhouette and fill in the skin tone.

Step 2. Fill in the valleys–the interiors– of the folds with the color of the fabric– black for the top and pink for the skirt– leaving a thin area of the paper on the top of each fold unmarked to show the highlights on on this crisp fabric. angular folds.

Step 3. Multiple layers of values of colors are used to show the deepest parts of the folds. In this garment the folds are sewn in multiple directions – it is very important to work slowly.

garments on the figure step-by-step

evening/shiny satin or silk dress

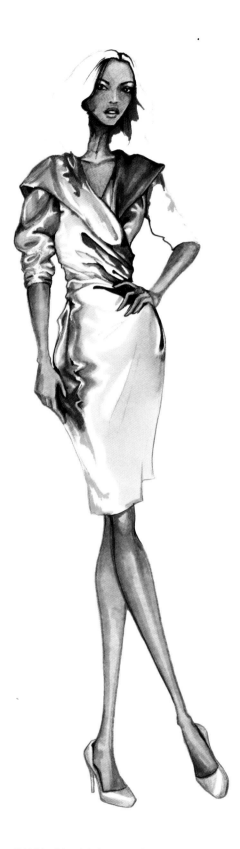

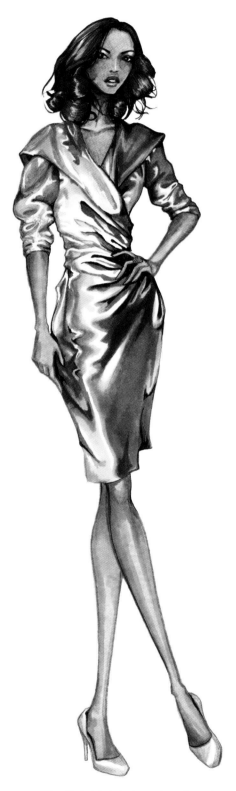

Step 1. Fill in skin tone, outline garment paying careful attention to the folds in the area at the waist where the fabric is compressed

Step 2. With shiny fabrics attention must be paid to the light source and how it hits the dress. In this three-quarter view pose the light strikes dramatically from the left. The highlights on shiny fabrics are thin and immediately adjacent to folds whose interiors are shaded with a high contrast dark value. The main highlight curves around the gathered folds and lines up with the center front of the leg and is shown by leaving the white of the paper unmarked. The base color of the dress is a medium warm grey with a second application of the same color to create the shadows on the right and left sides. Orange marker is added at the edge of the light on the left side to indicate a reflection of a secondary light source such as a neon sign/colored light bulb.

Step 3. A third, darker value of grey is added in the deepest parts of the folds, creating the dramatic contrast of light and dark

garments on the figure step-by-step

evening/pleated silk georgette dress

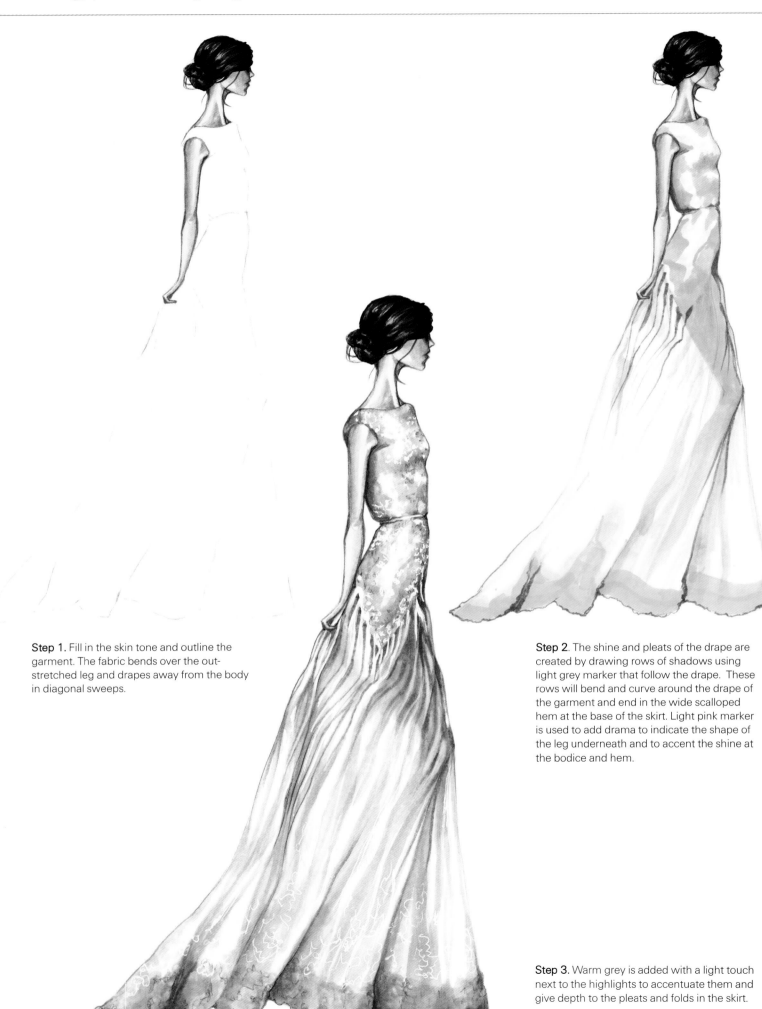

Step 1. Fill in the skin tone and outline the garment. The fabric bends over the out-stretched leg and drapes away from the body in diagonal sweeps.

Step 2. The shine and pleats of the drape are created by drawing rows of shadows using light grey marker that follow the drape. These rows will bend and curve around the drape of the garment and end in the wide scalloped hem at the base of the skirt. Light pink marker is used to add drama to indicate the shape of the leg underneath and to accent the shine at the bodice and hem.

Step 3. Warm grey is added with a light touch next to the highlights to accentuate them and give depth to the pleats and folds in the skirt.

garments on the figure step-by-step

evening/lined lace evening dress

Step 1. Fill in skin tone and outline the garment noting that the top part of the dress fits closely to the body and the lower unlined lace part floats away from the body in soft folds.

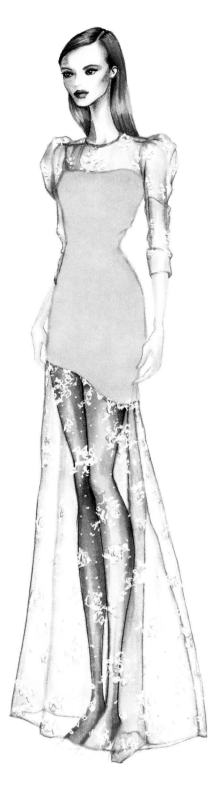

Step 2. Draw in the upper part of the dress with a light marker. The netting of the lace is then drawn in using a very diluted version of the same color. The lace netting fabric is transparent; each fold is shaded carefully with subtle shadows indicating the far sides of the folds through the transparent fabric; they should be drawn after shading the skin tone of the legs and arms. The pattern of the lace is created using a white gel pen. The hem is indicated with a fine line.

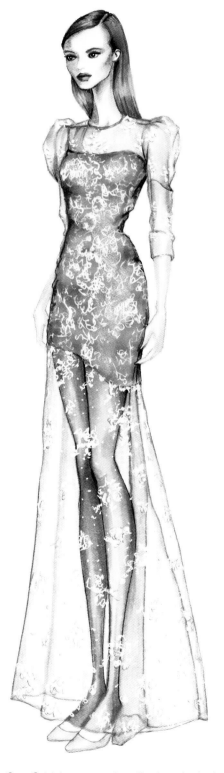

Step 3. Make a second application of color in the upper part of the dress and then add the lace in that area with white gel pen.

garments on the figure step-by-step

evening/veil costume

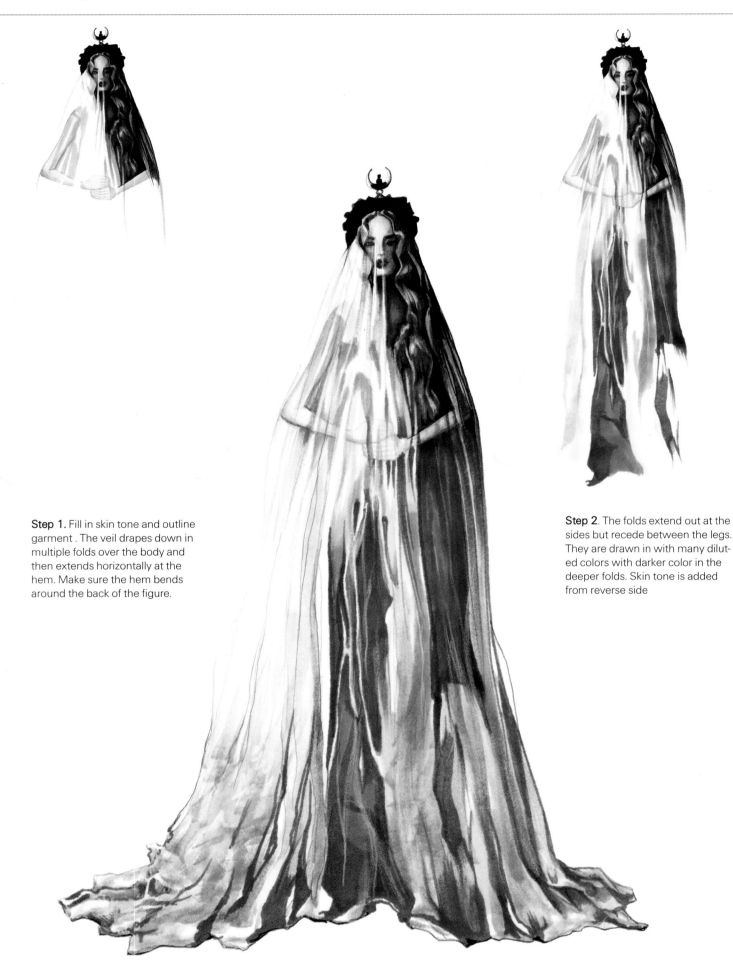

Step 1. Fill in skin tone and outline garment . The veil drapes down in multiple folds over the body and then extends horizontally at the hem. Make sure the hem bends around the back of the figure.

Step 2. The folds extend out at the sides but recede between the legs. They are drawn in with many diluted colors with darker color in the deeper folds. Skin tone is added from reverse side

Step 3. This veil is multi-layered and has considerable depth. This effect is accomplished by making multiple applications of diluted color to give the impression of transparent layers overlying transparent layers. Highlights are applied with gel pen over the arm to give the impression that the arm in underneath the fabric. Highlights can also be applied on the tops of the folds on the left, the direction of the light source.

garments on the figure step-by-step

evening/luxurious white evening gown

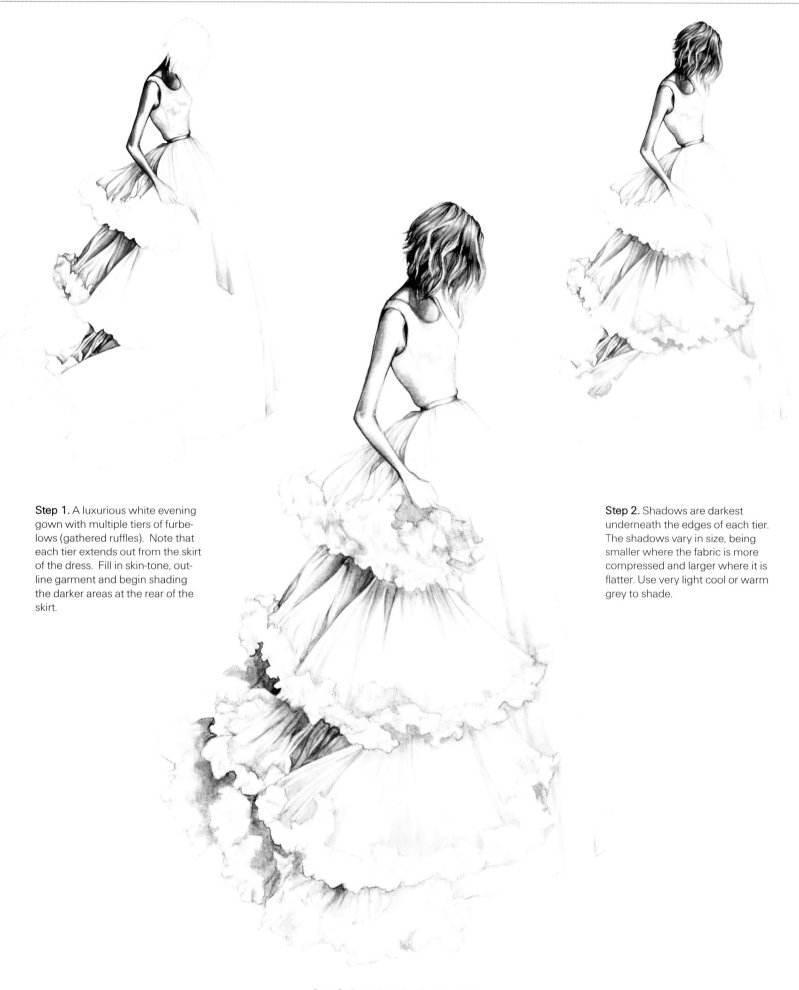

Step 1. A luxurious white evening gown with multiple tiers of furbelows (gathered ruffles). Note that each tier extends out from the skirt of the dress. Fill in skin-tone, outline garment and begin shading the darker areas at the rear of the skirt.

Step 2. Shadows are darkest underneath the edges of each tier. The shadows vary in size, being smaller where the fabric is more compressed and larger where it is flatter. Use very light cool or warm grey to shade.

Step 3. Complete shading and add deeper shadows in the interiors of the gathers

garments on the figure step-by-step

evening/multi-tiered taffeta evening dress

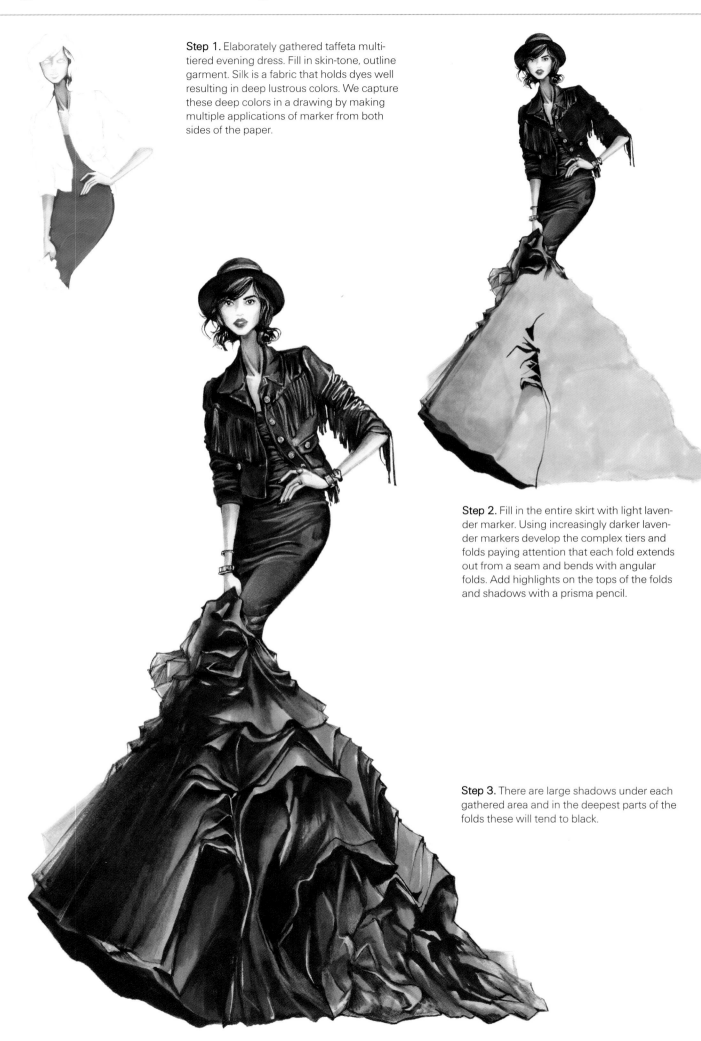

Step 1. Elaborately gathered taffeta multi-tiered evening dress. Fill in skin-tone, outline garment. Silk is a fabric that holds dyes well resulting in deep lustrous colors. We capture these deep colors in a drawing by making multiple applications of marker from both sides of the paper.

Step 2. Fill in the entire skirt with light lavender marker. Using increasingly darker lavender markers develop the complex tiers and folds paying attention that each fold extends out from a seam and bends with angular folds. Add highlights on the tops of the folds and shadows with a prisma pencil.

Step 3. There are large shadows under each gathered area and in the deepest parts of the folds these will tend to black.

garments on the figure step-by-step

evening/jeweled evening dress

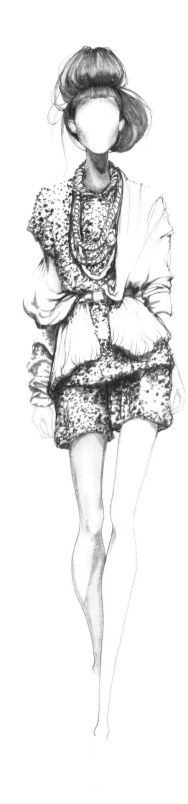

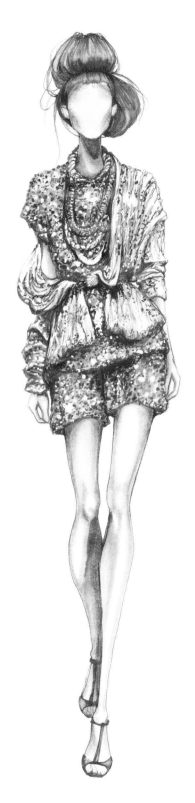

Step 1. Outline garment and fill in skin tone. This is a multi-layered garment and each layer is clearly defined with its own shadows using black marker.

Step 2. When black has been liberally applied as a first step it is necessary either to change medium and work with pencil or to make further applciations of marker from the reverse side of the paper in order to avoid smearing. Here the beige base color of the garment is applied from the reverse side. Going back to the front of the paper, the cast shadows of the numerous beads are applied with black pen and the details of the necklaces are drawn in.

Step 3. Diluted brown is added for the shawl from the reverse side of the paper and then white gel pen is appied in a scattered application from the front to show the reflections on the beads and jewelry.

garments on the figure step-by-step

evening/chiffon over opaque silk dress

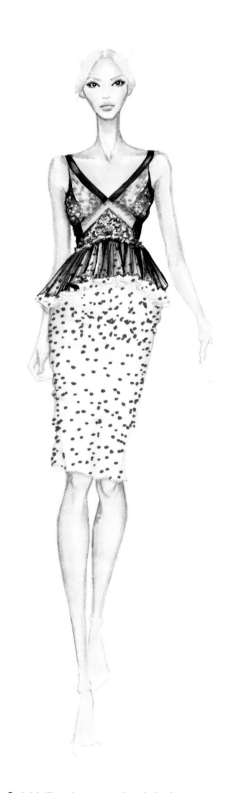

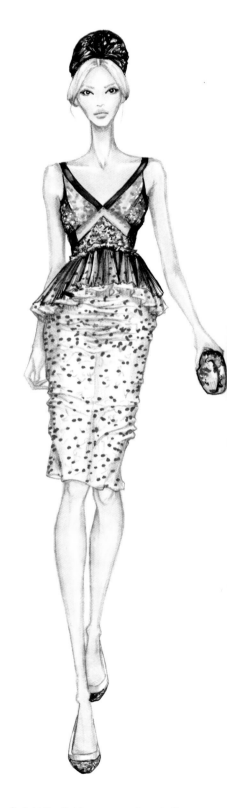

Step 1. Draw the outline of the dress and fill in the skin tone. Note that the fabric of the peplum is gathered into small folds from the seam at the waist.

Step 2. Add diluted cream-colored shadows around the sides of the skirt and between the legs to express the body underneath and diluted black shadow around the bust. Add shadows inside the tiny folds of the skirt, the peplum and the bust. Finally add scattered dots of blue and green to the skirt and bodice to create the effect of shine and detail.

Step 3. Add the light orange pattern to the skirt. Add shading to define the drape below the peplum and at the sides of the legs. This gives a value contrast with the rest of the skirt and accentuates the appearance of it being a shiny print.

garments on the figure step-by-step

evening/structured silk print jacket

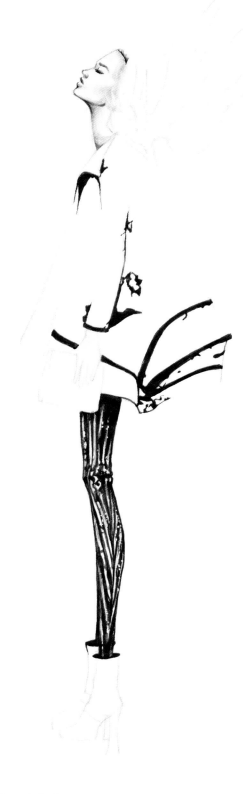

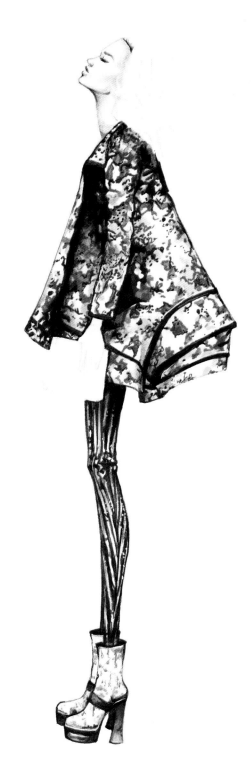

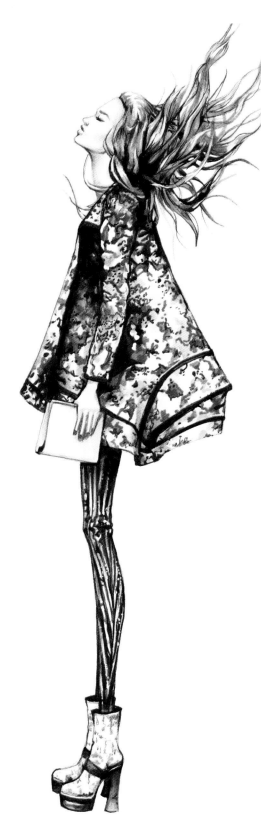

Step 1. Outline garments noting the jacket's triangular profile. The thin shape of the legs, the print of the leggings and the shape and texture of the hair contrast with the shape and smooth shiny surface of the jacket.

Step 2. Clearly identify the direction of the light source and start building up the print around the white highlight on the back of the jacket. Use black to indicate the shadows under the arm and lapel–this gives a value contrast that makes the garment look shiny.

Step 3. Fill in the hair and the bag.

garments on the figure step-by-step

evening/black and white/ velvet and satin evening dress

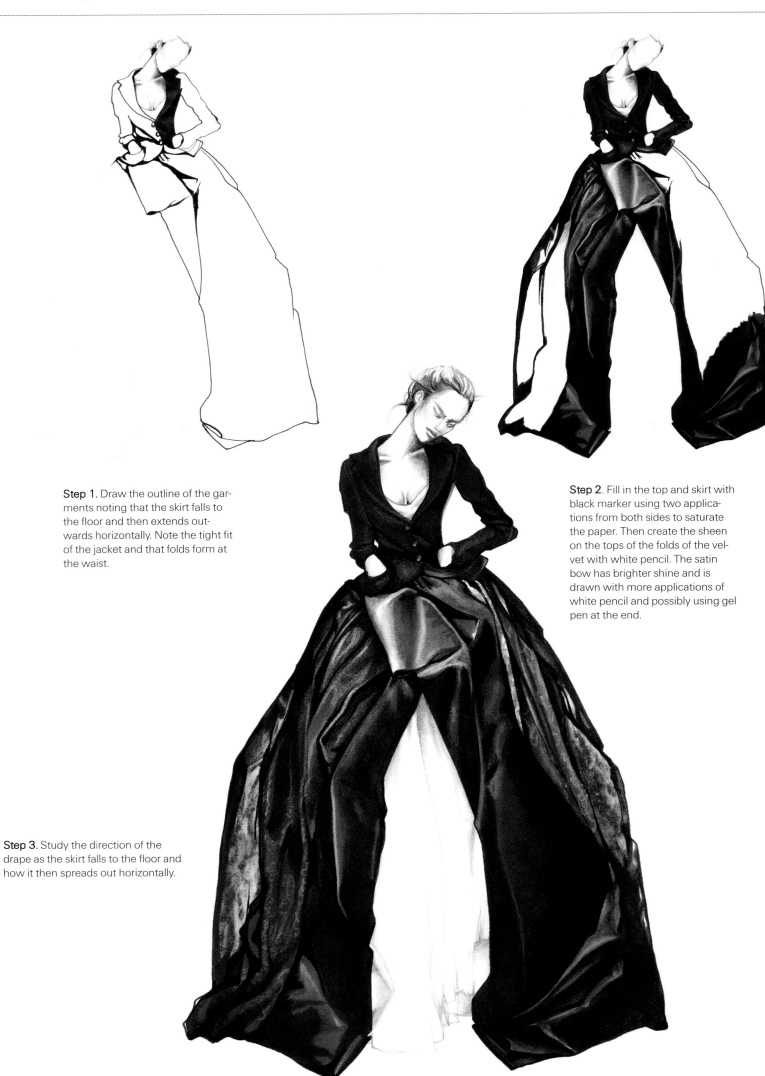

Step 1. Draw the outline of the garments noting that the skirt falls to the floor and then extends outwards horizontally. Note the tight fit of the jacket and that folds form at the waist.

Step 2. Fill in the top and skirt with black marker using two applications from both sides to saturate the paper. Then create the sheen on the tops of the folds of the velvet with white pencil. The satin bow has brighter shine and is drawn with more applications of white pencil and possibly using gel pen at the end.

Step 3. Study the direction of the drape as the skirt falls to the floor and how it then spreads out horizontally.

garments on the figure step-by-step

evening/silk jersey dress with capelet

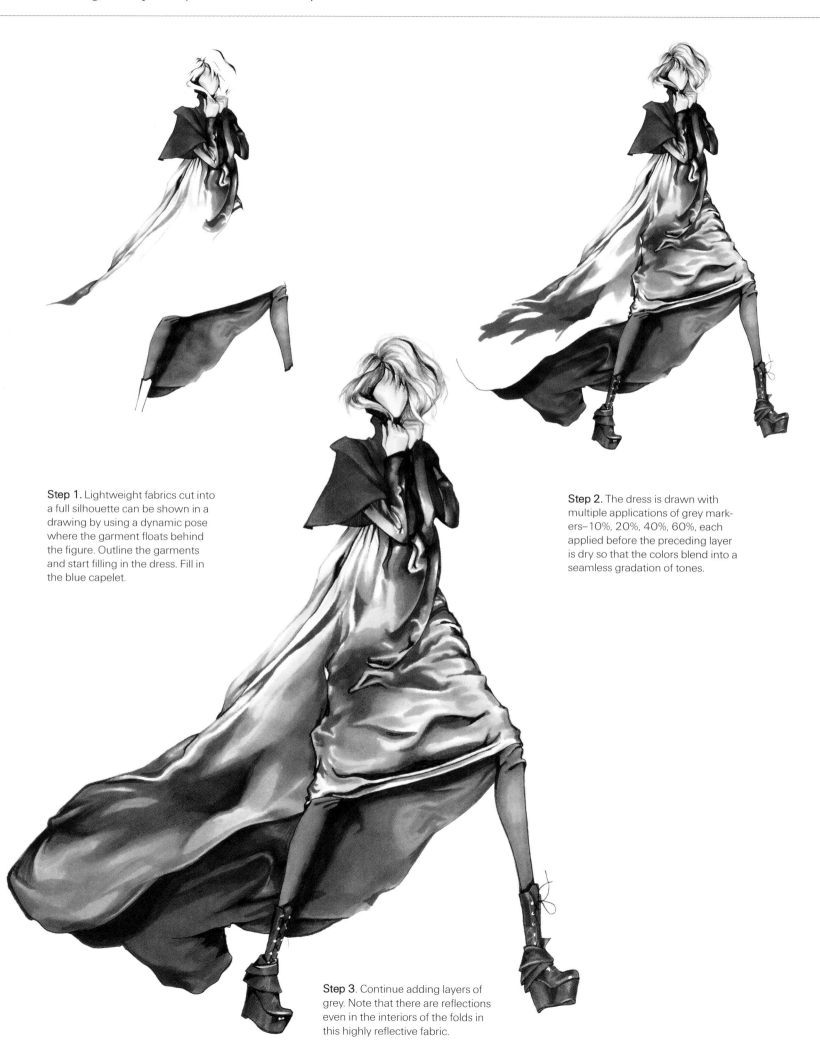

Step 1. Lightweight fabrics cut into a full silhouette can be shown in a drawing by using a dynamic pose where the garment floats behind the figure. Outline the garments and start filling in the dress. Fill in the blue capelet.

Step 2. The dress is drawn with multiple applications of grey markers–10%, 20%, 40%, 60%, each applied before the preceding layer is dry so that the colors blend into a seamless gradation of tones.

Step 3. Continue adding layers of grey. Note that there are reflections even in the interiors of the folds in this highly reflective fabric.

garments on the figure step-by-step

evening/wool jacket and skirt

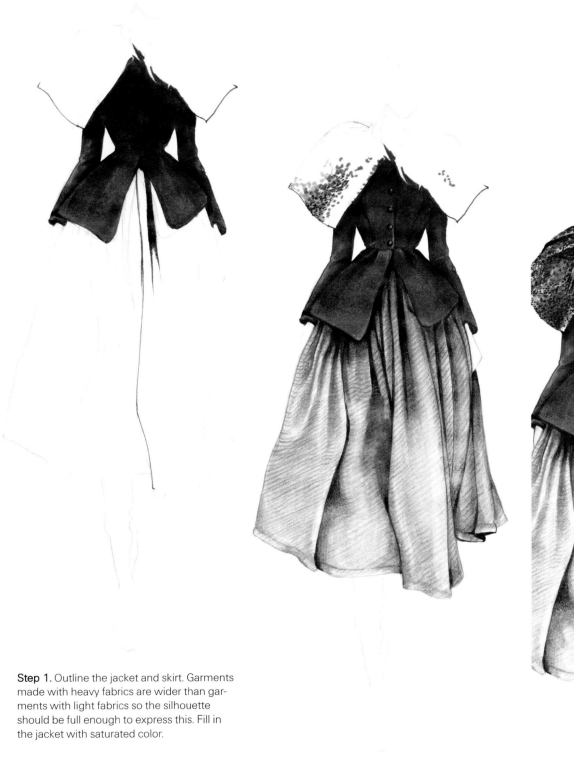
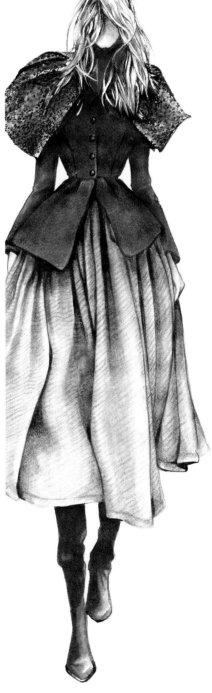

Step 1. Outline the jacket and skirt. Garments made with heavy fabrics are wider than garments with light fabrics so the silhouette should be full enough to express this. Fill in the jacket with saturated color.

Step 2. This soft fabric has rounded shadows in rounded folds. After making the base application of beige in the skirt add soft shadows with a brown pencil in the interior of the folds. Note that the edges of the garment are soft so pencil can be used right up to the edge. The jacket casts a wide shadow on the skirt. Add the pattern on the capelet with markers using a stippling effect.

Step 3. Finish off the hair and boots.

garments on the figure step-by-step

evening/printed minidress

Step 1. Draw the silhouette of the garment. The skin tone is theatrically colored to complement the colors in the garment. Make a first application of diluted cream, purple and black markers for the skin tone.

Step 2. The detail of the print appears to sit on top of applications of washes of diluted blue, turquoise, and yellow. Apply those first in the respective areas of the garment then define the pattern of the print with black marker. Begin to add the additional accent colors.

Step 3. Complete the print, adding the remaining accent colors, noting how it bends around the arm. Finish off hair and skin tone.

garments on the figure step-by-step

prints/men's and women's separates

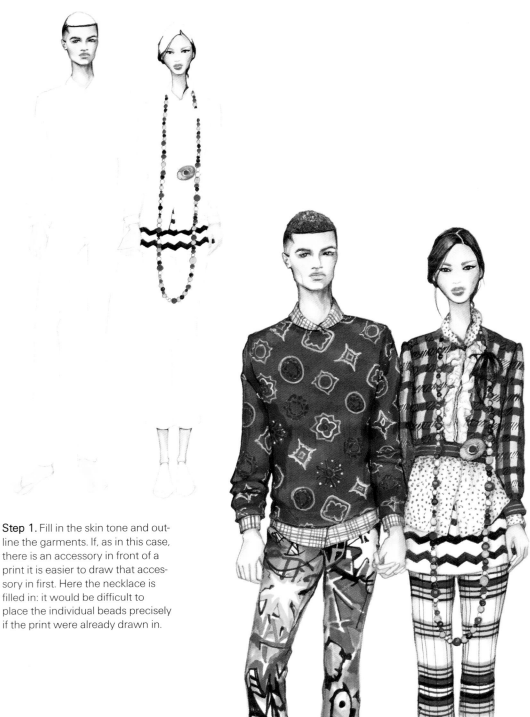

Step 1. Fill in the skin tone and outline the garments. If, as in this case, there is an accessory in front of a print it is easier to draw that accessory in first. Here the necklace is filled in: it would be difficult to place the individual beads precisely if the print were already drawn in.

Step 2. It is easiest in this case to draw in the solid background of the man's sweater and then add the colors of the pattern with pencils and white gel pen. For the woman's outfit, the larger stripes of the plaid of the jacket can be defined first as can the stripes on the pants. Remember to scale down the print by holding it next to the body—between the shoulders works well—and seeing how many pattern repeats are needed to cover that distance.

Step 3. The graffiti print on the man's pants is more organic—it does not repeat—so does not require careful planning. Fill in with primary colors and black marker for background. For the woman's pants also remember to make the print repeat the correct scale—the fabric can be held against the leg to see how many repeats fit in.

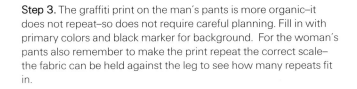

garments on the figure step-by-step

prints/ women's separates

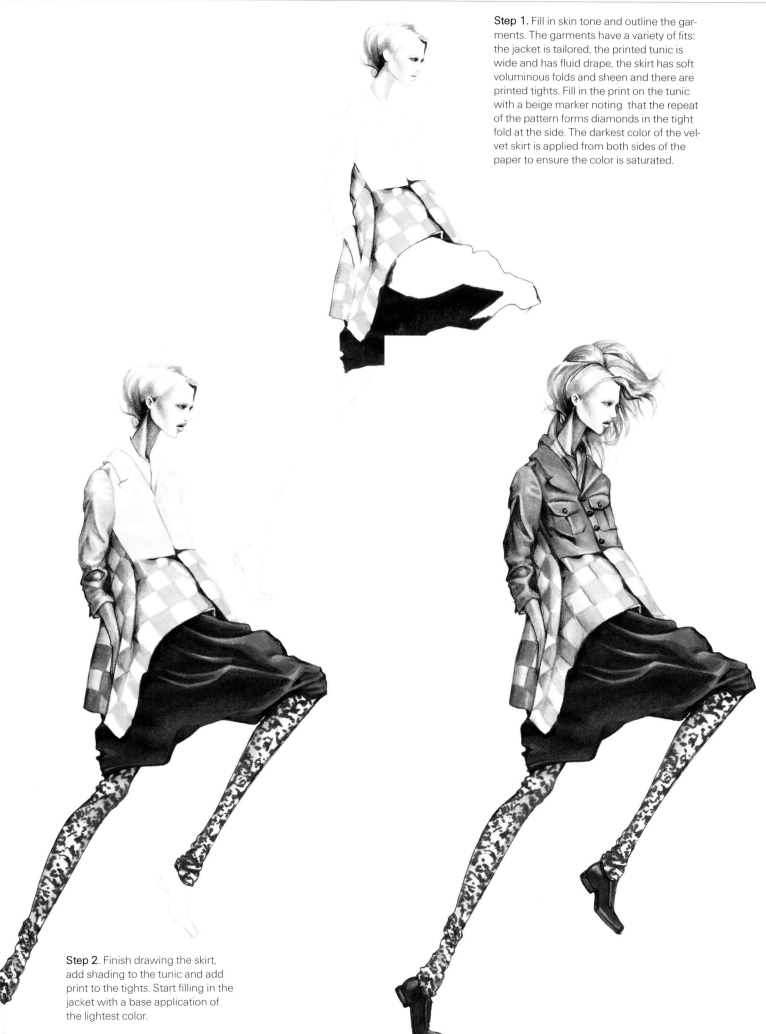

Step 1. Fill in skin tone and outline the garments. The garments have a variety of fits: the jacket is tailored, the printed tunic is wide and has fluid drape, the skirt has soft voluminous folds and sheen and there are printed tights. Fill in the print on the tunic with a beige marker noting that the repeat of the pattern forms diamonds in the tight fold at the side. The darkest color of the velvet skirt is applied from both sides of the paper to ensure the color is saturated.

Step 2. Finish drawing the skirt, add shading to the tunic and add print to the tights. Start filling in the jacket with a base application of the lightest color.

245

garments on the figure step-by-step

prints/printed coat/pants

Step 1. Fill in the base color of the coat, color of lining and sleeves, draw in the face and skin tone.

Step 2. This is a tailored garment, the fabric has considerable body with few folds so the pattern of the print sits almost undistorted by drape–it can in fact be draw as a grid using a ruler–use colored pencils and work from top to bottom. The shadows are drawn in around the print after it has been applied (if added before this fine print is drawn in they will overpower the print). If pressed for time it is not necessary to draw in the whole print–draw in about one-third of the print on the side that is in shadow and let it fade away in the light.

Step 3. Print is added to the pants– a green base color is applied, black pen and then white gel pen are used for the print. Fill in the hair and bag. The soft hair adds an interesting contrast to the rigid contours of the garments and bag.

garments on the figure step-by-step

prints/graphic print full skirt

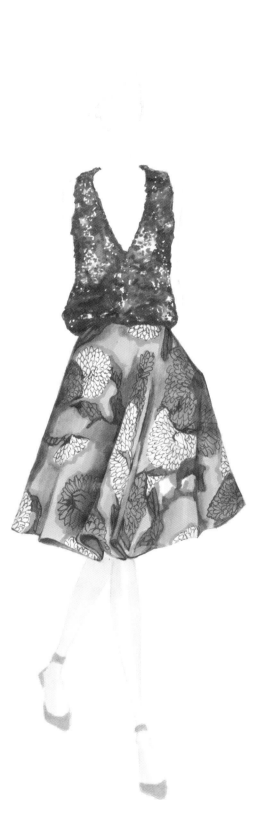

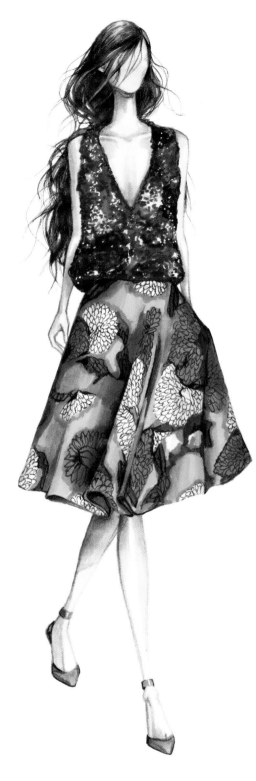

Step 3. Add hair and remaining skin tone.

Step 2. Apply shadows and finer detail over the print of the skirt with the thin point of the marker and colored pencils. Fill in the top with markers using a stippling technique–repeated tapping strokes–also from light to dark. Add skin tone.

Step 1. Outline the garments noting how the fabric bends around the multiple folds. Fill in the graphic shapes of the skirt with marker working from light to dark.

ruben alterio

accessories

hats

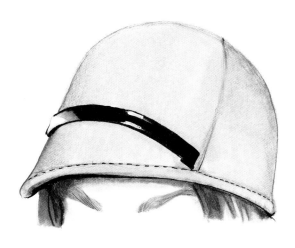

Vintage cloche with small brim, band and floral sprig. note that the band and the crown are subtely shaded to appear 3 dimensional. The brim extends beyond the eyes and casts a shadow on the face. The interior of the hat is very dark.

Close-fitting felt hat. Note this hat fits close to the skull. Felt is a matt fabric and is drawn with subtle gradations of tone.

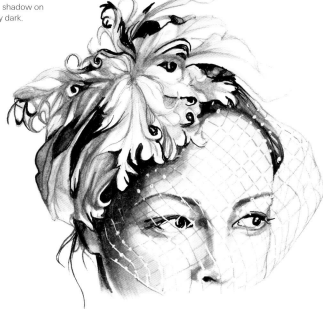

Floral hat with veil. This has to be drawn with a fine touch and very sharp pencil or pen. The upper leaves cast shadows onto the lower leaves which in turn cast shadows onto the face

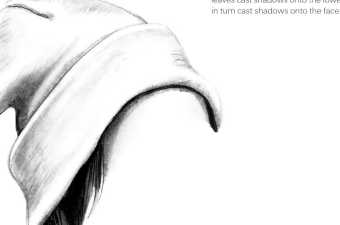

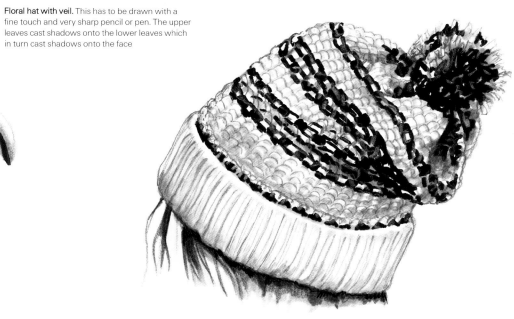

Beanie. A tight knit cut and sewn fabric. Note the fabric curls to form rounded edges and drapes where there is excess at the back of the hat. The thickness of the fabric is indicated by the wide white highlights around the edges.

Knitted woolen hat with pompom. Note the excess fabric in the crown of the hat drapes into folds and the stripes disappear into those folds. The ribbed band bends around the head.

accessories

bags/shoes

Satin high heels. Satin is drawn using three or four different values of marker, applied from light to dark. Identify first the direction of the light source. Each part of the shoe is shaded as a different form: the heel is a sphere so it is shaded as though seeing part of a sphere; the ankle strap is shaded as a cylinder and the toes is triangular funnel shape. The shoes are in two planes–the top and the side. The light bounces off the edge where the two planes meet.

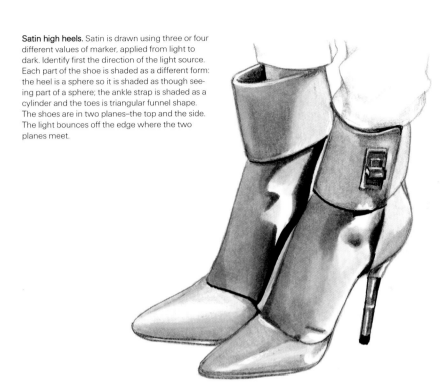

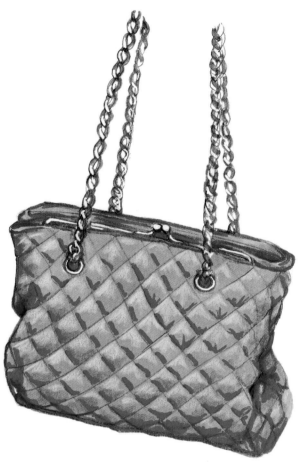

Quilted purse with gold chain handles. Fill in the bag with marker and create the appearance of the quilt with applications of black and white pencil on top. The gold chain is drawn in a similar manner using an ochre base color and black pen to show the shadows and white pencil for the highlights of the chain.

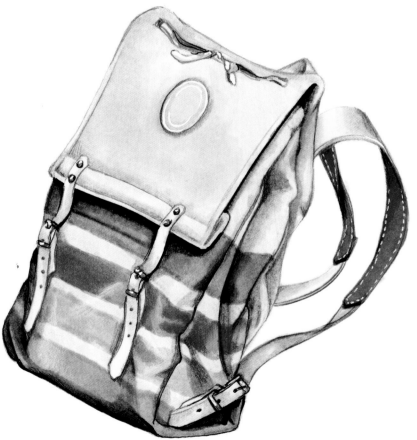

Canvas back pack. This is drawn with markers, carefully drawing the shapes and using colored pencil to add shadows between each layer and under the straps to give dimension.

accessories

bags

Evening clutch of shiny gold fabric. This clutch has a wide range of values from the white highlights on the surface of the drape and the clasp to black in the deepest parts of the folds. Bags are best shown in three-quarter view so fronts and sides can be seen.

Canvas messenger bag with leather handles and shoulder strap. The soft folds in the top, sides and front of the bag are shown with a very diluted grey. Lettering on the bag is applied with pencil and then smudged slightly with blender. Straps and handles are filled in with marker in multiple layers of marker and highlights shown with white pencil.

Leather tote. This is drawn with an application of light brown marker with slightly darker value pencil used to shade and create the subtle texture of leather. Highlights are added on the tops of the folds with a gel pen.

accessories

clutch, brooch, earring, cuff, necklace, tiara

Green suede clutch with jewel embellishments. Draw the bag carefully and fill in with green leaving the areas where the embellishments will appear unmarked. Build up the jewels by filling in each jewel with a light color except for the highlights around the edges and adding a darker color for shadow. Pay attention to the shape of the shadow which will have the same shape as the jewel. Define all the facets of the jewels and chain with an .005 pen. Add a little black around the edge of the purse to show dimension.

Tiara. This is drawn in the same way as the brooch above right.

Brooch. Outline the many spheres of the brooch and then add light color–warm grey– to create rounded shadows around a highlight for each sphere. If desired white highlights can be added with gel pen. The dark shadows where the lines of beads are separated are drawn in with dark marker. The edges of the beads are drawn in with .005 pen.

Earring. The gold of these Rococo earrings is created by combining a number of colors ranging from gold to ocher to brown for the deeper shadows. Highlights can be applied using a yellow gel pen. The gems are drawn by making an application of black marker and then applying teal blue and white pencil on top.

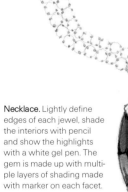

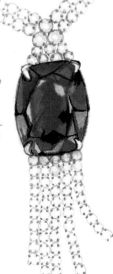

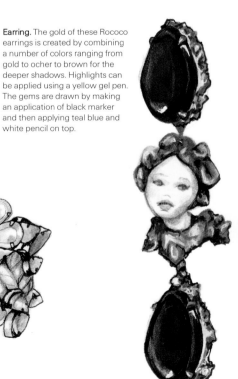

Necklace. Lightly define edges of each jewel, shade the interiors with pencil and show the highlights with a white gel pen. The gem is made up with multiple layers of shading made with marker on each facet. The prongs holding the gem in place have reflections drawn in with white gel pen.

Jeweled cuff. First carefully draw the outside shapes of each jewel with pencil and the inside shapes with a lighter pencil. Define the light source and draw in the shadows on the opposite side using a number of pastel colors, leaving the white of the paper to show the highlights on the light side. Like the jewels in the brooch this is drawn using multiple layers of color to create the shadows seen on the opposite side from the light. Define the claw-like prongs that hold the stones in place with a .005 pen.

accessories

eye glasses

Round horn-rimmed glasses. This three-quarter view clearly shows the fit of the glasses–they sit away from the face and tilt diagonally into the cheek. The shadows are drawn with light brown marker. The reflection through the lenses onto the skin is drawn with a very diluted yellow marker. Note the edge of the lens is defined with a sharp line–it makes it appear more solid.

Round or Lloyd glasses with colored lens. The eyes are drawn in first and then the color of the lenses applied with a light touch using colored pencil. A light application of pencil results in a transparent effect that tints the eyes but does not obscure them. Cast shadows help to create the illusion of dimension–that the glasses are sitting away from the face

Lolita glasses. Here the lenses are opaque–the eyes cannot be seen under them. Frames are drawn with markers. The lenses are drawn with diluted marker which gives the watercolor effect.

Lacquered cat eye with colored lenses. The left part of the lens and frame show the reflection of a nearby window drawn by leaving the white of the paper unmarked and using light grey fine-pointed marker or pencil. The violet shadows are blended marker.

Cat eye with tortoise shell frame and colored lenses, The lenses are drawn in very lightly with colored pencil.

accessories/shoes

ruben alterio

accessories

shoes

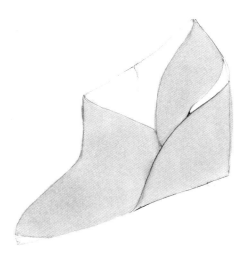

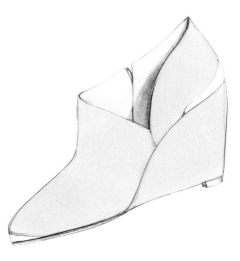

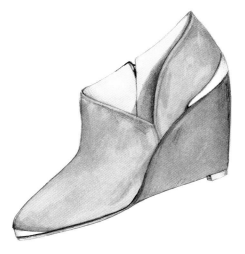

Suede wedge bootie 1. Draw silhouette. Many shoes are shown in 3/4 view as it gives information on the heel height, the shape of the front of the shoe and the interior. Fill in with first application of marker.

Suede wedge bootie 2. Add interior color with cast shadow,color of heal and sole.Add light applications of white and taupe pencil to create the appearance of the suede.

Suede wedge bootie 3. Add light applications of white and taupe pencil to create the appearance of the suede.

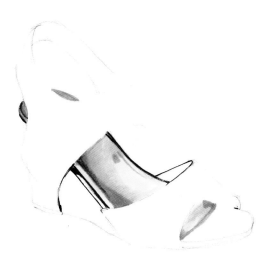

Open toe sling-back embossed leather and wood sandal 1. .Draw the outline. Make sure every area of the shoe bends properly, aligning the front ellipses of the toe band with the with the straps at the back of the foot

Open toe sling-back embossed leather and wood sandal 2. Add color of wedge, add cast shadows and define buckle.

Open toe sling-back embossed leather and wood sandal 3. Fill in the base color of the top surface of the leather with a brown marker and draw in the pattern of the embossing with a pen.

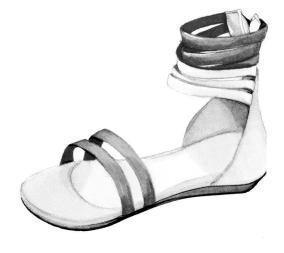

Flat sandal with ankle strap 1. Draw the outline of the shoe in three-quarter view indicating the ellipses of the straps. Fill in the straps. Note the high point of the toe straps in this view is on the left and also that a second line is drawn to indicate the thickness of the sole.

Flat sandal with ankle strap 2. Fill in the color of the insole and heel with beige marker. Add shading to the inside of the heel.

Flat sandal with ankle strap 3. Add a second layer of color to the sole to indicate the cast shadows from the straps and the heel. Complete coloring of the ankle straps, the bottom of the sole and the leather strap at the back of the ankle.

accessories

shoes/running shoes/loafers

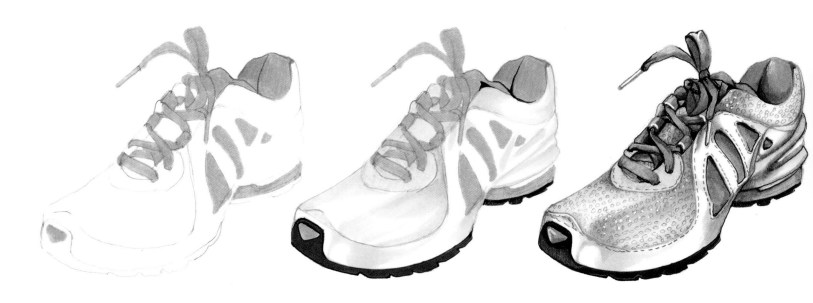

running shoe 1. Carefully draw in the outline of the shoe in three-quarter view which allows a clear view of the toe, upper, sole and inside of the heel. Note that all areas of the shoe bend around the foot. Fill in the blue areas of the shoe with a marker.

running shoe 2. Add shadows with a grey marker. Fill in the the sole and toe detail.

running shoe 3. Add the stitching and perforation details with grey marker. Shadows in the interior of the shoe and under the laces are added using black marker.

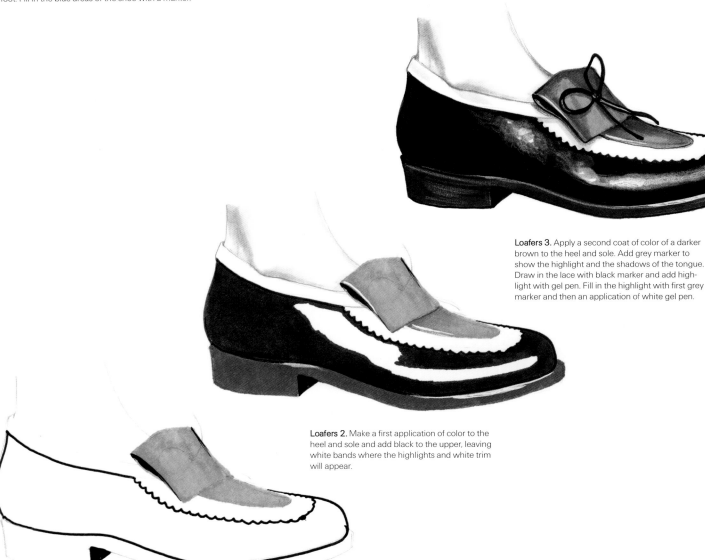

Loafers 3. Apply a second coat of color of a darker brown to the heel and sole. Add grey marker to show the highlight and the shadows of the tongue. Draw in the lace with black marker and add highlight with gel pen. Fill in the highlight with first grey marker and then an application of white gel pen.

Loafers 2. Make a first application of color to the heel and sole and add black to the upper, leaving white bands where the highlights and white trim will appear.

Loafers 1. Outline the side view of the shoe. When drawing solid black areas it is a good idea to draw the outline first–it shows the area to be filled in and how far to go–errors with black are difficult to correct. Add color to the extended tongue.

accessories

shoes/perforated leather flat/high lace

Perforated leather flat 1.
This view is chosen so the perforation design can be clearly seen. Add a first application of color to the shoe.

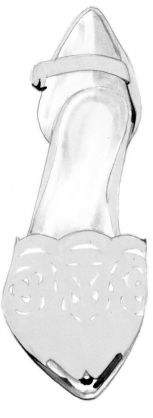

Perforated leather flat 2.
Add diluted beige marker to the interior of the shoe. Make a second and third application of the same color to indicate shadows. A second coat of light green is applied to the body of the shoe and the toe cap drawn with grey and black marker.

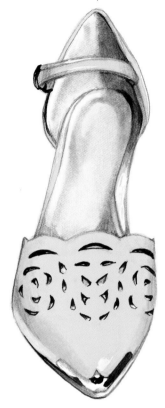

Perforated leather flat 3.
Shadows are applied to the interior of the heel and to define the perforations and the shadow along the side of the shoe using blended black pencil.

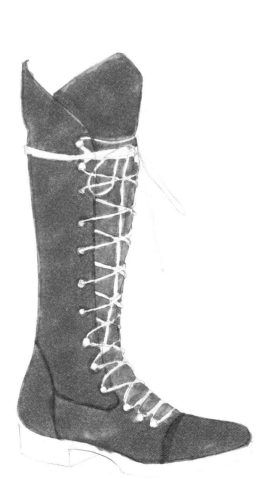

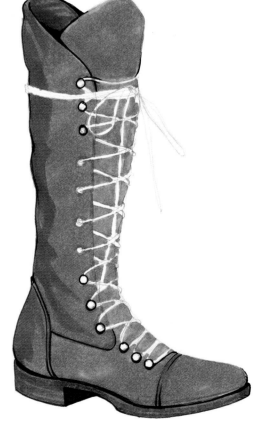

High lace-up leather boot 2. Define the heel and sole, the seams and the interior with brown and black marker. Define the eyelets and hooks with a black pencil or .005 pen.

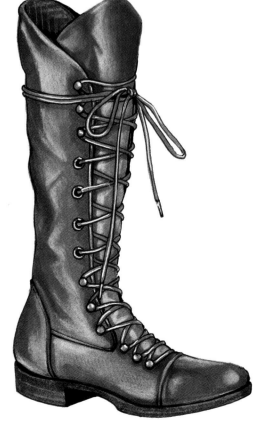

High lace-up leather boot 1. Draw the boot in three-quarter view which allows the details of the laces, the side and the bottom of the boot to be clearly seen. Carefully fill in the boot using a light brown marker leaving the white of the paper for the laces. Alternatively fill in the whole boot, planning to draw in the laces afterwards with marker and gel pen.

High lace-up leather boot 3. Add the sheen with white pencil and the shadows with dark brown pencil. The laces and hooks are filled in with brown marker.

257

practice and exercises

Beginners

1. (i) Copy a figure from this chapter that has simple garments.. Add a belt, necklace and change the shoes. This exercise is to learn that garments fit round the figure. (ii) Copy the same croquis and add the silhouette of a jacket and skirt. (iii) Copy the same croquis, add the silhouette of a jacket and skirt, and add shading. (iv) Copy the same croquis and silhouette, add color, shading and texture (this could be lace, fur, corduroy, beaded paillettes or quilting).

2. (i) Draw the silhouette of any of the garments in this chapter and fill in with markers to create flat colors. (ii) Using the same silhouette, divide into two sections, head and torso and legs. FIll in the head and torso with a floral pattern ignoring the facial and body features. Fill in the legs with a plaid pattern.

3.Take the silhouette of (i) a jacket and pants, (ii) a full skirt ,(iii) a party skirt. Fill in the silhouette with one of the following design patterns: (i) stripes,. (ii) animals,. (iii) musical notes. The silhouette can be two- or three-dimensional, draped or flat. The drawing can be embellished with images of choice as background elements.

4. Draw a lace bathing suit.

5. Draw three jackets on croquis, the first made from corduroy, the second from tweed and the third with a Prince of Wales pattern.

6. Draw an outfit consisting of a hand-knitted sweater and jeans, using cable and popcorn stitching in the sweater (see Chapter Three for references).

7. Draw your wedding dress or outfit then draw your bridesmaids' (or wife-to-be's bridesmaids') dresses.

8. Draw a simple black skirt with a white trim and a white blouse with a black trim.

9. Copy a picture of a hat and add a rose.

10. Copy a picture of a handbag and change the colors.

Advanced

11. Draw an outfit with a floral printed blouse and an iridescent silk jacket and pants.

12. Using ten different printed fabrics draw two ensembles (prints may be used in any area of the garments including lining, trims, buttons or accessories).

13. Draw (i) a lace nightgown, (ii) a satin wedding dress, (iii) a quilted jacket and wool pants for a wedding trousseau (the bride's honeymoon wardrobe).

14. Draw three bathing suits with graphic prints using cartoon characters, faces of well-known personalities or exotic animals.

practice and exercises

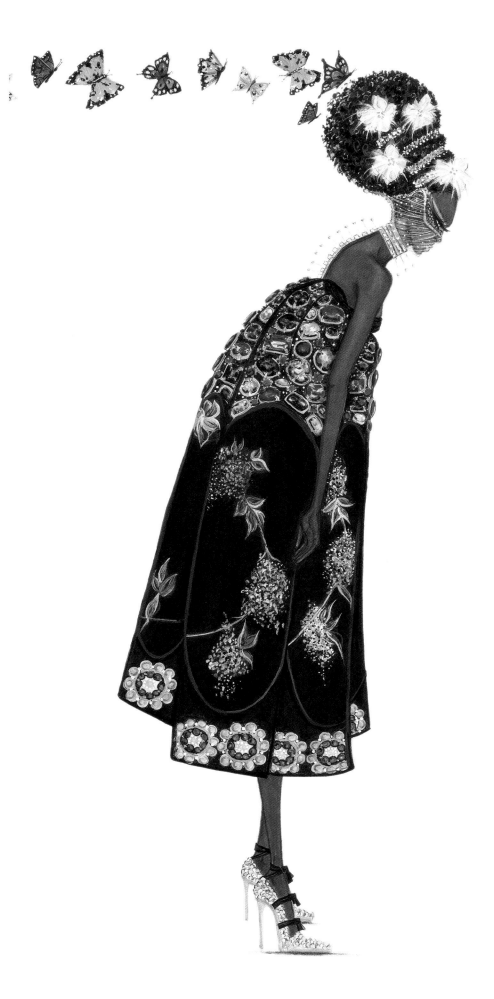

15. Copy the silhouette of the Yohji Yamamoto jacket and full skirt from this chapter and fill in with a different print.

16. Draw an evening gown encrusted with jewels.

17. Draw two jackets for a cold climate with fur accents.

18. Draw a pant suit made from heavy silk fabric and accessorize with satin items.

19. Using an active pose, draw the silhouettes of (i) blouse and pants on the croquis, and (ii) the silhouettes of active sportswear garments. Fill in both drawings with marker and shade with pencil.

20. Draw a cocktail dress made of (i) a matt fabric, (ii) a fabric with a sheen and (iii) a fabric with shine.

21. Draw night-club outfits showing fabrics with (i) a fringe, and (ii) sequins.

22. Spot a trend in a fashion magazine—it could be patterns, texture, accessories or a silhouette—and tear out the photo. (i) Trace the image to learn the silhouette. (ii) Translate the photo into a nine-head drawing, copying the details exactly using markers and colored pencils. (iii) The same as (ii) but changing the details—the buttons, hem, size of sleeves, pockets, trims.

23. Using a croquis from the this chapter draw an outfit inspired by a swatch of fabric.

24. Take any garment from this chapter and re-draw in a different fabric (though one still suitble for the garment). Indicate in the drawing where the silhouette, drape and shading are diferent from the original version of the garment.

25. Draw three croquis and design simple outfits. Add a total of 15 accessories to the three figures.

26. Using the section in this chapter on accessories for reference, draw a shoe, a purse and jewelry for (i) a wedding, (ii) the beach, (iii) a nightclub.

27. Draw shoes for (i) a movie star, (ii) a business executive, (iii) an Olympic athlete.

28. Draw a range of accessories for a woman and, keeping the silhouettes the same, change colors, fabric and styling to make them suitable for a child.

CHAPTER SEVEN

MEN'S FASHION

trends in men's fashion/selection of garments

single-breasted suit

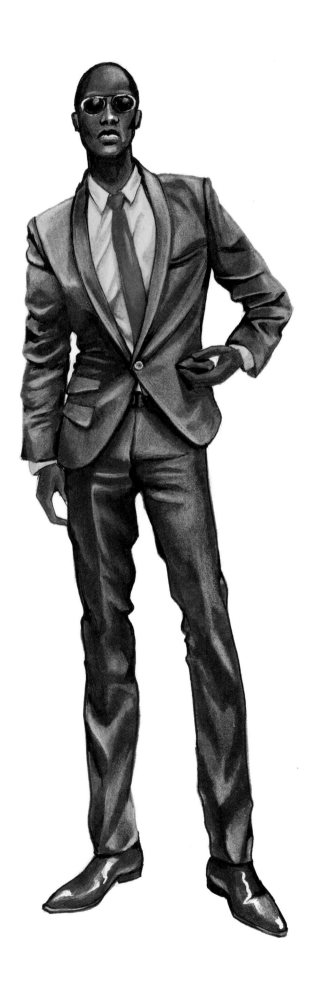

Trends in Mens' Fashion

"Menswear has undergone a quiet, though seismic, revolution in the last decade. The combination of technological innovation and demographic shifts has brought forth a new male consumer who is acutely aware of fashion. The Internet has not only provided easy access to global style information and increased awareness of previously elitist markets but also provided a platform for peer-to-peer communication via social networking. Those two factors have made it possible for men everywhere to become informed about designer-driven shifts in silhouette, textile and color.

The increasing awareness and influence of designers and luxury labels despite global economic uncertainty is indicative of a major change in the male consumer mind-set. Demographic shifts in terms of generational and nationalistic statistics reveal that a younger male is more eager to adopt changes and the traditional business/leisure mode of the affluent Caucasion male is no longer the aspirational motivator. The entertainment arena has become increasingly influential. Active sportswear and the techno textiles it demands is forecast as the next big movement in menswear. "
David Wolfe, Creative Director, The Doneger Group.

While men's fashion is changing, as the above quote makes clear, the traditional suit, jacket, pant, shirt and tie are still much in evidence. The ranges of those staples, however, have been broadened out of all recognition by the introduction of new fabrics, new colors, new tailoring styles and a wealth of new accessories. Variations of those garments, previously seen mainly in formal settings in decades when life as a whole was more formal, have come to be increasingly accepted as casual wear. The clear dividing lines between men's formal and casual wear have started to blur, and it is now common to see a formal suit worn with a t-shirt, or a pair of jeans with a tailored jacket. A number of examples of these smart/casual outfits are included in this section.

Selection of Garments in this chapter

The selection of garments included in this chapter does not attempt to be exhaustive: the clothes are different, but many of the techniques covered in drawing women's fashion are used in drawing men's fashion and do not have to be repeated here. Examples are included, though, that emphasize the most important aspects of drawing men's fashion, which are the same as for women's fashion: the emphasis on drawing the fabric correctly, showing how a garment fits–the way pants pull from the knee and the hems fall over the shoes for example; showing the lighting of the figure in a clear and consistent way.

The garments that *are* included range from loose-fitting sports garments and casual garments to tailored garments of structured construction. A variety of fabric has been shown of different weights from light summer wear to heavy cold weather wear and different surface appearances from matt to shiny,

men's poses/body features and proportions

demetrios psillos

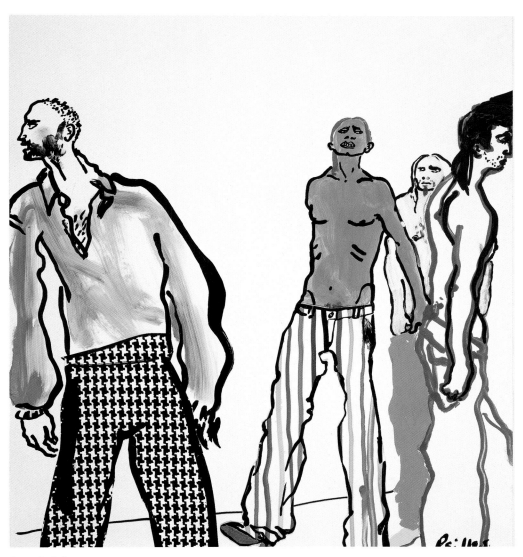

Demetrios Psillos
Male Fashion Show

Men v Women

The main difference between men's and women's fashion, of course, stems from the fact that men's and women's bodies have different shapes and proportions and to be accurate the garments must reflect these differences. Even at an advanced level of fashion drawing, particularly if one is used to drawing women's fashion more than men's, it is easy to feminize parts of the body or face, resulting in a distorted representation of both the clothes and the body underneath.

Men are, in general, flat and angular: shoulders, foreheads, chins, jaws, hands, feet and the silhouette are based on straight lines and squares; lips are not as full. Note that for men, the width of the shoulders is two heads, the waist is at 3 ¼ heads (lower than for women), the hips are narrow and boxy—1 ¼ heads as opposed to 1 ½ for women. If one's drawings of men look insufficiently masculine it is worth reviewing the main differences in the male versus female croquis in *9 Heads —a guide to drawing fashion* or other sources.

Poses

It is also important to bear in mind that "body language"— physical expressions of the figure such as looks, poses, body language— is very different between the sexes and also develops over time in the same way as linguistic expressions or fashion itself. Mens' poses are graceful and natural, but in general are more solid than women's; often the legs are apart, suggesting strength and an aggressive attitude and there is little pivoting of the hips.

For men in particular, the new ranges of clothing—active sportswear especially—mean that new poses can (and should) be explored in order to show off the full range of garments and fabrics. Simple, upright poses are often still appropriate for a number of garments (though overall the poses and attitudes of today are much "looser" than in earlier times) but new, more physical poses can be eye-catching as well as truer to how the garments actually look in use. The garments in this chapter contain a range of poses considered to be appropriate for the type of garment, and the reader is encouraged to experiment with new poses even further.

Styling

Styling is also important: Although there is not usually as much variation as in women—fewer accessories are worn, make up and hair shape and color do not vary as much— men's styling, particularly hair and facial hair, is also always in a state of flux. Overall, unless the figure in a male fashion drawing reflects modern styling and body language then, no matter how chic and contemporary the clothes are, it will appear awkward and dated.

Two Tips

Two simple tips which will avoid common errors when drawing men's fashion are to make sure shirt collars cover necks and to make sure that pant hems almost completely cover shoes.

tailored clothing

single-breasted suit

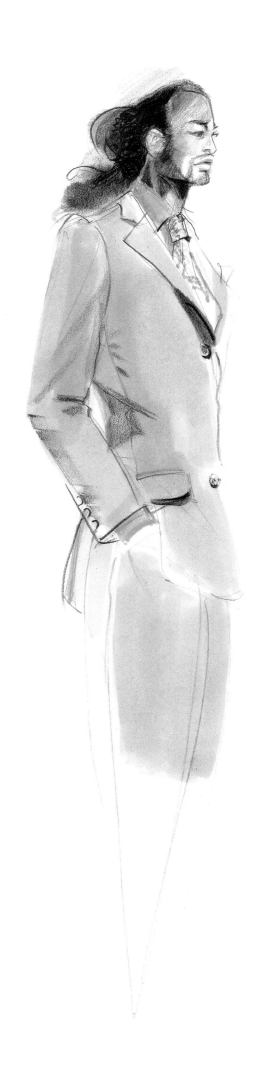

The three-quarter pose reveals a different set of details from the frontal view. As there is some fore-shortening in the three-quarter figure it is easiest to begin the drawing with a well -planned-out croquis, showing the proportions of the figure and where the central axis falls.

Draw the silhouette of the jacket and fill in with pink marker. Shadows are drawn in using the side of a brown colored pencil. The shirt is light blue marker. Hair is drawn with simple shapes and filled in with brown pencil. The face is drawn using brown and black colored pencils.

Skin tone is the same color as the suit, a light pink, applied from the reverse side of the paper. The tie is drawn using the fine points of the blue and pink markers.

tailored clothing

three piece suit

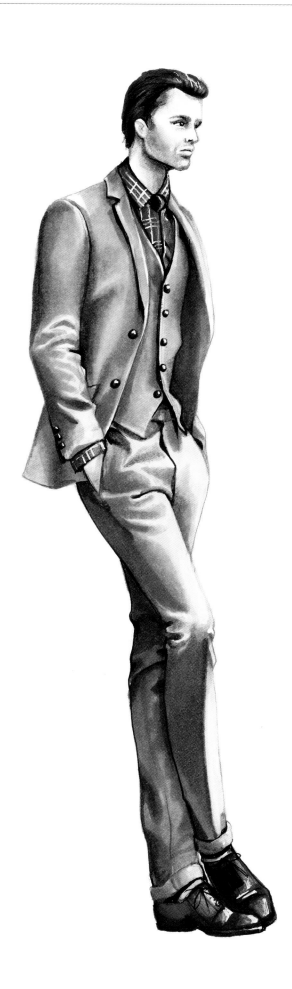

When drawing complex outfits where layering and overlap is involved it is important to show the details of the inside layer garments as well as those of the outer layers. Each layer of this garment casts a shadow on the layer underneath–the jacket on the vest (waistcoat), the vest on the shirt and pants.

Placing the hand in the pocket pulls back the jacket allowing the vest to be seen. Note that the buttons of the vest have to line up with the center-front of the figure; in the three-quarter figure this has to be done carefully. Note also the curve of the pant cuff over the shoe and the shirt cuff seen below the sleeve of the jacket.

mens' separates

soft fabrics/stripes/white, black and grey fabrics

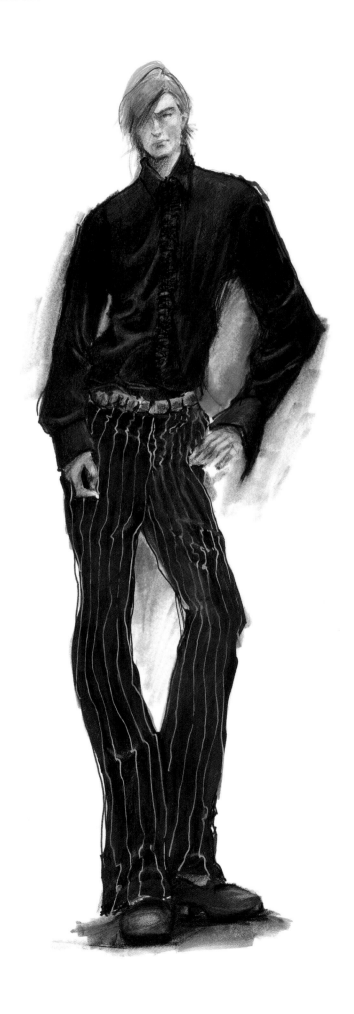

men's separates

soft fabrics/stripes/white, black and grey fabrics

This drawing shows how light stripes are drawn on dark, draped fabrics.

Carefully draw the silhouette of the shirt and pants, noting that the pants are slightly flared. The shirt is filled in with several layers of burgundy marker from the front and reverse sides of the paper. The pants are drawn in the same way with several layers of a dark cool-grey (Step 1). Begin to draw the stripes on one side of the pants with a white pencil. Show the sheen of the shirt using the side of the same pencil and the shine on the belt with the point of the pencil (Step 2).

This drawing is completed using black pencil to define the shadows of the shirt and pants and reinforce the three-dimensionality of the drape. The blended grey used in the pants is applied to the shirt, the belt and the background from the reverse side of the paper, and in the same manner the blended magenta of the shirt is applied to the pants, also from the reverse side. Finish defining the stripes of the pants with the point of a white pencil, bending the stripes in the curves of the drape. Use the side of the pencil to add a sheen to the top of the fold of the drape on the right side.

Hair is filled in with layers of blended orange marker with a darker layer close to the face. The features of the face are drawn with light pink pencil with a second layer of grey applied on top.

Skin tone is drawn in with beige marker applied from the reverse side of the paper, and blended pink is used to highlight the cheekbones. The shoes are filled in with magenta marker with highlights drawn in with white pencil.

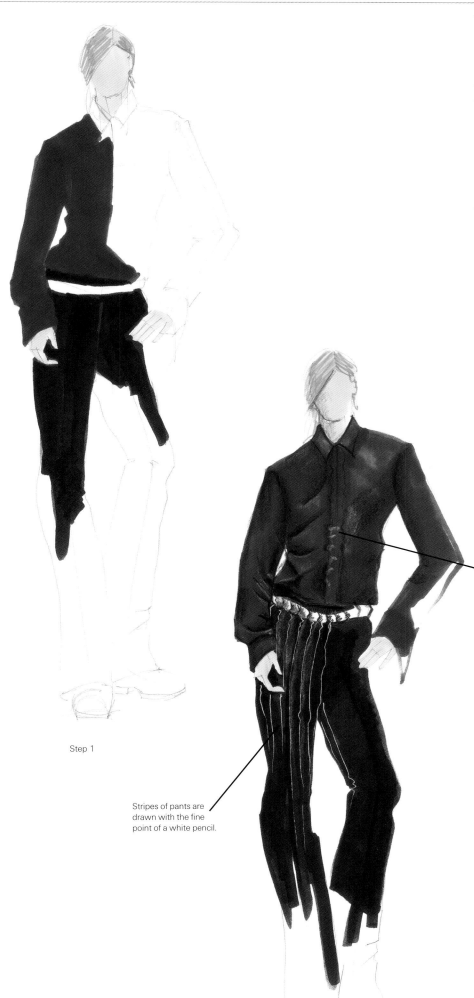

Sheen appears on top of folds and is drawn in with white pencil; shadows appear at the bottoms and are drawn in with black pencil.

Step 1

Stripes of pants are drawn with the fine point of a white pencil.

Step 2

267

street wear

denim/patterned fabrics

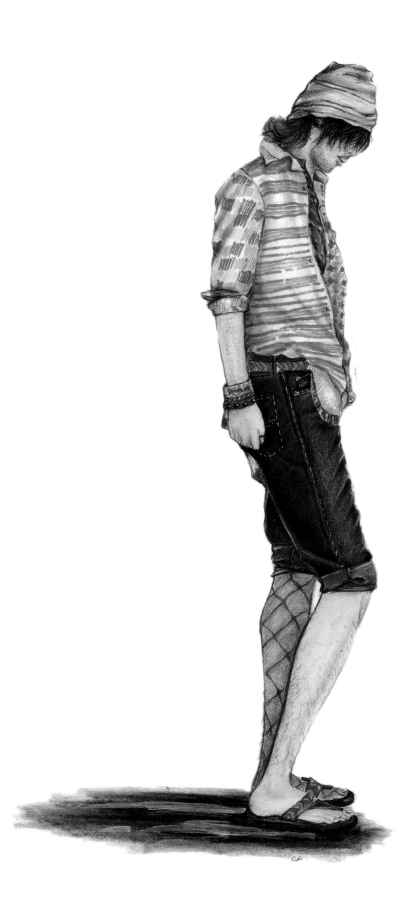

Draw the silhouette of the clothes with a light colored pencil, paying attention to the drape in the hat, the outer shirt and the denim pants.

The shirt is a combination of complex patterns which could look garish and sloppy if not well balanced. Here, however, patterns of different scales are subtly combined to result in a strikingly successful design. The drape of the shirt is shaded with a light-blue colored pencil and the horizontal stripes drawn in, breaking the line of the stripes at the fold to indicate the reflection of light at the highest point. The other stripes are drawn in—the order does not matter as they are all of the same level of saturation—with blended magenta, pink, green and yellow markers.

The sleeve and the interior of the shirt have different patterns but are drawn in the same manner. The collar of the shirt is blended magenta and the t-shirt is filled in with turquoise and red marker. The denim pants are filled in with blue marker with white pencil used on the surface of the folds to show the texture and color of the pants. Note that the lining of the denim is shown where the fabric is reversed at the waist. This is drawn by first applying a light layer of blended blue, and creating the white texture of the reversed denim by drawing a cross hatch pattern with a white pencil. The stocking is drawn with blended magenta and the pattern of the stocking is drawn with magenta pencil. Take care to draw the pattern design of the stocking as a curve around the calf of the leg. The hair is drawn using blended grey, blended blue and blended magenta applied in successive layers to create a luminous effect.

The fabric at the wrist is filled in with turquoise and magenta markers and the shadows are defined with turquoise and magenta colored pencils. The flip-flops are filled in with turquoise and black markers.

Skin tone is beige marker with a second layer of beige marker mixed with pink applied to show the shadows. The stubble of the beard is indicated using grey or brown pencil. The hat is drawn with blended blue marker applied from the reverse side; the shadows of the folds are defined with blue colored pencil and blended light-blue marker.

A cast shadow is finally applied under the body with blended black, magenta, yellow and green marker, with white pencil highlights. This shadow further enhances the textural richness of this drawing.

street wear

wool/layered fabrics

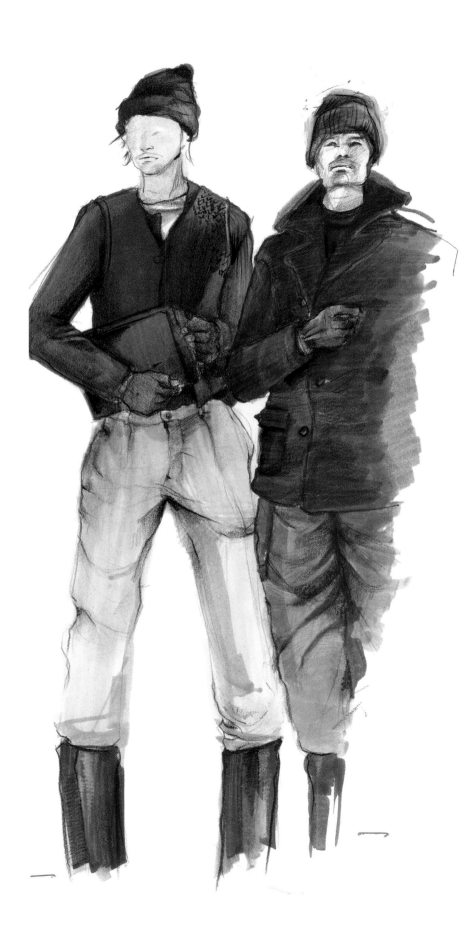

For outdoor activities in cold weather garments are often layered. When layered garments are drawn, the upper garments should be partly open so the garments underneath can be seen.

All of these fabrics are soft and thick, and require mutliple layers of marker. Note the overlapping arms help to unify the composition.

Draw croquis for both figures and the silhouettes of the garments on top. Take great care to show the layers of each garment and how it follows the contours of the body. Fill in each separate garment with a base color—on the left, taupe for the t-shirt, olive green for the vest, beige for the pants; on the right, warm-grey for jacket, sweater and pants, cool-grey for the gloves. Because these fabrics are textured, a second and third layer of a slightly darker value color are added, and a final application of pencil used in all garments to indicate texture. The figure on the right has been left unfinished on the right side so the way in which the layers of marker are built up can be clearly seen.

White pencil is used to bring out highlights on buttons, the hand, the white t-shirt and the edges of the lapel. The gloves and hats are drawn in the same manner.

Skin tone is taken from the base color of the pants for each of the figures, helping to unify the composition of each figure.

street wear

tailored clothing

single-breasted suit

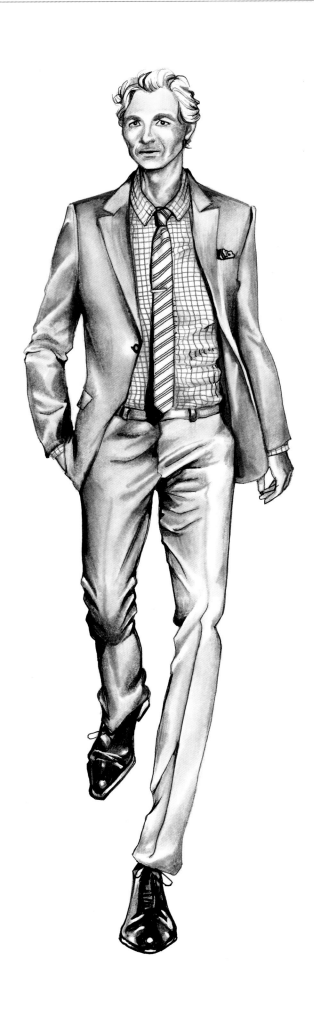

Well-tailored suits have clean lines at the shoulders, lapels and front; drape is seen in the sleeves and legs of the pants. The cap of the sleeve (the vertical seam at the armhole) and the crown of the sleeve (the slight bump at the top where the sleeve fits the body of the jacket) must be carefully drawn to show the precise tailoring.

The folds in the sleeves are drawn with multiple layers of grey markers with the lighter values on the tops and the darker in the interiors. Note that the drape extends from the armhole to the elbow and bends around the lower part of the sleeve. In the pants drape is seen at the crotch, pulling to the knee and from the knee to the ankle. Note the hems skim the tops of the shoes and that there is a crease down the front of the pants. Shadows are present under all the layers of the fabric: the lapels cast a shadow on the body of the jacket and on the shirt, the tie casts a shadow on the shirt and the collar of the shirt has a shadow.

The shirt is first filled in with colored pencil and darker pencil added to show the shadows and the stripes. The tie is drawn with green pencil. The shoes are filled in with black marker and highlights are added with a gel pen.

sportswear/activewear

rugby gear/hiking outfit

Examples of different clothing used for two outdoor activities–rugby and hiking. Note the loose fit of the rugby shirt and shorts that allows for freedom of movement. The hiker is dressed in cool weather gear designed for warmth and protection.

In general with sports and activewear functionality is important–the fabrics are chosen for the right type and degree of protection and fit, often with multiple seams. The garments are usually more rugged and carefully constructed to absorb rougher treatment.

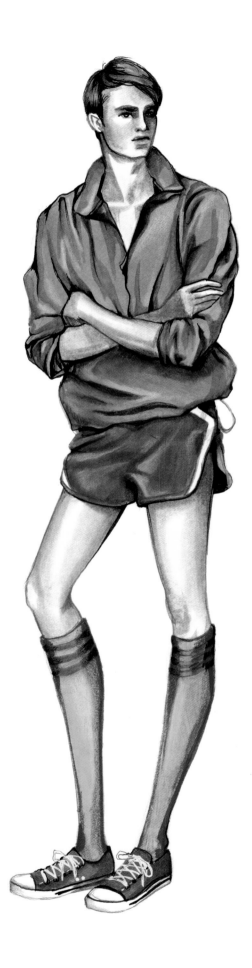
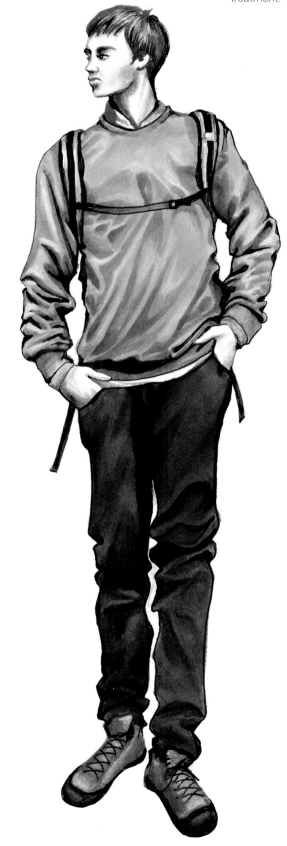

casual separates

tee-shirt, khaki shorts, blazer/leather jacket, cotton pants, shirt, scarf, bag

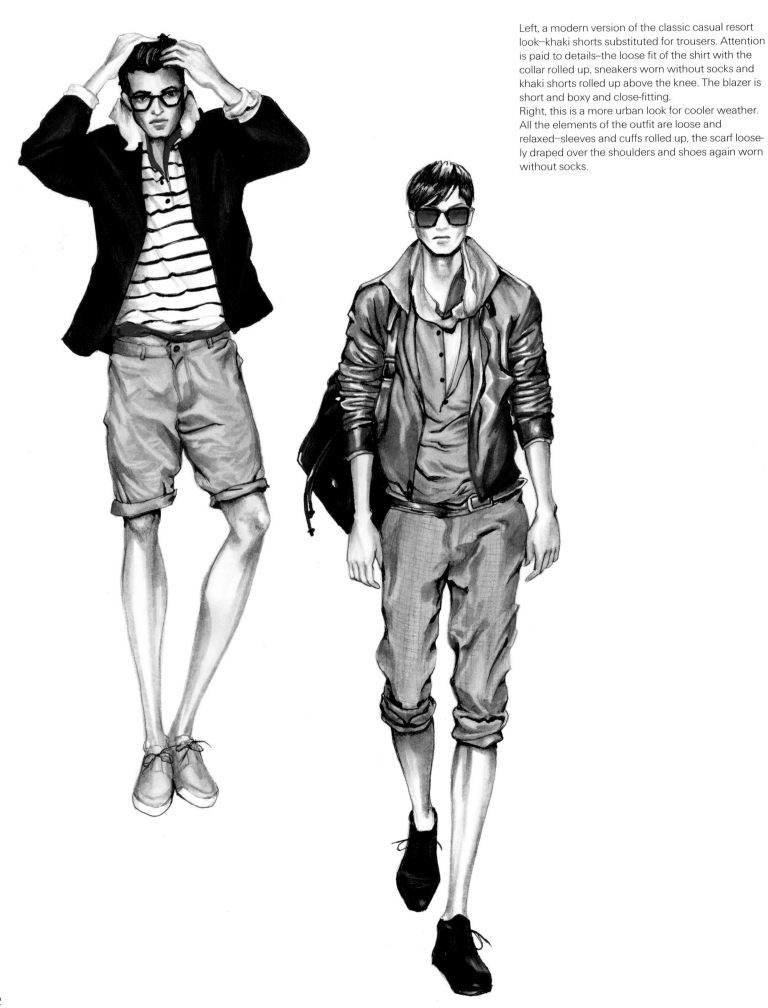

Left, a modern version of the classic casual resort look—khaki shorts substituted for trousers. Attention is paid to details—the loose fit of the shirt with the collar rolled up, sneakers worn without socks and khaki shorts rolled up above the knee. The blazer is short and boxy and close-fitting.
Right, this is a more urban look for cooler weather. All the elements of the outfit are loose and relaxed—sleeves and cuffs rolled up, the scarf loosely draped over the shoulders and shoes again worn without socks.

casual separates

knit sweater over check shirt, classic denim jeans, chukka boots

Cool weather look with sweater that has some bulk but is still slim fitting and flatters the body. The pose is dynamic accentuating the casual, active look.

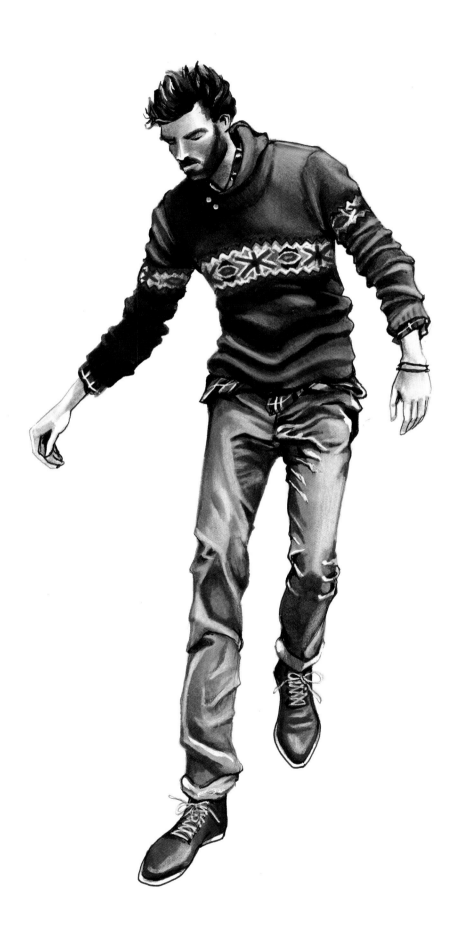

mens' separates

printed fabrics

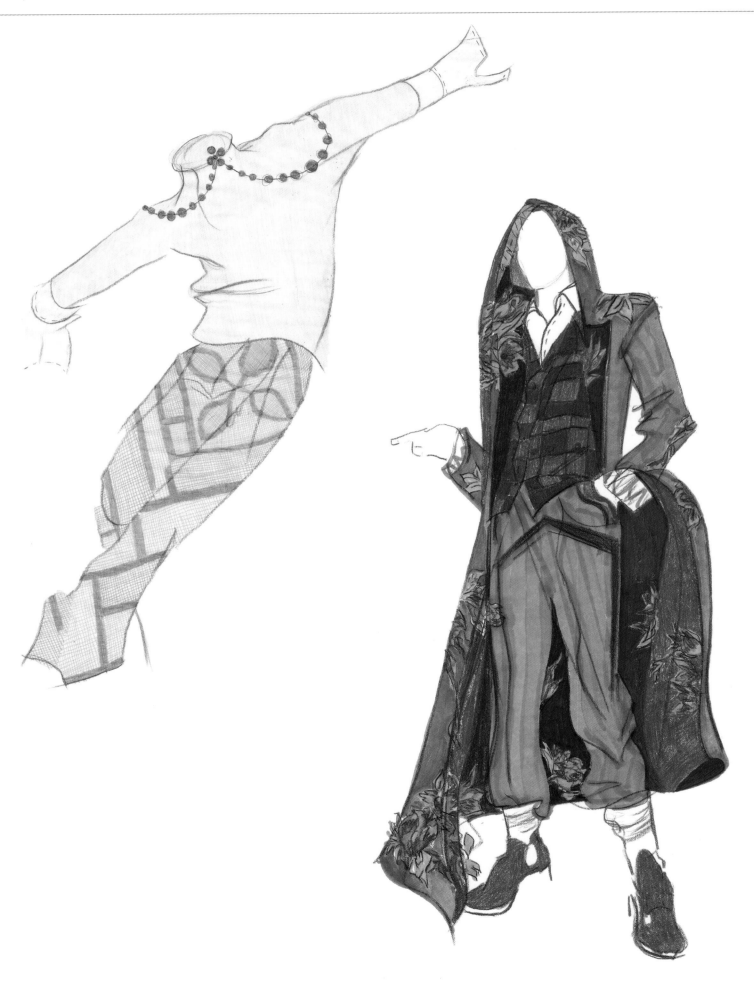

mens' separates

printed fabrics

Two-dimensional applications of pattern and color on three-dimensional figures.

The drawings on these pages, the previous page and overleaf are made using the same technique: the figures and silhouettes are rendered three-dimensionally using perspective and foreshortening in the poses and two-dimensional pattern and color is applied by filling in the silhouettes in a uniform manner and leaving out the shading that is normally employed to indicate the drape. This results in a drawing with a strong, modern, graphic look. It is often a shorthand used to express an idea where a detailed, complete drawing is not necessary but the three-dimensional rendering of the croquis gives a clear idea of how the garment will fall and drape.

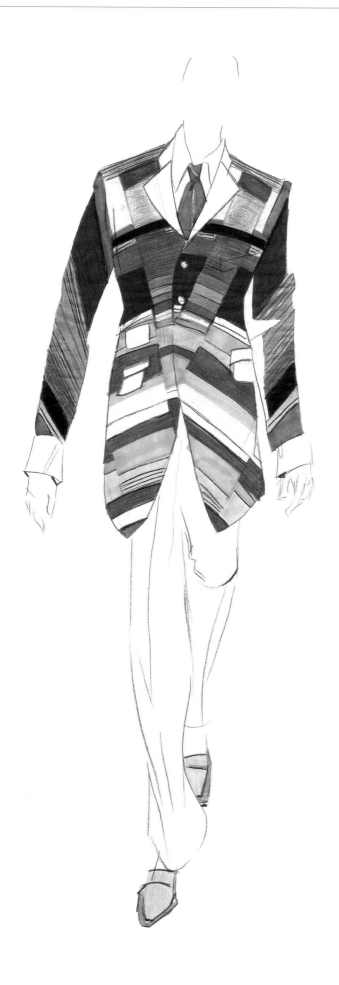

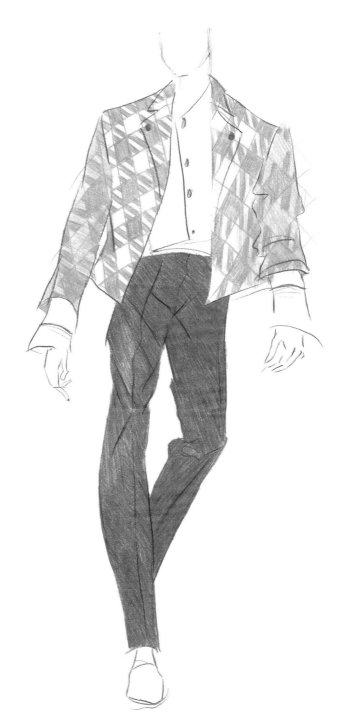

do not do's of men's fashion drawing

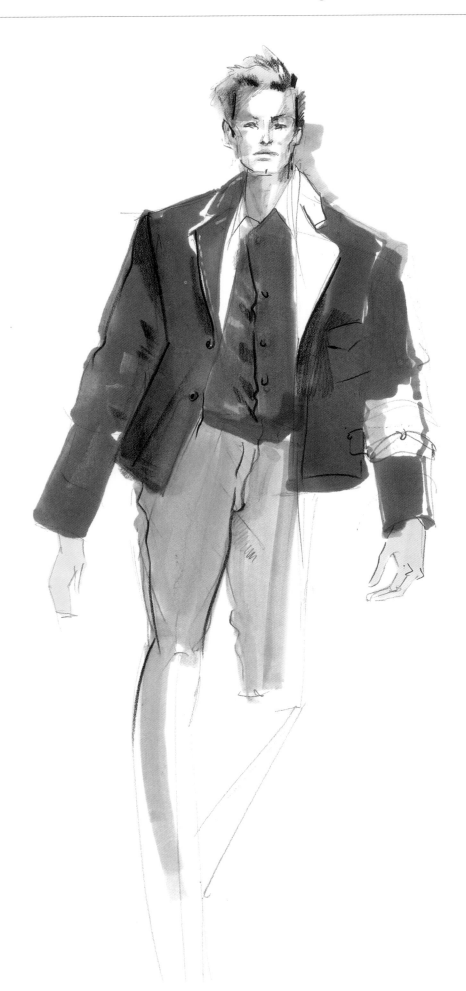

There are a number of DO NOT DO's in this drawing: the silhouette of the garments do not reflect how they would fit on a male figure—the cap of the right sleeve is too wide, the sweater is too short and the pants are shaped at the hip more for a female shape. Shading and light is inaccurate, does not follow the drape and is randomly placed: the patch of light on the right sleeve bears no relation to anything. The head is too small for the body, and, not surprisingly, the figure looks rather anemic.

DO NOT DOs OF MEN'S FASHION DRAWING

Many mistakes can be made when drawing men, especially when they are drawn by women: for women, men are both difficult to understand and difficult to draw! In general, women tend to draw men in the same way they draw themselves— that is, as women— giving them too many curves and overly feminine faces.

The following are among the most common mistakes made when drawing men's fashion. These are definite DO NOT DO's.

1. DO NOT place shirt collars too low on the neck. They should reach almost to the jaw-line.

2. DO NOT add too much fullness to the sleeve at the shoulder seam or it will resemble a woman's sleeve.

3. DO NOT draw closures from left to right— for men they fasten right to left (in the drawing the closure is in fact one of the few things that *are* correct).

4. DO NOT draw hips too wide.

5. DO NOT draw the waist too high—it should be at 3 1/4 heads (a woman's is at 3).

6. DO NOT draw eyebrows arched like a woman's; they are more horizontal.

7. DO NOT make the face soft and curved—it should be angular.

8. DO NOT draw the chin and jaw too small—men's are larger and squarer.

9. DO NOT make the forehead too slim.

10. DO NOT make the hair too full and rounded.

11. DO NOT make eyes too rounded and too large.

12. DO NOT make hands and feet too small.

men's accessories

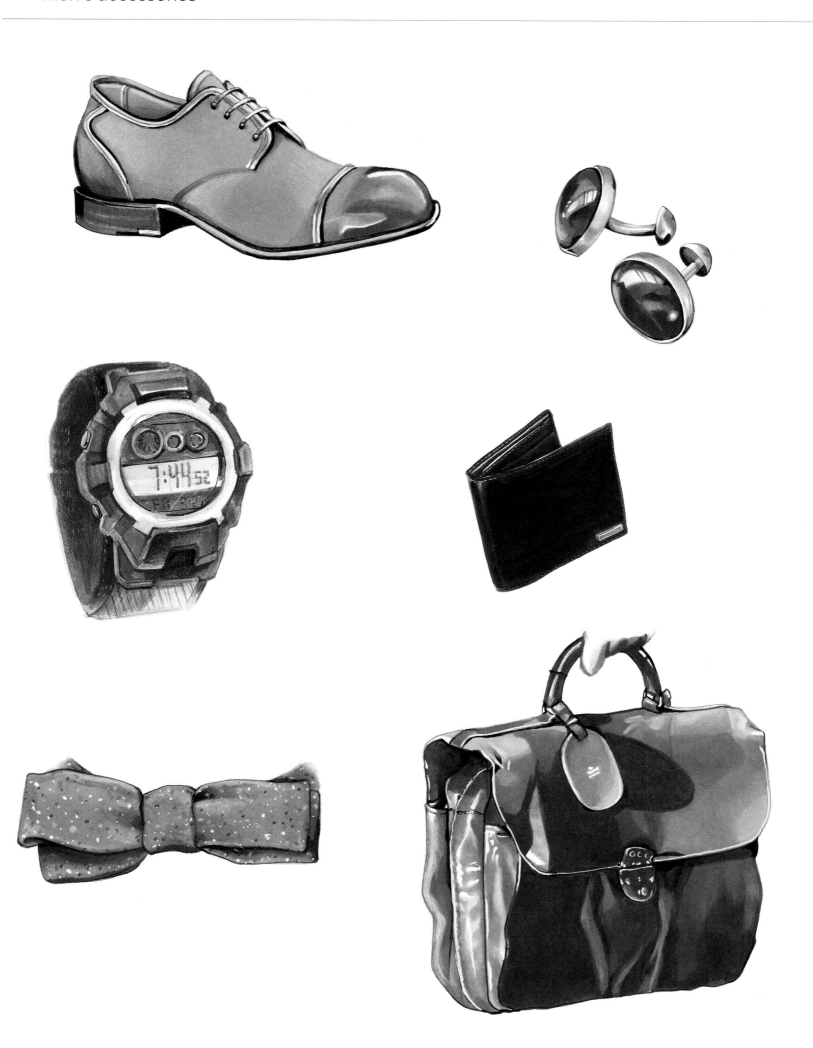

men's templates

Left, three–quarter back view; right, front view, weight on left side.

men's templates

Left, side view; middle, front view; right, three-quarter view

practice and exercises

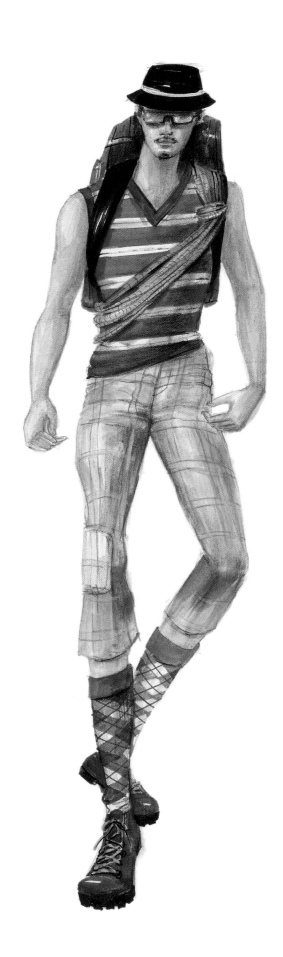

1. Using a croquis from the Appendix draw the silhouette of a shirt and pants. Fill in the shirt with a floral print and the shirt with geometric print.

2. Draw a croquis in an active pose. Add the silhouette of a t-shirt and shorts to the figure and add stripes.

3. Draw three figures wearing jeans (i) with two zippers, (ii) with four pockets, (iii) with frayed bottoms.

4. Using a croquis from the Appendix, draw a shirt and pants for the following activities: (i) watching TV with friends, (ii) attending a birthday party, (iii) walking in the park.

5. Design two outfits to accompany accessories chosen from those included at the end of this chapter.

6. Copy the drawing on the opposite page and change the colors of the fabrics.

7. Copy an image of a man in a tailored wool coat. Use the image in this chapter or one from a magazine.

8. Copy a photograph of a man in denim jeans. Copy a photograph of a man in a leather jacket.

practice and exercises

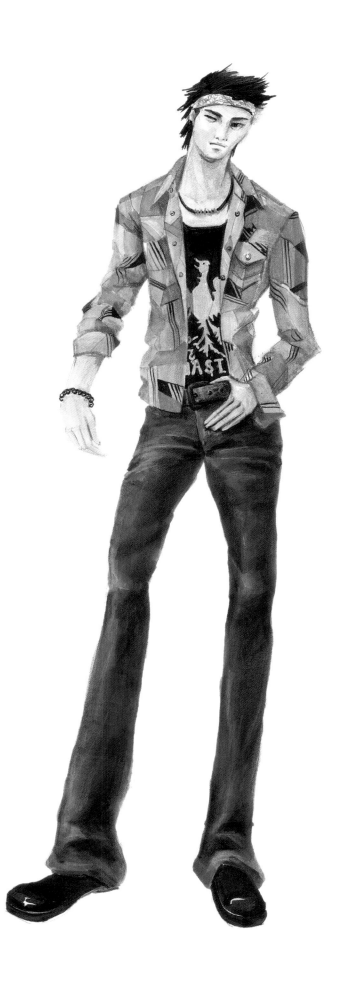

9. Using images from this chapter as references draw (i) an outfit with an "edgy" street look, (ii) a young businessman's outfit, (iii) an outfit for an athlete .

10. (i) Draw a man's two-piece business suit. (ii) Take the jacket from the suit and match it with a different pair of pants to create a "more hip" look.

11. Draw a croquis wearing a sleeveless t-shirt and pants and add a graphic image onto the t-shirt.

12. Draw a croquis in an active pose and dress with top and pants using (i) three zippers, (ii) ten snaps, (iii) toggles and/or velcro.

13. Draw a shirt and casual pants on a croquis and include prints showing ethnic influences.

14. Draw any garment or accessory using shiny fabric.

15. Draw a shirt, necktie, jacket, pants and coat in plain fabric on a croquis.

16. Draw an outfit for a man using all of the following fabrics: snakeskin, printed cotton, fur and leather.

17. Draw an active sportswear outfit.

18. Draw an outfit with plain fabric and then draw again using printed fabric.

CHAPTER EIGHT

CHILDREN'S FASHION

physical characteristics of different age groups

Drawing children and teenagers

As with men's fashion, the variety of garments available for children and teenagers has grown enormously. Children can now wear a full range of clothes designed exclusively for them, as well as small-sized versions of many adult clothes. The market for children's clothing continues to grow rapidly in pace with parents' increasing affluence and the generally lower cost of clothes.

While the great masters of drawing and painting have for several centuries drawn children with the same care and attention as for adults (often knowing that the parents who commissioned the drawings wished to see their offspring as attractive miniature versions of themselves), in fashion drawing children have not always been accorded the treatment they deserve. Children are still often drawn only as caricatures—cartoon-like creatures or dolls with two-dimensional figures and personalities. While cartoons are appropriate for depicting children in some situations (and given the roundness and softness of children's features it is certainly easy to draw them as cartoons), cartoons cannot fully do justice to children's personalities and the variety and quality of children's clothing now available.

Fashion designers have long recognized that children are complex in their own unique ways and are designing sophisticated clothing for them, much of which echoes the clothes their parents wear. This increasing sophistication in design, though, should be reflected in fashion drawings of children. The approach to drawing children taken in this book is that, although poses, sizes and expressions will be different, in most situations it is best to draw children in the same way as adults, that is to say, a realistically rendered three-dimensional representation of figures and garments. This approach, it is hoped, will further assist the creation of new designs for children's clothing.

Physical characteristics of children of different ages

Children's bodies, faces and facial features are soft and round with very few planes. Until about the age of twelve children rarely show bone structure under their faces or musculature on their bodies. Because of this children should be drawn using a light touch to convey the softness of the features. If drawn with too heavy a touch they will appear unnatural, like many of the babies drawn by Renaissance artists, who often look more like tiny old men and women than like babies.

Children change shape and size very quickly and can change appearance radically over the course of a few months. The usual age group categories for children are **infants/layettes, toddlers, young girls and boys (3-6), older girls and boys (6-12), juniors/teenagers (12-18).** The croquis and main physical features corresponding to the different categories of children are as follows:

Babies/layettes

Generally drawn with 3 – 3½ head croquis. Small children have low eye levels—about ⅔ down from the top of the head (adult eyes are half way down the head). Heads and limbs are rounded so they will bounce off hard objects. No necks are visible.

Toddlers:

The croquis is about 4½ heads. Growth from infant has occurred mainly in the legs. Still no necks are visible.

Young girls and boys

The croquis is about 5½ heads. This age group has become longer in the torso than toddlers and necks are defined. Children start to participate in decisions about their clothes around this age. Accessories start to become important-bows, hair pieces, backpacks, belts, shoes and so on. Small boys start to have angles and planes in their faces.

Older girls and boys

The croquis is 6½–7 heads. Girls especially start to grow in their legs around 8 or 9 years old. Bone structures become more defined, poses are more graceful. Eye levels have moved up to about the same level as adults—half-way down the head. Vanity reigns: clothes become extremely important and a wide and increasing range caters to the children's and parents' whims.

Juniors/Teenagers

The croquis is 8 heads. The appearance is almost exactly like an adult except the facial features are slightly more rounded. Poses are generally more exuberant than adults, with arms and hips akimbo and considerable attitude displayed. Colors in general are saturated and vibrant; skin tone is healthy and rosy.

Illustrations of the proportions of the croquis of different ages of children and teenagers and a variety of poses are included later in the chapter.

This chapter contains a small sampling of the enormous variety of garments now available across the different age groups.

baby/toddlers

Babies and toddlers have soft, round and slightly chubby bodies. Babies' heads are large in relation to the rest of the body and eyes are wider than one eye apart. The nose is like a piece of putty–there is no definition to the bridge.

Toddlers have learnt to stand and walk but are still a little off balance most of the time and this should be reflected in their poses. Heads are still large in relation to the rest of their bodies and round but slightly less chubby than babies' heads.

Toddlers' garments have to fit loosely because they are so active; they also have large tummies, so roomy silhouettes are flattering. The loose fits should be clearly shown in drawings. Small children and toddlers are exuberant and not self-conscious so are best shown in typical natural poses that capture their uninhibited moods. They often also adopt awkward poses that add to their charm and can be effective for showing off their garments. Arms and legs are often stretched out in playful displays.

Sleeveless sun dress with scalloped trim along seams and bow and buttons on front panel

Pinafore dress with ruffled flounce.

little girls 4–6

Left, shorts with blouse and blow. Right, tunic dress. Note the composition of these drawings: The figures are drawn in slightly awkward poses with heads tilting and eyes looking away and eyes closed. The scale of the accessories accentuates the small size and delicacy of these young ladies. Note again the clothes are cut for comfort: roomy and not tight. The head and features are all rounded and as there is very little difference in features between boys and girls at this age it is clothes and hair that indicate gender.

little boys 4–6

Left, jacket and jeans, tee shirt/sweater. Right, rain jacket, knitted cap, rolled up pants.
Little boys have very slightly longer torsos than girls, slightly bigger feet and a slightly squarer jaw line. Eyes are still wide apart and features are still small and little-defined; cheeks are full, necks are getting a little longer. Typical poses and expressions for little boys include mischievous, earnest or (occasionally) angelic. Cold weather clothes appear bulky worn on small bodies.

little girl 4–6

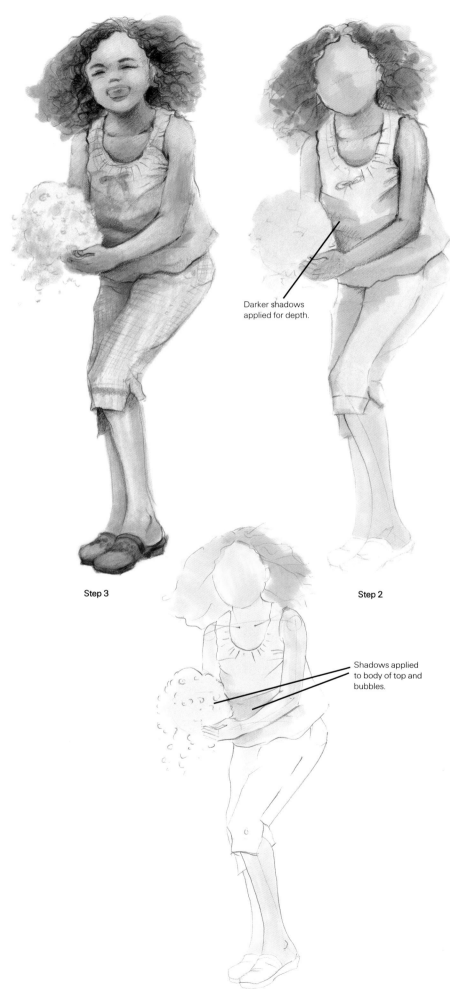

Children do not have the angular features of adults and their faces and bodies are drawn using soft, round shapes. In composing drawings of children, including objects with similar soft, round shapes accentuates those same shapes occurring in their bodies and helps create the right playful mood. Pastel colors, usually obtained by diluting colors with colorless blender, reinforce the softness of children's complexions and are often used in clothes and accessories. For this little girl, the bubbles, hair and soft drape of the top, as well as the soft pastel colors all reinforce the soft, round features of the face and body.

Darker shadows applied for depth.

Step 3

Step 2

Shadows applied to body of top and bubbles.

Step 1
Croquis is 5 1/2 heads.

girls 6–8

Left, printed summer dress, wide bottom pants.. Right, duffle coat, dress and tights.
As children grow up they become longer and leaner. They hold themselves more upright and poses are more self-conscious, but still not grown-up. Necks are longer and features are more defined, though cheeks are still full and faces rounded.

Traditional garments are still worn in many cultures, both as daily clothing and on special occasions. Modern design also makes extensive use of elements from traditional dress, often in combination with modern garments and accessories.

Combination of South-East Asian design elements.
A light, long-sleeved cotton sweater is combined with a t-shirt delicately embroidered with traditional Chinese designs, a silk obi, a red silk brocade skirt and a belt. This little girl has a tranquil pose and intelligent and attentive look that is well suited to her elegant garments.

Left, knitted poncho with fringe; right, Tyrolean outfit: lightweight jersey blouse with lace trim, suede lederhosen.

little girls, 4–6

On chilly mornings children have to bundle up well for their walk to school. The cold makes cheeks and knees ruddy.

Left, short skirt, jacket, scarf, argyll socks, leather shoes; right, kilt, sweater, shawl, beret, argyll socks.

pre-teens 11–12

By the time children reach this age they are starting to grow up quickly. Usually legs have lengthened noticeably and features have become more refined; eyes are closer together. While they try to look grown up faces are still very young and poses not yet self-conscious.

Left, soft cotton pants, henley shirt, blazer and watch cap, basketball boots; right, tee-shirt, denim vest, denim cut-off pants, scarf, ballet shoes.

teenagers 13–14

Teenagers at this age still have soft and charming faces and slightly larger heads in relation to the body. The bodies are slender-shoulders and hips are narrower than adults and muscles not yet fully formed. Teenagers of this age strike adult poses but their bodies are still more child-like. Boys at this age like to wear relaxed casual clothes with a wrinkled look, often with shirt tails worn outside pants.

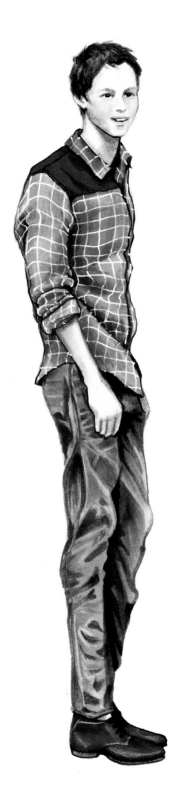

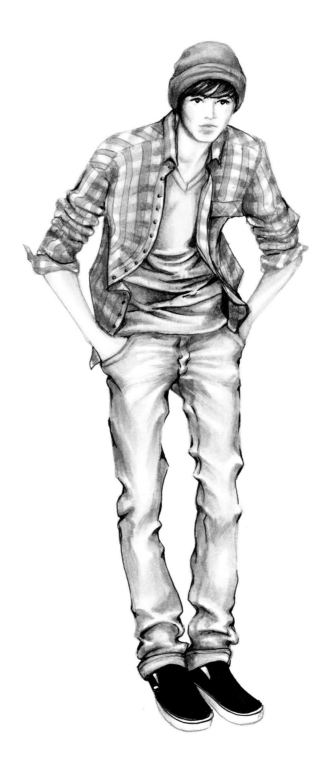

Left, grey denim pants, plaid shirt with blue yoke, leather lace up shoes; right, beanie hat, plaid shirt, v-neck tee shirt and worn classic denim jeans with slip on sneakers. s

teenagers 16–18

Teenagers are almost like adults: a little shorter (½ to 1 head) and with slightly rounder faces; limbs are adult-like. Teenage boys have softer faces and fuller lips than men who have more planes on their faces. They strike self-conscious grown-up poses but faces are still innocent and younger-looking. The outfit of the young lady here is a play on that of a little girl.

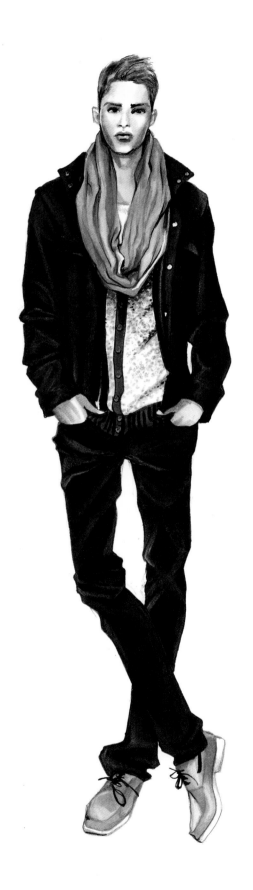

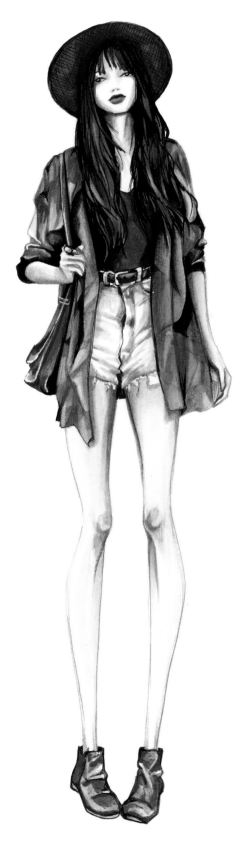

Left, denim jacket and jeans, cotton shirt, scarf, casual lace-ups; right, cut-off jeans, tee-shirt, scarf, school satchel, wide-brimed floppy hat, ankle boots.

dogs/puppies

Dogs make great accessories to any garment—but particularly children's—and sometimes sport some stylish garments themselves.

faces

winston churchill/baby/girl 7–10

Winston Churchill as a baby, contemplating future military strategy. Note the round face, soft skin tones and absence of dark shading.

Babies have round faces, soft skin tones, and no black shading.

Note that babies have large eyeballs. The eyes remains the same size through life, so appear much larger in a smaller head. The cheek is shaded with soft blended color to make it appear soft and round.

A young girl of eight or nine with rosy, freckled complexion and striking red braids.

faces

baby/little girls/pre-teen 10–12

Toddler, drawn with colored pencil and subtle accents of blended beige marker in the hair and blended pink roses in the hat.

Another orange-haired girl. The shape of the hair is filled in with orange marker and curls added with orange pencil.

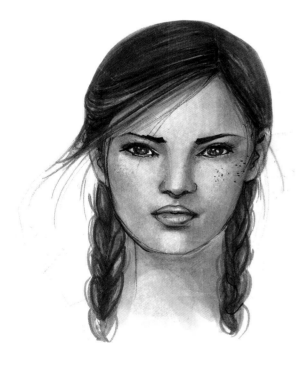

Pre-teen with natural look and soft shading for skin tone. With pre-teens the eye level is slightly lower than in teenagers or adults (the eyes move progressively higher on the head through childhood). Note how the braids are drawn.

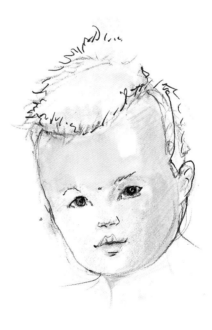

Happy baby drawn with blended pink and black marker.

children's templates

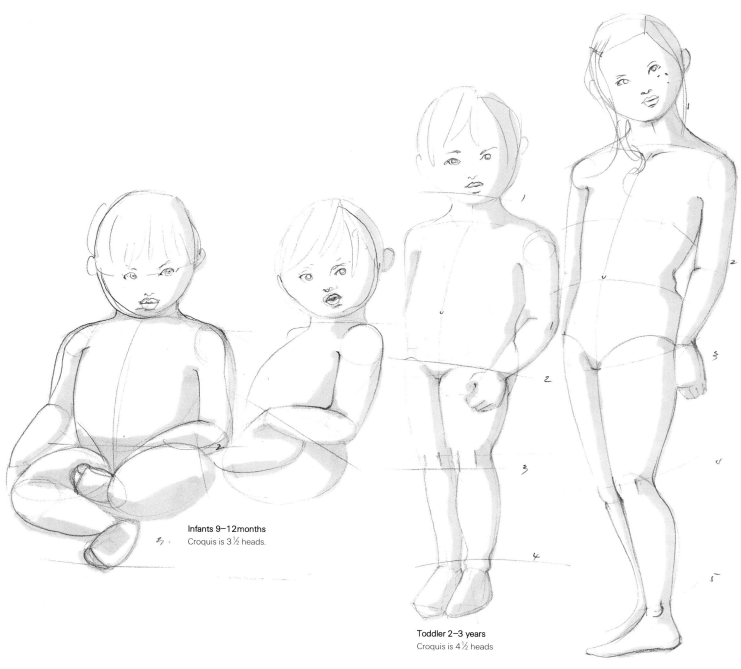

Infants 9–12 months
Croquis is 3½ heads.

Toddler 2–3 years
Croquis is 4½ heads

Little boy or girl 5–7 years.
Croquis is 5½–6 heads.

children's templates

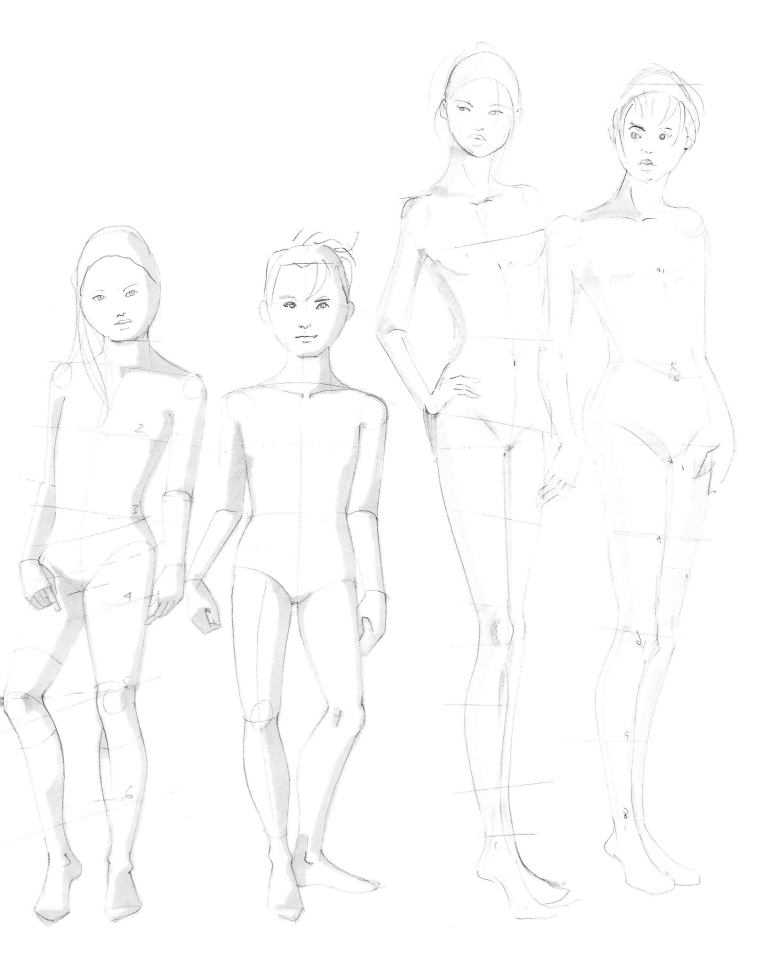

Big girl and boy
6-9 years. Croquis
is 6–7 heads..

Teenager, 13–14,
croquis is 8½–9
heads. Pre-teen, 12, cro-
quis is 8 heads.

toddler/baby do not do's

The features of the toddler on the left are defined in black making his features appear too mature and giving him a cartoon-like look. He has also been drawn too flat, and appears two-dimensional.

The face of the baby on the right has the eyes placed too high on the head, giving him too an overly mature appearance. Also, the pose is unnatural for a baby: it is very unlikely a baby would be able to extend its arms out without the support of a pillow or something similar.

practice and exercises

Beginners

1. Choose a croquis of a toddler from the Appendix. Draw the silhouette of any outfit on top of the croquis and fill in with a flat application of color.

2. Draw the croquis of an infant, toddler and small child.

3. Using a croquis from the Appendix, draw a little boy and girl croquis noting the differences in the shapes of the face and body.

4. Draw a toddler wearing a party dress. Draw the same toddler wearing a bathing suit.

5. Draw an infant wearing an outfit made of a fabric with a pattern of polka dots, cherries and apples.

Advanced

6. Draw a croquis of a little boy and a little girl and fill in the faces using only blended color.

7. Take photos from magazines of children of different ages—infants toddlers, little children, teenagers. Copy the images using the Appendix as a guide.

8. (i) Draw the croquis of a little girl. Using a photograph of a little girl, copy the clothes onto the croquis. (ii) Draw the croquis of a little boy. Using a photograph of a little boy copy the clothes onto the croquis.

9. Draw the croquis of an infant, toddler and little child and clothe each with the same garment. Add accessories to each figure, making them appropriate for the different ages.

10. Draw a group of three or four children of different ages (i) dressed for a wedding, (ii) dressed for a picnic, (iii) dressed for a day at the beach.

11. Draw croquis of a young boy and a young girl about eleven years old. Dress each in a cotton t-shirt and jeans. Refer to Chapter Three: Fabrics for how to draw denim.

12. Draw croquis of a five-year-old girl and a ten-year-old girl and outfit them in the same jacket and skirt.

using photoshop in fashion drawing/alphabet 3: silhouette repetition

Original hand drawing
(smaller scale)

Image transformed in Photoshop

Using Photoshop in fashion drawing

Photoshop is an ideal application for manipulating original images to create new, radically different compositions. This book is about making hand drawings of fashion garments in color, and Photoshop affords endless possibilities for transforming our drawings in many different ways. Here are a few of the different techniques and effects that Photoshop can bring to our fashion drawing:

-Enhancing a garment with cast shadows
-Changing scale / changing composition
-Fixing mistakes
-Cleaning up lines
-Adding backgrounds
-Changing hair color
-Changing make-up
-Changing fabrics

When creating the drawings of our collections, Photoshop's filters, tools and layers can help change elements of a garment, face or figure quickly and easily, as well as creating interesting grapic effects that can be used to enhance the hand drawing and the overall presentation of a portfolio.

This appendix contains a number of examples of compositions created by manipulating hand drawings in Photoshop. The compositions are intended to show what is possible and provide inspiration. The tools and techniques used to create the compositions are outlined but this is not intended as a comprehensive guide to how to use Photoshop for fashion drawing: a fuller step-by-step description of the techniques used, plus the other basic techniques of Photoshop can be found in Appendix a of *9 Heads–a guide to drawing fashion by Nancy Riegelman*.

Note: Setting up your document is something very important to do at the start of working on a project: If the document is intended for printing then CMYK is chosen; if for the web or projection then RGB is chosen. The appropriate resolution should be chosen depending on the final use of the image. Margins/bleeds, print/page marks should also be set up at the outset and the background color– white, color or transparent should be selected.

Alphabet 3.
Purpose: Repetition. Silhouettes can be isolated and repeated as a graphic device or to show variations in a collection. This could be used for branding and to create a strong message about the silhouette of a particular garment in a collection.
Photoshop Tools used: Magic Selection, Eraser tool, inverse, Paint bucket tool, duplicate layer, layers
1. Use the Magic Selection tool to select the part of the image to work with–here the outline of the complete figure was selected.
2. Use the eraser tool to delete the illustration. This leaves the outline of the figure against the background.
3. Select inverse and delete the background.
4. Select inverse to reselect the outline of the figure. This gives us the silhouette of the figure in a form we can manipulate.
5. Choose the paint bucket tool, select the color (here pale green) and positioning the cursor over the silhouette to be filled in click to fill in.
6. Creating a duplicate layer of the selected silhouette. You can now change the color to suit your taste (here we chose black).
7. Create a layer for your text.
8. Create a duplicate layer of the Paint bucket image and erase the color.
9. Merge the text layer with the erased layer to create text in a shape.

plants: silhouette variation

Plants
Purpose: Mood, Advertising, PR
Could be used as a decorative element on a garment
Photoshop Tools used: Magic Selection, Paint bucket, Layers, Merge layers, Eraser
1. Use the Magic Selection tool to select the part of the image that you would like to work with – In this image we selected the complete outline of the illustrated figure.
2. Use the eraser tool to delete the illustration – we are now left with a white figure.
3. Select inverse and delete the background and fill with whatever you wish – pattern, texture, color, scanned image, drawing, photograph etc.
4. Select inverse to reselect the outline of the figure.
5. Apply pattern, fill, and texture inside the selected silhouette.

black, purple and orange scarves

Black, Purple and Orange Scarves
Purpose: This is a demonstration of what is possible when changing the color of one element of an ensemble-with photoshop it is easily and quickly accomplished. How do accessories change the garment?
Photoshop Tools used: Quick Selection tool, refine edge, Hue/Saturation, Opacity
1. Use the quick selection tool to select the area you wish to work with – in this image we have selected the scarf.
2. Make sure to refine the edge by clicking the refine edge option at the top menu bar. A pop-up window will appear and you will have control over edge detection, smoothness, contrast of edge etc.
3. Experiment with the Hue/Saturation tool to change the color
4. Experiment with the opacity tool to change the transparency of the scarf

black/white

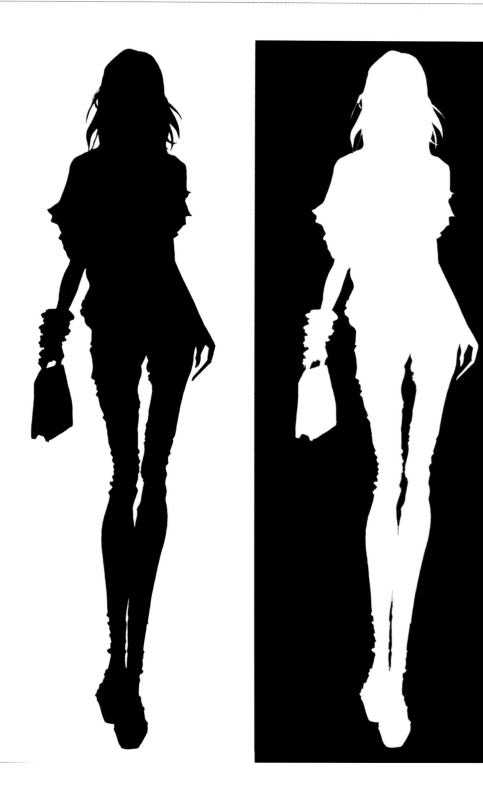

Black/White:

Purpose: Using photoshop it is easy to create the silhouette of a figure and vary its color and the background color. This is an interesting graphic device to be used in a portfolio and also places the emphasis on the silhouette of a garment.

Photoshop Tools used: Magic Selection tool, Eraser Tool, Paint bucket, Rectangle tool

1. Use the Magic Selection tool to select the part of the image that you would like to work with – In this image we selected the complete outline of the illustrated figure.
2. Use the eraser tool to delete the illustration – we are now left with a white figure.
3. Select inverse and delete the background. We are left with only a white figure and no background.
4. Select inverse to reselect the outline of the figure.
5. Create a duplicate layer of the selected silhouette. You can now change the color to suit your needs – in this example we chose black.
6. Create a new layer and on that layer make a rectangle – In this example we use black.
7. Repeat last step changing the color of the rectangle – in this example we use white.
8. Arrange levels so that the correct figures are on top of the correct rectangles.

blue/blue, red/blue

Blue/Blue, Red/Blue

Purpose: Another interesting graphic device that again highlights the silhouette of the outfit in an unusual and effective way.

Photoshop Tools used: Magic Selection, Paint bucket, Layers, Merge layers, Eraser

1. Use the Magic Selection tool to select the part of the image that you would like to work with – In this image we selected the complete outline of the illustrated figure.
2. Use the eraser tool to delete the illustration – we are now left with a white figure.
3. Select inverse and delete the background and fill with whatever you wish – pattern, texture, color, scanned image, drawing etc.
4. Select inverse to reselect the outline of the figure.
5. Apply pattern, fill, and texture inside the selected silhouette.

effects

Effects
Photoshop Tools used: Quick Selection tool, Neon Glow filter, Hue/Saturation, Opacity
1. Use the Magic Selection tool to select the part of the image to work with – In this image the complete outline of the illustrated figure.
2. Use the eraser tool to delete the illustration – we are now left with a white figure.
3. Select inverse and delete the background.
4. Select the neon glow filter from the filter gallery and experiment with the glow size and brightness.
5. Experiment with the hue/saturation.
6. Experiment with the opacity.

face 1–9/hair1–4

Face 1 -10, Face 1-4

Purpose: Variations in Make-up and hair color. Experiment in changing the make-up and hair color with the different colors in a collection. Experiment with different color ideas – Monochromatic? Tertiary colors? How does color affect the mood?

Photoshop Tools used: Lasso Tool, Hue/Saturation, Opacity

1. Use the Magic Selection tool to select the part of the image that you would like to work with like the just the hair or the eyes or both together.
2. Experiment with the Hue/Saturation
3. Experiment with the Opacity

long hair 1–7

Original hand drawing

Long Hair:
Purpose: Experiment in changing the make-up and hair color with the different colors in a collection. Experiment with different color ideas – Monochromatic? Tertiary colors? How does color effect the mood?
Photoshop Tools used: Lasso Tool, Hue/Saturation, Opacity, Color Balance
1. Use the Magic Selection tool to select the part of the image that you would like to work with like the just the hair or the eyes or both together.
2. Experiment with the Hue/Saturation.
3. Experiment with the Opacity and Color Balance.

patterned backgrounds

Pattern Backgrounds

Purpose: Decorative application can be used for advertising or to show other fabric choices.

Photoshop Tools used: Lasso Tool, Eraser, Color adjustment, Line Tool, Snap to grid, Show Grid, Layers

1. Use the Magic Selection tool to select the part of the image that you would like to work with – In this image we selected the complete outline of the illustrated figure.

2. Select inverse and delete the background.

3. Duplicate the layer

4. Create background by using the line tool. To help with placement of lines turn snap to grid and Show Grid on.

5. With image 2 it is possible to experiment with the opacity of the lines.

6. Arrange layers so that the figure is on top of the patterned background.

polaroid portraits 1-5

Polaroid Portrait 1-5:
Purpose: Graphic effects, branding.
Photoshop Tools used: Quick Selection tool, Hue/Saturation, Opacity, Rectangle
1. Use the Magic Selection tool to select the part of the image that you would like to work with – In this image we selected the complete outline of the illustrated figure.
2. Use the eraser tool to delete the illustration – we are now left with a white figure.
3. Select inverse and delete the background.
4. Select inverse to reselect the outline of the figure.
5. Select a color and with the paint bucket fill the selection with color.
6. Create a new layer and fill with color using the paint bucket
7. Create a new layer and make a rectangle with the color and size of your choice. In this example we are using Instant Photography as our sizing inspiration.
8. Arrange your levels so that figure is on top of the box which is on top of the layer of color.

pop

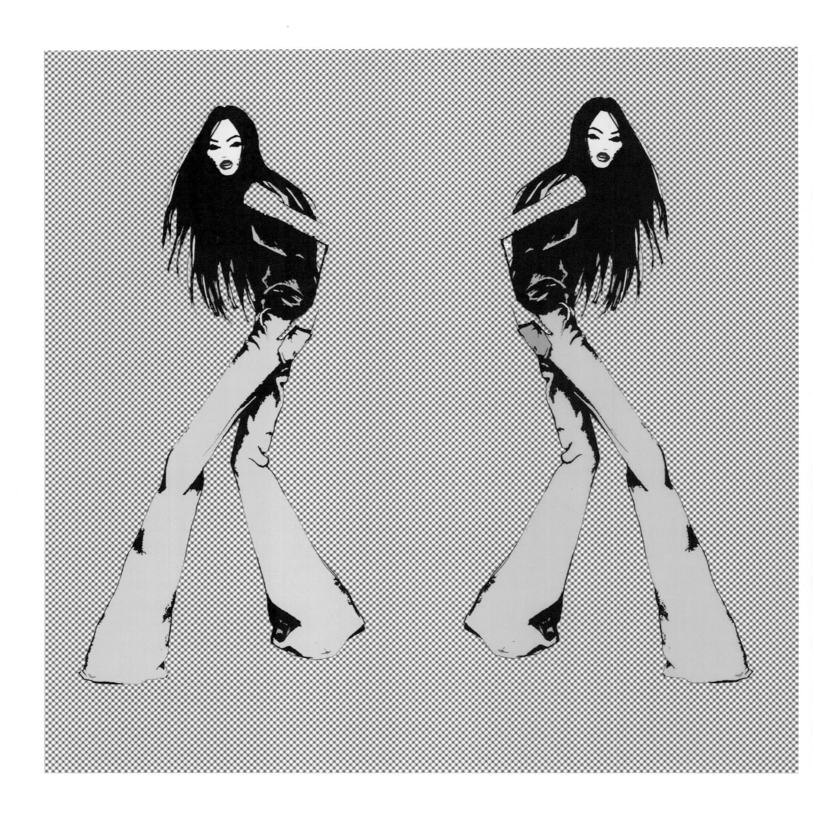

Pop
Purpose: Graphics, advertising.
Photoshop Tools used: Quick Selection tool, Hue/Saturation, Opacity, Paint Bucket, Halftone, Image Rotation
1. Use the Magic Selection tool to select the part of the image that you would like to work with – In this image we selected the complete outline of the illustrated figure.
2. Select inverse and delete the background.
3. Select inverse to reselect the outline of the figure and rotate the image so it mirrors the other image.
5. Using the magic or quick selection tool select the part of the image you would like to work with – in this example we selected the pants and the pocket separately.
6. Use the paint bucket to fill in the selected areas.
7. Experiment with the hue/saturation and opacity.
8. Create the background by experimenting with the halftone filter.

scale 1-3

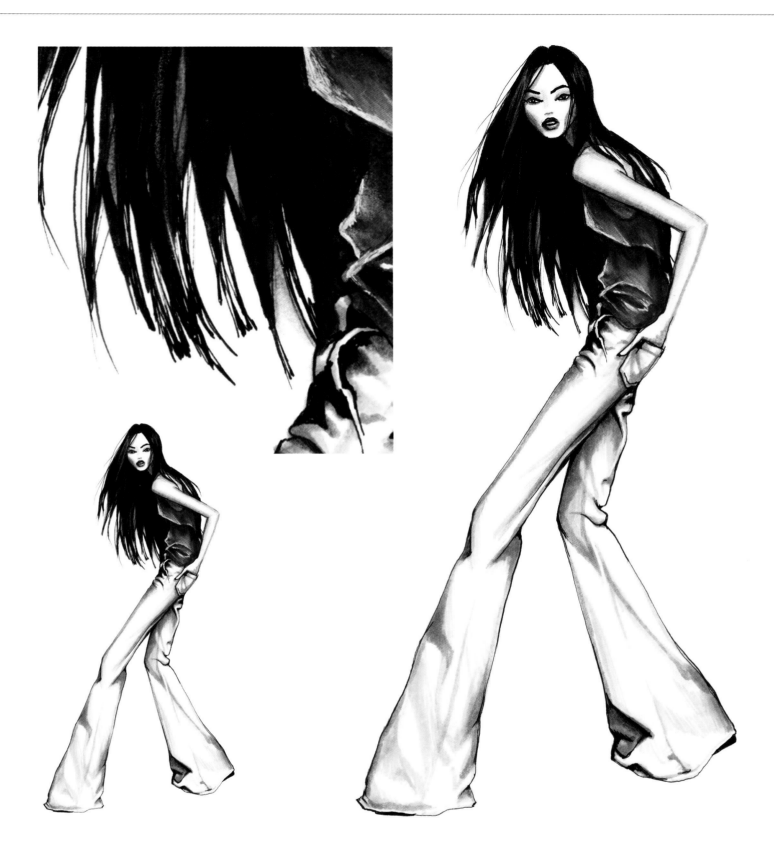

Scale 1-3.

Purpose: Introducing versions of the main image using different scales is a useful way to provide interesting backgrounds whose content is directly related to the subject matter. Blowing images up to a very large scale as seen top left can result in what look like abstractions that can be used as independent graphic elements in the design of a presentation.

Photoshop Tools used: Crop, Selection

1. Use the move tool to change sizing – possibilities of increasing size greatly and decreasing size greatly.

yellow/red

Yellow 1-2:
Purpose: Quickly change color elements in a garment to change the mood and seasonality of a collection.
Photoshop Tools used: Magic Selection, Refine Edge, Hue saturation, Opacity
1. Use the quick or magic selection tool to select the area you wish to work with – in this image we have selected parts of the dress.
2. Make sure to refine the edge so you have selected exactly what you want to alter.
3. Experiment with the Hue/Saturation tool to change the color.
4. Experiment with the opacity tool to change the transparency.

filters

Blur

Oilpaint

Cut-out

Pencil

Crystallize

Neon glow

Liquify

Rough pastels

Plain

Filters

Photoshop has a number of filters that can change the style of an image with a simple operation. This allows for numerous interesting graphic variations of a central image to be produced with a minimal effort. These images can now be used as separate graphic elements in designing portfolios or other applications. In each case the image is selected with the Lasso tool and the chosen filter applied.

gradients/watercolor/butterfly face

Original hand drawing

Gradient 1, 2 and Watercolor
Purpose: Mood and Color
Photoshop Tools used: Paint Bucket, Shapes, Overlay
1. Use the Magic Selection tool to select the part of the image that you would like to work with like the just the hair or the entire face. In this example we have selected the entire face.
2. Inverse the selection and delete the background.
3. In a separate layer create a color block or shape of your choosing. This will appear to color the illustration. You can experiment with patterns and gradients. Experiment with making your own watercolors etc. for texture and color application.
4. Choose overlay to the color layer.
Butterfly Face
Purpose: Mood
Photoshop Tools used: Move tool, duplicate layers
1. Open the illustration you would like to enhance
2. Open the vector or additional element you would like to use with the illustration
3. Arrange the vector (s) thinking of composition and scale.

snowflakes

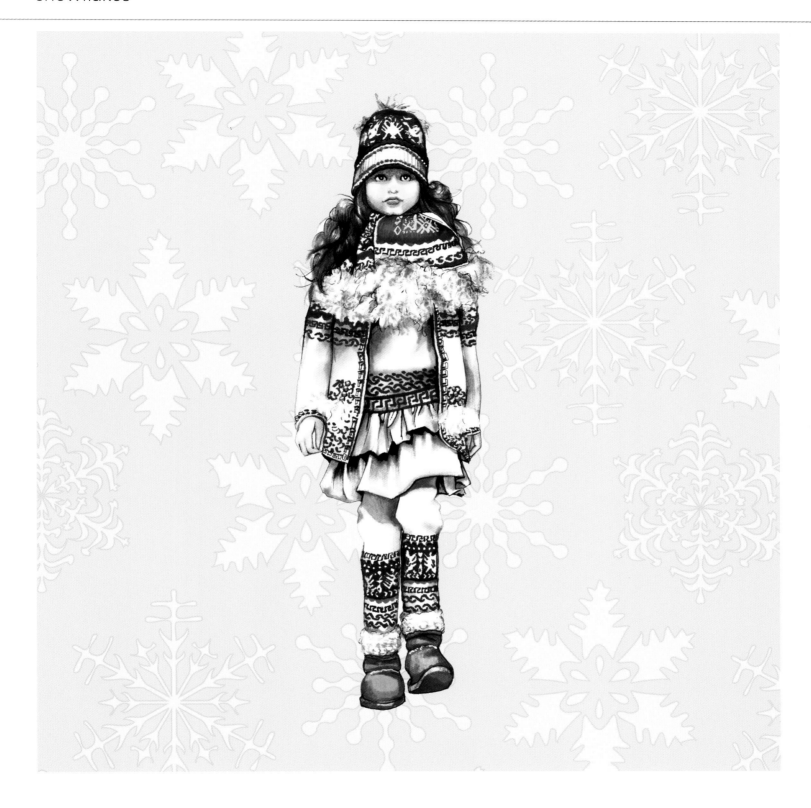

Snowflake Print
Purpose: Mood
Using a hand drawing with a vector to create an effect. In this example we are complimenting the child in winter wear with a winter themed vector background. This would work great for a children's clothing company winter season campaign.
Photoshop Tools used: Magic Selection, Duplicate layers, Vectors
1. Use the Magic Selection tool to select the part of the image that you would like to work with – In this example we selected the complete outline of the illustrated figure.
2. Place selection onto new layer.
3. Open Vector image or background you would like to use to accompany illustration. Here we chose a snowflake vector to accompany the illustration of the child in winter wear.
4. Arrange layers so that the child is in front of the background.

prints/doggies

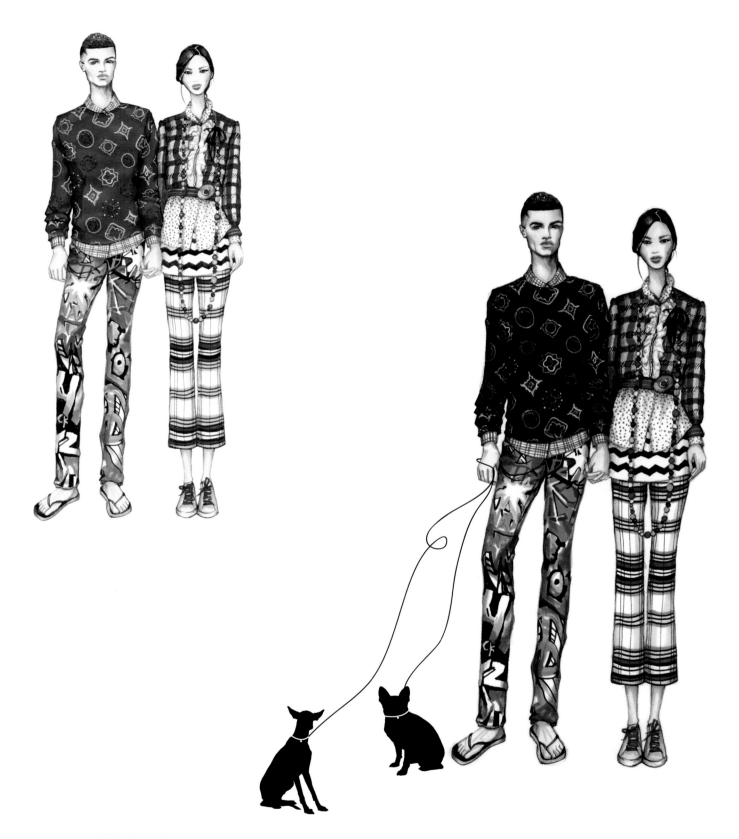

Prints/Doggies

Purpose: Narrative and Perspective

Interesting elements can be added to drawings with Photoshop.

Photoshop Tools: Duplicate layers, Vectors, Paint Brush tool

1. Open illustration you would like to enhance.
2. Create vectors or line art. In this example we have used dogs.
3. Add Vectors to new layer.
4. Complete the composition. In this example we have used the paintbrush tool to add leashes to each dog.

hand drawn

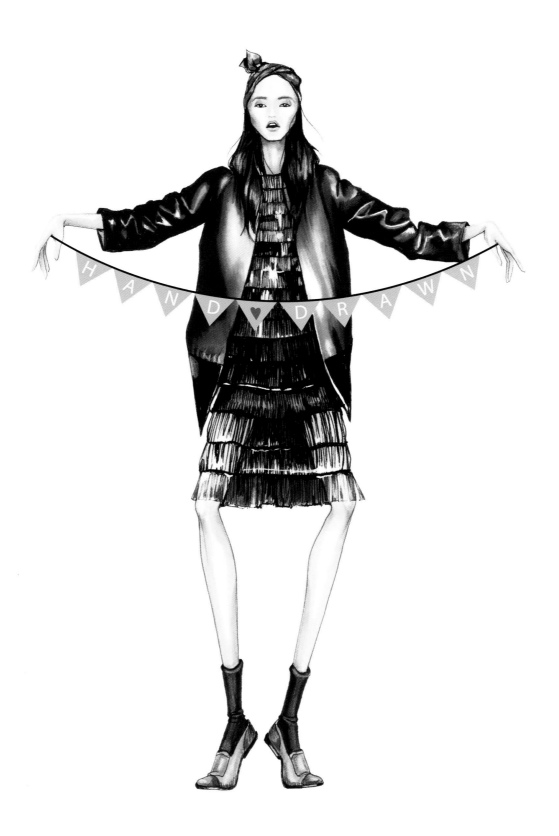

Hand drawn

Purpose: Say something, literally, with your illustrations. My obsession is with hand drawing.

Photoshop Tools: Shape tool, Text tool, rotation tool, pen tool

1. Position illustration.
2. Use the pen tool to create a ribbon like swoop from one hand to the other.
3. Create a shape that will be used for the flags – in this example we chose a triangle.
4. Use the type tool to individually place the letters on the appropriate flag.

dandelion

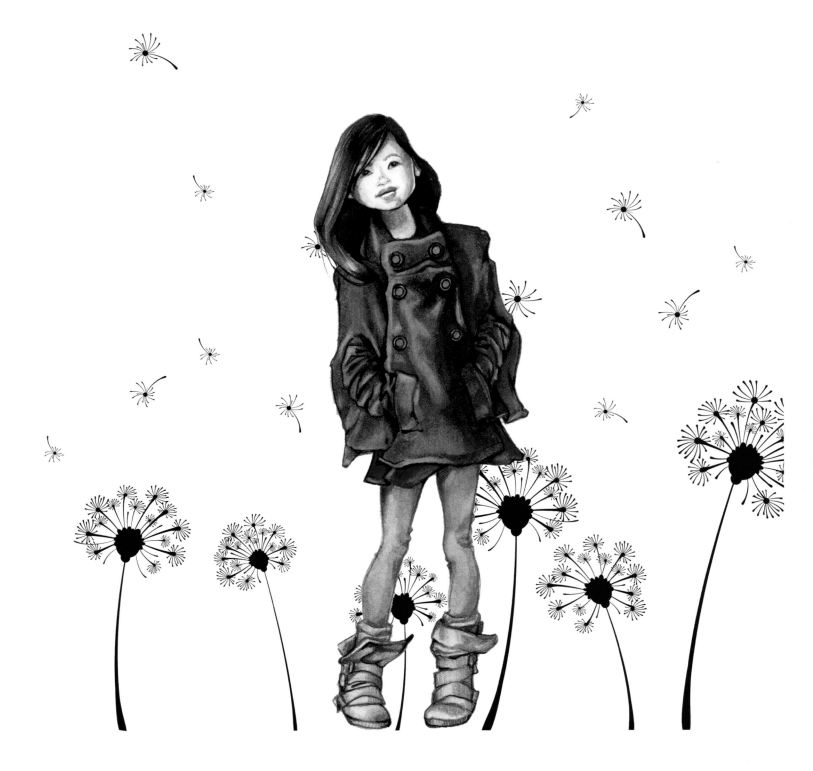

Dandelion
Purpose: Mood and Balance.
Using a hand drawing with a vector to create an effect. In this example we are complimenting the whimsical nature of the illustrated child with the blown wishes of the dandelion.
Photoshop Tools: Magic Selection, Duplicate layers, Vectors
1. Use the Magic Selection tool to select the part of the image that you would like to work with – In this example we selected the complete outline of the illustrated figure.
2. Place selection onto new layer.
3. Open Vector image or background you would like to use to accompany illustration. Here we chose a dandelion vector and hand placed the blown seeds for movement and interest.
4. Arrange layers so that the child is in front of the background.

butterfly print

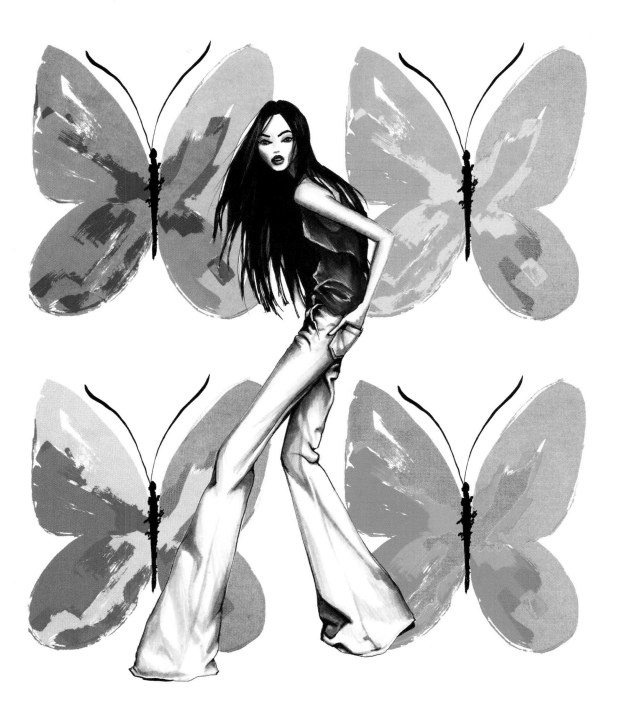

Butterfly Print
Purpose: Scale and Attitude
The background enhances the illustration and adds a pop art mood to the overall image.
Photoshop Tools used: move tool, duplicate layers
Flower Fabric: Vera Neumann
1. Research and collect images for a background. In this example we chose the butterfly motif by Vera Neumann and used Andy Warhol as our inspiration when repeating the design to give a pop effect
2. The original butterflies color was manipulated three separate times by experimenting with hue/saturation.
3. Arrange each butterfly in a grid.
4. Place illustration over the butterfly background.

butterfly web

Butterfly Web

Purpose: Scale, Repetition, Graphic. Fabric: Vera Neumann

Using a pattern and manipulating scale you can express the mood for a brand. This would work great as part of an ad campaign.

Photoshop Tools used: Magic Selection, Paint bucket, Layers, Merge layers, Eraser

1. You will need to delete the background of your illustration first. Select the silhouette of the illustration and choose inverse from the select drop down menu.

2. Inverse the selection and delete the background.

3. Create a layer from the layer window. This will be used for thebackground. It is best to name the each layer as they are created-this will help clear up any confusion by having layer upon layer of unlabeled items.

4 .Insert your background on the layer – in this example we have placed a butterfly pattern by Vera Neumann.

5.Create another layer from the layer window – this will be used for the background layer that we will scale and place over the jeans as shown in this illustration.

6. Scale the background image to the size you would like over the jeans.

7. Erase the overlapping pattern outside the bounds of the pants.

8. Experiment with the opacity of the pattern until desired effect is achieved.

butterfly print

Black_Flowers

Purpose: Repetition, Variation, Graphic

This combination of hand drawing and Photoshop could be used as a print on textiles, a hang tag or to enhance a portfolio.

Photoshop Tools used: Magic Selection tool, Eraser Tool, Paint bucket, Opacity

Flower Fabric: Vera Neumann

1. Use the Magic Selection tool to select the part of the image that you would like to work with – In this image we selected the complete outline of the illustrated figure.
2. Use the eraser tool to delete the illustration – we are now left with a white figure.
3. Select inverse and delete the background.
4. Select inverse to reselect the outline of the figure.
5. Create a duplicate layer of the selected silhouette and mirror the image. You can now change the color to suit your needs – in this example we chose black.
6. Place two figures onto background of your choosing.
7. Create a duplicate layer of the background image and arrange about two figures.
8. Lower the opacity of the background image on the top of the layers.
9. Use the eraser tool and create the look you want – erasing and/or not erasing parts of the image.
10. Increase opacity and make any further adjustments to your image.

watercolors

Watercolors are a common and effective medium for fashion drawing. As can be seen in these two watercolor drawings, they can produce subtle and delicate effects. The colors do not appear as uniform as marker colors, however, even when the marker color is diluted, and it is not easy to achieve high levels of saturation. As noted in Chapter One, watercolors are not as easy to use and transport as markers: it would be difficult, for example, to make a watercolor drawing while watching a runway show.

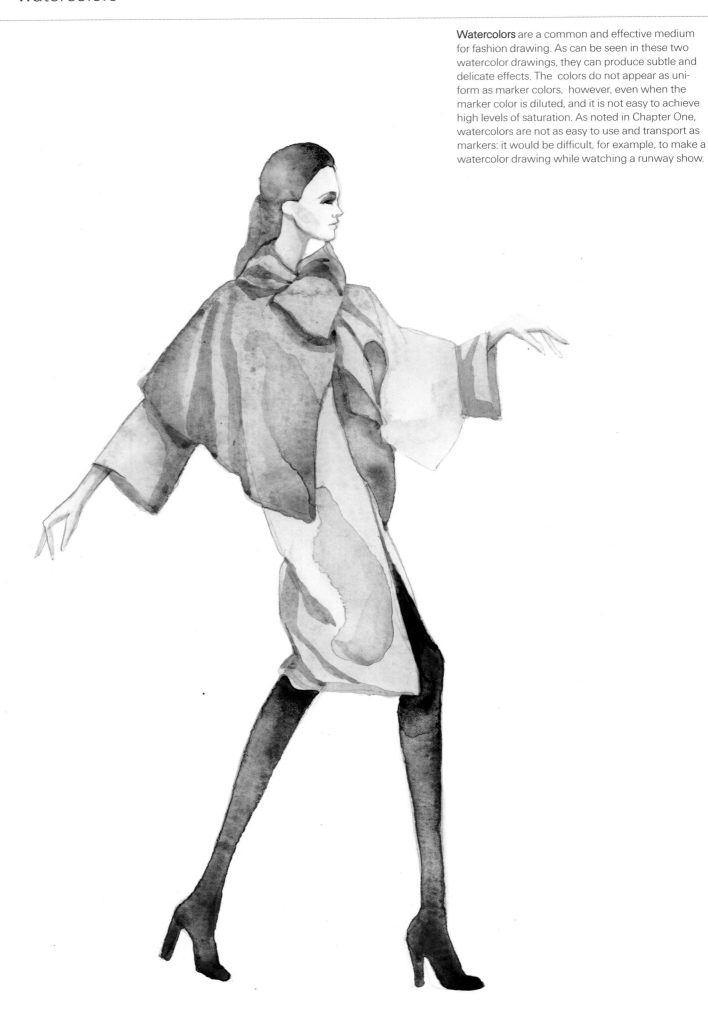

watercolors

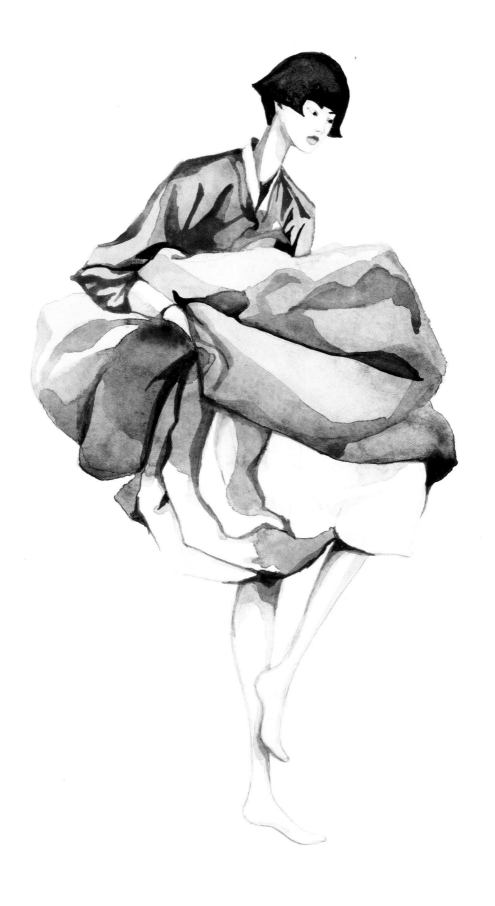

GLOSSARY OF TERMS

INDEX

glossary of terms

Glossary of Terms
This glossary contains definitions of the technical and semi-technical terms relating to fashion drawing (abbreviated here to FD), art, and color and design theory that are most frequently used in this book. It does not contain definitions of specialized fashion terms as most of those used here are explained when they first appear. For explanations of technical fashion terms not defined in the text reference should be made to a specialized dictionary of fashion.

Most of the terms included here are discussed in detail in Chapter Two: Color and Design and elsewhere in the book.

Abstraction/abstract shape or form
Way of communicating the essential aspects of a shape or form with a simplified visual shorthand. As more elements are removed from a drawing or part of a drawing it becomes progressively more abstract. In FD it is often used for parts of the body or face when the garments are complex.

Achromatic
Literally, without color. Achromatics are black and white and combinations of them—greys.

Additive system
The system of mixing the colors of light, as opposed to pigments—what paints are made of. The primary colors of light when combined add together to create white light. See also Subtractive system.

Analogous colors
Analogous colors are colors adjacent to each other on the color wheel. Analogous color schemes are based on two, three or more adjacent colors.

Asymmetry/Asymmetrical
Condition where the two sides of a garment or drawing are not symmetrical: they are not exactly the same.

Asymmetrical Balance
Compositional balance achieved between objects of different visual characteristics (e.g., shape, color, size) but with similar visual weight or attraction.

Axis/axis-line
The line that divides a figure (croquis) into two. Its position shifts according to changes in poses:iln the front view the axis line divides the figure into two symmetrical or balanced parts; in three-quarter view the figure is divided asymmetr-ically in the portions three to one; in "S curve" poses the axis line follows the curve of the body. It is often sketched in as a guideline

Balance
State of equilibrium among the different elements in a composition.

Black graphite pencil
Standard black pencils in either wooden or mechanical form.

Blending
In this book "blending" is the term used to refer to diluting marker color with colorless blender so less saturated, more transparent versions of the color are obtained. See descriptions and illustrations of blending in Chapter One: Materials and Technique.

Cast shadow
The shadow cast by an object onto a surface, for example that cast by buttons onto a coat. The cast shadow gives a three-dimensional effect to the object being drawn.

Chiaroscuro
Drawing technique dating from the Italian Renaissance, from the Italian words meaning light and dark. It is the use of ranges of values from light to dark to approximate the appearance of shadows on real objects, indicating the three- dimensional nature of objects portrayed in two-dimensional drawings.

Chromatic
The opposite of achromatic: literally, with color. All colors that are neither black, white nor greys are chromatic colors.

Chromatic neutrals
Neutral colors formed by mixing complementary colors as opposed to neutrals formed from achromatics.

Color
Light of a particular wavelength that creates a sensation of "color" in the brain when perceived by the eye.

Color accents
Small amounts of a single color applied as contrasts to the dominant color in a composition or outfit.

Color contrast
The various ways in which colors differ from and contrast with each other. These include (according to **Johannes Itten**):

Contrast of hue
Light-dark contrast
Cold-warm contrast
Complementary contrast
Simultaneous contrast
Contrast of saturation
Contrast of extension

Color chord
Groups of colors from non adjacent parts of the color wheel that combine in a harmonious fashion, similar to the combination of notes in a harmonious musical chord.

Color discord
Color discord occurs when two or more colors clash rather than harmonize with each other. See also Color harmony

Color dyad
Color chords formed of two complementary colors.

Color harmony
Pleasing color relationships or schemes based on groups of colors with formal relations within the color wheel (See also: analogous colors, color triads, color tetrads)

Color schemes
Systems for combining colors harmoniously. Color schemes are either formal, based on relations within the color wheel, or informal, based on looser principles.

Color temperature
The color wheel is roughly divided into warm and cool colors, with the warm centered around red and the cool around blue. Colors also have warm or cool aspects— warm or cool whites or neutrals are used extensively in fashion drawing.

Color triad
Three equidistant colors on the color wheel. When connected they form an equilateral triangle. Triads can be formed of primary, secondary or tertiary color combinations.

Color weight
The theory that different colors have different "weights" in relation to other colors. For example, pink is light, brown is heavy.

Color wheel
An ordering of the colors, (or "hues") of the spectrum of white light (with the addition of purple by Sir Isaac Newton) into a wheel, or circle, simplifying the study of relations among the different colors. Color wheels have also been created relating to the pigment (or "subtractive" colors). See: Chapter Two: Color and Design.

Colorless blender
The solvent that the pigment of markers is suspended in, but with no color pigment— hence "colorless". Colorless blender is available in tubes like markers and is an essential tool for mixing colors and creating a range of subtle effects with gradation of color.

Cold/cool colors
Colors on the blue side of the color wheel.

Complementary colors
Colors directly opposite each other on the color wheel. The primary complementaries are blue andorange, red and green, and violet and yellow. Opposing secondary colors and secondary/tertiary colors are also complementary colors. Complementary colors neutralize each other when mixed together in pigment form.

Content
In composition, the subject matter of a drawing (in FD the garments or accessories being drawn) as opposed to the form of the composition—the way the subject matter is presented.

Core light
A long highlight that forms on shiny fabric along the length of the leg or arm or other cylindrical form in close-fitting garments or similarly in transparent or semi-transparent fabric where the body underneath is perceived.

Croquis
The French word for "sketch" refers to the nine-head figure (an elongated figure whose length is equivalent to nine heads, as opposed to approximately eight heads in reality). The croquis is basic to all modern fashion drawing.

glossary of terms

Cross-hatching
A technique for representing shading/value in drawings usually with ink or pencil by layering series of parallel lines.

Design
Any ordered arrangement of visual components.

Design Elements/Elements of Design
The basic visual elements used in creating art and design: line, shape, form, space, value, texture, scale and color.

Design Principles/Principles of Design.
The principles underlying "good" compositional design. They are harmony/unity, focal point/ emphasis, balance, scale and proportion.

Details/constructional details
The smaller constructional parts of a garment that are visible, for example, top-stitching, buttons, hems, seams, cuffs, collars, trim. Often details are shown that appear constructional but are purely decorative and are included for stylistic reasons.

Drape
In general, the way a fabric made into a garment hangs on the human figure. The "drape" of a fabric or garment is the part of the fabric on the figure that hangs loosely and does not touch the figure. Different fabrics drape differently on the figure and often have a characteristic "drape."

Elements of Design
See Design elements.

Equilibrium
Balance achieved among different design elements in a composition.

Flat application of color
An application of a single color. When drawing fabric or skin tone, a single application of one color gives a flat, two-dimensional look. Three-dimensional effects require the application of more than one color in order to realistically represent the lighter and darker parts of the surface.

Focal point
Part of a composition emphasized so that the eye is drawn to it and then to the other parts.

Foreshortening
The way parts of objects appear to shorten the further they are from the viewpoint they are observed from, and the way this is accurately represented in drawing on a two-dimensional surface. A simple "flat" pose such as the standard front view croquis has no foreshortening. Complex poses where limbs extend towards and away from the viewer require parts of the body to be drawn with foreshorten **Form**

The purely visual aspects of a composition as opposed to its content—the information, idea or meaning being communicated.

Gradation of tone
Gradual changes in color and value observed particularly as a surface moves into and out of shade, and, in drawing, the corresponding subtle changes in tone used to represent this, achieved with markers by blending and layering of colors and introducing other pencils and other media.

Harmony
A pleasing combination of colors or the parts of a composition.

Highlight
Points or lines of light on the surface of a shiny fabric where no light is absorbed—it is all reflected and appears bright white. In FD highlights are usually shown by leaving the white of the paper to show through or by applying white pencil or gel pen onto the surface.

Hue
Literally, a color. In this book "hue" and "color" are used interchangeably. Elsewhere, sometimes "hue" is used solely to refer to one of the pure spectral hues, and "colors" are the variations of those hues. For example, in discussing the spectrum of white light, red would be a hue and crimson a color.

Imbalance
A state of non equilibrium among the different elements in a composition.

Implied line
A line with no physical appearance but "implied" by the extension of a gesture or points in a drawing so the eye follows the implied direction.

Intensity *See also* **Saturation**
The degree of saturation of a hue in a color. For example a red color is made more intense or saturated by adding more pure red; less intense or saturated by adding grey.

Layering
The application of different colors on top of each other, with a soft edge of each layer sometimes showing. Layering—sometimes called "underpainting"—gives depth and complexity to a colored area.

Line
Any mark whose length is greater than its width; the closest path between two points; the path described when a point moves.

Line quality
The basic characteristics of a line: weight, thickness, direction, and variation in thickness (nuanced line).

Linear perspective/perspective
System used in drawing and other two-dimensional art to create the illusion of three-dimensional space by representing the way objects appear progressively smaller, or parts of objects appear to get shorter (foreshortening) the further away they are from the viewing point. The way objects are depicted in correct perspective involves locating them inside parallel lines stretching from the viewing point to the horizon, hence the term linear perspectiv

Medium/artistic medium
The materials used in making a drawing or work of art.

Mixing
Colored markers are mixed to produce different colors according to the pigment subtractive process either by mixing directly tip-to-tip or using colorless blender. See: Chapter One: Materials and Technique.

Monochromatic
Literally, one color. A monochromatic color scheme is based on one color and its variations in value and saturatio

Negative space
The empty space around the figures and other objects in a composition.

Neutral colors/neutralizing
Neutral colors contain little or no color pigment, appearing subdued and sometimes dull. If they contain no pigment at all they are achromatic greys, white or black. If they do contain pigment they are close to grey, or mud-like colors. A color is neutralized by mixing it with an a neutral color or with its complementary color.

Nuanced line
A line with variations in thickness along its length.

Opaque
A surface or medium through which light cannot pass.

Palette
The physical tool used for holding colors. With oils, the palette is used to hold the prepared colors for application to the. canvas With markers, as the colors are applied directly from their tubes, palettes are used only for mixing purposes and are usually acetate sheet.
Palette also refers to the selection of colors used for a drawing—those that, traditionally, with oils, would have been mixed and placed on the palette before beginning to paint.

Pastels/ pastel colors
Pastels are crayons made of pigments in a dried paste. Pastel colors are pale and subdued colors.

Pattern
Repetition of a visual element in an object or drawing.

Pigment
The material usually held in solution or suspension which leaves its color when applied to a surface.

Plane
A flat, two-dimensional surface.

Point
An exact location; a dot, either visible or implied.

Primary colors
The three colors that cannot be obtained by mixing other colors and from which, in theory, all other colors can be mixed. The primary colors of light are red, green and blue. The primary colors of pigments are red, yellow and blue.

Principles of Design
See: Design Principles

Proportions
The relative sizes of objects. The proportions of different parts of the nine-head croquis used in FD are fixed, and measured in terms of whole and fractions of the size of the head.

Process colors
The colors used in commercial printing and photography: cyan, magenta, yellow and black (CMYK). Cyan, magenta and yellow approximate

glossary of terms

Process colors continued
the subtractive primaries red, yellow and blue. Using CMYK colors on a computer matches the colors on the screen to the colors used in printing.

Proximity
A design principle for unifying a composition by placing objects in a composition close to each other.

Realism/realistic drawing
Representational drawing based on accurate reproduction of the surface appearance of objects
as they are perceived. Showing objects as having three dimensions, depth as well as height and breadth, is a key part of realistic drawing where linear perspective and chiaroscuro techniques play important roles. Realistic elements can be combined with non-realistic, abstract elements, particularly where the emphasis is required on the realistic elements (e.g., abstract figures or hair with realistic clothes) (*See*: Representational drawing, Abstract-ion).

Reflected light
In FD, reflected light is the light reflected from the garments onto the skin or onto other garments. As a compositional device, showing the color of the garments reflected on the skin tone shifts the emphasis back to the garments so the face or figure itself do not distract.

Repetition
A device where a visual element is repeated to aid in unifying a composition.

Representational drawing
Drawing that represents a real object, either with realistic or abstract elements or a combination of both.

Saturation
The degree of intensity, or purity of a color. The saturation of colors is increased by adding more of a pure version of the same color or reduced by adding grey, black or white.

Secondary color
The result of mixing two primary colors. The secondary colors lie mid-way between the primary colors on the color wheel.

Scale
The relative sizes of objects in a drawing. Objects drawn to the same scale display the same ratio between their size in the drawing and the actual objects they represent (allowing for foreshortening if the objects are drawn with linear perspective).

Sfumato
Smoky effect involving hazy, softened outlines that shade off into each other.

Shade
A darker variation of a color created by adding black or a darker grey to the color.

Shading
Indicating the position of shadows on an object—in FD a garment, fabric or a figure—to give a realistic, three-dimensional effect. Two or more variations in the value of a color can be used to indicate the gradation of values from light to dark.

Silhouette
The outline of the shape of a garment, garment and figure or other object.

Simultaneous contrast
The effect of juxtaposing two complementary colors. The interaction of the colors makes each appear simultaneously brighter and more vibrant.

Space
In reality space has three dimensions, height, width and depth. In drawing, three-dimensional space is depicted on a two-dimensional surface through a range of techniques including linear perspective and realistic representation of light and shade.

Split complementaries
A color scheme based on three colors where a color is paired with the two hues adjacent to its complementary color on the color wheel.

Stippling
Technique for applying markers using a push-pull motion so marker is applied in dots. It is used, for example, in drawing lace or tweeds.

Subject
The principal content of a drawing.

Subtractive System
Objects are perceived to be of a particular color because their surfaces have absorbed, or "*sub-tracted*" all the constituent elements of white light except those of the color that is perceived. The subtractive system also refers to the way pigments, as opposed to rays of light, mix. Pigments filter out, or "subtract" certain frequencies of light waves corresponding to different colors. As more pigments are mixed together more and more colors are subtracted, resulting finally in black or near-black.

Symmetry
A quality of a composition where the elements on either side of a central axis are identical.

Tertiary colors
The colors that result from combining a primary color and an adjacent secondary on the color wheel. Each primary color can combine with two secondaries to give a total of six tertiaries.

Tetrad
A color scheme of four hues based on a square or rectangle defined by the position of the hues in the color wheel.

Texture
The surface quality of an object when felt. Although the feel or "hand" of a fabric cannot be directly represented in a drawing, fabrics of different textures can have markedly different appearances. If a fabric is drawn realistically and accurately a viewer who is familiar with fabrics will be able to intuitively sense how the fabric feels to the touch as well as how it appears.

Tint
The result of mixing white or a lighter grey to a hue.

Tonality
If a composition is dominated by a single hue or color, even though other colors are present, it is described as exhibiting a "tonality" of that color.

Tone
The result of mixing a color with grey, black or white, i.e., a tint or shade. Accurate depiction of colors in realistic light conditions involves reproducing subtle, continuous gradation of tones as the surface moves towards and away from the light source. *See also*: **Gradation of tone.**

Translucent
Translucent materials allow the passage of a certain amount of light but not sufficient to allow the forms of objects beyond the surface to be clearly distinguished.

Transparent
Transparent materials or surfaces allow the uninterrupted passage of light. In drawing, transparency is indicated when two materials or surfaces overlap but both are clearly visible.

Triad
A color scheme based on three colors from the color wheel, that are spaced at equal distances from each other and that form an equilateral triangle if connected. A triad is often regarded as the most balanced color scheme because the colors always stand in the same relation to each other on the color wheel as the relations among the three primary colors.

Unity
One of the basic principles of design stating that the different parts of a composition should be related to each other in unified whole.

Value
The degree of lightness or darkness of chromatic or achromatic colors.

Value emphasis
Creating emphasis or a focal point in a composition through use of a dramatic contrast in values.

Value contrast
The light and dark contrast existing between colors, both chromatic and achromatic.

Vibrating colors
Colors that create a vibrating or flickering effect where they touch. Usually seen with colors of contrasting hues and similar values.

Warm colors
Colors from the "warm" side of the color wheel, those closest to red/yellow.

Warm–cold contrast
The contrast between "warm" and "cold" (or cool) colors.

index

index

index

acknowledgments

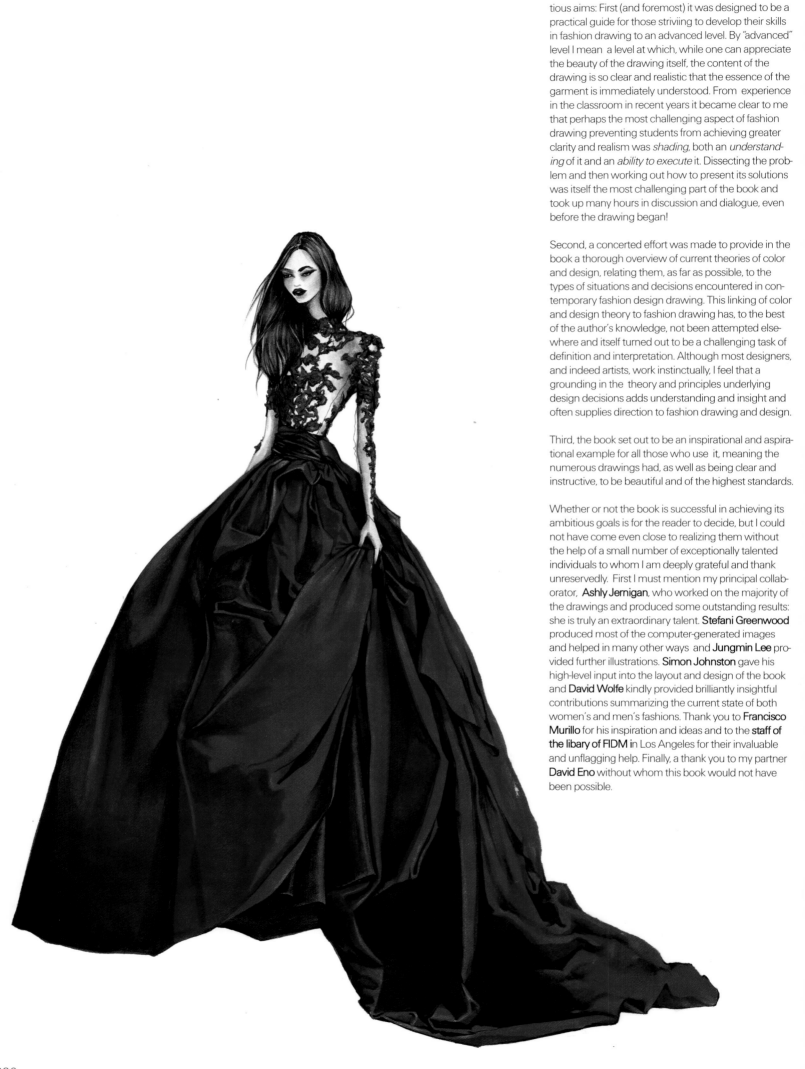

This book has had from the outset a number of ambitious aims: First (and foremost) it was designed to be a practical guide for those striving to develop their skills in fashion drawing to an advanced level. By "advanced" level I mean a level at which, while one can appreciate the beauty of the drawing itself, the content of the drawing is so clear and realistic that the essence of the garment is immediately understood. From experience in the classroom in recent years it became clear to me that perhaps the most challenging aspect of fashion drawing preventing students from achieving greater clarity and realism was *shading*, both an *understanding* of it and an *ability to execute* it. Dissecting the problem and then working out how to present its solutions was itself the most challenging part of the book and took up many hours in discussion and dialogue, even before the drawing began!

Second, a concerted effort was made to provide in the book a thorough overview of current theories of color and design, relating them, as far as possible, to the types of situations and decisions encountered in contemporary fashion design drawing. This linking of color and design theory to fashion drawing has, to the best of the author's knowledge, not been attempted elsewhere and itself turned out to be a challenging task of definition and interpretation. Although most designers, and indeed artists, work instinctually, I feel that a grounding in the theory and principles underlying design decisions adds understanding and insight and often supplies direction to fashion drawing and design.

Third, the book set out to be an inspirational and aspirational example for all those who use it, meaning the numerous drawings had, as well as being clear and instructive, to be beautiful and of the highest standards.

Whether or not the book is successful in achieving its ambitious goals is for the reader to decide, but I could not have come even close to realizing them without the help of a small number of exceptionally talented individuals to whom I am deeply grateful and thank unreservedly. First I must mention my principal collaborator, **Ashly Jernigan**, who worked on the majority of the drawings and produced some outstanding results: she is truly an extraordinary talent. **Stefani Greenwood** produced most of the computer-generated images and helped in many other ways and **Jungmin Lee** provided further illustrations. **Simon Johnston** gave his high-level input into the layout and design of the book and **David Wolfe** kindly provided brilliantly insightful contributions summarizing the current state of both women's and men's fashions. Thank you to **Francisco Murillo** for his inspiration and ideas and to the **staff of the libary of FIDM in** Los Angeles for their invaluable and unflagging help. Finally, a thank you to my partner **David Eno** without whom this book would not have been possible.